Elementary Air Survey

Elementary Air Survey

W. K. KILFORD
M.A.(Cantab.), C.Eng., M.I.C.E., F.R.G.S.
*Formerly Senior Lecturer in Estate Development at the
North East London Polytechnic
Now Lecturer in Civil and Structural Engineering
at the University of Sheffield*

THIRD (METRIC) EDITION

Pitman Publishing

Second edition 1970
Third edition 1973

SIR ISAAC PITMAN AND SONS LTD.
Pitman House, Parker Street, Kingsway, London, WC2B 5PB
P.O. Box 46038, Portal Street, Nairobi, Kenya

SIR ISAAC PITMAN (AUST.) PTY. LTD.
Pitman House, 158 Bouverie Street, Carlton, Victoria 3053, Australia

PITMAN PUBLISHING COMPANY S.A. LTD.
P.O. Box 11231, Johannesburg, S. Africa

PITMAN PUBLISHING CORPORATION
6 East 43rd Street, New York, N.Y. 10017, U.S.A.

SIR ISAAC PITMAN (CANADA) LTD.
495 Wellington Street West, Toronto, 135, Canada

THE COPP CLARK PUBLISHING COMPANY
517 Wellington Street West, Toronto, 135, Canada

©
W. K. KILFORD
1970, 1973

Cased edition ISBN: 0 273 36187 2

Paperback edition ISBN : 0 273 25204 6

Printed in Great Britain by Bell and Bain Ltd., Glasgow
G2—(T.1259/1364 : 73)

PREFACE TO THIRD EDITION

THE main purpose of this new edition has been to complete the change to metric units. This has made some elementary relationships rather less easy. By far the most popular focal length used in air cameras is 6 inches (152·4 mm). This was very convenient for elementary calculations in imperial units in that it meant that the flying height in feet was just half the scale number. In this edition, in common with normal practice, the individual references will usually be to a nominal focal length of 152 mm, and in most examples the calculations will be simplified by rounding the figure to 150 mm.

The opportunity has been taken to incorporate a little information in Chapter 7 on plotting from obliques, and to introduce two new chapters, one dealing with a range of commercially used plotting instruments, and the other with photo interpretation.

Since the first publication of this book, many more groups of individuals have become interested in air survey, and although land surveyors, civil engineers, cartographers, and geographers specializing in Surveying will probably need to read the whole book, it is thought that many other students will find the contents easier to assimilate if some parts are omitted. Provided that proper use is made of the index when unfamiliar terms are encountered, it is felt that those persons requiring only a general understanding of the use of air survey and air photographs (e.g. geographers, general surveyors, and town and country planners) will find the following reading pattern adequate—

Provided that the reader has a little understanding of photography, he can begin at page 12, with "TYPES OF PHOTOGRAPH USED IN MAP MAKING" and read the rest of Chapter 1 followed by Chapters 2 to 7 inclusive, but omitting—

in Chapter 2, all under the main heading "ANHARMONIC RATIOS AND TILT ANALYSIS" (pages 39–47),

in Chapter 3, pages 57–65,

in Chapter 5, the details of internal adjustment of the graphical radial-line plot (pages 105–108), and all under the main heading "ANALYSIS OF ERROR",

in Chapter 7, (pages 114–9), all under the sub-heading "Optical Rectifiers" (pages 149–58),

then read Chapters 13 and 14.

Chapter 11 goes beyond the simple graphical methods of Chapters 5, 6, and 7; but many will actually find the Multiplex easier to understand.

January, 1972 W.K.K.

PREFACE TO FIRST EDITION

DURING the past eight years I have been teaching air surveying to potential land surveyors and civil engineers, and have always been seriously hampered by the complete lack of any suitable comprehensive but understandable introductory textbook. This book is an attempt to remedy the situation. It has grown up gradually over several years, and many classes of students have contributed either directly or indirectly to its present form. It is mainly concerned with the use of " vertical " air photographs, and the " simple " methods of map-making have been dealt with fairly fully, because they help to explain the basic theory behind the more advanced methods of machine plotting, which are introduced in the final chapter.

Help in compiling and correcting the work has come from so many sources that it would be impossible to mention them all, but I feel that I must express my thanks to Dr. H. Lowery, the Principal of my College, whose backing was the spur I needed to begin the work. I must thank my colleagues and the many students who have been concerned in so many different ways, and in particular I must acknowledge my indebtedness to Mr. B. R. Jones, some of whose practical exercises are included in the text. The other group who have been especially helpful are the manufacturers of the various instruments, and some of the air survey firms. Not only have these commercial concerns supplied most of the photographic illustrations between them, but they have been very helpful in supplying full literature on the most modern instruments and techniques. In dealing with map-reproduction I must acknowledge the modernizing influence of the management and staff of Messrs. Geo. Philip and Son Ltd., and express my thanks to Mr. D. Corkett of Pictorial Machinery Ltd.

References to other works are given at the end of each chapter. These are intended not only to furnish further information relevant to the subject matter of the particular chapter but also to give the opportunity of studying the subject from a different point of view. Few references are given for the earlier chapters, but Chapter 11 is intended mainly to prepare the way for further, more detailed, reading.

The beginner is recommended to read this book through fairly quickly first, and to read it again more closely before following up

the references to other works. The first reading could omit the whole of Chapters 8, 9 and 11, and part of Chapter 7 from " Optical Rectifiers " onwards, the example at the end of Chapter 5 and the latter part of Chapter 4 under the heading " Modern Trends in Air Navigation " could also be omitted.

To save unnecessary repetition of the full particulars of any book, the more frequently used references are listed as a brief bibliography, placed immediately in front of the index. For books in this list the references given at the end of any chapter will record only the author's name.

1962 W.K.K.

ACKNOWLEDGMENTS

THE author wishes to thank the following organizations for permission to use questions from some of their past examinations—

The Institution of Civil Engineers
The North East London Polytechnic
The Royal Institution of Chartered Surveyors
The University of Reading
The University of Sheffield

He also wishes to give acknowledgment to the following firms who have kindly supplied photographs and information which has been incorporated in the book.

Abrams Instrument Corporation, Michigan, U.S.A.; The Aeroflex Corporation, New York, U.S.A.; The Aero Service Corporation, Philadelphia, U.S.A.; Bausch & Lomb Optical Company Ltd., London, W.C.2.; C. F. Casella & Co. Ltd., London, W.1.; Chicago Aerial Industries Inc., Illinois, U.S.A.; Fairchild Camera & Instrument Corporation, New York, U.S.A.; Fairey Air Surveys Ltd., Maidenhead, Berks.; Officine Galileo, Florence, Italy; Hilger & Watts Ltd., London (now Rank Precision Industries Ltd.); Hunting Surveys Ltd., Boreham Wood, Herts.; Ilford Ltd., Ilford; P. B. Kail Associates, Colorado, U.S.A.; The Kelsh Instrument Company Inc., Maryland, U.S.A.; Kern & Co. Ltd., Aarau, Switzerland; Sidney R. Littlejohn & Co. Ltd., London, N.7; Ottica Meccanica Italiana, Rome, Italy; Pictorial Machinery Ltd, Crawley, Sussex; Société d'Optique et de Mécanique de Haute Précision, Paris XXme, France; Waite & Saville Ltd., Otley, Yorks; Wild Heerbrugg Ltd., Heerbrugg, Switzerland; Williamson Manufacturing Co. Ltd., London, N.W.10; Zeiss Aerotopograph, Munich, Germany; Carl Zeiss, Jena.

CONTENTS

CHAPTER 1

Introduction to Maps and Air Photographs

Broadly speaking, we can regard the production of a map for sale to the public as a combination of three main processes—

 1. the choice of projection, and design of the map sheets and sheet system,

 2. the survey and drawing,

 3. the reproduction of the map in large numbers.

Chapter 8 deals briefly with reproduction, and the rest of the book is devoted mainly to one method of carrying out the survey and plotting the map detail. The aim of this second process is the production of a map or plan suitable in every way for the specified purpose, and capable of being reproduced in the numbers required.

Design is outside the scope of the book, but a note on projections seems desirable.

In a mapping operation, a relatively few ground points are first chosen, and their latitude and longitude are very accurately determined. This is the work of the geodetic surveyor. The points are usually known as Trig. points (short for trigonometrical).

The surface of the earth, if we ignore the hills and valleys, forms approximately an oblate spheroid, which is a slightly flattened sphere. As with the sphere, the surface of the earth is not developable (a hollow sphere cannot be flattened without fracture or buckling). Thus although the positions of the Trig. points are very accurately known they cannot be plotted on a plane sheet of paper so that they are correctly positioned relative to one another: this is the problem of map projections.

A map projection is a set of rules specifying the exact pattern which will be made on the map by the lines of latitude (parallels) and lines of longitude (meridians). The pattern is known as the graticule. There is an unlimited variety of projections, each being particularly suitable for some special purpose. For general purposes at medium scales we normally require that bearings remain correct and that the scale error at any point is kept to a minimum.

After the graticule has been drawn the Trig. points are plotted in relation to it. Then the position of each point of detail is determined

relative to the Trig. points and plotted accordingly; this is the work of the topographical surveyor. In practice a squared grid would be plotted instead of the graticule and the position of the Trig. points would then be plotted in relation to the grid. Latitude and longitude of each point are converted mathematically into the grid equivalent.

The field work for a topographical survey will be carried out either by ground methods (e.g. a theodolite traverse or a plane table survey) or by a photogrammetric plot. It is with the latter method that this book is concerned, and we shall consider how to plot the map detail relative to the plotted position of Trig. stations, or other ground control.

So far we have ignored height differences and have spoken only of " planimetric " detail. The stereoscope (see Chapter 3) enables us to reconstruct a three-dimensional image from two separate photographs of the same area of ground. Height differences in this " model " can actually be measured. The technique is fairly complicated and the accuracy of the " simple " methods is comparable only with cruder methods of " levelling " in the field; but the method as used in some expensive automatic plotting machines gives much greater accuracy.

Maps at scales larger than about 1 in 10,000 are usually referred to as plans. The essential difference between a plan and a map is that in the former all detail is shown to scale, whereas on maps certain detail is shown by conventional notation; such details as roads, for example, might be shown of exaggerated width so that they stand out better. The surveys for plans are generally known as Engineering or Cadastral surveys according to the required use of the plan. Photogrammetry can be used for this type of work but this is a specialized branch of the subject and nearly always entails the use of the more complicated instruments which are introduced in Chapter 11.

BRIEF HISTORY

Photography began some two hundred years ago and it was soon realized that photographic images were formed according to the laws of perspective and that if two photographs were taken, one from each of two stations, then any point which appears on both photographs could be located in space.

During the nineteenth century little real progress in photogrammetry was made as photographic technique itself was still crude and the preparation of plans was slow and laborious. However, the possibility of air surveys from balloon photographs had been considered and experiments were made.

It was the impact of war which caused the recent developments in photogrammetry. Air photographs were of considerable value in piercing camouflage and even in the First World War it was realized that maps could be made from vertical air photographs which were at first taken with hand cameras. The technique of making maps from such photographs has progressed steadily, and although the principles involved are quite simple, the machines and the graphical plotting methods are intricate. Before these processes can be understood we must have some basic knowledge of photography which in turn requires an elementary understanding of light.

LIGHT

Light can be thought of as a vibration, the rays travelling in ways similar to those of sound waves. Thus, like ocean waves, a lightwave has length and periodicity. The latter is the frequency with which the pulsations repeat themselves in a given period of time.

$$\therefore \text{ velocity} = \text{wavelength} \times \text{frequency}$$

The velocity of light in air is approximately 299,000 km/sec. We may regard this as constant, so that frequency must vary inversely with wavelength. Pulsations giving rise to light have varying wavelengths: visible light consists of waves between about 0·40 microns and 0·70 microns, but similar vibrations having both greater and lesser wavelengths also occur. (A micron is a one-millionth part of a metre.)

Variations in wavelength give rise to the sensation of colour changes. Daylight is often described as white light and comprises light of all the visible wavelengths intimately mixed together.

The three basic laws relating to light are—

1. Light travels in a straight line in a homogeneous medium. That is it travels in a straight line during its journey through the air unless some object other than air lies in its path.

2. When light meets an opaque surface it is reflected back from the surface in such a way that the angle of reflection equals the angle of incidence (see Fig. 1.1). Both reflected and incident rays lie in the same plane. The surface will absorb light of some colours and reflect others. If only the blue light is reflected the object appears blue, and if only red light is reflected the object appears red. If all the light is absorbed the surface will appear black, whereas if it is all reflected the object will look white.

3. When a light ray passes from one medium to another medium of different density (e.g. from air into glass) the ray is deflected.

This is known as refraction, and the incident ray, the normal to the surface, and the refracted ray, all lie in the same plane (see Fig. 1.2). The angle between the incident ray and the normal is known as the angle of incidence, and the angle between the refracted ray and the normal is known as the angle of refraction. The sine of the angle of refraction is proportional to the sine of the angle of incidence—

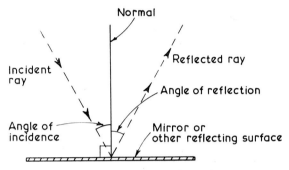

FIG. 1.1. REFLECTION OF LIGHT RAYS

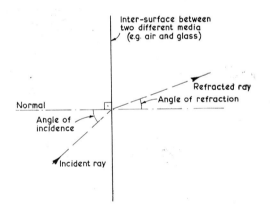

FIG. 1.2. REFRACTION OF LIGHT RAYS

$$\frac{\text{sine of angle of incidence}}{\text{sine of angle of refraction}} = \text{a constant}$$

When the incident ray is in dry air, this constant is called the *refractive index* of the second medium, and is often denoted by *n*.

When light passes through a glass prism it is refracted in such a way that the shorter the wavelength, the greater the amount of refraction.

White light is thereby split up into constituent parts of the colour spectrum, popularly known as red, orange, yellow, green, blue indigo and violet. Such a spectrum occurs naturally in the rainbow. The list of colours given above is in the order of decreasing wavelengths and increasing frequencies but the list is misleading in that there is an infinite number of colour shades in the spectrum. A more practical way of dealing with the problem is by considering the spectrum as split into three almost equal groups of colours: blue-violet, green, and red. In Fig. 9.8 it will be seen that rays of longer wavelength than red are known as *infra-red* because they are of lower frequency than the red rays, and rays of greater frequency than the blue-violet group are known as *ultra-violet*. These rays are not visible, but their effect on things other than the eye is similar to the effect of the rays of the visible part of the spectrum.

THE PIN-HOLE CAMERA OBSCURA

The pin-hole camera was probably known at least as early as the eleventh century. It consists of a closed box from which light is completely excluded except through one small pin-hole. If the

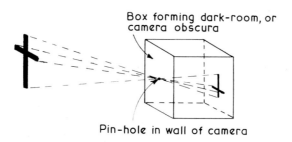

Box forming dark-room, or camera obscura

Pin-hole in wall of camera

FIG. 1.3. THE PIN-HOLE CAMERA

pin-hole is small enough and is made in very thin metal, an image will occur on the inside of the opposite side of the box. As in Fig. 1.3, this image will be both inverted and reversed.

There are substances which are altered when they are acted upon by light. If the rear wall of a pin-hole camera were coated with one of these substances, a photographic image could be obtained.

In modern cameras a lens is used instead of the pin-hole and the light-sensitive substance is coated in a thin film on a transparent base material. Light falling on the film will cause a change in

chemical composition; this is known as a photo-chemical change. Subsequent processing causes a purely chemical change which will remove that part of the film remaining unaffected by light leaving an opaque substance representing the bright areas of the picture; the transparent base is exposed over the remainder of the image. Thus we obtain a picture, or negative copy, on which bright objects are represented by dark and opaque areas, and dark objects by transparent areas. It is the reversal in tone values which makes the image negative.

THE NEGATIVE

There are many chemical substances which change in some way when exposed to light. In modern photography, one group of such chemicals, the silver halides, is used for all negative production. Halides include chlorides, bromides, iodides and fluorides. One of the older processes for producing negatives on glass plates is the wet collodion process which has remained in use because the light-sensitive plate can be made on the photographer's premises and it allows him more latitude in adjusting the exact properties of the plate. Some map-reproduction works still use this process but the improved range of qualities of dry-plates has gradually reduced the use of the wet process.

Collodion

Collodion is a solution of pyroxyline (gun-cotton) in ether or alcohol, forming a gummy liquid which will spread evenly and thinly on to a glass plate. One or more of the following are added to the collodion: the iodide, bromide or chloride salts of ammonia, cadmium, lithium, strontium or calcium. The " iodized " collodion is left to " ripen " until the accumulation of free iodine causes the solution to take on a reddish hue; this may take about a fortnight. The choice of salts will influence the quality of the collodion, e.g. a cadmium salt will increase the hardness and durability of the final image.

When it is ripe, the collodion is spread on to the glass plate by pouring a small amount on to one corner of the plate, and then tilting it so that the bulk of the solution passes gradually round the surface and then the surplus collodion is allowed to drain off. A satisfactory even covering can be obtained in this way provided that the glass itself has been thoroughly cleaned by oxidation, usually by sulphuric acid. Adhesion used to be assisted by first coating the plate with egg-albumen but nowadays a rubber edging is usually fixed to the face of the plate.

The collodion film is left to set and then the plate is sensitized by dipping in a " silver bath " consisting of a solution of silver nitrate. This is the trickiest part of the proceedings since the whole plate must be immersed at the same instant. The silver nitrate reacts with the iodides and bromides to form silver iodide and silver bromide. The plate is again drained, and should then be exposed in the camera.

When the silver salts are exposed to the light they change their physical composition but no change is apparent to the eye, and we say that exposure in the camera gives rise to a *latent image*. The image is developed, or rendered visible, by treating the plate with a reducing agent such as a solution of ferrous sulphate, which causes metallic silver to be precipitated. This silver is deposited only on that part of the film which was affected by the light and the density of silver particles will faithfully record the intensity of light at any point.

The image is then rinsed and surplus silver salts are removed by " fixing ", i.e. washing in a solution of potassium cyanide, which is a solvent of silver iodide. The silver now forms an opaque image on the transparent background of the glass plate.

Collodion plates must be used as soon as they have been sensitized, and developed immediately after exposure.

The Modern Roll Film

The more usual type of negative is manufactured in bulk in the form of pliable film. This may be stored for a time before use and need not be developed immediately after exposure. This is the type of negative used in present day air-cameras, and is similar in most respects to the film used in modern snap-shot and cine cameras.

There are two main components of a film: the base material, and the emulsion in which the sensitizing material is suspended.

The sensitizing material is composed of a mixture of silver nitrate, potassium iodide, potassium bromide, and gelatine. After setting, the mixture is ground into small particles and washed free of unwanted salts. The most important constituent is now silver bromide which appears in granular form as very minute crystals. This mixture, in the form of a milky suspension, is spread on the film base.

Exposure to light again results in the formation of a latent image which is developed chemically. As before, the final image is formed of metallic silver, this time in the form of very minute matt black particles. The amount of silver deposited per unit area governs the opacity, and therefore the " density " of the negative.

The main attributes of a negative are that—

1. It shall record clearly as much detail as possible; this is known as *resolution* or *definition*.

2. The relative position of each point in detail shall be accurately recorded, i.e. *distortion* shall be at a minimum.

The gelatine is more than a suspending medium; it is transparent, hard when dry, and allows penetration of the developer. It also assists the growth of silver halide crystals, prevents the developer from acting on the non-light-affected halide crystals, and increases the sensitivity to light of these halides.

The requirements of a film base, or support, are that it should be thin, transparent, pliable, strong, and unaffected by changes in temperature and humidity. (An air-camera is exposed to great and rapid changes of temperature as the altitude changes.)

The normal base material is cellulose acetate or triacetate which is transparent, thin, pliable, and far less inflammable than its predecessor, cellulose nitrate. The main attribute in which this base is inferior to glass is that of stability. This quality is so important in photogrammetry that a special base material has been developed; cellulose butyrate (a polyester) is so little affected by expansion and contraction that it is known as *topographic base*, a term usually reserved for materials which are sufficiently stable to be used as bases for fair-drawing of topographic maps.

Besides temporary expansion or contraction, the base material is also subject to gradual chemical change which may cause brittleness and, if subjected to strain, it may yield by plastic flow.

THE POSITIVE PRINT

A contact print (see Fig. 1.4) is made by placing a sensitized piece of paper under a negative and passing light through the negative. This operation may be carried out in a machine similar in principle to the vacuum frames shown in Fig. 8.8. Since the sensitized paper is in contact with the negative image, this is known as a contact print. The paper is sensitized with a thin film of silver halides, and its reaction to light and development is similar to that of the negative emulsion. The opaque parts of the negative will, of course, allow less light to pass through than the more transparent parts, and the image will suffer a reversal in tone values. Thus on the positive prints the highlights will be represented by light-toned areas, and shadows will be represented by dark tones; it is therefore a positive image.

Positive prints are sometimes made on glass, when they are transparent and are known as *diapositives*. Paper prints are cheaper

and easier to handle; they are therefore preferred for most simple photogrammetric purposes though diapositives are used in most of the larger plotting machines.

Ideally a print is required to reproduce all the information contained on the negative, without loss of resolution, and without

FIG. 1.4. A CONTACT PRINT (shown reduced from 230 mm × 230 mm)
(*Fairey Surveys Ltd.*)

further distortion of the image. Perfection in these respects is almost achieved with a diapositive but paper prints are relatively unstable and usually involve a slight loss of resolution especially in the lightest and darkest tones.

The raw material of the photogrammetrist is normally the contact print which is necessarily of the same scale as the negative. It consists essentially of a paper base and a sensitized emulsion. The

latter is nearly always sensitized with silver bromide or silver chloride and the processing is very similar to that of negatives.

The Paper Base

In the manufacture of paper, the sheets are made by pressure rolling. If the rolling is only in one direction the fibres tend to arrange themselves so that their longitudinal axes lie parallel with the direction of rolling. Such a paper would be liable to expansion and contraction (caused by changes in humidity and temperature), mainly in the direction of rolling. A photograph on such a paper would thus be liable to a change in shape. This is known as differential expansion and contraction, and is minimized in modern paper manufacture. When expansion and contraction is much the same in all directions it is of relatively little consequence since it only has the effect of a general change of scale.

There are a number of grades of printing paper—

1. *Single-weight paper* is very unstable but it is used for model making where the print needs to be stretched to fit the three-dimensional model. It is sometimes used for uncontrolled mosaics.

2. *Double-weight paper* is more stable and is used for all ordinary purposes, including the making of controlled mosaics.

3. *Waterproof paper* is the most stable of the paper bases, except in and near the tropics.

4. *Aluminium-foil* is more stable than any paper base and is used for special purposes only, usually sandwiched between layers of paper.

The Emulsion

The emulsion may have a matt, semi-matt or glossy finish. The last will give greater reflectivity and consequently a brighter image, but a matt surface is better for writing on. For general work a semi-matt finish will be specified.

The duration of the exposure will depend on the density of the negative and must usually be determined by experience.

THE SIMPLE LENS

We must now consider the general effect of the simple lens on the incident light rays. For the moment we will consider the simple lens to be a flat circular disc of optical glass. If the lens is very thin then it can be considered as lying in one plane, known as the *plane* of the lens. The *axis* of the lens is then that line which is perpendicular to the plane of the lens and passes through the centre of the lens.

If we imagine a point source of light then rays of light will be broadcast along a series of straight lines from this point. This deviating group of rays is known as a pencil of light. In practice there is no such thing as a point of light, and light from a finite source forms a group of pencils known as a beam. In air photography, the light has travelled thousands of feet to the camera, and the rays reaching the camera from a ground object can be thought of as forming a beam of parallel rays. Although we have spoken of " sources " of light, this light is really reflected sunlight.

Focal length

In the theoretically perfect thin lens, the main purpose of the lens is to replace the pin-hole in the pin-hole camera. It captures the

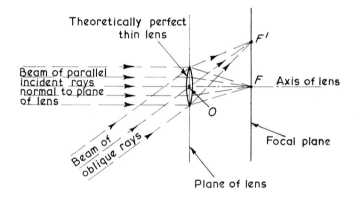

FIG. 1.5. THE FOCAL PLANE IN RELATION TO A THIN LENS
O is optical centre
F is one of principal foci or focal point
OF is focal length
FF' is focal plane

beams of parallel rays and concentrates each beam to re-form the image of the object from which the rays emanated. This action is shown in Fig. 1.5 and is known as focusing. The object lying along the axis of the lens will be brought into focus at the principal focal point F in Fig. 1.5. If O is the optical centre of the lens, then OF is the focal length of the lens. All other points should come into focus in the *focal plane* which is a plane perpendicular to the lens axis and containing the *principal focus F*. In Fig. 1.5, F' is a typical image point in the focal plane. Since the image is formed in the focal plane, the film should lie in this plane at the moment of exposure.

The effective area of the focal plane in the camera is usually

square, and is known as the format. As this governs the maximum size of the negative and therefore of the print, the dimensions of the image area of the print are usually referred to as the *size of format*.

TYPES OF PHOTOGRAPH USED IN MAP MAKING

Photographs of the ground can be taken with the optical axis of the lens vertical, horizontal or inclined to the vertical at some oblique angle. This gives rise to the classification of photographs as—

1. verticals;
2. obliques;
3. ground (or horizontal or terrestrial).

1. A vertical photograph will record an impression of the ground similar to that shown on a map. If the ground were perfectly flat, and the optical axis truly vertical at the moment of exposure, then the resulting photograph would be a map representation of the ground, although all objects would be shown photographically and not by conventional signs. Photographic maps such as these are sometimes produced by joining parts of a number of vertical photographs; they are then known as mosaics (see Chapter 7). Mosaics suffer from excess of detail and are not sufficiently accurate to be used as maps for all purposes.

Unfortunately for our purpose the ground is rarely flat, and the great difficulty in keeping an aircraft completely steady means that an exposure made when the optical axis is truly vertical is very rare. The term vertical is therefore usually extended to include all photographs taken with the axis so nearly vertical that they may be used in the standard graphical plotting methods. These are the photographs with which this book is mainly concerned.

The term " near vertical " should normally be avoided, as some people use it to indicate the photograph which we have just mentioned, whilst others use it to denote a photograph which is so nearly vertical that it can be used as such, *except* for plotting by simple graphical methods.

2. Obliques are photographs taken with the optical axis of the camera inclined. That is, they are neither verticals nor ground photographs. Maps can be plotted from obliques but the methods are different from those employed with the first class of photographs. We shall consider some of the geometrical properties of obliques in Chapter 2.

(*a*) High obliques are photographs which include the image of the horizon and are sometimes called horizon obliques. They are taken with the optical axis of the lens making a " high " angle with the vertical.

(*b*) Low obliques include all other oblique photographs. They do not possess the easy geometrical relationships of verticals, and they do not cover as large an area as high obliques.

3. Ground photographs are taken from ground stations with the optical axis of the lens horizontal. The views produced are those familiar to our eyes.

THE AIR CAMERA

The basic air camera is similar in principle to the ordinary hand camera, though it is fully automatic in working and is adapted to its specialist role. There are many different makers each of whom

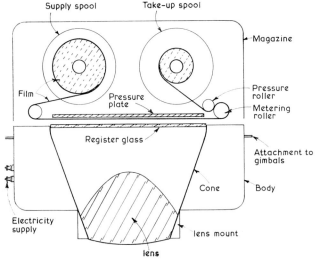

FIG. 1.6. A LONGITUDINAL SECTION THROUGH A BASIC AIR CAMERA
N.B. In a vacuum type the register glass would be omitted and the pressure plate would be relabelled " locating back."

produces a range of different types. Although some of these cameras are designed for some special conditions of operation, and in spite of the recent developments in design, it can still be said that all cameras now in use are basically similar in construction.

Figure 1.6 shows a diagrammatic section through a typical simple air camera. (See also Figs. 1.7 and 1.8). Such a camera comprises—

1. the lens; 2. the lens cone;
3. the body; 4. the magazine;
5. the shutter; 6. the gimbal mounting.

Fig. 1.7. RC10 Camera and Accessories
(*Wild Heerbrugg Ltd.*)

Fig. 1.8. Eagle IX 152 mm MK. 2 Camera
(*Williamson Manufacturing Co. Ltd.*)

The Lens

In practice, all camera lenses are of a complex nature and can be said to comprise two or more of the individual lenses shown in Fig. 1.9.

Figure 1.10 shows an outline section through such a complex lens with the central ray of each beam entering and leaving the lens.

FIG. 1.9. TYPICAL SINGLE LENSES (CROSS-SECTIONS)

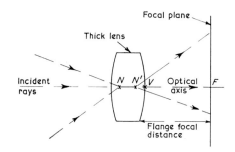

FIG. 1.10. NODAL POINTS IN A COMPLEX LENS
(Outline section only)

N = front node N' = rear node
V = vertex of rear glass F = principal focus
VF = back focal distance

The incident rays are seen to converge to a point N; these all pass along part of the optical axis, and then diverge from the point N'. Each of these emerging rays follows a path parallel to its direction at incidence. N and N' are called nodal points or Gauss points: N is called variously the node of admission, front node, or exterior perspective centre; N' is the node of emergence, back node, rear node or interior perspective centre. It is the rear node which is assumed to be the perspective centre S in the perspective diagrams of Chapter 2.

Equivalent focal length is the focal length of a thin lens which may be said to be equivalent to the complex lens under consideration.

It becomes the perpendicular distance from the rear node on to the focal plane. Note that the *principal distance* is the perpendicular distance from the rear node on to the plane of the negative at the time of exposure, and is therefore an attribute of the camera rather than of the lens.

Calibrated focal length is the focal length determined when calibrating, i.e. testing, the lens experimentally.

When making actual measurements during calibration of a camera, it is not possible to locate the rear node accurately, so that the principal distance and focal length cannot be measured. It becomes necessary to make two other measurements (see Fig. 1.10)—

1. *The back focal distance* (*VF*) which is the perpendicular distance from the vertex of the rear glass of the lens to the focal plane.

2. *The flange focal distance* which is the perpendicular distance from the mounting flange of the rear glass to the focal plane.

Lens Mount and Cone

The special feature of the lens cone is that it excludes all light, other than that entering through the lens, from that part of the camera lying between the lens and the focal plane, whilst at the same time allowing sufficient room for the legitimate rays of light at the time of exposure. It is responsible for maintaining the correct lens to focal plane relationships and is the part of the modern camera which represents the room itself in the original pin-hole camera.

The mount is the frame holding the lens and securing it to the lens cone. A badly designed mount might cause a masking of the lens, with consequent loss of definition at the edges of the negative. This is known as vignetting, a photographers' term denoting that the image shades off gradually into the border of the picture. It is by its reflection of light rays that the mount may effect this gradual reduction in definition towards the edges.

Flare light is any haphazard arrangement of light rays within the lens cone. The effect is to reduce the sharpness of tone changes over all or part of the negative, giving an appearance of fogging. The main cause of flare light is light scatter of incident rays when they are deflected on meeting dust particles on the lens or within the cone of the camera. The " ground " surface of a worn lens might cause the same effect, or it could be caused by the reflection of rays from the sides of a lens cone which was too narrow.

The Camera Body

The body is that part of the instrument which attaches the lens cone and magazine to the gimbal mounting and in modern cameras

it may form the inner ring of the gimbal mounting. It contains the main mechanisms and an example is shown in Fig. 1.11.

The altimeter, timepiece and serial number counter are housed in the wall of the body and are photographed through pinhole orifices,

FIG. 1.11. EAGLE IX BODY
(*Williamson Manufacturing Co. Ltd.*)

or small lenses, so that their images appear in the margin of the negative; thus the altitude, time and serial number are automatically recorded at the moment of exposure.

The Film Magazine

The magazine comprises two main parts: the spools for carrying the film, and the pressure plate as shown in Fig. 1.6. There are two spools: the supply spool and the take-up spool (see also Fig. 1.12). A mechanism causes the film to wind on to the take-up spool between exposures but it must be accurately synchronized with the shutter so that there is no film movement during the time of exposure. If the drive were direct to the take-up spool, then as the film wound on to this spool so the effective diameter of the spool would increase and the movement of the film per revolution would also increase. Suppose four revolutions of the unloaded spool are required to move the film through a distance equal to the length of the format. If the mechanism were set so that exactly four revolutions of the spool occurred between exposures, then the leading edge of the second negative would just touch the trailing edge of the first but there would be a narrow strip of unused film between the second and third negatives. The width of this piece

of unused film between pairs of consecutive negatives would increase as more film was wound on to the take-up spool and there would be a considerable wastage of film. Some means of reducing the speed of revolution as more film is wound on must be used. This is generally achieved by introducing a metering roller as in Fig. 1.6. The drive may be direct to this roller, in which case the speed of revolution and movement of the film will be constant and a spring-loaded mechanism for rotating the take-up spool to make up

FIG. 1.12. EAGLE IX (F.96) CAMERA MAGAZINE (305 m)
(*Williamson Manufacturing Co. Ltd.*)

the slack in the film is all that will be required. Sometimes the drive will be to the spool, and the metering roller will merely stop the mechanism as soon as it has revolved the correct number of times. In either case the film will normally be kept in close contact with the metering roller by another pressure roller, so that no slipping of film relative to roller will take place.

In order that there is no slack in the film between the two spools, the supply spool must be fitted with an over-run brake whose function is to stop this spool turning immediately there is any lessening in tension in the film.

The capacity of the magazine is related to the length of film which can be loaded at any one time and to the maximum width of film. Magazines are nearly always detachable so that the camera may be

reloaded in the air. Besides giving additional capacity, spare magazines are desirable in case of failure because the magazine usually contains the most intricate moving parts in the camera.

One of the most difficult operations in the camera is to ensure that at the moment of exposure the film is absolutely flat and in the focal plane. The difficulty is increased by the fact that between exposures the film must be free to move and in such a way that no scratching results.

Film Flattening Devices

There are four methods of holding the film in the focal plane during exposure—

1. direct tension;
2. mechanical pressure on to a glass plate;
3. air pressure against a locating back;
4. suction by creating a vacuum in the locating back.

1. *Direct tension* is exerted by the pull of the spring-loaded take-up spool against the brake of the supply spool. This is only possible where the length of format does not exceed about 100 mm and is never used in an air camera.

2. *The glass plate* is placed so that its rear surface lies in the focal plane. At the time of exposure the film is pressed against this surface by a pressure pad (see Fig. 1.6) which is released while the film is being wound on. There will be distortion of the image due to the rays passing through the glass plate, but this can be largely offset by adjusting the distance of the focal plane from the lens. The glass must be kept perfectly clean to prevent light scatter, scratching of the film, and to minimize the build-up of static electricity. The last-named is an accumulation of electricity, which eventually discharges causing a phenomenon on the negative similar to intense partly-localized flare-light, or to lightning patterns. The build-up is said to be caused by the rubbing of the film over the glass surface.

The great advantages of the glass plate are the mechanical simplicity of its functioning, and the fact that collimating marks (see Fig. 2.1) and the principal point itself can be engraved on it.

A squared réseau is also sometimes engraved on the plate. This will make apparent any distortions of the negative due to non-flatness in the focal plane, because such distortions will cause bending of the lines. It is especially useful when accurate measurements are made on the face of a print, by a stereocomparator.

3. *An air pressure system* involves pumping air into the camera cone, which must be airtight; the junction between the cone and

the magazine must also be airtight. The air under pressure presses the film flat against the backing plate, or locating back, which here takes the place of the glass plate. The film passes in front of the locating back, which is attached to the cone. This was the system favoured in Europe but the more efficient vacuum is now replacing it. The main disadvantage is that, in spite of an air filter, minute dust particles tend to enter the camera causing scratching of the film and increasing flare-light.

4. *In the vacuum system,* air is pumped out through the backing plate, thus holding the film firmly to the plate by suction. The front of the locating back is engraved with a regular system of straight or curved channels in which, at suitable points, there are small orifices through which the air is pumped. The channel pattern is sometimes rectangular and sometimes radial, but there are many designs actually used and the efficiency of the design determines the efficiency with which the whole of the air is excluded. If any air bubbles remain between film and back at the time of exposure, distortion of the image will occur. Exhaustion of the air is achieved by coupling the system with the aircraft venturi or by a separate vacuum pump.

This appears to be the most popular system at the moment, but it is more complicated than the physical pressure method, and flare patterns from static electricity discharges still occasionally affect the negative. In addition, if the channels are a little too coarse, or the vacuum too great, there is a tendency for the pattern to appear as a background image on the negative.

The Camera Shutters

The function of the shutter is to regulate the light passing through the lens on to the film. During exposure, the shutter opens and admits the image-forming rays. At all other times the shutter remains closed in order to protect the focal plane from light.

Ideally the shutter must expose the whole face of the format to light at exactly the same time, and there must be an accurate method of controlling the time of exposure. In an air camera the duration of the exposure must be so short that the image of a ground point cannot be seen to have moved relative to the focal plane. If an image moves during exposure by as much as 0·25 mm, a visible blur will occur.

There are three main types of shutter—
1. between the lens,
2. focal plane,
3. louvre.

1. *The between the lens shutters* are placed within the lens system at a point where the bundle of rays is narrowest. There are several varieties of this type of shutter. The sector type is in the form of a diaphragm. A number of thin metal leaves are pivoted at their outer edge in such a way that, as the leaves rotate in one direction, a hole appears in the centre. At this stage the shutter will appear similar to the apertures of Fig. 9.11. At exposure the shutter is fully opened, and as it is spring-loaded the leaves immediately return to the closed position. Since the opening begins at the centre and finishes at the centre, the central part of the bundle of rays is admitted for a longer time than the outer parts; the shutter is therefore said to lack efficiency. However, the cross-section of the beam here is so small that the resulting unevenness of illumination is relatively unimportant.

FIG. 1.13. ROTATING DISC SHUTTER
(i) AEROTOP SHUTTER CLOSED
(ii) AEROTOP SHUTTER OPEN
(*Zeiss Aerotopograph, Munich*)

In the rotary variety (see Fig. 1.13), each disc rotates continuously in one direction only. The shape of the leaves causes the shutter to open and shut, and reduces any tendency to uneven illumination so that efficiency is increased. Normally the lever arm will keep the aperture closed; but exposure is achieved when the arm changes position to bring the circular hole into the centre of the aperture.

This is the most popular type of shutter in air cameras, but in a camera having interchangeable lenses each lens would need to incorporate a separate shutter.

2. *The focal plane shutter* (Fig. 1.14), as its name implies, moves in, or at least in contact with, the focal plane. It consists of a blind with a slot cut out. The exposure is made by causing this slot to travel across the face of the film. The speed of exposure can be varied both by altering the speed of shutter movement and by altering

the width of the slot. When we use the term "speed" in its normal sense of governing the time during which any particular part of the film is exposed, then the focal plane shutter is much faster than the other types. However, the whole of the format is not exposed simultaneously, and there may be distortion due to the image movement between the time of exposure at one edge and that at the

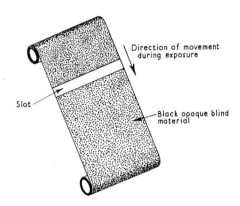

FIG. 1.14. FOCAL PLANE SHUTTER
During " winding-on " between exposures, the movement will be reversed.

other. If, during exposure, the slot always travels in the same direction as the aircraft, the consequent foreshortening tendency may be used to offset the normal blur distortion. This is not as straightforward as might appear, and the possibility of making use of the superior speed of this type of shutter has been the subject of much controversy and experiment.

If the blind is always required to make the exposure while it is moving in the same direction, then the " winding-up " of the shutter between successive exposures must be done with a second blind in front of the shutter itself.

Although the width of the beam of light is at its greatest in the focal plane and the focal plane shutter is therefore bigger than the others, the slot covers the full width of the format. It can be made to travel at a uniform speed so that every part of the negative will receive the same exposure, and the shutter is therefore said to be " efficient." Acceleration at the start of the exposure and deceleration at the end are aided by spring loading.

3. *The louvre shutter* (Fig. 1.15) fits into the cone of the camera and operates like a venetian blind. Its construction and operation are very simple but it is rarely used in an air camera.

The continuous strip air camera does not contain any conventional type of shutter. The film is simply pulled past a slit opening at a rate equal to the apparent motion of the ground relative to the aircraft.

Closed Opening Fully open Closing Closed

FIG. 1.15. SECTIONS THROUGH A LOUVRE SHUTTER

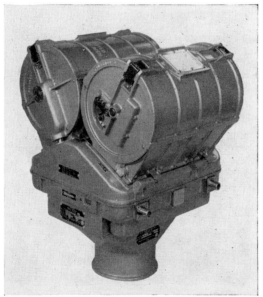

FIG. 1.16. CONTINUOUS STRIP AERIAL CAMERA
(*Chicago Aerial Industries Inc.*)

The KA-18A (see Fig. 1.16) incorporates an electronic computer which automatically adjusts the slit-width and the aperture diameter according to the lighting conditions and the velocity of image movement. A pair of stereoscopic continuous strips can be obtained in one

B

camera but each would only be half the width of the film.

The Gimbal Mounting

This is the mechanism which attaches the camera to the aircraft, and enables changes of orientation of the camera relative to the aircraft. It is dealt with in Chapter 4 and illustrated in Fig. 1.17. It must incorporate some sort of shock absorber (e.g. rubber bushes) to isolate the camera from aircraft vibrations.

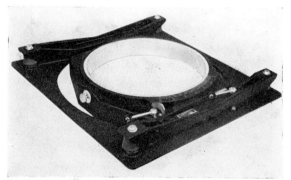

FIG. 1.17. EAGLE IX (F.49) CAMERA MOUNTING (R.A.F. TYPE 77 14A/4135)
(*Williamson Manufacturing Co. Ltd.*)

FURTHER READING

Although this book has been written with the idea of conveying some knowledge of air surveying to those with a general educational background, it would be foolish to think of actually making maps without the use of land surveying methods. There are many books available on the subject some of which are listed below.

Books on general land surveying for the civil engineer—

1. BANNISTER, A., RAYMOND, S., *Surveying* (Pitman).
2. STEPHENSON, H. W., *Solution of Problems in Surveying and Field Astronomy* (Pitman).

Books on general land surveying for specialists—

1. ALLAN, HOLLWEY and MAYNES, *Practical Field Surveying and Computations* (Heinemann).
2. MIDDLETON, CHADWICK, *A Treatise on Surveying*, Vols. I and II (Spon).
3. CLARK, D., *Plane and Geodetic Surveying*, Vols. I and II (Constable).

The HISTORY of photogrammetry, or more particularly of air survey, is recorded in the following books—
(i) Schwidefsky, Chapter 1; (ii) Hart, pages 7–23; (iii) Lyon, Chapter 8.

(See Bibliography (page 346) for the full titles.)

Simple Properties
of a Single Air Photograph

In the pin-hole camera the aperture is so small that a beam of rays can be considered as reduced to one central ray. Although a lens focuses a whole beam of rays to one point and increases the illumination, we can still use the central ray to demonstrate in diagrammatic form the relationships between the object, the lens, and the image. This chapter is concerned mainly with these relationships.

A vertical air photograph can be regarded as a special case of an oblique; the theoretical properties of a vertical will therefore be similar to those of an oblique. We have to examine the relationship between various points of detail on the ground and their images on the photograph. The diagrams will illustrate the positions of the negative, the lens, and rays of light from ground objects at the instant of exposure. If at this moment the optical axis were truly vertical, the plane of the negative would be truly horizontal and parallel with the ground plane. For convenience, we use a diagram which represents the conditions applying to an oblique photograph. A set of definitions relating to this figure is given in dictionary form at the end of this chapter.

The size of the format, i.e. of the photograph, not including the marginal notes, is usually 230 mm × 230 mm though 230 mm × 180 mm and 180 mm × 180 mm are also popular and in Europe 130 mm × 130 mm is often used. We shall normally consider the size of format to be 230 mm × 230 mm and the focal length of the lens to be 152 mm, although focal lengths of 88·5 mm and 305 mm are also used.

On the face of the photographs certain *collimating, calibration* or *fiducial* marks will be found. Examples of collimating marks are shown in Fig. 2.1 (i), (ii) and (iii). If opposite points are joined as shown, the point of intersection of the resulting pair of lines will indicate the photograph's principal point. There is also a tendency for cameras to be constructed so that the principal point itself is marked with a fine cross, as in Fig. 2.1 (iii). This last arrangement may be found in conjunction with any of the previous types of collimating marks.

DEFINITION OF TERMS

In Fig. 2.2, *plane I* can be considered as the plane containing the negative at the moment of exposure. S is the optical centre of the camera lens, and is called the *perspective centre*. The *principal point*, p, is defined as the foot of the perpendicular from S to *plane I*, and should be the point indicated by the collimating marks. *Plane II*

FIG. 2.1. COLLIMATING MARKS ON AIR PHOTOGRAPHS

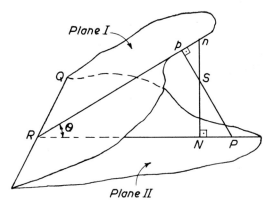

FIG. 2.2. PART OF THE PERSPECTIVE DIAGRAM

Plane I = plane containing negative	p = principal point of negative
Plane II = ground plane	P = ground principal point
S = perspective centre of lens	N = ground plumb point
QR = horizontal trace	n = photo plumb point
θ = angle of tilt	pR = principal line

represents the ground as a plane horizontal surface at sea level—in other words the *datum plane*, from which all heights can be considered to be measured. *Plane II* is the plane which the map will represent. It should strictly be a curved surface representing the surface of the earth, but over the restricted area covered by a single photograph

this curvature is too small to measure, and would give rise to unnecessary complications in considering the elementary geometrical relationships. Curvature is important in small-scale photography.

Planes I and *II* intersect one another in the line *QR* which is known as the *horizontal trace*. If *R* is the foot of the perpendicular from *p* on to the line *QR*, then *pR* is a line of greatest slope in the negative plane. If *PR*, in *plane II*, is now drawn perpendicular to *QR* then the ∠ *pRP* (θ in Fig. 2.2) is the dihedral angle between the two planes, i.e. θ is the angle of inclination to the horizontal of the negative plane. θ is called *the angle of tilt*, and *pR* is called the *principal line*.

The point *S* is the point through which all rays of light may be said to pass, and is represented by the pinhole in the pinhole camera. The line *pS*, sometimes known as the principal axis, lies along the optical axis of the lens, and the distance *pS* is known as the *principal distance*. In a properly adjusted camera the principal distance should be about equal to the focal length of the lens, and it is usual to refer to the length *pS* as *f*. It is important to remember, however, that there is a real distinction between the focal length (of the lens) and the principal distance (of the camera).

The line *pS* is perpendicular to the negative plane; therefore ∠ *SpR* is a right angle, and all planes containing *p* and *S* are perpendicular to *plane I*. The plane containing *Sp* and *R* is known as the *principal plane*.

The principal plane is perpendicular to *plane I*, and meets the latter in *pR*.

QR lies in *plane I* and is perpendicular to *pR*.

Therefore *QR* is perpendicular to the principal plane.

But *QR* lies in *plane II*, and is therefore horizontal.

Therefore the principal plane is vertical, and must contain the vertical line through the perspective centre. This vertical line through *S* is known as the plumb line, and meets the negative plane in the plumb point or nadir *n*, and the ground plane in the ground plumb point *N*. Both *n* and *N* lie in the principal plane, so that *n* must lie on the principal line.

Since *N* and *P* both lie in the principal plane and the ground plane, *R*, *N* and *P* are collinear and form the ground principal line.

In the triangles *RnN* and *Snp*, the angle at *n* is common, and the angles at *N* and *p* are right angles ∴ the triangles are similar and the angles at *R* and *S* are equal, i.e. ∠ *pSn* = θ = angle of tilt. This angle is also sometimes called *t*.

Now construct *iI* to bisect ∠ *pSn*, and let *iI* meet the negative plane in *i*, and the ground plane in *I* (see Fig. 2.3); *i* is the isocentre and falls on the principal line; *I* is the ground isocentre.

We may regard pP, nN and iI as rays of light at the instant of exposure. The image at point p on the developed negative will be the image of the point of ground detail P. Similarly, the images at i and n will be the images of the ground points I and N respectively.

So far we have considered only pairs of points lying in the principal plane. Choose a an image point in any general position on the

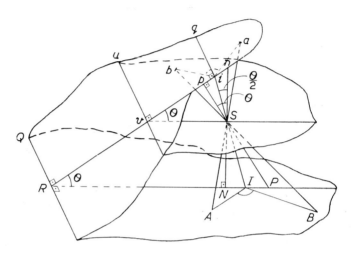

FIG. 2.3. THE PERSPECTIVE DIAGRAM

$i =$ isocentre
$I =$ ground isocentre
$iq =$ isometric parallel
a and b are any two image points with A and B as their respective homologues

photograph. Remember that Fig. 2.3 represents a three-dimensional figure, and draw aS and produce to meet the ground plane in A; a is the image of the ground point A.

These pairs of points a, A; p, P; n, N and i, I are known as pairs of homologous points: a is the homologue of A, and A the homologue of a. Similarly, p and N are respectively the homologues of P and n, and so on.

The horizon plane is a horizontal plane through S, cutting the negative plane in uv, which is known as the *true horizon*.

Let v lie in the principal plane, then from Fig. 2.3, vS is parallel with RP, and these lines meet at infinity. Thus V, the homologue of v, lies at an infinite distance from N. Similarly, the homologue of u or any other point on the true horizon lies at an infinite distance.

uv is horizontal and is therefore perpendicular to the principal

line which is the line of greatest slope through p. Any line in the negative plane and perpendicular to the principal line will be horizontal. Any such horizontal line is known as a *plate parallel*.

That plate parallel which passes through the isocentre is known as the *isometric parallel* or sometimes as the *axis of tilt*. The latter term has, in some writings, been used to indicate the plate parallel which passes through the principal point. The term might also refer to a straight line through S parallel with the plate parallels. The meaning will therefore depend on the context, and the term should be avoided.

The length SN represents the flying height, i.e. the height of the lens above the horizontal datum plane at the time of exposure. The datum plane is generally taken to be at mean sea level, and the flying height is referred to as H.

If we take a second pair of general homologous points b and B, then b, B, S, a and A will lie in one plane, known as an epipolar plane or perspective plane. Neither of these is a good technical term as we shall meet another type of epipolar plane in Chapter 3, and " perspective plane " often refers to *planes I and II*. However, epipolar has an ordinary scientific meaning, and any plane containing S and two image points is an *epipolar plane*.

ELEMENTARY MATHEMATICAL RELATIONSHIPS
In Fig. 2.4—
1. $\angle nSp = \theta$ and $\angle pSi = \angle iSn = \theta/2$.
2. Distance from principal point to plumb point
 $$pn = pS \tan \theta = f \tan \theta.$$
3. Distance from principal point to isocentre
 $$pi = pS \tan \theta/2 = f \tan \theta/2$$
4. Distance from principal point to true horizon
 $$pv = pS \cot \theta = f \cot \theta.$$
5. $PN = NS \tan \theta = H \tan \theta$
 $$PI = PN - NI = H \tan \theta - H \tan \theta/2 = H (\tan \theta - \tan \theta/2).$$

If the photograph is truly vertical, then $\theta = 0$, so that both pn and $pi = 0$, and n and i coincide at p, i.e. in a negative produced from a truly vertical exposure, the plumb point and the isocentre coincide with the principal point.

Individual photographs will rarely, if ever, be taken entirely free from tilt, but the angle of tilt of photographs used in the processes dealt with in this book must not exceed $3°$. Thus the displacement of n and i from p will be very small. In the diagrams of this book the distances pi and pn will normally be exaggerated for the sake of clarity.

Scale

In photogrammetry we use the Representative Fraction, or R.F. The R.F. is a fraction in which the numerator is unity and the denominator is the number of units on the ground represented by one unit on the photograph or map.

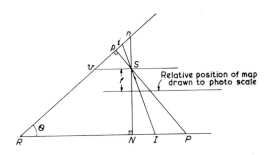

FIG. 2.4. LINE DIAGRAM IN PRINCIPAL PLANE

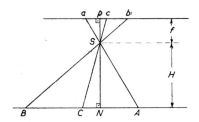

FIG. 2.5. ANY VERTICAL SECTION THROUGH S OF AN UNTILTED PHOTOGRAPH

In a truly vertical photograph any line in the negative plane of the perspective diagram will be horizontal and parallel with its homologous line on the ground. Fig. 2.5 then represents the section through the principal axis and any line through p in the plane of the negative. Let a and b be any two points on the line, and let their homologues A and B lie in the ground datum plane. Then ab is parallel with AB, and pSN is a vertical straight line. Since ab on the negative represents AB on the ground, the scale along ab is ab/AB or $\dfrac{1}{AB/ab}$, usually written as $1 : AB/ab$, e.g. $1 : 10,000$ (or $1/10,000$).

But triangles abS and ABS are similar, so that—

$$\frac{ab}{AB} = \frac{pS}{SN} = \frac{f}{H}$$

$$\therefore \quad \frac{ab}{AB} = \frac{f}{H}$$

We can show that the scale $= f/H$ holds good for any part of the line ab since pS and SN are the perpendicular heights of the triangles acS and ACS and any other such pair of triangles.

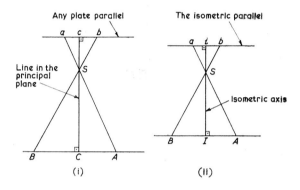

FIG. 2.6. SECTION THROUGH S AND
(i) ANY PLATE PARALLEL
(ii) THE ISOMETRIC PARALLEL

Thus we may say that the " correct " scale of an air photograph is f/H.

Figure 2.6 (i) illustrates a section through the perspective diagram of Fig. 2.3. This section is one containing a typical plate parallel ab and the perspective centre S. The figure is very similar to Fig. 2.5, except that the perpendicular heights of the pair of similar triangles are now cS and SC respectively. The scale along any part of this plate parallel is then cS/SC.

Figure 2.6 (ii) shows a similar diagram to Fig. 2.6 (i) but a special plate parallel, the isometric parallel, is now chosen. From previous arguments it can be seen that the scale along any part of the isometric parallel is iS/SI.

Referring back to Fig. 2.4, the triangles pSi and NSI are similar, since $\angle ipS = \angle SNI = 90°$ and $\angle pSi = \angle NSI$.

$$\therefore \quad iS/SI = pS/SN = f/H$$

But f/H is the correct scale for an untilted photograph.

∴ *Scale along the isometric parallel is correct.*

Figure 2.7 again shows that section of the perspective diagram, contained in the principal plane. *a* is any point on the principal line and the ∠ *aSp* is equal to α.

In this figure the scale along the principal line *pn* changes from point to point, and we can only speak of a scale at a particular

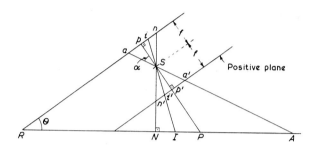

FIG. 2.7. INTRODUCING THE POSITIVE PLANE IN THE LINE DIAGRAM

point. Thus, as before, the scale along the isometric parallel = iS/SI, so that the scale AT the isocentre is iS/SI. Similarly, the scale at *a* is aS/SA.

But

$$\frac{aS}{SA} = \frac{pS \sec \alpha}{SN \sec (\alpha + \theta)}$$

$$= \frac{f}{H} \times \frac{\cos (\alpha + \theta)}{\cos \alpha}$$

$$= \frac{f}{H} \times \frac{\cos \alpha \cos \theta - \sin \alpha \sin \theta}{\cos \alpha}$$

$$\therefore \quad \frac{aS}{SA} = \frac{f}{H} (\cos \theta - \tan \alpha \sin \theta) \quad . \quad . \quad . \quad \text{(i)}$$

θ is constant for one photograph ∴ cos θ and sin θ are constants. Similarly f/H is constant for one photograph.

Thus tan α is the only variable on the right-hand side of equation (i) and since tan α bears a negative sign aS/SA increases in value as tan α decreases.

Whatever position *a* takes up on the principal line α cannot exceed 90° or be less than − 90°.

But tan α decreases continuously as α decreases from + 90° to − 90°.

∴ Scale at *a* increases continuously as α decreases. That is, as *a* moves continuously from the lower end of the principal line to the upper end, so the scale at *a* increases.

THE POSITIVE PRINT

So far we have considered only the photographic negative but in practice we would nearly always use a positive contact print of this negative. In the perspective diagrams the plane of the positive print may, in theory, be considered as parallel with the negative plane, and lying at a distance equal to the principal distance in front of the perspective centre. In Fig. 2.7 we can see that, by congruent triangles, $p'i' = pi$ and $p'a' = pa$. Similarly any other image point

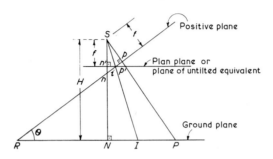

FIG. 2.8. RELATIONSHIP BETWEEN THE PLAN PLANE AND THE POSITIVE PLANE

in the positive plane will be as far from p' as the corresponding negative image is from p. Thus we have a picture identical with that on the negative, except that it is reversed, as can be seen from the figure.

Figure 2.8 illustrates the type of figure we shall most often meet, i.e. one with no indication of the negative plane.

DISTORTION

It may be instructive at this stage to consider the relationship between shapes on the photograph and shapes on the ground. Let us consider four photo points a, b, c and d, such that they form the angular points of a square. Let us assume also that the isocentre falls at the centre of the square, and that the principal line is parallel with the side ad (see Fig. 2.9(i)).

Consider now the correctly plotted plan positions of these points in Fig. 2.9(ii), where the scale is equal to the correct photo scale.

The scales along the isometric parallel will be the same on both photo and plan, i.e. $KL = kl$.

In these two figures a, A; b, B; etc. are pairs of homologous points, although A, B, C, etc. are plan points instead of ground points. Figure 2.8 makes the relationship between the ground plane

and the plan clear. Figure 2.4 shows the relationship between the negative plane, the plan and the ground plane. It will be seen that the plan plane is horizontal and parallel with the ground plane, but that it is at a distance f below the perspective centre, so that the plan scale is f/H, i.e. correct photo scale.

Figure 2.8 shows the relationship between the positive plane, the plan and the ground plane. It will be seen that the intersection of the positive plane and the plan falls at the isocentre of the positive plane. This can be proved as follows—

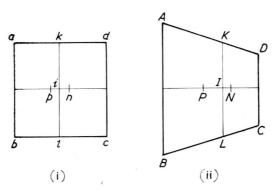

FIG. 2.9. SHAPE ON PLAN COMPARED WITH SHAPE ON PRINT
(i) THE PRINT
(ii) THE PLAN

Triangles $Sn'i$ and Spi are congruent since

$$Sn' = Sp = f$$
Si is common

and $\quad \angle\ Sn'i = \angle\ Spi = 90°$

$\therefore \quad \angle\ n'Si = \angle\ iSp$ i.e. i is the isocentre of the photo.

That i is the isocentre can also be deduced from the fact that the scale along the isometric parallel is correct.

Figure 2.8 is the one used to illustrate the relationship between the tilted photograph and an untilted photograph taken with the perspective centre in the same position. The untilted print is known as the untilted equivalent.

Bearing the foregoing in mind we can easily construct a figure similar to Fig. 2.9, but with the four original points A, B, C and D forming a square on the plan.

Figure 2.10 illustrates this construction. It can be seen that on

that side of the isometric parallel towards the plumb point the scale of the print is too great, and on the other side of the isometric parallel (i.e. the principal point side) the scale is too small, e.g. the scale along *ab* is too great, and the scale along *cd* is too small.

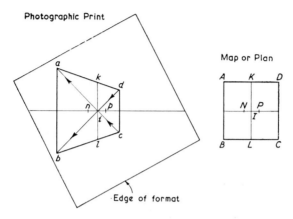

FIG. 2.10. SHAPE ON PRINT COMPARED WITH SHAPE ON PLAN

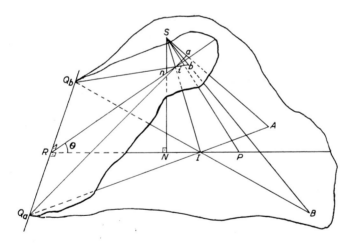

FIG. 2.11. PERSPECTIVE DIAGRAM ILLUSTRATING THE PROOF THAT TILT DISTORTION IS RADIAL FROM THE ISOCENTRE

Tilt Distortion

Tilt distortion is radial from the isocentre. This means that in Fig. 2.10, the point *a* has been displaced outwards along the line *ia*,

and that the correct position of the image of A lies on the line ia at a point nearer to i. Similarly, the true position of the image of D lies along id. The arrows in the figure show the direction of displacement. Thus $\angle aid = \angle AID$ and the angle subtended at i by any two image points can be shown to be equal to the angle subtended at I by the homologues of those points.

Thus in Fig. 2.3, A and B are any two ground points, and a and b are their respective images; then $\angle aib = \angle AIB$. The same relationship will, of course, hold if a and b were images in the positive plane.

In Fig. 2.11 let a and b be any two image points on the print with ground homologues at A and B respectively.

S, a, i, A and I are coplanar, and since any three planes must normally meet in a point, ai produced will meet AI produced in the horizontal trace QR. Let them meet in Q_a.

Similarly bi and BI will meet in Q_b.

In triangles piS and NIS, $\angle ipS$ and $\angle INS$ are right angles, and $\angle pSi$ and $\angle NSI$ are equal.

$$\therefore \quad NIS = \angle piS = \angle RiI$$

i.e. $\angle RiI = \angle RIi$

$$\therefore \quad \triangle RiI \text{ is isosceles and } Ri = RI$$

Now $\tan \angle pia = \tan \angle RiQ_a = \dfrac{Q_aR}{Ri} = \dfrac{Q_aR}{RI} = \tan \angle RIQ_a.$

$$= \tan \angle PIA$$

$$\therefore \quad \angle pia = \angle PIA$$

Similarly it may be shown that $\angle pib = \angle PIB$

$$\therefore \quad \angle pia + \angle pib = \angle PIA + \angle PIB$$

i.e. $\angle aib = \angle AIB$

$$\therefore \quad \text{angles are correct at the isocentre.}$$

Thus distortions due to tilt must take place along radials through the isocentre,

i.e. tilt distortion is radial from the isocentre.

As tilt distortions have been shown to be linear, and no two straight lines can intersect in more than one point, then the isocentre is unique in possessing this property.

Plotting by Intersections from Isocentres (Fig. 2.12)

Suppose that we have two air photographs whose isocentres i_1 and i_2 can be located on the photographs. Assume that the ground is perfectly flat and that the positions of I_1 and I_2 (the homologues of i_1 and i_2 respectively) have been plotted accurately on to a map.

Then if A is a ground point whose images a_1 and a_2 are recognizable on both photos, we could plot the position of the point A on the map by a method of intersections.

Height Distortion

In plotting a map we are concerned firstly with the relative *horizontal* distances between all points of ground detail. As stated

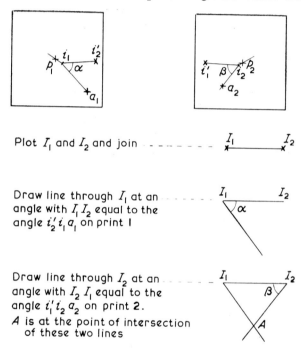

Plot I_1 and I_2 and join ----------

Draw line through I_1 at an angle with $I_1 I_2$ equal to the angle $i_2' i_1 a_1$ on print 1

Draw line through I_2 at an angle with $I_2 I_1$ equal to the angle $i_1' i_2 a_2$ on print 2. A is at the point of intersection of these two lines

Fig. 2.12. Plotting by Intersections from Isocentres

in Chapter 1, the earth may be considered basically as a globe, the surface of which falls at mean sea level. The position of all ground points is referred to this globe, and mean sea level is known as *datum level*. The plotted position of each ground point will really represent that point at datum level which is vertically above or below the actual point of ground detail (see Fig. 2.13 (i)).

For areas of limited extent the basic globe can be considered as a plane, and for the present, we may continue to think of maps and plans as being plots on a datum plane. Each point of detail will

then be considered as plotted at that point at which a perpendicular from the detail point strikes the datum plane. This is known as an *orthogonal projection*, whereas the photo is a perspective projection.

We will call the height of any point above datum h. Thus in Fig. 2.13 (ii) Aa is h. So that we know to which point h refers, we would usually let the height of A above datum be h_A, the height of B above datum h_B and so on.

(i) (ii)

FIG. 2.13. MAP POSITION OF A POINT
(i) RELATIVE TO EARTH
(ii) EARTH'S CURVATURE NEGLECTED

A is the point we require to plot and a is the point we really do plot. a is the orthogonal projection of A.

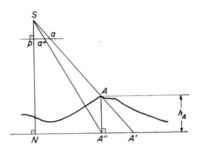

FIG. 2.14. VERTICAL PHOTOGRAPH SHOWING HEIGHT DISTORTION $a''a$

In Fig. 2.14 a'' is the correct plan position of both A and A''; but although the correct photo position of A'' is also at a'', the correct photo position of A is at a. The distance $a''a$ is known as the height distortion of A; but this must not be taken to imply that the plan positions are any more " correct " than the photo positions.

If the photograph is not truly vertical there will be both height distortion and tilt distortion.

In order to make the following discussion clearer, we will consider the relative displacement of two points vertically one above the other. The figures (2.15 (i) and (ii)) show a chimney whose base has no height displacement as it lies at datum level.

Consider the vertical exposure, Fig. 2.15 (i). *A* is the top of a vertical chimney and *B* the bottom. *B* falls on the datum plane, so that *b* is the true plan position of *B*; but *B* is the orthogonal projection of *A* on the datum plane, therefore *b* also represents the true plan position of *A*. The image of *A* actually falls at *a*, and the height distortion of *A* is *ab*.

SnN is the plumb line, and is vertical, and *AB* is a vertical line. Thus points *S*, *n*, *N*, *A* and *B* are coplanar in a vertical plane. *a* and *b* must also lie in this plane as they lie along *AS* and *BS* respectively,

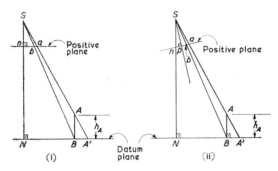

FIG. 2.15. HEIGHT DISTORTION IS RADIAL FROM PLUMB POINT
(i) VERTICAL EXPOSURE (ii) TILTED EXPOSURE

but *n*, *b* and *a* also lie in the photo plane. Since any two planes must intersect in a straight line, then all points which lie in both planes must be collinear, i.e. *nba* is a straight line. In other words the height distortion *ab* is radial from the plumb point *n*.

Exactly the same argument can be applied to Fig. 2.15 (ii), so that height distortion is always radial from the plumb point. If then there were no tilt distortion, we could plot the position of any image point, using the method of intersections as in Fig. 2.12, but using the plumb point instead of the isocentre. (When no tilt is present, of course, *p*, *i*, and *n* coincide anyway.)

In Fig. 2.15 (i) $ab = A'B \times \dfrac{f}{H} = an \times \dfrac{h_A}{f} \times \dfrac{f}{H} = an \times \dfrac{h_A}{H}$

ANHARMONIC RATIOS AND TILT ANALYSIS

Figure 2.16 illustrates once again the perspective diagram; but *a*, *b*, *c* and *d* are any four image points in the positive plane with homologues *A*, *B*, *C* and *D* respectively. The positive plane, *plane I*, meets the ground plane, *plane II*, in the line Q_1Q_3.

SaA and *SbB* are collinear, therefore points *S, a, b, A* and *B* are coplanar. If Q_1 is the point at which the line Q_1Q_3 cuts this plane, then *a, b* and Q_1 are collinear as they lie in the line of intersection of this plane with *plane I*. Similarly, *A, B* and Q_1 are collinear.

In the same way it may be shown that *ac* and *AC* produced meet in a point Q_2 lying on the line Q_1Q_3, and *ad* and *AD* meet in another point Q_3 lying on the same line.

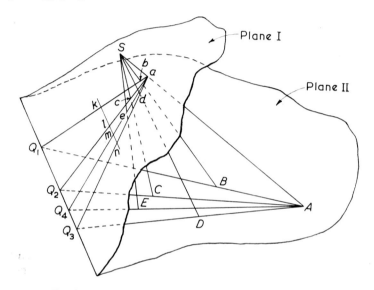

FIG. 2.16. ANHARMONIC PROPERTIES OF AN AIR PHOTOGRAPH

Now suppose we rearrange the figure for convenience as in Fig. 2.17. We have merely turned the photo plane about the line Q_1Q_3 as axis. Suppose *e* is a fifth photo point, and that the line *ae* produced cuts Q_1Q_3 in Q_4; then *E*, the homologue of *e* must lie on the line Q_4A.

Now superimpose a similar figure having *b* and *B* as poles instead of *a* and *A*. *ba* will again cut Q_1Q_3 in Q_1, and *bc, bd* and *be* will cut Q_1Q_3 in R_2, R_3, and R_4 respectively. Since *E* lies on the line BR_4, the point is now fully determined at the intersection of AQ_4 and BR_4.

A similar sort of figure would apply if we substituted the map plane for the ground plane. It would, however, rarely be possible for the intersection of the photo and map planes to be included in a figure of construction. In order to use this type of construction for

plotting from photographs, we must take advantage of the anharmonic properties of a pencil of rays. In Figs. 2.16 and 2.17, the pencil of rays ab, ac, ae and ad, cut the line Q_1Q_3 in Q_1, Q_2, Q_4 and Q_3 respectively; then the ratio of Q_1Q_2/Q_2Q_3 to Q_1Q_4/Q_4Q_3 is called the anharmonic ratio of Q_1Q_3. If kn is any line cutting this pencil of rays in the points k, l, m and n, then the anharmonic ratio of this line is kl/ln to km/mn or $\dfrac{kl/ln}{km/mn}$. For any pencil of four rays

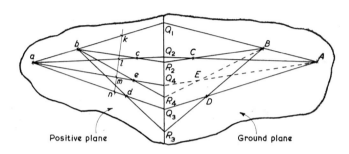

FIG. 2.17. PLANE 1 OF FIG. 2.16 ROTATED ABOUT Q_1Q_3

it can be shown, by successive applications of the sine rule, that this ratio is constant.

i.e.

$$\frac{\dfrac{kl}{ln}}{\dfrac{km}{mn}} = \frac{\dfrac{Q_1Q_2}{Q_2Q_3}}{\dfrac{Q_1Q_4}{Q_4Q_3}}$$

Similarly with any line cutting the right-hand set of rays in Fig. 2.17. Thus if Q_1Q_3 did not appear on the print, the ray AE in Fig. 2.17 could still be constructed by transferring the line kn exactly to the right-hand side of the diagram.

In practice the construction involves the use of a paper strip with a clean straight edge, and it forms an accepted method of plotting additional points on a map if four plotted map points are recognizable on the photograph. The method is known as the four-point or paper-strip method, and is most useful when plotting from oblique photographs but it can be used for verticals.

In Fig. 2.18, a, b, c and d are photo image points and A, B, C and D are respectively the correctly plotted map positions of these points; e is the image of a fifth point whose position is required to be plotted on the map.

Construction. Join *ab, ac, ad* and *ae* and produce. (*a* is here called the pole.)

Place the paper strip across this pencil of rays as shown, and mark the points opposite each ray.

Join *AB, AC, AD* and produce.

Pick up the marked paper strip and lay it across the three rays drawn on the map, so that the mark *b* lies on the radial *AB*, the mark *c* on the radial *AC* and the mark *d* on the radial *AD*.

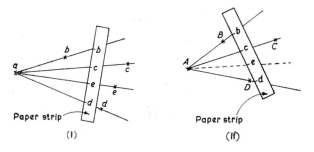

FIG. 2.18. PAPER STRIP METHOD OF POINT TRANSFERENCE
(i) PHOTOGRAPH
(ii) MAP

Mark the map opposite the paper strip mark *e*, remove the paper strip, and draw a radial through *A* and this point. This is the radial *AE* and the correct position of *E* must fall on this line.

By drawing radials through *b* and *B* (i.e. using *b* and *B* as the new poles), similarly construct a line *BE*.

AE and *BE* intersect at the required point *E*.

It is usual in a construction such as this to draw in a third radial, for example *CE*, and thus obtain a trisection. The ray *CE* may not exactly intersect *E* as already plotted, so that there are three possible positions of *E*. In land surveying this is known as a *triangle of error*, and a most probable corrected position can be found by the rules set out in Chapter 3.

Inclination of any Line on a Photograph (see Fig. 2.19)

Let *XY* be any line in the plane of the photograph, with *O* any point on the line.

Let *Ob* be the line of greatest slope through *O*, then *Ob* is parallel with (and may coincide with) the principal line, and the angle of tilt of *Ob* is θ, where θ is the tilt of the photograph.

Draw *ba* perpendicular to *Ob* in the plane of the photograph,

and let ba meet XY in a. Then ab is a plate parallel and is therefore horizontal.

Consider a horizontal plane through O on which c and d are orthogonal projections of a and b respectively.

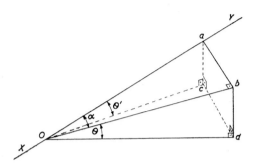

FIG. 2.19. THE INCLINATION OF ANY LINE IN THE PLANE OF A PHOTOGRAPH
$\theta =$ angle of tilt
$\theta' =$ required angle of slope of line XY
$\alpha =$ angle between line XY and line of greatest slope Ob

ab is parallel to cd and the $\angle bdc = \angle dca = 90°$,
i.e. $abcd$ is a rectangle, and $ac = bd$.

Then in $\triangle Odb$, $\sin \theta = \dfrac{bd}{Ob} = \dfrac{ac}{Ob}$ \therefore $ac = Ob \sin \theta$

in $\triangle Oba$, $\cos \alpha = \dfrac{Ob}{aO}$ i.e. $aO = \dfrac{Ob}{\cos \alpha}$

in $\triangle acO$, $\sin \theta' = \dfrac{ac}{aO} = \dfrac{Ob \sin \theta}{Ob/\cos \alpha} = \sin \theta \cos \alpha$

i.e. $\sin \theta' = \sin \theta \cos \alpha$

If the tilt is very small we may use the approximation
$$\theta' = \theta \cos \alpha$$

Graphical Determination of Tilt

The anharmonic properties of an oblique photograph may be used in a graphical method of determining the magnitude and direction of tilt.

Suppose that in Fig. 2.20 (ii) A, B, C, D are four map points forming a parallelogram, and that a, b, c, d in Fig. 2.20 (i) are their homologues. If we join ab and produce to meet dc produced in v_1, then v_1 is a point in the true horizon (or vanishing line) since it is the homologue of a point at infinity. Similarly ad produced will meet bc produced in v_2, another point on the vanishing line, which

is therefore the line v_1v_2. Since we can always find the principal point, p of a print, we may now drop a perpendicular from p to meet v_1v_2 in r. pr is the principal line—compare with Fig. 2.3.

Set off pS perpendicular to pr and of length f = principal distance. Again comparing with Fig. 2.3, we see that the $\angle prS$ equals θ, the angle of tilt. We may also find the plumb point by setting off $\angle rSn = 90°$.

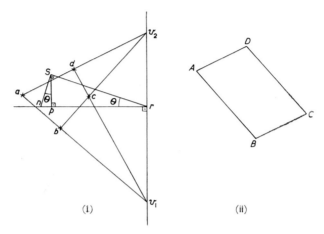

FIG. 2.20. GRAPHICAL DETERMINATION OF TILT OF AN OBLIQUE PHOTOGRAPH
(i) PHOTOGRAPH
(ii) MAP

If any four map points A, B, C and E are recognizable on the photograph, then we may choose a fifth point D, such that $ABCD$ forms a parallelogram and find the homologue of D on the photo by using the paper-strip method of point transference.

In cases where ab and cd are so nearly parallel that they would meet in a very distant point, then the construction may be modified by choosing a point k in ac, and drawing a line through k, parallel with dc, and meeting ab produced in v_1'. Similarly draw a line through k parallel with bc to meet ad produced in v_2'. Then $v_2'v_1'$ is a line parallel with the true horizon, i.e. it is a plate parallel. Thus the perpendicular from p on to $v_1'v_2'$ is the principal line (see Fig. 2.21 (i)). Let the principal line cut ab and bc respectively in e and g. Find the homologues of e, g and p on the map by the paper-strip method. Locate S on the photo by drawing pS perpendicular to eg and equal to the principal distance.

To transfer S to the map, orient the map so that EG is parallel with eg on the photograph and draw ES and GS respectively parallel with eS and gS. Alternatively S may be transferred by simple resection (see Chapter 3) on E, P and G. Drop a perpendicular from S to EG to meet EG in N; then $\angle NSP$ is the angle of tilt. (Compare Fig. 2.21 (ii) with Fig. 2.4.)

Height distortion tends to invalidate these constructions, and to offset this effect the four points chosen should be all at the same height above datum level.

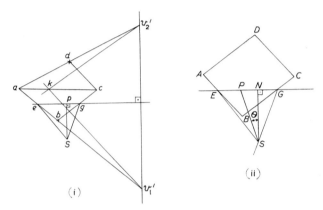

FIG. 2.21. GRAPHICAL DETERMINATION OF TILT OF LOW OBLIQUES
(i) PHOTOGRAPH
(ii) MAP

Theoretically this construction would hold for a vertical photograph, but $\angle av_1'k$ would be so small that the location of v_1' would be very inaccurate.

In a vertical photograph it should theoretically be possible to determine the direction and magnitude of tilt by measuring the displacements of the photographic images from their true positions, relative to the isocentre. There are practical difficulties involved in such an analysis and a rather more useful method is one sometimes known as the Anderson method. In such an analysis the ground points used should all be at approximately the same height. Alternatively height distortion may first be almost eliminated by adapting the formula derived from Fig. 2.15 (i) in which $ab = an \times h_A/H$; thus height distortion of a may be taken to be approximately $pa \times (h/H)$ along pa. This will enable us to use any points of known height in the following construction.

In Fig. 2.22, a, b and c are the images of A, B and C respectively, so that, if A, B and C are plotted on the map (or on slotted templet plot of Chapter 5), then we can readily find the mean scale along the lines ab, bc and ca. Let m_1 be the mid-point of ab, and d_1 the foot

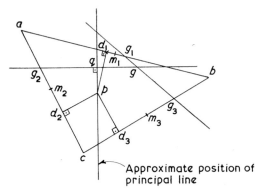

FIG. 2.22. ANDERSON METHOD OF ANALYSING THE TILT OF A VERTICAL PHOTOGRAPH

of the perpendicular from the principal point on to ab. Mark a point g_1 in ab and on the opposite side of m_1 from d_1, such that $m_1g_1 = m_1d_1$. The scale at g_1 will be approximately the mean scale of ab, and g_1 will sometimes be referred to as the *scale point*.

Similarly locate scale points g_2 and g_3 in ca and bc respectively. If the scale at say g_2 lies between that at g_1 and g_3, join g_1g_3, and determine a point g in g_1g_3 such that the scale is equal to that at g_2. This may be done by a linear interpolation between the scales at g_1 and g_3. Join gg_2: this line now indicates the general direction of the plate parallels. The perpendicular from p on to gg_2 will then be an approximation to the principal line.

The scale at the point of intersection of the principal line with the line gg_2 is known. Let this point be q, and let the scale at q be M, then comparing q with a in Fig. 2.7, we have

$$M = \frac{f}{H}(\cos\theta - \tan\alpha\sin\theta) = \frac{f}{H}(\cos\theta - \frac{qp}{f}\sin\theta)$$

where the length qp can be measured on the face of the photograph.

$$\therefore \quad M = \frac{1}{H}(f\cos\theta - qp\sin\theta)$$

i.e. $f\cos\theta - qp\sin\theta = M \times H$

This equation may be solved for θ by the standard method for this type of equation, i.e. by introducing an auxiliary angle ϕ, such that $\tan \phi = \dfrac{f}{qp}$, the equation then becomes

$$\sin \phi \cos \theta - \cos \phi \sin \theta = \frac{M \times H}{\sqrt{(qp)^2 + f^2}}$$

thus $\sin (\phi - \theta) = \dfrac{M \times H}{\sqrt{(qp)^2 + f^2}}$, where θ is the only unknown.

Determination of tilt by this method might be used to enable a tilted photograph to be oriented in a rectifier, and to set the tilt of such an instrument though adaptation would be necessary.

CENTRAL PERSPECTIVE

Angle of tilt is the angle subtended between the principal line of the positive (or negative) plane and the horizontal; $\angle PRp$ in Fig. 2.23.

Alternatively it is the angle between the optical axis of the camera at the moment of exposure and the vertical; $\angle nSp$ in Fig. 2.23.

Usually denoted by θ or t.

Axis of tilt is that plate parallel through the isocentre (see isometric parallel). In older writings it has been used to indicate the plate parallel through the principal point. It has also been used to indicate a line parallel with the plate parallels, but passing through the perspective centre.

Basal planes, see perspective planes.

Conformal point. An alternative name for isocentre.

Flying height is the height of the optical centre of the camera lens above the datum plane, usually called H. $SN = H$.

Homologue. If a is the photographic image of A, then a and A are homologues. a is the homologue of A, and A is the homologue of a.

Homologous points. If a is the photographic image of A, then a and A are a pair of homologous points.

Horizon plane is the horizontal plane containing the perspective centre.

Horizontal trace is the line of intersection between the positive (or negative) plane and the ground plane; QR in Fig. 2.23.

Isocentre is the point in which the bisector of the angle between the plumb line and the principal axis meets the positive (or negative) plane; i in Fig. 2.23. Its homologue I, is the ground isocentre.

Isometric parallel is that plate parallel which contains the isocentre; iq in Fig. 2.23.

Perspective centre is the optical centre of the lens, and is the point S through which all rays joining pairs of homologous points are assumed to pass. In Chapter 1 we saw that it really represents the rear node of the lens.

Perspective planes is a term sometimes used to denote the ground and positive (or negative) planes in the perspective diagram. Such planes are sometimes known as basal planes.

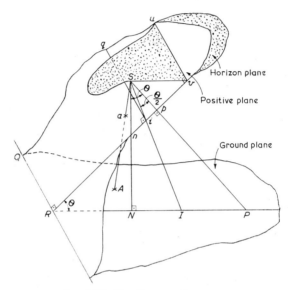

FIG. 2.23. THE CENTRAL PERSPECTIVE

Plate parallel is any line lying in the positive (or negative) plane, and at right angles to the principal line. It is therefore always a horizontal line.

Plumb line is the vertical line through the perspective centre; SnN in Fig. 2.23.

Plumb point is the image n of the ground plumb point, N. The latter is the ground point vertically below the perspective centre.

Principal axis is the line through the perspective centre and perpendicular to the positive (or negative) plane; SpP in Fig. 2.23.

Principal distance is the perpendicular distance from the perspective centre (rear node in Chapter 1) to the positive (or negative) plane; Sp in Fig. 2.23, often loosely called f.

Principal line is the line of greatest slope in the positive (or negative) plane which passes through the principal point; pn in Fig. 2.23.

Principal plane is the vertical plane containing the plumb line and the principal line.

Principal point is the point *p* in which the principal axis meets the positive (or negative) plane.

True horizon is the line of intersection between the horizon plane and the positive (or negative) plane; it is sometimes called the vanishing line and is represented by *uv* in Fig. 2.23.

FURTHER READING

Alternative descriptions of the PERSPECTIVE DIAGRAM may be found in—
 (i) *Manual of Photogrammetry*, Vol. I, Chapter 2.
 (ii) Hart, pages 136–55.
 (iii) Moffitt, Chapter 3.
 (iv) Lyon, Chapter 9.

The following deal with the DEFINITION OF TERMS—
 (i) *Manual of Photogrammetry*, Vol. II, pages 1125–58.
 (ii) Lyon, Chapter 9.
 (iii) Merritt, pages 186–234, including a dictionary of terms on page 190.

A MATHEMATICAL TREATMENT of this part of the subject is given in—
 Merritt, pages 1–37.

TILT DETERMINATION is dealt with more fully in—
 Manual of Photogrammetry, Vol. I, pages 33–45.

ANDERSON'S "SCALE POINT" method (outlined on pages 46–47 above) normally involves a series of approximations, and is fully reported in—
 (i) *Manual of Photogrammetry*, Vol. I, pages 36–9.
 (ii) *Applied Photogrammetry*, R. O. Anderson (Edwards Bros., Inc., Ann Arbor, Michigan).

(See Bibliography (page 346) for the full titles.)

Properties of Pairs of Photographs

Although single photographs can be used for plotting maps, a more practical procedure involves the use of pairs of photographs. Horizontal photographs can be used in this way, and as the principles will help to introduce certain aspects of mapping from the air, we will consider ground photogrammetry first.

Ground Photogrammetry

The map is plotted using methods similar to those used in plotting a theodolite survey. A theodolite is an instrument used for measuring horizontal angles. Basically it consists of a telescope mounted so that it can revolve in a horizontal plane. A pointer attached to the telescope moves over a horizontal disc graduated in a similar way to a protractor.

The instrument used in ground photogrammetry is called a photo-theodolite, but an ordinary theodolite and separate camera may also be used.

The photo-theodolite (see Fig. 3.1) is essentially a camera mounted in the same way as a theodolite so that angles may be read at the time of exposure. Immediately in front of the photographic plate a horizontal and a vertical hair are tautly mounted. These hairs intersect at the centre of the plate, and are so placed that their image is formed on the plate at the time of exposure. The image of their point of intersection is the principal point. When the camera is in proper adjustment the optical axis will meet the plate in the principal point. The image of the vertical hair is the *principal line* and the plane containing the principal line and the optical axis is the *principal plane*.

Figure 3.2 represents a diagrammatic plan view of the photo-theodolite at the moment of exposure. The camera plate can be thought of as the negative plane, on which the images of field objects A and B will appear at a and b respectively. A contact print of the negative would fit into this diagram in the position marked " picture trace," with the images of A and B falling at a' and b' respectively. Since the distances between image points on the print must be the same as those on the negative, then $a'b' = ab$. The camera plate and picture trace are both perpendicular to the optical axis and must

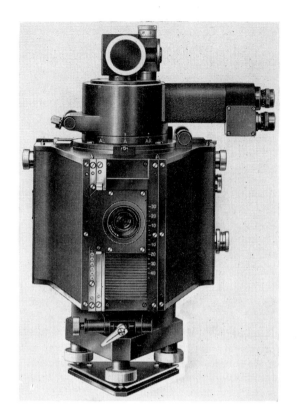

FIG. 3.1. Photo-theodolite
(*Zeiss, Jena*)

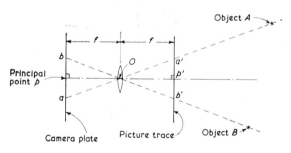

FIG. 3.2. Diagrammatic Plan of Rays for Horizontal Photograph

therefore be parallel. Therefore, by similar triangles, $p'O = pO = f$. That is, the perpendicular distance of O from the picture trace is equal to the focal length of the lens.

In Fig. 3.3, print 1 is the photograph taken from camera station O_1 (see Fig. 3.4); p_1 is the principal point, and a_1 the image of the object point A. Print 2 is the photograph taken of the same area

FIG. 3.3. SKETCHES SHOWING IMAGE OF A POINT ON TWO HORIZONTAL PHOTOGRAPHS

of land from the station O_2; p_2 is the principal point and a_2 the image of the object point A. Knowing the positions of O_1 and O_2 on the map, and having measured the appropriate angles at the moments of exposure, we can plot the position of A on the map. The procedure is as follows—

(i) Join O_1O_2 on map. Set out the angle $p_1O_1O_2$ equal to the angle measured for the first camera station, and the angle $p_2O_2O_1$ equal to the angle measured at the second camera station.

(ii) Set out $O_1p_1 = $ focal length, and set out picture trace perpendicular to O_1p_1 and passing through p_1.

(iii) On Fig. 3.3 drop a perpendicular from a_1 to the horizontal axis, cutting that axis at a_1'.

(iv) On Fig. 3.4 set out $p_1a_1' = p_1a_1'$ on Fig. 3.3.

(v) Join O_1a_1' on Fig. 3.4 and produce.

(vi) Carry out the same procedure from O_2, using print 2 from Fig. 3.3.

(vii) O_1a_1' and O_2a_2' meet at A, which is then the intersected position of the point A on the map.

If we know the height of O_1, we can find the height of A. Figure 3.5 represents a vertical section along the O_1A of Fig. 3.4. As before a_1' is the point at which the picture trace intersects the vertical section, and $a_1'a_1$ represents the vertical distance of a_1 above the horizontal axis in Fig. 3.3. Draw AA' perpendicular to O_1A to cut

O_1a_1 produced in A'. A' is then the position in space of the object point A, while A in Fig. 3.5 is the map position. The length AA' then represents the height of station A above station O_1. Since the image point a_2 in Fig. 3.3 lies below the horizontal axis of print 2, A must be lower than O_2.

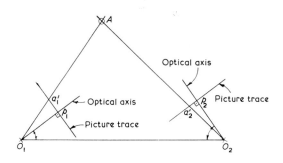

FIG. 3.4. GRAPHICAL PLOTTING FROM HORIZONTAL PHOTOGRAPHS

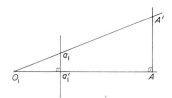

FIG. 3.5. HEIGHTING FROM GROUND PHOTOGRAPHS

Although it is more obvious when described as above, the length O_1p_1 in Fig. 3.4 need not be equal to f. If in Fig. 3.4, O_1p_1 were plotted equal to say $\frac{1}{2}f$, and p_1a_1' were also plotted at half scale, then the tangent of $\angle a_1'O_1p_1$ remains the same, i.e. $\angle a_1'O_1p_1$ remains unaltered if O_1p_1 and p_1a_1' are plotted to the same scale as one another. Similarly for O_2p_2 and p_2a_2'. All other distances will be plotted automatically at the same scale as O_1O_2, i.e. at map scale.

In practice, if the point A is an important point, or is to be used as a control point for future work, its position would be trisected. That is, a third photograph would be taken from a known point O_3 and a further ray O_3A would be drawn. If this ray passes through the same point as the other two rays, then this is the correct position

FIG. 3.6. ELIMINATING THE TRIANGLE OF ERROR
O_1, O_2 and O_3 are the three camera stations
PQR is the triangle of error
A is the correct position of the point

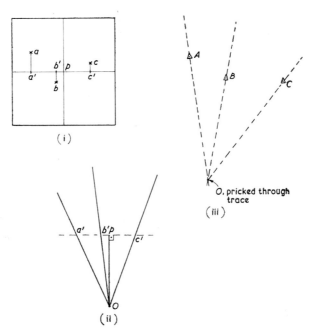

FIG. 3.7. RESECTING CAMERA STATION ON MAP
(i) PHOTOGRAPH
(ii) TRACE
(iii) MAP SHOWING TRACE RADIALS (BROKEN LINES) INTERSECTING THE CONTROL
POINTS

of A, but if they form a triangle of error PQR, as in Fig. 3.6, then we must find the correct position of A by using the following rules—

1. If the triangle of error falls within the triangle $O_1O_2O_3$ then the correct position of A falls inside the triangle of error.

2. If, as in the figure, the triangle or error falls outside $O_1O_2O_3$, then A must be either to the left of all three rays or to the right of all three, i.e. in area 1 or 4 of the figure.

3. The exact position of A will be such that the perpendicular distance of A from each ray is proportional to the lengths of the respective rays.

If the camera stations are unknown they can be resected from three points of detail as follows—

On the photograph, drop perpendiculars from the images of each of the known points on to the horizontal axis. In Fig. 3.7 (i), a, b, and c are the three image points, and a', b', and c' are the feet of each perpendicular respectively.

Secure the print to the table. Superimpose a plastic transparency.

On this trace, set off $Op = f$ and perpendicular to the horizontal axis. Join Oa', Ob', and Oc' and produce (see Fig. 3.7 (ii)).

Lift the trace and place it over the map (see Fig. 3.7 (iii)), so that Oa' intersects A, Ob' intersects B, and Oc' intersects C. This will be possible for only one position of the trace.

Prick through O on to the map: this is the map position of the camera station. If we prick through p at the same time, we can immediately establish the position of the optical axis.

Plotting may now proceed as before.

Other constructions can be evolved for special circumstances.

Ground photogrammetry is often used in mountainous areas such as Switzerland, and parts of Canada and Australia, but some of the photographs are taken with the optical axis pointing slightly downwards which involves a slightly more complicated procedure.

In practice, plotting machines may be used for making such maps.

Air Photographs

Vertical air photographs are also taken so that they may be used in pairs, and at least half the ground covered by one photograph must also appear on its fellow. To facilitate description we shall refer to the left-hand print as photo 1 and to the right-hand print as photo 2. Image points on photo 1 will be given the suffix 1, as a_1, and image points on photo 2 will bear the suffix 2. The principal points of photos 1 and 2 will be p_1 and p_2 respectively. If p_2 is the homologue of P_2, then the homologue of P_2 on photo 1 will be at p_2'.

The line p_1p_2' on photo 1 (see Fig. 3.8) is known as the *base line*,

c

and it represents the apparent track of the aircraft between the two exposure stations.

If, exactly at p_2, there is a minute point of detail whose image can be found on photo 1, then $p_1 p_2'$ may be drawn in directly, but base-lining will normally entail a series of approximations as follows.

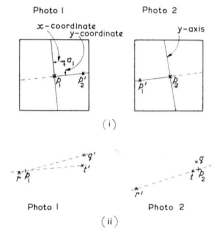

FIG. 3.8. BASE-LINING A PAIR OF PRINTS
(i) COORDINATE SYSTEMS ON A PAIR OF PRINTS
(ii) BASE-LINING BY SUCCESSIVE APPROXIMATIONS

In Fig. 3.8 (ii), q is the nearest easily identifiable point of detail to p_2. Using a magnifying glass mark the image q' of the same point of detail on photo 1. Now align a short steel straight-edge through p_1 and q' and pick a point of detail on this line lying as near to p_1 as possible. Call this point r and transfer it to r' on photo 2. Place the straight-edge to intersect both p_2 and r', and mark a suitable point of detail t on this line as near as possible to p_2. Transfer to t' on photo 1, and use this in place of q'. $p_1 t'$ is a second approximation to the correct position of the base line on photo 1. Continue finding successive approximations for each base line until the last approximation coincides with its predecessor.

When it is required to mark a point of detail, it should normally be pricked through with a very fine needle. To facilitate recognition it should then be ringed on the face of the print with a chinagraph pencil or preferably annotated on the back of the print. Lines should be drawn either with a very fine pencil or scribed with a fine needle, or drawn in red ink. All lines and pricks, however small, will obscure detail and they should therefore be used very sparingly.

The base line of a photograph is usually taken as the line of reference, and is called the x-axis. The line through the photo principal point and perpendicular to the base line is the y-axis (see Fig. 3.8 (i)). x-coordinates are positive to the right and negative to the left. In this book, except where stated otherwise, y-coordinates are positive downwards and negative upwards.

Note that the base line relates to the overlap between two photographs. Thus in an overlapping series of say three photographs in a line, the first photo will have only one base line, whereas the second will have two base lines, one relative to photo 1 and the other to photo 3 (see Fig. 5.2).

Both the base line and the principal line pass through the principal point, but they are two entirely different lines. The direction of the principal line is described by the angle it makes with the positive direction of the x-axis.

Binocular Vision

Viewing normally with both eyes is known as binocular vision. Stereoscopy is a method of reconstructing the binocular view from a pair of photographs. It is only a method of viewing the photographs using both eyes in order to be able to see the ground in three dimensions, but the ability to see a three-dimensional model of the ground from air photographs is a great advantage both in recognizing ground objects and in facilitating heighting and plotting operations. The stereoscopic " model " plays no direct part in the actual plotting of maps from air photographs either in the simple methods of Chapter 7 or in the major instruments, and stereoscopic theory is therefore not essential to a proper understanding of photogrammetry. However this " model " is perhaps the most dramatic phenomenon associated with the subject, and because students are always eager to understand its peculiarities, and because it seems to fascinate both examiners and teachers, it is considered advisable to enter into a brief but approximate discussion of stereoscopy.

When our eyes are functioning normally, each acts in a similar way to that of a camera at the time of exposure. Light rays pass through the lens which causes the bundle of rays from each light source to converge to a focus in the same way as in the case of the camera lens (see Fig. 1.5). The image is formed on the retina which is the inner skin of the wall of the eye. The brain is closely connected with the retina, and thus receives the impression of sight.

By changing the curvature of the lens, each eye automatically

changes its focus to accommodate objects at different distances from the eye.

The apparent size of any object is dependent on the angle subtended by the object at the eye. In Fig. 3.9, tree A subtends an angle

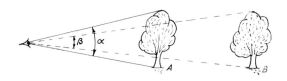

FIG. 3.9. APPARENT SIZE OF OBJECTS

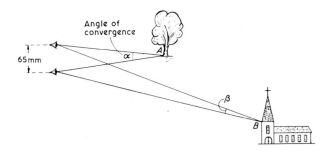

FIG. 3.10. BINOCULAR VISION—ANGLE OF CONVERGENCE

α and so appears bigger than tree B, which subtends the smaller angle β. A normal eye can discern objects which subtend angles as small as thirty seconds of arc.

The distance separating our eyes is known as the eye base, or inter-ocular distance, and averages about 65 mm in length. We therefore obtain a slightly different view of any object with our left eye from that obtained by our right eye.

The direction of the line of sight of each eye is automatically adjusted to obtain a particular field of view. When looking at one object we may say that the closer it approaches to our eyes the greater the angle through which each eye must turn towards the other; this action is known as convergence. The sum of the angles through which each eye is turned to view a particular object (e.g. A in Fig. 3.10) is equal to the angle between the lines of sight from each eye to that object.

This angle is, for convenience, sometimes referred to as the angle of convergence, or even as the parallactic angle. Because it decreases as the viewing distance increases, the angle of convergence enables our eyes to convey the idea of distance to the brain, which then builds up a three-dimensional impression of the view. In Fig. 3.10, A appears nearer than B because α is greater than β.

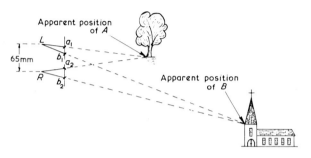

FIG. 3.11. RECONSTRUCTION OF THREE-DIMENSIONAL MODEL

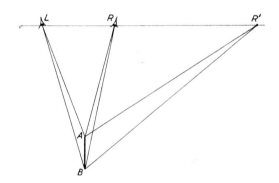

FIG. 3.12. EXTENSION OF THE EYE BASE
AB is a vertical ground object
LR is the normal eye base
LR' is the extended eye base

The minimum change in the angle of convergence which our eyes can appreciate is here taken to be about thirty seconds, and there is therefore a limit to the distance at which our eyes can obtain a three-dimensional impression. For normal views this limit will be reached well within three hundred metres distance, and a person in an aircraft several thousand metres above ground level will have no appreciation of normal ground relief. However, if we could somehow

increase our inter-ocular distance we should at the same time increase the angle of convergence, and also the variations in convergence. In Fig. 3.12, *LR* represents the normal eye-base, and *LR'* the eye-base of a giant. In this figure (\angle *LAR'* $-$ \angle *LBR'*) is greater than (\angle *LAR* $-$ \angle *LBR*), and the height *AB* appears greater when viewed by the giant.

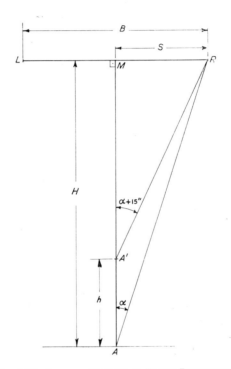

FIG. 3.13. LIMIT OF BINOCULAR DEPTH PERCEPTION
LR is eye base
M is mid-point of *LR*

We can illustrate this mathematically by reference to Fig. 3.13, in which *LR* represents the eye base, of length *B*. We can assume that we are looking vertically downwards at a vertical pole *AA'*, of height *h*, where the bottom of the pole *A* is at a distance *H* below our eyes.

Our eyes automatically tend to centralize the object of our attention, so that we may assume that *AA'* lies on the right bisector *AM* of the eye base.

Let $S = \frac{1}{2}B$ and $\angle MAR = \alpha$

Then if h is the shortest distinguishable depth at a distance H (i.e. if h is the height of the shortest pole that can be seen to have any height)—

$$\angle MA'R = \alpha + \frac{30''}{2} = \alpha + 15''$$

Let $d = \tan 15'' = 0.000075$

Now $\tan \alpha = \dfrac{S}{H}$

and $\dfrac{S}{H - h} = \tan(\alpha + 15'') = \dfrac{\tan \alpha + \tan 15''}{1 - \tan \alpha \tan 15''} = \dfrac{S + H.d}{H - S.d}$

$\therefore H - h = \dfrac{S(H - S.d)}{S + H.d}$

i.e. $h = \dfrac{S.H + H^2.d - S.H + S^2.d}{S + H.d}$

$\therefore h = \dfrac{H^2 + S^2}{\dfrac{S}{0.000075} + H} = \dfrac{H^2 + \frac{1}{4}B^2}{H + B \times \dfrac{10^5}{15}}$

Viewing A from 30 m, $H = 30$ m, $B = 65$ mm, $\therefore h \simeq 2$ m

Thus normal binocular vision will enable appreciation of a change of distance of 2 m, at a distance of 30 m.

If H is increased to 3,000 m, then $h \simeq 2,600$ m, which means that at a height of 3,000 m, variations in height are virtually unnoticed. But if we were giants with say a 2,000 m eye base, then from 3,000 m we could distinguish changes of height as small as 0.75 m, and with a 4,000 m eye base it would be only 487 mm.

The Reconstructed View

Let us consider that we are standing in the field looking at a view as in Fig. 3.10. Take a photograph with a pinhole camera in the place of the left eye, and a second photograph with the camera in the place of the right eye. In both cases the optical axis of the camera can, for convenience, be considered to be perpendicular to the eye base. If we use our eye base LR to represent the line O_1O_2 in Fig. 3.4 we can use the idea of the picture trace to plot from the photographs. This idea can be carried a step further by actually setting up the photographs themselves so that they take up the three-dimensional positions of their respective picture traces.

If we could place our eyes at L and R respectively so that the left

eye saw only the left-hand photograph and the right eye only the right-hand print, then we could actually reconstruct the lines of sight of the original field view, as in Fig. 3.11.

The Exaggerated Impression of Depth

We have seen that with a normal eye base it would be impossible to obtain a reasonable perception of ground height from an aeroplane. However, exposures are usually separated by a distance of a thousand feet or more. The position from which each exposure is

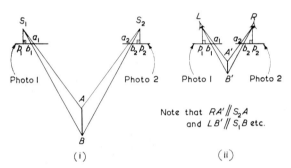

FIG. 3.14. APPARENT EXAGGERATION IN STEREOSCOPIC HEIGHTS
(i) THE FORMATION OF THE IMAGES ON THE PRINTS
(ii) VIEWING THE SAME PRINTS STEREOSCOPICALLY

made is called an air station (or camera station) and the distance between two successive stations is known as the air base: $S_1 S_2$ in Fig. 3.14 (i) where S_1 is the perspective centre at the time of the first exposure, and S_2 the perspective centre of the second photograph.

If two successive photographs could be viewed simply (without lenses) as in Fig. 3.14 (ii), then a three-dimensional model would be seen, in which a giant's impression of depth would be maintained. In this model the horizontal scale is reduced in the proportion $\dfrac{\text{eye base}}{\text{air base}}$ so that the apparent increase in scale in depth of model is

$$\frac{\text{length of air base}}{\text{length of eye base}} \text{ or } \frac{B}{b}$$

This ratio is sometimes referred to as the *specific plastic*; the term is presumably derived from the habit of referring to the stereoscopic image as the plastic model.

It must be remembered that we have been considering a purely theoretical case; in practice the photographs cannot be taken with a pin-hole camera, nor are the ideal viewing conditions of Fig. 3.14 likely to be satisfied. In addition, the use of lenses will alter the angular relationships. Nevertheless the ratio does suggest a reason why gradients appear to be so much steeper in a stereoscopic model than they do on the ground, and this is the only abnormality of the stereoscopic model of which we are usually aware.

The effect of increased viewing distance is illustrated in Fig. 3.15, in which the apparent height of AB depends on the difference

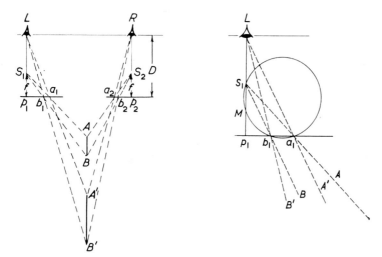

FIG. 3.15. STEREOSCOPIC MODEL—VIEWING DISTANCE GREATER THAN f
D = viewing distance
f = focal length of camera lens

between $\angle LA'R$ and $\angle LB'R$, i.e. on $(\angle A'LB' + \angle A'RB')$. In the circle which passes through S and contains the chord b_1a_1, $\angle b_1S_1a_1 = \angle b_1Ma_1$; thus, ignoring the effect of the right eye, when L lies between S_1 and M then $A'B'$ will appear taller than AB would have done, whereas as L is removed beyond S_1 the apparent height of the model will begin to diminish.

There will be a corresponding, but different, circle for the right-hand photograph. It can therefore be seen that for long viewing distances $(\angle b_1La_1 + \angle b_2Ra_2)$ is less than $(\angle b_1S_1a_1 + \angle b_2S_2a_2)$, but that in other cases the position is not clear-cut. Thus we cannot say that there is any simple relationship between distance and

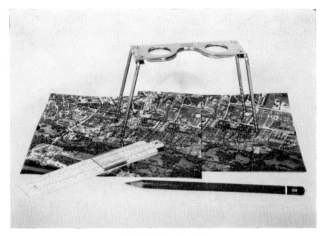

(*Zeiss Aerotopo*)

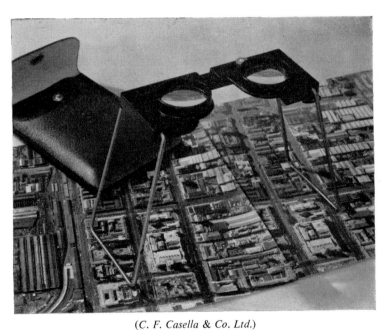

(*C. F. Casella & Co. Ltd.*)

FIG. 3.16. THE POCKET STEREOSCOPE

apparent heights, though an increase in viewing distance is often accompanied by a decrease in apparent gradients.

Magnification has various complicated effects upon the angular relationships, but as it increases the horizontal scale it might be expected to cause some decrease in apparent gradients (in accordance with general experience in stereoscopic viewing).

The combined effect of extending the eye base and magnification is sometimes called the *total plastic*, but the term has little value.

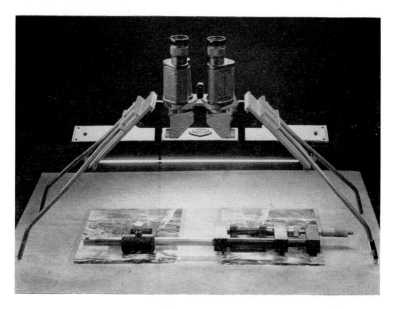

FIG. 3.17. MIRROR STEREOSCOPE WITH MAGNIFIERS AND PARALLAX BAR
(*C. F. Casella & Co. Ltd.*)

In Fig. 3.14 (ii), the eye base has been assumed to be greater than the width of one photograph. This can only be true for photographs less than 65 mm wide. To overcome this difficulty specially adapted viewing instruments known as stereoscopes are used.

STEREOSCOPES

The first stereoscope was invented by Wheatstone in 1838. Improvements were added by Pulfrich, and the stereoscope became very popular in Edwardian households for viewing family groups in three dimensions.

There are two main types of simple stereoscopes used at present in photogrammetry—

1. THE POCKET STEREOSCOPE. This is sometimes known as the lens stereoscope, and consists essentially of a pair of convex lenses (see Fig. 3.16).

The lenses give slight magnification and the refraction of the light rays enables a slight increase in the spacing of the photos for viewing. The main drawback of this type of instrument is that the width of stereoscopic model is small, so that the whole of the overlap of two 230 mm × 230 mm prints cannot be used unless the prints are cut or folded. It is very useful for stereoscopic examination of air photographs in the field.

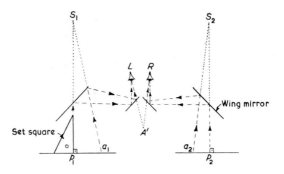

FIG. 3.18. STEREOSCOPIC FUSION WITH MIRROR STEREOSCOPE IGNORING THE EFFECT OF LENSES AND MAGNIFICATION

2. THE MIRROR STEREOSCOPE (see Fig. 3.17). This is the basic instrument in manual methods of heighting, and the idea is used in many of the automatic plotting instruments. Such an instrument enables the photographs to be spaced well apart, and yet to be viewed simultaneously, so that the largest of air photographs can be seen stereoscopically.

The Magnifier Unit

The magnifier unit (which in Fig. 3.17 looks like a pair of binoculars) is normally detachable, and some older mirror stereoscopes were suppiled without lenses. Fig. 3.18 shows a diagrammatic section through the eye base of such an instrument. It will be seen that the total length of the line of sight from the right eye R to the photographic image a_2 is equal to S_2a_2, so that S_2p_2 can be regarded as the

viewing distance (similarly for S_1p_1). The effect of extending the distance between wing mirrors is much the same as increasing the viewing distance (Fig. 3.19), and mainly for this reason the apparent exaggeration of gradients is normally less under a mirror stereoscope than under a pocket instrument. It will be seen that this might also be explained by regarding the increased separation of the photographs as an increase in eye base, and therefore as a decrease in the B/b ratio.

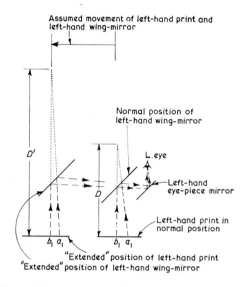

FIG. 3.19. MIRROR STEREOSCOPE—EFFECT OF INCREASING MIRROR SEPARATION
D=normal viewing distance
D'=increased viewing distance

The Effect of Lenses

Eye-piece lenses are incorporated in most modern instruments. Apart from producing some magnification, their main effect is to bend the light rays so that they enter the eyes along more or less parallel paths. Thus the conditions of viewing distant objects are simulated, and the eyes operate under the most comfortable conditions. Such eye-pieces obviously invalidate much of the earlier argument, especially that relating to viewing distance.

TRAINING THE EYES IN FUSION

Let us try to build up a stereoscopic model using a purely theoretical reconstruction.

Take two small sheets of paper and make two identical dots of about 3 mm diameter, one near the edge of each sheet. Place the dots opposite one another and about 60 mm apart as in Fig. 3.20. Place the head about 250 mm above the table on which the pieces of paper are resting. Take a suitably sized piece of cardboard or stiff opaque paper and place it in a vertical plane between your nose and the mid-point between the two dots. Make sure that your eye base is parallel with the line joining the dots. You should now be able to see only the left-hand dot with your left eye, and only the right-hand dot with your right eye. Now view with both eyes open: the dots should appear to fuse into one dot. Persevere until only

FIG. 3.20. STEREOSCOPIC FUSION OF TWO DOTS

one dot is seen: push the pair of dots slightly closer together until fusion is obtained.

Practise alternatively pushing the two dots closer together and drawing them further apart. You should find that the dots will remain fused at gradually wider and wider separations. This is known as increasing the "tolerance" of fusion. After much practice you may be able to obtain fusion without using the piece of cardboard to separate your binocular vision.

The foregoing is a useful exercise in preparing for the use of stereoscopic instruments.

Now add a second pair of dots to the two sheets of paper, as in Fig. 3.21 (i) and repeat the exercise ($b_1 b_2$ must be parallel with $a_1 a_2$). You should be able to fuse both pairs of dots simultaneously, but the new fused dot will appear to be lower down than the original dot, i.e. dots b_1 and b_2 will appear to fuse at a greater distance from the eyes than dots a_1 and a_2 (see Fig. 3.21 (ii)).

Thus we can appreciate the relative depth of the fused points, and if we could measure the stereoscopic depth, we should actually have measured the difference in height between the two points in the stereoscopic model. We shall see in Chapter 6 that this is the basis

of an instrument used for measuring heights from air photographs.

Figure 3.22 shows a reconstruction of the stereoscopic model from two points on a pair of photographs. A comparison of Figs. 3.21 and 3.22 shows the similarity of the two reconstructions (see Fig. 5.5).

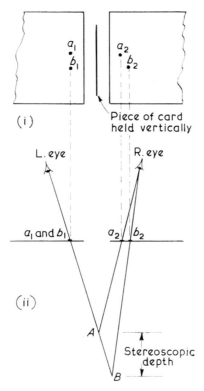

FIG. 3.21. SYNTHESIS OF STEREOSCOPIC DEPTH
(i) PLAN VIEW OF THE TWO PAIRS OF DOTS
(ii) SECTION SHOWING FUSION AND STEREOSCOPIC DEPTH

From Fig. 3.21 it seems that the apparent depth of a particular point depends on the distance apart of the two dots in a direction parallel with the eye base. In Fig. 3.22 the x-axis of both photographs has been aligned parallel with the eye base. In reconstructing the " solid " model we have seen how the eye base takes the place of the air base S_1S_2, so that for correct orientation the image of the air base should be parallel with the eye base. a_1 and a_2 in Fig. 3.22

are the two images of A and are sometimes known as a pair of conjugate points.

The fact that variation in distance causes an apparent relative movements of points only in a direction parallel with the eye base can be very simply illustrated. Hold a pencil vertically and at arm's

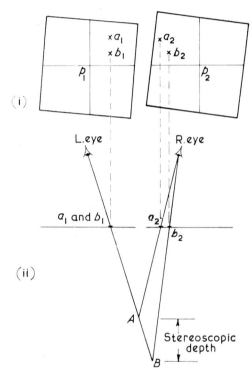

FIG. 3.22. ANALYSIS OF STEREOSCOPIC DEPTH
(i) PLAN VIEW OF TWO PAIRS OF IMAGE POINTS
(ii) SECTION SHOWING FUSION AND STEREOSCOPIC DEPTH

length in front of you, close your right eye and note the alignment of the pencil with respect to the corner of the room. Now close your left eye and open your right, and note that the pencil appears to move rapidly to the left, but that the apparent movement is wholly horizontal and can be shown to be solely a relative motion in which the nearer object appears to move more than the further object. Repeat the experiment with your head tilted sideways, and note that the apparent movement is now wholly parallel with your eye base.

Viewing under the Stereoscope

When it is desired to view a pair of air photographs stereo-scopically, it will be found convenient to observe the following rules.

The photographs should first be base-lined relative to one another. The operator should then choose a position so that the light is falling towards him. Place the photographs on the table so that the base lines are collinear, and parallel with the eye base. The shadows on the photographs should fall towards the operator. The shadows of solid objects on the table now fall in approximately the same direction as the shadows on the photos. Make sure that the over-lapping parts of the photographs are adjacent to one another. If the base lines are made collinear and the stereoscope is placed in position with the eye base parallel with the base lines, then one of the photographs should be moved laterally until comfortable fusion is achieved. Provided that the base lines remain truly collinear, this method of setting is adequate for all practical purposes, though, to obtain an angularly correct model, the ray of light from the principal point of each photograph should be perpendicular to the plane of the photograph. This could be checked by erecting a set square so that one edge rises perpendicularly from the principal point, then moving the photograph so that this edge of the set square appears as a single point (see Fig. 3.18).

If the lighting in the room does not fall in roughly the same direction as the photographic shadows, there may be a tendency to see the hills as valleys, and vice versa. This phenomenon is known as *pseudoscopic vision*, and may be obtained by the beginner even under correct conditions of lighting.

A pair of photos mounted together for stereoscopic viewing is known as a stereogram. The term may also apply to a pair of stereo drawings correctly mounted, or even to the model itself.

THE REAL MODEL

The image seen in a stereoscope is a figment of the brain, i.e. it is not real and measurements could not be made directly from the model which is therefore termed a virtual model. If light were projected through transparent positive prints (known as diapositives), in such a way that the light rays themselves set up a three-dimensional model of the ground, then the model would be real, and linear measurements could be made on the model itself.

If the model in Fig. 3.15 were real, as it is in the multiplex type of plotting instrument, then measurements of height could be made on

the actual model, and an increase in the focal length of the projector would cause an increase in measurable model depth.

Parallax

Figure 3.24 shows a section along the air base, and illustrates the perspective rays set up by a pair of overlapping vertical photographs at the moment of exposure. In this figure not only are both

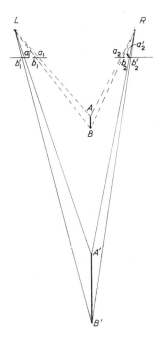

FIG. 3.23. EFFECT OF OUTWARD DISPLACEMENT OF A PAIR OF PHOTOGRAPHS ON THE RECONSTRUCTED " MODEL "

a_1 = image of A on photo 1 a_2 = image of A on photo 2
b_1 = image of B on photo 1 b_2 = image of B on photo 2
a_1', b_1', a_2', b_2' are the positions of the image points after the prints have been displaced outwards.

photographs free of tilt, but they are taken with the lens, i.e. the perspective centres, at exactly the same height. A and B are any two points of ground detail. In Fig. 3.24 (ii) p_1a_1 represents the x-coordinate of the image of A, whatever its y-coordinate may be.

The lens positions are S_1 and S_2. On photo 2, p_2 is the principal point, and a_2 and b_2 the two image points. Suppose that the positive plane is carried along with the camera, so that a_1 is carried forward to

a_1', and b_1 to b_1'. p_2 is still the principal point and, relative to the camera lens, is the same point as p_1. The ray from A now strikes the positive plane at a_2, and there has been an apparent movement of the

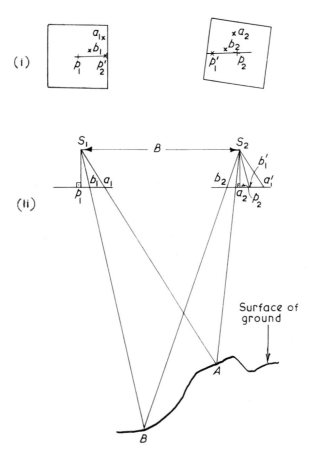

FIG. 3.24. PARALLAX OF A POINT
(i) PLAN
(ii) SECTIONAL ELEVATION

image of A relative to the camera, from a_1' to a_2. This length $a_1'a_2$ is known as the *parallax* of A (sometimes as the absolute parallax of A), and $b_1'b_2$ as the parallax of B. We see that

$$a_1'a_2 = p_1a_1 + p_2a_2$$

but p_1a_1 is the x-coordinate of A on photo 1 and $-p_2a_2$ is the x-coordinate of A on photo 2.

$$\therefore \quad \text{parallax of } A = a_1'a_2 = p_1a_1 - (-p_2a_2)$$

= the algebraic difference in the x-coordinates of A on the pair of photographs.

($a_1'a_2$ could be measured with a millimetre diagonal scale.)

We shall see in Chapter 6 that the difference in parallax of two points is a measure of their difference in height. The parallax of B, a lower point than A, is b_2b_1' which is demonstrably less than a_2a_1'.

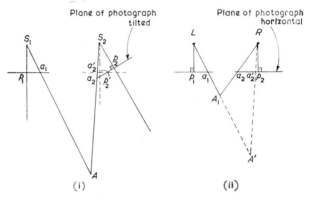

FIG. 3.25. ERROR IN RECONSTRUCTED MODEL DUE TO TILT
(i) LINE DIAGRAM AT EXPOSURE
(ii) PROJECTED MODEL

Errors in Parallax Due to Tilt

If one of the photographs is tilted, then the x-coordinates of points on that photograph are incorrect. For example see Fig. 3.25 (i), where the second photograph was tilted so that the image of A fell at a_2, whereas in the untilted photograph it fell at a_2'. Thus $p_2'a_2'$ is the correct x-coordinate, but p_2a_2 is the actual coordinate. Figure 3.25 (ii) shows how the reconstructed position of A will be at A_1, whereas the correct reconstructed position would have been at A'.

The more expensive plotting machines generally aim at recreating a correct spatial image or model by orienting each photograph at the actual angle of tilt. The manual methods and cheaper

instruments generally produce an erroneous model or measure the photographs lying in a horizontal plane; corrections are then made mathematically or graphically.

Even when both photographs are truly vertical, errors in the x-coordinates may occur through a change in height of the aircraft between the two exposures as in Fig. 3.26. This situation is known as inclination of the air base. From the figure it can be seen that the angle $a_2 S_2 p_2$ is less than the correct angle $a_2' S_2' p_2'$. Therefore $a_2 p_2$ is less than the correct x-coordinate $a_2' p_2'$.

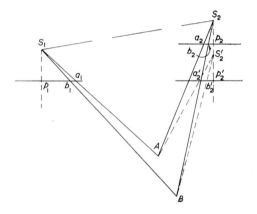

FIG. 3.26. EFFECT OF INCLINATION OF AIR BASE ON x-COORDINATES
S_2' is position which S_2 should have occupied if height of aircraft had remained constant. A and B are ground objects.

This is of course to be expected, since S_2 is too high, making the scale of the photograph too small. Thus if we regard the height of the first exposure as correct, the x-coordinates of points on the second photograph will be too small if S_2 is too high, or too great if S_2 is too low.

Want of Correspondence

So far we have considered only changes in the x-coordinate, because it is this coordinate which is used in heighting measurements; but since height displacement will have the same effect on the y-coordinate of one photo as it has on the y-coordinate of the next, a difference in y-coordinates is often regarded as a measure of the relative tilt between two photographs of an overlapping pair.

Figure 3.24 shows a section containing the air base of a pair of untilted photographs whose perspective centres are at the same height.

If we were to draw a sectional elevation of the same conditions but looking along the air base, the result would be as in Fig. 3.27. Thus the y-coordinate of A on photo 1 is p_1a_1 and on photo 2

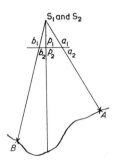

FIG. 3.27. SECTIONAL ELEVATION LOOKING ALONG AIR BASE
A and B are ground points. All rays to S_2 overlie corresponding rays to S_1.

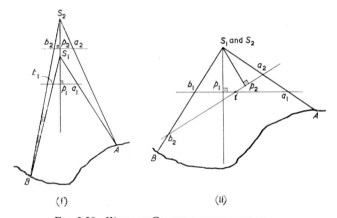

(i) (ii)

FIG. 3.28. WANT OF CORRESPONDENCE DUE TO—
(i) INCLINED AIR BASE
(ii) LATERAL TILT
Both diagrams are sectional elevations looking along the air base.

p_2a_2. These lengths are obviously the same so the y-coordinates of the pair of photographs are the same, and the photographs are said to be in correspondence.

Figure 3.28 (i) shows the sectional elevation looking along the air base of the conditions depicted in Fig. 3.26. The scale of photo

2 is again less than that of photo 1, and the y-coordinates no longer correspond.

In Fig. 3.28 (ii) the air base is no longer inclined, but photo 2 is tilted in the y-direction (i.e. the principal line is assumed to lie along the y-axis). p_2a_2 is much less than p_1a_1, and there is " want of correspondence " between the pair of photographs.

Tilt purely in the x-direction of photo 2 will cause a scale error in the y-direction. This is because the principal line lies along the x-axis, and the lines parallel with the y-axis are all plate parallels along which there is no tilt. Thus except for images lying along the isometric parallel of photo 2 there will again be want of correspondence.

Tilt of one photograph relative to its pair will always give rise to want of correspondence, though tilts in the y-direction have a much bigger effect than those in the x-direction. If both photographs are tilted by the same amount and in the same direction correspondence will remain. Want of correspondence can also be due to inclination of the air base. In practice there will usually be relative tilts in both the x- and y-directions and also inclination of the air base.

Want of correspondence is sometimes referred to as y-parallax, vertical parallax, or more simply as K.

Check on Base-lining

Set up the photographs for viewing under a stereoscope. Turn each photograph through a right angle, both in the same angular direction. Move photo 2 so that p_1' falls on the extension of the y-axis of photo 1. If want of correspondence is present, then the differences of y-parallax will now occur in a direction parallel with the eye base, and will cause apparent variations in depth of image points below the eyes. Thus an appearance of hills and valleys is generated, giving another type of pseudoscopic vision. This gives a method of checking the accuracy of base-lining. If both base lines have been accurately drawn then the fused image should appear to be in contact with the ground throughout its length.

Base-lining under a Stereoscope

We have described a purely graphical method of drawing in the base-lines on a pair of photographs, and the beginner has been advised to use these for setting up his photographs accurately to form a stereogram, so that he may more readily obtain a stereoscopic view. However, in practice the experienced photogrammetrist will be able to obtain fusion from an approximately oriented pair of photographs, and can then proceed to a much quicker method of base-lining.

The pair of prints are placed under the stereoscope with the shadows falling towards the observer, and with the common image portions adjacent to one another. Choose a particularly conspicuous group of images which can be easily recognized on both photographs, e.g. two intersecting hedges, one roughly at right angles to the other. Now look through the eye-pieces, cover up the right-hand photograph, and pick out the chosen detail on the left-hand photograph; do the same with the detail on the right-hand photograph. Move the photographs laterally (in both the x- and the y-directions) until the two images of the hedge intersection coincide; then rotate the prints until the two images of both hedges coincide. Study the stereogram until the stereoscopic model becomes apparent, adjusting the lateral position and rotating the photographs until the most comfortable fusion is obtained. The prints are now secured to the table with masking tape to form a stereogram.

To transfer the principal point p_1 to p_1' on photo 2, we require two fine needles, which we hold one in each hand. With all the magnification we can get, and looking only at photo 1, we make the left-hand needle-point touch exactly the left-hand principal point p_1. Now again view the stereoscopic model and (keeping the left-hand needle point in contact with p_1) move the right-hand needle-point gradually over the face of the right-hand photograph until the two needle-points coincide exactly. The right-hand needle-point should now indicate the correct position of p_1'.

Transfer the principal point of photo 2 to photo 1 in the same way. It should now be possible to lay a straight-edge so as just to touch each of the points p_1, p_2', p_1' and p_2; if this cannot be done, the stereogram must be adjusted and the procedure repeated. Join p_1p_2' and $p_1'p_2$. Check by turning the two photographs through a right angle and viewing the pseudoscopic model.

This technique is not so easy as it sounds, mainly because under most conditions of lighting the needle-points tend to disappear from view at frequent and unpredictable intervals. Perseverance is required, but it is still a lot quicker than the graphical method.

FURTHER READING

GROUND PHOTOGRAMMETRY
 (i) Schwidefsky, pages 91–106.
 (ii) Moffitt, Chapter 14.
 (iii) Hallert, pages 73–102.
 (iv) Zeller, pages 34–103.
 (v) *Manual of Photogrammetry*, Vol. II, Chapter 19.

STEREOSCOPY
 (i) Schwidefsky, pages 59–74.
 (ii) *Manual of Photogrammetry*, Vol. I, Chapter 11.
 (iii) Hart, pages 156–81.
 (iv) Moffitt, Chapter 7.
 (v) Hallert, pages 52–62.
 (vi) Lyon, Chapter 2.

PLANE TABLE SURVEYING, RESECTION AND INTERSECTIONS
 H.M.S.O., *Manual of Map Reading, Air Photo Reading and Field Sketching*, Part III.

(See Bibliography (page 346) for the full titles.)

CHAPTER 4

Flying for Cover

In Britain, and especially in the Royal Air Force, it is usual to speak of a single flight of an aircraft from take off to touch down as a *sortie*. It has thus become usual to speak also of the set of photographs taken during one flight for mapping purposes as a *sortie*. A photographic sortie will usually be flown for the specific purpose of taking photographs sufficient to enable the mapping of a definite area of land to be carried out by photogrammetrical methods. However, one sortie might cover two or more entirely separate areas. When an area of ground has been covered by a satisfactory sortie, we say that *air cover* for that area is available.

The main objects of flying for air cover will be to obtain, in the quickest and cheapest manner, a set of photographs which will enable the surveyor to carry out the necessary plotting of the required map.

To secure satisfactory air cover the following points must be considered—

1. Proper equipment must be used. This aspect will be further discussed in Chapter 9.

2. Weather conditions, including height and intensity of the sun, must be favourable.

3. The flying height is so chosen that, with the given lens, contact prints of a suitable mean photo scale are produced.

4. The whole area must be completely and systematically covered so that adequate stereoscopic vision of the land is possible.

5. The optical axis (principal axis) is sufficiently nearly vertical at the time of exposure.

Taking each of these points in turn—

1. Equipment. The aircraft itself must be specially adapted to carry the air camera and viewfinder. Until recent years a slow-flying but stable aeroplane was the rule; but nowadays moderately fast speeds can be tolerated. The aeroplane must be capable of flying on an even keel at the height required, and at the same time carrying the camera and the operator, who will often also be the navigator. Many different types of aircraft have been successfully used for

this purpose, and it is unusual for a specially designed plane to be advocated. The direction along the keel, from nose to tail, is known as *fore and aft*, and the direction from wing tip to wing tip as *lateral*.

The camera is a precision instrument designed for the specific purpose of air photography and was described in Chapter 1. This instrument is gimbal-mounted in the fuselage or body of the aeroplane, so that it can be turned through any vertical or horizontal angle with respect to the aeroplane's axes.

The camera is mounted in the inner ring of the gimbal (see Fig. 1.17), in such a way that the optical axis is perpendicular to the plane of the ring, and passes through the centre of the ring. The instrument is free to rotate about the optical axis within the ring, and can be set so that the side of the format makes any desired angle with the fore-and-aft direction of the aircraft. This angle is known as the *drift ring setting*.

2. WEATHER CONDITIONS. When an old steam-engine belched out steam and smoke from its funnel, it caused dense, whitish, turbulent clouds; you could see the air currents at work. The similarity between these artificial clouds and the billowing mountains of cumulus cloud is most striking. The obvious turbulence of the cumulus cloud is evidence of strong, often upward, air currents. Such currents may occur elsewhere than within cloud formations. Other disturbing influences are air pockets, in which there is a sudden downward current of air. All these disturbances seriously affect the stability of relatively slow-flying aircraft, and photography should not normally be undertaken when such turbulence is known to occur at flying heights.

Photographs cannot normally be taken through cloud or fog; smoke, dust and haze all affect the photography adversely. However, if the sun is too intense the shadows of the photograph become too dense, and obscure the detail. For this reason a thin film of high cloud known as cirrus will be an asset as it will lessen the sun's intensity without causing any obstruction between the lens and the ground.

Bad weather conditions, including rain, are obviously to be avoided, but heavy rain tends to wash out the suspended dust and smoke from the atmosphere. A bright day following a day of heavy rain will often be best for air photography, especially in or near large cities. Lying snow will obscure ground detail, but may be desirable for special purposes. Intense cold may affect the camera, and although heating can be provided, it is very expensive and is not usual at normal flying altitudes in mid-latitudes.

Shadow tends to obscure detail, so that the sun should be fairly high in the sky to give a reasonably short shadow. However, the shape of a shadow is often the best guide to the identity of a ground object from the air, so that the shadow must not be too short. It is usually considered that the photography should be undertaken when the sun's rays make an angle with the horizontal of between say 30° and 65°.

In many countries there will be very few days during any year on which satisfactory air photography could be undertaken. In the British Isles in particular, there is little likelihood of knowing in advance when these suitable days are to occur. Thus it may be necessary for aircraft, camera and crew to stand by for many days before the desired sortie can be flown successfully. This keeps the cost of flying for cover somewhat disproportionately high.

3. FLYING HEIGHT. When simple plotting methods are to be used, the mean or average scale of the air cover should be approximately the same as the desired scale of the compilation drawing. Thus with a given focal length of camera lens, and a given compilation scale, the necessary height of aircraft above mean ground level can be calculated. Flying height, being the height above sea level, can then be found by adding in the mean height above sea level of the ground. Figure 4.1 is a development of Fig. 2.5 and illustrates that scale of photograph $= f/(H - h)$. Thus, if scale required is $1/10,000$, focal length of lens is 150 mm, and h is 100 m above sea level,

then
$$1/10,000 = \frac{0 \cdot 150}{H - 100} \text{ m}$$

i.e.
$$H - 100 = 1,500 \text{ m}$$
$$H = 1,600 \text{ m}$$

i.e. flying height must be 1,600 m.

Given the same focal length and the same size of format, the higher the aircraft flies the greater the area of ground covered, and the less the number of photographs required to cover any particular area of land. From this point of view the greater the flying height, the more economical the coverage.

On the other hand, the less the flying height, the greater the scale, the more detail that can be readily discerned and the greater the heighting accuracy. Similarly, a greater flying height increases the thickness of haze and dust that the light rays must penetrate, with consequent loss in quality of the photograph. Furthermore the cost of high flying exceeds the cost of flying at lower altitudes.

Air cover is nowadays often flown at over 10,000 m, but the

difficulties involved at such heights are immense. The average human body can cope with altitudes of up to 3,000 m, but even at such heights temperatures may be 18°C less than at sea level, and the pulse rate will have quickened due to the decrease in atmospheric pressure from about 101 kN/m² at sea level to 70 kN/m² at 3,000 m. Higher than this, the decrease in the oxygen supply tends to affect

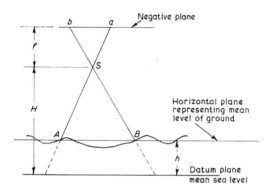

FIG. 4.1. SCALE OF A PRINT
A and *B* are two ground points occurring at the mean height of the ground covered by the photograph.

the normal functioning of the brain, and at about 4,500 m mental processes tend to slow down. As height is increased so the human body would gradually lapse into a state of coma, which is reached at something over 7,000 m. Thus oxygen should normally be taken at heights exceeding 4,500 m. Over about 10,000 m oxygen will usually be required under pressure, and at somewhere near 12,000 m even oxygen under pressure will be insufficient to prevent a lapse into a state of coma. Pressurized cabins in the aircraft can overcome these difficulties, but this necessitates additional cost. High altitudes call for additional clothing which, in turn, reduces efficiency in operating the instruments. The instruments themselves and the materials used in the photographic processes are also adversely affected by the intense cold, and it may be necessary to supply some heating for the instruments. In addition to pressurizing and heating, the aircraft used for higher altitudes will require much more power, and construction and design costs will be very much heavier.

Normal flying heights may be considered as, say, 1,000 to 4,500 m above ground level, so that we may expect flying costs to increase in mountainous areas. We shall see later that in determining the

flying height, not only must we consider the scale required, but also
the limitations set by the mechanism of the camera, and by the
errors due to height distortion. Improved techniques and knowledge
are leading to a gradual relaxation of height restrictions in flying for
cover.

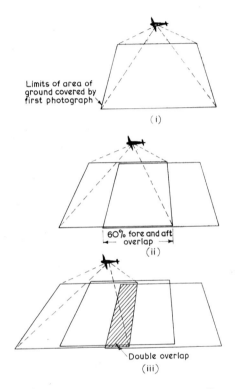

Limits of area of
ground covered by
first photograph

(i)

60% fore and aft
overlap

(ii)

Double overlap
(iii)

FIG. 4.2. COVERAGE OF PHOTOGRAPHS SHOWING OVERLAPS
(i) FIRST EXPOSURE
(ii) SECOND EXPOSURE
(iii) THIRD EXPOSURE
Perspective views of ground covered by the first three photographs of a
strip.

4. COVERAGE. Systematic coverage is obtained by flying the
aircraft at a fixed height, and in a series of straight lines. As the
aircraft flies along one straight line photographs will be taken at
regular intervals. The photographs taken during the time that the
aircraft flies along any one of these straight lines are known col-
lectively as a *strip*. Each photograph in a strip should overlap its

predecessor by 60 per cent (see Fig. 4.2). This is known as the fore and aft overlap. It will be seen in Fig. 4.2 (iii) that there is an area of land covered by each of the first three photographs. There will also be such an area common to any three consecutive prints, and it is known as the *double overlap* (or supra lap). On a perfectly flown strip the double overlap will comprise 20 per cent of each of the three photographs of which it forms part.

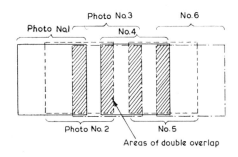

FIG. 4.3. PLAN VIEW OF A STRIP OF AIR PHOTOGRAPHS
Each photograph is set out relative to its correct plan position.

Figure 4.3 shows that 20 per cent near one edge of photo 3 covers ground which also appears on photos 1 and 2. The middle 20 per cent of photo 3 will also appear on photos 2 and 4, and that 20 per cent near the leading edge of photo 3 will also appear on photos 4 and 5. Thus a total of 60 per cent of photo 3 should appear on two other photographs as well.

Having flown one complete strip the aircraft must turn round and fly back along another straight line parallel with the first, again taking photographs at regular intervals so that each new photograph overlaps its predecessor by 60 per cent. The second strip of photographs must also overlap the first strip; this is known as the lateral overlap (see Fig. 4.4). Where the photographs may be wanted for making a mosaic or photo-map, then the lateral overlap must be 30 per cent. For other purposes 20 per cent lateral overlap is usually considered to be sufficient, though some authorities maintain that 25 per cent should be specified.

This means that, as each photograph in the first strip is taken, only 40 per cent of the format area covers new ground, and we say that the net gain is 40 per cent. Similarly each new strip, when a 30 per cent lateral overlap is specified, will gain only 70 per cent of

the full width. Thus only $(70/100) \times (40/100) = 28/100$ or 28 per cent of each photograph covers " new " ground. These facts become important when we try to calculate the number of exposures required for complete air cover of a particular area of land.

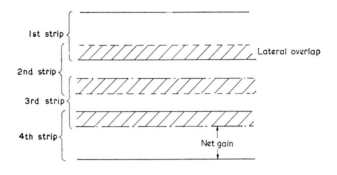

FIG. 4.4. PLAN SHOWING LATERAL OVERLAPS

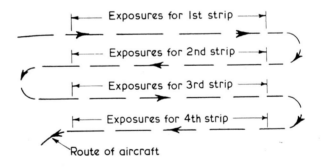

FIG. 4.5. A TYPICAL FLIGHT PLAN
The separation of flight lines to give a 20 per cent lateral overlap is equal to $80/100 \times$ width of format \times 1/scale.

The strips can normally be flown in a direction parallel with the longest dimension of the land to be covered (see Fig. 4.5). In temperate latitudes there is some advantage in flying east to west and west to east, because it will then always be possible to set the photographs under the stereoscope so that the shadows fall towards the observer. When this condition is satisfied it is easier to arrange the lighting in the laboratory to give the most satisfactory fusion.

If navigation were by compass, then there would be a definite objection to north–south flight lines, in that the needle would normally be thrown temporarily off balance at the turning points.

Unless radar is being used, navigation in a straight line involves flying along a prearranged course, throughout the length of which known ground objects at perhaps fifteen to twenty mile intervals are discernible from the aircraft. If no map of the area exists, it

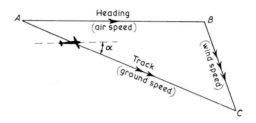

FIG. 4.6. DRIFT OF AIRCRAFT CAUSED BY A CROSS-WIND

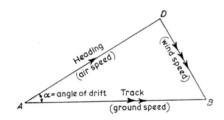

FIG. 4.7. DIAGRAM FOR CALCULATING THE ANGLE OF DRIFT

may be necessary to fly a skeleton cover of the area and prepare a rough photo map merely for purposes of navigation.

Suppose that when the aircraft reaches its required flying height there is a cross-wind blowing, such that if the plane heads from A to B (see Fig. 4.6) it actually travels along the line AC. If photographs were taken the result would be a strip of photographs along the line AC, which is known as the track of the aircraft. Throughout the flight along AC the fore and aft direction of the aircraft (or the heading) is assumed to have been parallel with AB. If the distance AB in Fig. 4.6 represents, to scale, the air speed in say km per hour, and BC represents the velocity and direction of the wind speed in km per hour to the same scale, then AC is the resultant and represents

D

the ground speed of the aircraft in km per hour. The air speed is the speed of the aircraft relative to the air, whereas ground speed is its speed relative to the ground. Alternatively, ground speed can be described as the speed with which the plumb point traverses the ground.

Suppose that the strip is required to be flown from A in the direction of B, i.e. along AB in Fig. 4.7. The navigator must calculate $\angle DAB$, so that he can head the aircraft correctly. This angle is the *angle of drift* and is usually denoted by α. Let us assume that we are required to find the angle of drift in the following circumstances.

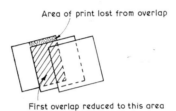

Area of print lost from overlap

First overlap reduced to this area

Fig. 4.8. Loss of Overlap due to Crab

Required direction of track is due east; air-speed of aircraft is 300 km/h; the wind has been determined as from the north-west with a velocity of 50 km/h.

The figure required is similar to Fig. 4.7, though there DB is of exaggerated length and the angle of drift therefore appears too big. The triangle can be solved by the sine rule.

$$\angle DBA = 45°$$

$$\frac{\sin \alpha}{DB} = \frac{\sin \angle DBA}{AD}$$

i.e.

$$\sin \alpha = \frac{50 \times \sin 45°}{300} = 0{\cdot}1178$$

$$\therefore \quad \alpha = 6° \, 46'$$

i.e. required angle of drift is $6° \, 46'$.

The aircraft must be set heading $6° \, 46'$ into the wind, that is $6° \, 46'$ north of east. The wind will then carry the aircraft along the line AB.

If the camera remains aligned so that two sides of the format are parallel with the fore and aft axis of the aeroplane, then the areas

of ground covered by each successive photograph would overlap one another as in Fig. 4.8. This phenomenon is known as *crabbing*. From Fig. 4.8 it can be seen that crabbing gives rise to loss of stereoscopic cover, since the area of overlap between two consecutive photographs is reduced. The base line is no longer parallel with the format sides, and the angle between the base line and the format sides is known as *the angle of crab*. This is offset by turning the camera through the appropriate angle about its vertical axis. This angle will be equal and opposite to that through which the heading was turned; it is sometimes referred to as the *drift ring setting*, and will be 6° 46' in a clockwise direction, or + 6° 46', in the example just illustrated.

Since both speed and direction of the wind vary according to the height above ground, there is no way of calculating the angle of drift and the drift ring setting until flying height is achieved. Thus as soon as the required altitude is reached, the pilot will make a trial run over part of the ground which is to be covered in the first strip. He will fly so that the track of the aircraft passes directly over his prearranged navigation points. This heading angle will be checked by the navigator in the viewfinder. When the track is correct, the navigator will turn the viewfinder (see Fig. 4.9) until the navigation objects appear to travel parallel with the side of the format. The viewfinder is actually part of a modern air camera, so that the latter moves with the viewfinder. Thus the drift ring setting is achieved. With the older cameras it may be necessary to calculate the angle of drift after correct flying height is reached and after wind speed and direction have been measured.

Trimming the camera for levels is by reference to spirit bubbles attached to the camera.

5. TILT. As will be seen in Chapter 5, the assumptions made when using simple plotting procedures depend on the fact that the plumb point and the isocentre are very close to the principal point. In other words the photograph must be very nearly vertical. Specifications for flying for air cover will usually include a clause to the effect that tilt of any single photograph must not exceed say 3°; relative tilt between any two consecutive photographs must not exceed 5°; the average tilt of photographs included in the sortie must not exceed 1°. A maximum tilt of $2\frac{1}{2}$° or even 2° for a single photograph is now possible, and the specifications are likely to be more demanding in the future.

However skilful the flying, and however stable the flying conditions, it is unlikely that perfectly vertical photography will be achieved. However, if, due to the incidence of the wind or for some other

reason, the aircraft is not flying on a perfectly even keel, then the camera can be " trimmed for levels " by turning it about each of the horizontal axes in turn. Such trimming would normally be done

(*Wild Heerbrugg Ltd.*)

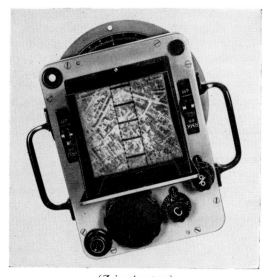

(*Zeiss Aerotopo*)

FIG. 4.9. VIEWFINDERS

again for each strip, especially where the unevenness of keel is due to a constant wind.

The importance of maintaining direction throughout each strip can be realized when it is stated that a 1° deviation from course

would result in a ground error of 0·17 km in a 10 km flying distance. If the lateral overlap were supposed to be 20 per cent with photography at a scale of 1/10,000, then the overlap on the ground would be only

$$\frac{230 \times 10,000}{1000 \times 1000} \times \frac{20}{100} = 0\cdot46 \text{ km}$$

Thus the error envisaged has already reduced the lateral overlap to less than a half its correct amount, and we have not yet considered the possibility of error in the overlapping strip.

Modern aids have made navigation a much more certain affair, and some of these are described below.

SOME AIDS TO AIR NAVIGATION

The main problems of the air-crew are those of maintaining—

1. direction of aircraft relative to the ground;
2. (i) orientation of the camera relative to the aircraft, and
 (ii) the exposure interval;
3. verticality of the camera axis;
4. constant known flying height.

The alternative to direct viewing of a predetermined route on the ground involves some form of radar. Two main systems are in use with survey aircraft: Shoran and Decca. Both involve accurate fixing of two or more ground stations before flying can be undertaken.

A modification of the Tellurometer is sometimes used in the same way, and its extra accuracy in distance measurement enables ground Trig. stations to be fixed from the air. The equipment used for this purpose is known as Aerodist.

Another use for radar is found by coupling it with the Doppler principle. The latter is usually illustrated by reference to the change in sound as an express train rushes past. As the train comes towards you, the time taken for the sound waves to reach your ear gradually lessens, so that the time between successive waves is reduced, i.e. the frequency is increased, and the pitch is therefore higher; whereas as the train recedes the frequency is reduced. The same effect is obtained with radar waves. If a radar beam from the aircraft is directed towards the ground, the frequency of the reflected rays as received at the aircraft will be a measure of the speed of the aircraft relative to the ground. In practice four such narrow beams are used, and, if properly correlated with information from other

instruments, the continuous measurement of velocity can be used to give deviation from course and camera position.

A modern commercial air survey firm would make use of these developments, e.g. Aero Service Corporation of Philadelphia use Shoran, Doppler and APR equipment, and among their aircraft are B–17's and P–38's which are capable of flying as high as 12,000 m.

Modern cameras are provided with built-in viewfinders, in which the operator can see the same area of ground as is being photographed, and that ground view will appear to travel across the viewfinder screen. This provides a check on the aircraft heading. The operator will also be provided with a plot (preferably photographic) of the flight lines. If the heading is correct, the principal point marked on the screen will appear to travel along the flight line. Crabbing is now removed by turning the camera in swing until the required flight line is parallel with the base line in the viewfinder (the " ladder " in the Zeiss viewfinder in Fig. 4.9).

The " rungs of the ladder " in the Zeiss instrument or the curved lines in the Wild instrument are made to travel across the viewfinder screen in the direction of flight. The operator can adjust the speed of this movement until the lines keep pace with the apparent movement of the ground. The shutter mechanism is so correlated with this movement that the interval between exposures will be correct for the specified fore and aft overlap. The latter is preset on the instrument to the required value. Figure 4.10 (i) shows the controls for an RC7 camera and Fig. 4.10 (ii) shows it mounted in an aeroplane with an operator at the controls.

Acceleration forces of earth and aircraft prevent the straightforward use of a gyroscope in establishing verticality of the camera axis. Much research has been done in this field, and the Aeroflex Corporation of New York now produce a stabilized platform (see Fig. 4.11) incorporating a double gimbal mounting for the camera. The manufacturers quote a probable error of 25′. Aeroflex have recently designed an inertial platform which provides a vertical reference, though not true verticality, to within 3′.

It is perhaps a little easier to measure the amount of tilt present at exposure. The two best-known methods are by the Santoni Solar Periscope and the horizon camera. In the first, a " solar camera " records the sun's direction with respect to the camera axis and heading; from this the instrument computes and records the tilt components.

The horizon camera is fixed with its axis perpendicular to that of the main camera, i.e. its axis is approximately horizontal. In the best systems there are two horizon cameras fixed in such a way that

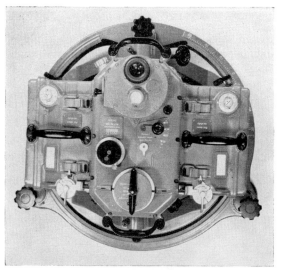

(i) Plan View of Wild RC7 Plate Camera

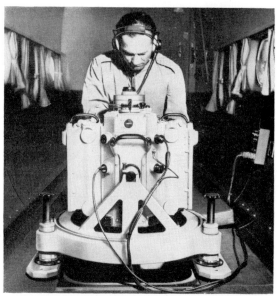

(ii) RC7 Camera Mounted in an Aeroplane
(*Wild Heerbrugg Ltd.*)

Fig. 4.10

the three camera axes are mutually perpendicular, and one of the horizon cameras points in the direction of flight. All three cameras are synchronized for simultaneous exposure. Figure 4.12 is a sketch

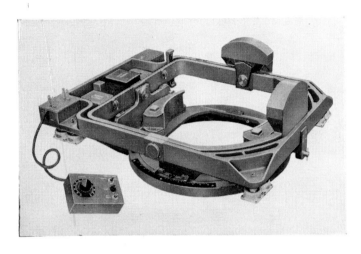

FIG. 4.11. STABILIZED PLATFORM
(*Aeroflex Laboratories Incorporated*)

FIG. 4.12. SKETCH DIAGRAM OF SUCCESSIVE HORIZON EXPOSURES

diagram of two successive exposures of the fore and aft camera. Two image points, *a* and *b*, are chosen so that they can be accurately recognized on both photographs, and so that they are as far apart as possible. Collimating marks on each photograph will enable the axes to be drawn in as shown. The perpendicular distances, a_1, b_1, a_2 and b_2 are measured and their differences, $a_1 - a_2 = p_a$ and $b_1 - b_2 = p_b$, are determined. This may be done by turning each print through 90°, viewing stereoscopically, and finding the

parallaxes, p_a and p_b, by the method described in Chapter 6, (the parallax of the x-axis being zero). From the diagram—

relative lateral tilt $= \dfrac{p_a - p_b}{\frac{1}{2}(x_1 + x_2)}$ in radians, and

relative fore and aft tilt $= \dfrac{\frac{1}{2}(p_a + p_b)}{f}$ in radians

($f =$ principal distance of the horizon camera).

The use of the second horizon camera allows a further determination of both components, and therefore gives greater accuracy. In practice this method has been found to give accuracies within 2'.

The flying height of an aircraft above datum is normally determined by barometric altimeter. Air pressure is subject to many variations, and the aircraft height can be only approximately measured by this method. The best accuracy which can be expected is of the order of 1·2 per cent of the flying height.

A statoscope is an instrument for measuring small differences in flying height. Essentially it comprises a barometer of very high sensitivity. It is capable of recording height differences as small as 300 mm, but it only operates over a limited range of altitude, and records only height differences from a particular isobaric surface. This surface is not flat, but in practice its height at any point is interpolated linearly between known heights at each end of a strip. The corrected altitudes can be expected to be accurate to within about 2 metres.

On the other hand, the aircraft's vertical clearance of the ground can be measured by a narrow radar beam. This beam is maintained nearly vertical by means of a gyroscope, and the distance to the ground is measured by recording the time taken for the beam to be reflected back to the aircraft from the ground surface.

If the ground clearances and the statoscope altitudes are both continuously recorded in graph form, then the difference between these two graphs will be a record of ground heights above datum. Instruments recording such data are known as Airborne Profile Recorders (more usually shortened to APR).

APR profiles are flown in conjunction with each strip of photography, so that the profiles can be related to each principal point. In order to obtain ground heights in positions suitable for the pass points of Chapter 5, intermediate profiles parallel with the flight lines are also flown, and some profiles are required in the transverse direction. This network will give sufficiently accurate height control

for the contouring of small- and medium-scale topographic maps by air survey methods.

With normal strip photography as practised today, the plumb points are regularly spaced in the fore and aft directions, but they bear no such relationship to plumb points of the adjacent strips. As will be seen from Chapters 5 and 6, this is inconvenient and wasteful of control points. Modern methods of navigation make it

FIG. 4.13. BLOC PHOTOGRAPHY—THE SLOTTED TEMPLET PLOT
(Compare Fig. 5.10)

possible to fly " bloc photography " in which the plotted positions of the principal points lie nearly at the intersections of a rectangular grid (see Fig. 4.13).

The mechanism controlling the time between successive exposures is often referred to as the intervalometer, and the setting is calculated as follows—

$$\text{Scale of photography} = 1/20,000$$

\therefore Ground distance between exposures

$$= 40\% \text{ of } 230 \text{ mm multiplied by scale factor}$$

$$= 230 \times \frac{40}{100} \times \frac{20,000}{1,000} = 1,840 \text{ m}$$

$$\text{Speed of plane, say } 300 \text{ km/h} = \frac{300 \times 1,000}{60 \times 60} \simeq 83 \text{ m/s}$$

$$\therefore \text{ Time interval} = \frac{1,840}{83} \simeq 22 \text{ sec}$$

The calculation would not be needed with modern cameras and viewfinders.

Convergent photography is also sometimes used in air surveys. Two exposures are made simultaneously: one camera pointing slightly forwards and the other slightly backwards. Each of the resulting photographs overlaps by about 100 per cent with one of the photographs taken from adjacent camera stations.

FURTHER READING

(i) Schwidefsky, SURVEY AIRCRAFT pages 142–3, NAVIGATION 139–42, the STATOSCOPE pages 122–3, APR page 126, SUN PERISCOPE page 127.

(ii) *Manual of Photogrammetry*, Vol. I, Chapter 5.

(iii) Hart, pages 122–35.

(iv) Moffitt, Chapter 4.

(v) Hammond.

(vi) Cimerman and Tomasegovic.

There is a comprehensive review of methods of FLYING FOR COVER in the following article—

CORTEN, F. L. (I.T.C., Delft), "Survey navigation and determination of camera orientation," *Photogrammetria*, **XVI**, No. 4 Special Congress No. C (1959–60).

In addition, *Electronic Surveying and Mapping* by Simo Lawila and published by The Ohio State University gives full information concerning ELECTRONIC NAVIGATIONAL AIDS.

(See Bibliography (page 346) for full titles.)

CHAPTER 5

Radial Line Methods of Increasing Control

We have seen in Chapter 2 how that if the ground is perfectly planar we can plot the position of points by intersections of radials from the isocentres of two or three consecutive photographs. We also saw how if all the photographs were untilted then plotting could be carried out by intersections of radials from the plumb point. In fact, of course, the ground is never truly planar and truly vertical photographs are extremely rare. However, in a very slightly tilted photograph, the plumb point and the isocentre will be very close together so that distortions due to height and tilt combined will be very nearly radial from either the plumb point or the isocentre. It is very difficult to identify either the plumb point or the isocentre on a photograph. Only the principal point may be readily found. In a nearly vertical photograph the principal point will be very close to the isocentre, and errors due to assuming that distortions are radial from the principal point will be small. Both the important graphical methods of plotting from air photographs involve the assumption that distortions are actually radial from the principal point. This principle is known as the *radial line assumption* or the *Arundel assumption*; it allows us to plot points of detail by intersecting radials from the principal points of consecutive photographs. The procedure is somewhat tedious and would not be suitable for the complete plotting of all detail, but only for increasing the number of plotted points on the map so that the bulk detail may be inserted by the methods suggested in Chapter 7.

The drill for plotting these additional control points, or *minor control points* as they are called, involves the construction of a series of *principal point traverses*, one for each strip of photographs. Each of these traverses is then replotted in relation to known ground (or major) control points. Every point must also be adjusted to its most probable position.

The first step is the plotting of what is known as the *base grid*. This is a series of grid lines, in relation to which the positions of previously surveyed ground control points are known. The grid is designed to satisfy the conditions of the particular projection chosen,

and the ground control points are accurately plotted on it (see Fig. 5.1).

The base grid must be plotted on some form of *topographic base.* The most suitable materials are those which are subject to very

FIG. 5.1. BASE GRID WITH GROUND CONTROL POINTS PLOTTED AT *B, K* AND *L*

FIG. 5.2. BASE-LINING FIRST FOUR PRINTS OF A STRIP

little expansion and contraction, and have a clear white surface on which it is easy to draw. There are several well-known stable plastic sheets on the market. Some are obtainable as transparent, opaque, or translucent sheets; others are available in a range of thicknesses to suit different purposes. This type of sheet is sold under various trade names, such as Astrafoil, Cobex, Ethulon, Kodatrace and Permatrace. Other materials in use for the purpose include zinc or aluminium sheets surfaced with white enamel and butt-jointed sheets of plywood, coated with white enamel.

The next stage is to base-line all the photographs (see Fig. 5.2), and then to deal with each strip in turn as follows. Assemble the

photographs so that the base $p_1'p_2$ on photo 2 falls over the base line p_1p_2' of photo 1, and so that the base line $p_2'p_3$ of photo 3 falls over the base line p_2p_3' of photo 2, and so on to the end of the strip (see Fig. 5.3). This layout is known as a *rough mosaic*, and enables a piece of transparency to be cut so that it is long enough to contain the full length of the strip, and wide enough to take the width of the mosaic about three times. At the same time the approximate

FIG. 5.3. A ROUGH MOSAIC

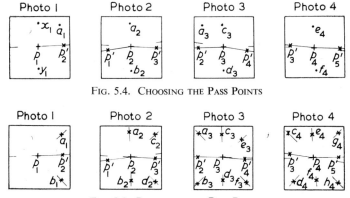

FIG. 5.4. CHOOSING THE PASS POINTS

FIG. 5.5. RAYING-IN THE PASS POINTS

direction of the principal point traverse $p_1'p_2'p_3'p_4'$, etc. should be lightly indicated in a central position on the transparency. One of the less expensive transparent stable plastic sheets could be used for this purpose.

Points of detail are now chosen on each photograph roughly in the positions indicated in Fig. 5.4. These should be easily-recognized, but very small, points of detail, such as the image of ground point A, which appears at a_2 in photo 2, and can be easily recognized at a_1 on photo 1 and at a_3 on photo 3. Similarly for points B, C, etc. (see Fig. 5.5). These points are the pass points or minor control points.

The method of marking these points on the photograph varies, but perhaps the least objectionable is to make a minute hole with

a very fine needle. If such a point is ringed round with a coloured chinagraph pencil it will be found again more readily.

Although some pass points will be readily recognizable on each of the photographs on which they occur, it will usually be necessary to use a magnifying glass or stereoscope. These points must be very accurately transferred, and it will often be best to set up a properly base-lined pair of photographs under the stereoscope as described in Chapter 3. With a needle, point accurately to the chosen point on say the left-hand print, then viewing stereoscopically move

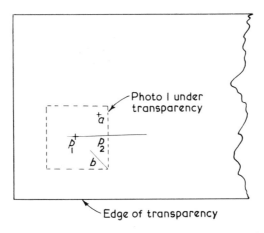

FIG. 5.6. THE TRANSPARENCY—TRACING FROM PHOTO 1

another needle over the right-hand print until the needle points appear to coincide: the second needle should now indicate the correct image on the right-hand print.

On photo 1 draw in from p_1 short radials through a_1 and b_1. On photo 2 draw in from p_2 short radials through a_2, b_2, c_2 and d_2; continue for each photo.

The next step is to take the transparent strip and place it over photo 1 so that the base line p_1p_2' lies approximately under the first leg of the lightly marked traverse. Trace in points p_1 and a_1, the base line, and a short length of radial through b_1. Figure 5.6 shows the detail traced and the way it should be marked up. The broken line indicates photo 1 in position under the transparency.

Fasten photo 2 face upwards on to the table, and place the transparency over it so that the line p_1p_2 on the transparency covers the line $p_1'p_2$ on photo 2. Keeping these two lines collinear, slide

the transparency over photo 2 until the point a is exactly over the radial through a_2. Maintaining these positions by securing the transparency to the desk, trace the radials through p_3', b, c and d as in Fig. 5.7.

The point b is now fixed by an intersection of two rays.

Photo 3 is now fixed to the table top, and the transparency placed over it so that the points a and b lie immediately over the radials through a_3 and b_3, and p_2 lies immediately over the base line $p_2'p_3$.

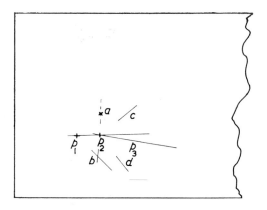

FIG. 5.7. THE TRANSPARENCY—TRACING FROM PHOTO 2

This will give a position for p_3 which might not lie exactly over the base line $p_2'p_3$. If the drawing has been carried out accurately, and the tilt distortion is not excessive, then this discrepancy will be very small, and can be neglected. Now trace in the radials from p_3 through c_3, d_3, e_3, f_3 and p_4'. Repeat this process as for photo 3, for each remaining photo of the strip in turn. We now have the complete principal point traverse plot on to the transparency as shown in Fig. 5.8.

The points B and L (see Fig. 5.1) have been deliberately chosen as pass points because they are ground control points. The traverse lines can now be transferred from the transparency to the base grid by plotting between these two points.

The scale of the strip is governed by the scale along the line p_1a_1 on photo 1, and a is therefore known as the *scale point*. The point A should be chosen, if possible, at about the average ground height of the area covered by the sortie; then the scale of the transparent plot will be about the same as the average scale of all the photographs, or *mean photo scale* as it is usually called.

The method of plotting the traverse on to the base grid is as follows. Choose any point m on the transparency (see Fig. 5.8), such that the points b, l and m form a well-conditioned triangle, i.e. a triangle in which no angle is less than 30°. m does not represent either a ground point or an image point but is chosen quite arbitrarily. If any one of the principal points or pass points itself forms a well-conditioned triangle with b and l, then there will be no need to introduce the point m.

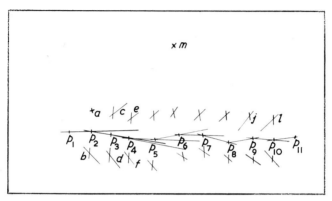

FIG. 5.8. THE TRANSPARENCY—PRINCIPAL POINT TRAVERSE COMPLETE

Join bl on the transparency, and BL on the base grid. Lay the transparency over the base grid so that b falls over B and bl lies directly over BL. Prick through m and call this point M'. Remove the transparency and draw a short radial from B through M'. Now set up the overlay so that l falls over L, and bl again lies directly over BL. Again prick through m and call the pricked point on the base grid M''. A radial from L through M'' will meet the radial BM' in M, which will be the position of m on the base grid.

Using the triangle bp_5m of the transparency (see Fig. 5.8), p_5 can be plotted on the base grid in the same way that M was plotted from the triangle bml. All the remaining principal points can be plotted by the same method.

If the strip we have just plotted is strip No. 2, and l lies in the overlap between this strip and strip No. 3, then in order to plot the principal point traverse for strip No. 3 we require another control point near the other end. Let us choose point c as falling in the overlap between the two strips; then we can plot C' from the transparency for strip No. 2, and plot strip No. 3 between C' and L.

To plot strip No. 4 we would first plot two points in the common overlap between strips 3 and 4 using the transparency of strip No. 3 for this purpose. Let these points be Q' and R' as in Fig. 5.9; then plot strip 4, including the two points S' and T' lying in the overlap with strip 5. S' and T' will be the control for strip 5.

Let us suppose that the third ground control point K lies in the 5th strip of photographs. Then we would plot on the base grid the

FIG. 5.9. THE BASE GRID—EXTERNAL ADJUSTMENT TO GROUND CONTROL

point K' as the position of k on the transparency, and using S' and T' as control. K' will not normally coincide with K; thus there will have been an accumulated error equal to $K'K$ in plotting the four strips. This means that we must make an adjustment to the positions of C', Q', R', S' and T'. This is done by joining $K'K$ and drawing short lines through each of the five points parallel to $K'K$ (see Fig. 5.9). The actual positions of the corrected points C, Q, R, S and T will be such that $S'S = K'K \times (BS'/BK')$ and $R'R = K'K \times (LR'/LK')$, etc. This is called the external adjustment. The principal point traverses would not be plotted on to the base grid until after the external adjustment had been made.

In making the external adjustment, the aim must be to find some strip having on it two recognizable points of ground control, and start plotting from this strip. The ground control points should normally be as far apart on the strip as possible (certainly not less than 70 per cent of the strip should lie between them), though the points concerned should lie on at least two and preferably on three photographs in the strip. These ground points will give the strongest control if they lie well away from the principal point traverse.

If there is no strip containing two ground control points then the task is not quite so simple. Suppose, for example, we are plotting the same sortie as before, except that the image of L did not fall on strip No. 2, but that it did fall in strip No. 3. We would complete the transparencies for strips No. 2 and 3 as before, and choose one

pass point, say *j* on Fig. 5.8, such that *j* lies both in strip No. 2 and in strip No. 3. Choosing *c* as before as the other control point common to the two strips, we would now take a further transparency, and trace on to it the points *b*, *j* and *c* from strip No. 2. We now trace *l* on to the further transparency from the transparency of strip No. 3, using *j* and *c* to control this setting. From the further transparency we now plot the positions of *C'* and *J'* on to the base grid using *B* and *L* as the base. Then proceed as before for strips 4 and 5, and the external adjustment.

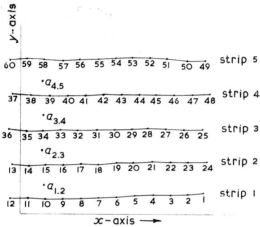

FIG. 5.10. THE BASE GRID—PRINCIPAL POINT TRAVERSES
The principal points are numbered 1 to 60.
The axes are used for internal adjustment.

Having got the principal point traverse for each strip plotted on to the base grid, we then plot the pass points from say strip 1. Next we plot the pass points from strip 2 on to the base grid. Unfortunately we shall probably find that points *d*, *f*, *h*, etc. (see Fig. 5.5) when plotted on the base grid as *D*, *F*, *H* do not coincide with the same points as plotted from strip 1. To overcome this difficulty the position of the principal point traverse must be adjusted. There are numerous methods of doing this, most of which are fairly involved and most of which are similar. Perhaps the simplest is as follows.

Let Fig. 5.10 represent the plotted positions on the base grid of the five principal point traverses. The principal points are numbered consecutively throughout all the strips from photo 1 to photo 60. $a_{1\cdot2}$, $a_{2\cdot3}$, $a_{3\cdot4}$ and $a_{4\cdot5}$ are pass points or other points in the overlaps, and when used for this purpose these points are often termed *tie*

points. The suffixes denote the strips in which the point falls. Figure 5.11 is an enlargement of a portion of Fig. 5.10, showing that the point $a_{1.2}$ in Fig. 5.10 is really composed of two points, a_1 and a_2 in Fig. 5.11. The distance between a_1 and a_2 is exaggerated for clarity. a_1 is plotted by intersections from the principal point traverse for strip 1, and a_2 from the traverse for strip 2.

The problem is to adjust the positions of each principal point traverse in the sortie so that all points common to two strips will plot as a single point. If we adopted the mean position for $a_{1.2}$, i.e. if we treated the mid-point of a_1a_2 as the correct position, and replotted p.p.s (principal points) 14, 15 and 16 accordingly, we might find that we had made the error at $a_{2.3}$ greater than before. So that to find the most likely positions for $a_{1.2}$, $a_{2.3}$, etc., we must find the correction for each which will give the least total of corrections. This is achieved by measuring the errors a_1a_2 in Fig. 5.11 in two directions at right angles to one another and applying two corresponding corrections to each point. Choose the two directions such that one is roughly parallel to the direction of the principal point traverses (x-axis in Fig. 5.10), and the other is perpendicular to this (y-axis in Fig. 5.10). Draw lines through a_2 and a_1 parallel to the x-axis and y-axis respectively. Measure the distance marked x in Fig. 5.11 and call this the x error. Similarly measure the distance y as the y-error. Measurements made on the face of a photograph are invariably in millimetres.

A set comprises one pass point from each lateral overlap, chosen so that the whole set lies as nearly as possible on the same perpendicular to the general direction of the principal point traverses. A schedule as in Table 1 is made out for each set of tie points. The first column relates to the strip from which the tie point has been plotted. The next three columns refer wholly to x-errors and corrections, and the next three columns to y-errors and corrections. The second column gives the measured x-error. Consider that we are measuring the error of the plotting of a_2 relative to a_1 in Fig. 5.11; then if we find a_2 is to the right of a_1 the error will be positive, and if to the left it will be negative (similarly for the point $a_{2.3}$, should the position as plotted from strip 3 be to the right of the position as plotted from strip 2, the error is positive); that is, we take the lower strip first. In the same way if the position of say $a_{2.3}$ is too high when plotted from strip 3 and compared with strip 2 the y-error is positive. Thus for a positive y-error the p.p. traverses are too far apart, and for a negative y-error they are too close together. Other conventions can be adopted if thought desirable.

In the schedule of Table 1 the horizontal lines represent the

individual strips, but the x- and y-errors refer to the overlaps between any two strips, and are therefore entered in the spaces between the two appropriate lines.

In the third column of Table 1 it has been assumed that strip 1 is correct, and that a_1 in Fig. 5.11 is therefore given zero correction. This being so, a_2 must be given a correction to the right, that is in a positive x-direction, so that this correction must represent the

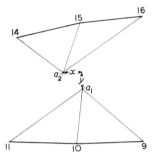

FIG. 5.11. THE BASE GRID—PASS POINT PLOTTED FROM DIFFERENT TRAVERSES
This is an enlargement of part of Fig. 5.10.

Table 1

EXTRACT FROM SCHEDULE FOR INTERNAL ADJUSTMENT

	x-error			y-error			
	Error	Adjusted to strip 1	Correction	Error	Adjusted to strip 1	Correction	
Point $a_{4.5}$	+1·3	−0·1	−1·1	−1·2	+1·0	+0·9	strip 5
Point $a_{3.4}$	+0·9	+1 2	+0 2	+0·7	−0·2	−0·3	strip 4
Point $a_{2.3}$	−0·4	+2·1	+1·1	−1·3	+0·5	+0·4	strip 3
Point $a_{1.2}$	−1·7	+1·7	+0·7	+0·8	−0·8	−0·9	strip 2
		0	−1·0		0	−0·1	strip 1
	sum +4·9			+0·5			
	average +1·0			+0·1			

whole x-error for the point $a_{1·2}$ in Fig. 5.10. If such a correction were given to strip 2, then the position of $a_{2·3}$ as plotted from strip 2 would be moved 1·7 mm to the right. Thus the negative x-error applying to $a_{2·3}$ would be increased from − 0·4 to − 2·1, and the position as plotted from strip 3 would need moving 2·1 mm to the right, i.e. the whole strip, at this cross-section would be moved 2·1 mm to the right. These figures then apply to the individual strips and must be entered on the appropriate lines.

The assumption that no correction should be made to strip 1 is obviously fallacious, and we must find the correction to be applied to this strip to give the least overall total correction to all the strips combined. This is done by taking the algebraic sum of the adjustments in the third column, and finding the mean of these corrections, in this case $+ 1{\cdot}0$ mm. This means that the whole sortie has at this cross-section been moved bodily $1{\cdot}0$ mm to the right. This can be offset by moving each strip $1{\cdot}0$ mm to the left; thus we obtain the final adjustments in the fourth column.

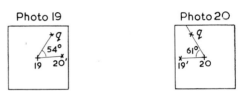

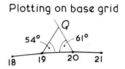

Plotting on base grid

FIG. 5.12. PLOTTING FURTHER CONTROL POINTS BY INTERSECTIONS

When the same procedure has been followed for the y-errors, then corrected single positions of $a_{1{\cdot}2}$, $a_{2{\cdot}3}$, $a_{3{\cdot}4}$ and $a_{4{\cdot}5}$ can be plotted.

The plotting of strip 5 may again show an error at K, and the external adjustment may need to be repeated.

Using these corrected pass points, together with the ground control points, the p.p. traverses are replotted from their respective transparencies by the method of intersections as before.

Further points of detail can now be added as required by using the adjusted principal point traverses as base lines, and transferring radials from the principal points direct from the photographs (see Fig. 5.12). This is not a practical method for plotting the full topographic detail, but it is quite suitable for obtaining sufficient points of minor control to enable the use of some of the simple methods of plotting the final detail, such as those described in Chapter 7.

The purely graphical drill described above is suitable when no instruments, other than ordinary drawing office equipment, are available. It is obviously tedious, but with only comparatively minor equipment a simple and efficient method of applying the radial line assumption is available. This is known as the graphical mechanical, or *slotted templet* method.

SLOTTED TEMPLET METHOD

Every photograph of the sortie is base-lined as before, and pass points are chosen in similar positions to those in Figs. 5.4 and 5.5. These points are pricked through and ringed as before. Transparencies are now cut to represent each photograph. For each photograph a piece of relatively thick (about 0·25 mm) stable plastic transparency is cut to a size about one inch greater than the photograph in each direction, and is carefully numbered with the serial number of the photograph which it is to represent. It is then placed over the appropriate photograph, the principal point is marked, and base lines and pass point radials are very carefully traced in with fine lines. A purpose-made hand-punch (see Fig. 5.13) is now used to make a 5 mm diameter circular hole at the principal point. This is made very accurately since the punch is centred by means of a needle point at the centre of the circular cutting edge. The templet is then removed and placed on the table of the slotted templet cutting machine (see Fig. 5.14) so that the p.p. hole lies over the spindle. This spindle is free to move only in a straight line because it is confined within a slot. The cutting edge of the machine is so placed that it will always contact the table top centrally over this slot. When the handle is depressed the cutting edge will contact the templet and cut a slot in it precisely 5 mm wide, and 40 to 80 mm long. Such a slot is cut for each of the pass points and base lines, i.e. eight slots per templet. Accuracy is maintained by sighting the pass point mark on the templet through a small telescope. Each templet slot is radial from the p.p. because both p.p. and pass point lie centrally along the machine slot. The exact distance of the slot from the p.p. can be adjusted by moving the p.p. pivot along the machine slot. Fig. 5.15 shows a marked-up and partly cut templet.

It must be remembered that the slotted templet cutting machine is a precision instrument costing between say £300 and £400, and the slots are precisely cut. There are variations of the above drill to suit the particular equipment available, and one instrument obviates the need for tracing the pass points from photo to templet. In this instrument the photo and templet are mounted simultaneously on one vertical spindle and each is securely taped to a separate

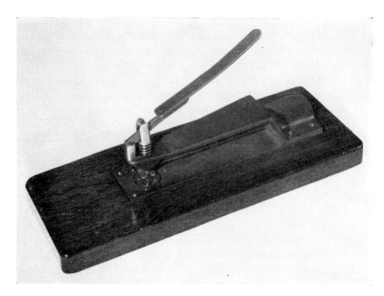

FIG. 5.13. ONE TYPE OF CENTRE PUNCH
(*C. F. Casella & Co. Ltd.*)

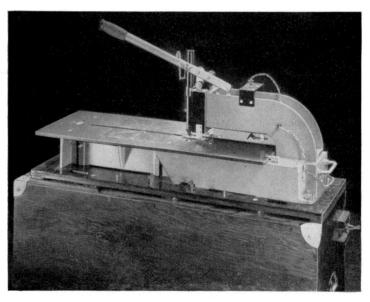

FIG. 5.14. SIMPLE SLOTTED TEMPLET CUTTING MACHINE
(*C. F. Casella & Co. Ltd.*)

turn-table. The spindle and turn-tables are rotated until one of the pass points lies centrally under the telescope. At this stage the turn-tables are clamped, and the cutting edge depressed to cut the appropriate slot in the templet.

When all the templets of the sortie have been cut, they can be mounted over the ground control points plotted as before on to the base grid. For this operation small studs are required (see Fig. 5.16)

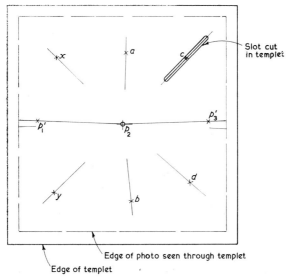

FIG. 5.15. PARTLY-CUT TEMPLET SUPERIMPOSED ON ITS MARKED-UP PHOTOGRAPH
($\frac{1}{4}$ × full size)

Natural dia. of hole	= 5 mm
Natural width of slot	= 5 mm

with a centrally-pierced hole through which the pin must be just capable of passing. The external diameter of the shank is 5 mm and is only just able to enter the slot or centre hole of the templets. These studs may be of either metal or plastic but the metal ones are usually considered the more satisfactory.

A pin is inserted vertically in every ground control point on the base grid, and, as before, a fairly central strip containing two well-spaced ground control points should be chosen first. Let us assume this to be strip 2 in Fig. 5.10, i.e. the strip shown in Fig. 5.8, where the two ground control points are B and L. Place a stud over

the pin at B and then mount templet No. 2 by placing the slot representing the radial through b_2 over this stud. Place further studs through the hole and remaining slots in this templet; these will represent the points P_2, A, C, D, P_1 and P_3. Now mount the appropriate slots of templet No. 3 over the studs A, B, C, D and P_2, and fill in all empty slots and the p.p. hole with a stud. These studs will represent points E, F and P_4. Continue in the same way with

FIG. 5.16. SLOTTED TEMPLET ASSEMBLY UNDER CONSTRUCTION

templets 1, 4, 5, 6, etc. in turn, until the templets containing radials through L are reached. When the stud representing L is inserted in the templet assembly it should also be placed over the pin at L in the base grid. It will be found to be perfectly easy to adjust the scale of the assembly between B and L by pulling out or pushing in; the studs will act like the pivots in adjustable trellis work. The remaining templets of the strip can then be added, followed by the laying of the adjacent strips. Control for the latter will be provided by the studs representing pass points in the lateral overlaps concerned. Each of the other strips will then be laid in a similar manner until the assembly is complete. Each time a stud representing a ground control point is reached it is placed over the appropriate pin, and the assembly is pushed into shape to accommodate it. Figure 5.16 shows

a slotted templet assembly under construction. On completion, the assembly is allowed to rest for at least twelve hours to give all the templets time to settle. Then all the studs are pricked through with pins which are left sticking in the base grid. The templets are then removed carefully one by one; the pass points and p.p.s are ringed and numbered as the pins are removed. It is usual to mark p.p.s in a different colour from that used for pass points. Principal point traverses can now be drawn in, and used for the plotting of further control as before, if this is required.

Using the slotted templets we have achieved at least as good a result as before, without the need for complicated internal and external adjustments. These adjustments are made mechanically by the templets sliding over one another. If the assembly shows signs of buckling, then this is an indication of lack of precision in making the templets, or of poor flying, or excessive variations in height of the terrain. Generally speaking, for slotted templet work, the variation in ground heights should not exceed 7 or 8 per cent of the flying height. Occasionally one templet, or a group of templets, will not fit into the assembly at all. To remedy this it might be necessary to make new templets from rectified prints (see Chapter 7).

To facilitate the assembly and subsequent adjustment to scale of parts of the assembly, it is usual to pare off the unnecessary portions of the cut templet, particular attention being paid to the removal of angular parts of the edges (see Fig. 5.16). If the assembly is particularly big, it may be necessary to wax each of the templets to enable them the better to slide one over the other, and so take up their relative positions of equilibrium. Sponge-rubber mats are used as stepping stones when working on large assemblies, which are generally made on the floor because the area covered may be the size of a large hall.

The only disadvantage of the slotted templet relative to the purely graphical radial line plot is the additional cost both for instruments and material.

In recent years an empirical formula relating the necessary amount of ground control with the number of templets in the assembly has become fairly widely accepted. This formula is usually stated as if it were a guide to accuracy in the form

$$e = 0 \cdot 16\sqrt{(t/c)},$$

where
t = number of templets,
c = number of ground control points,
e = average point displacements, in millimetres.

Such an equation has more application if expressed as a method of

determining the amount of control required, that is as $c = t(0.16/e)^2$. The accuracy required is determined by the ability of the draughtsman, who should be capable of drawing a line not greater than 0·25 mm thick. It would therefore be wasteful to plan for an accuracy greater than this on the compilation sheet. Since e is an average value, it will not normally be less than say 0·4 of a millimetre. It is generally agreed that at publication scale the accuracy should be such that all well-defined points of detail should be within 0·5 mm of their true position. If publication scale is the same as compilation scale then the accuracy at compilation scale can be reduced to give e a value of 0·5 mm.

Suppose then that $e = 0.5$ mm and there are 130 templets in the assembly; then

$$c = 130\left(\frac{0\cdot16}{0\cdot5}\right)^2 = 13$$

The disposition of these 13 control points is also important though no formula can be applied. It has been found experimentally that control in the four corners of an assembly is of paramount importance, and that the bulk of the remaining ground control should be near the ends of each strip. Further control points should be located in the two extreme lateral overlaps, and only a few points would be needed over the central part of the assembly. This pattern appears to be the best for even very large assemblies.

ANALYSIS OF ERROR

In Fig. 5.17 (i) a represents the image of any ground point A. a' is the corrected position of a, and aa' the tilt distortion. a' must lie on ai, and since a is on the same side of the isometric parallel as n, the scale at a must be too great. Therefore the correct position, a' of a must be such that $ia' < ia$. Had a fallen at e the corrected position would have been further from i, e.g. at e'. d lies on the isometric parallel and therefore has no tilt distortion.

Figure 5.17 (ii) illustrates the error due to the radial line assumption, assuming that the ground is a perfectly horizontal plane. The assumption is that a' falls on ap, and since its position along pa is influenced by radial lines from other photographs, the tendency is for g (where g is the plotted position of a on the minor control plot) to take up the least erroneous position consistent with its lying along pa. That is, $a'g$ will tend to be perpendicular to pa, since $a'g$ is the error in position due to the radial line assumption. In this figure the tilt distortion $aa' = cc' \sec \phi$.

Figure 5.17 (iii) shows a section through the perspective centre of

the perspective diagram and containing the line *ia*. As relationships in the principal plane are more easily established, Fig. 5.17 (iv) would be preferred in any analysis.

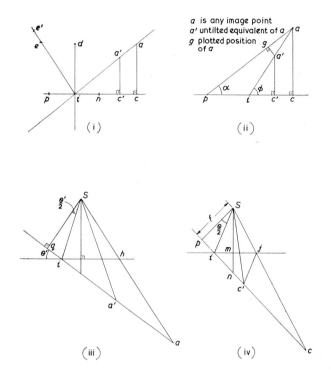

a is any image point
a' untilted equivalent of *a*
g plotted position of *a*

FIG. 5.17. ANALYSIS OF ERROR IN RADIAL LINE PLOTTING
(i) PLAN VIEW OF PRINT
(ii) PLAN VIEW OF PRINT
(iii) SECTION IN EPIPOLAR PLANE *iSaa'*
(iv) SECTION IN PRINCIPAL PLANE

Provided that tilts do not exceed 3° for any photograph, and that variations in ground height do not exceed 8 per cent of the flying height, then errors due to the radial line assumption should not exceed 0·4 mm. Thus it is unusual to make a mathematical analysis in practice.

In the following example the error due to the combined tilt and height distortions is shown to be 0·009 in., a barely plottable amount, but it can be seen that, if the variations in ground heights were to

approach nearer to the allowable 8 per cent instead of $2\frac{1}{2}$ per cent of the flying height, the error due to making the radial line assumption would become appreciable. It must be remembered,

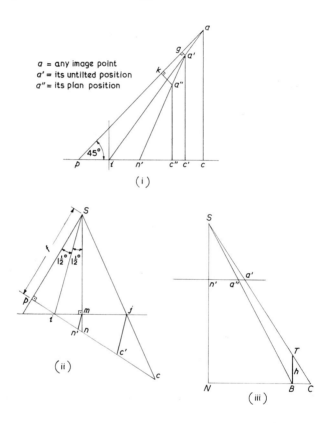

FIG. 5.18. ERRORS DUE TO COMBINED TILT AND HEIGHT DISTORTION
(i) PLAN VIEW OF PRINT
(ii) SECTION IN PRINCIPAL PLANE
(iii) VERTICAL SECTION THROUGH $a''a'$

however, that not only have we assumed the worst conditions for the tilt distortion, but we have also assumed a height displacement in the same general direction as the tilt distortion, i.e. both have been assumed to have displaced a away from p.

Example to illustrate the error in plotting a particular point. Figure 5.18 (i) shows a point a, such that ap makes an angle of

45° from the principal line, and we are going to assume that ac is 100 mm long and is perpendicular to the principal line. The tilt of the photograph is assumed to be 3°. These conditions should make as great an error as may normally be expected when dealing with the points used in a slotted templet plot.

The following analysis uses elementary coordinate geometry, without introducing any of the less obvious approximations or other mathematical short cuts.

Our work is simplified by using the principal line as the x-axis, and i as the origin; but we must remember that it is the base line which is normally the x-axis.

We shall assume the flying height to be 3,000 m, and the principal distance to be 150 mm.

In Fig. 5.18 (ii) $pi = f.\tan 1\frac{1}{2}° = 3.9285$,

∴ in Fig. 5.18 (i) coordinates of p are $(-3.9285, 0)$

But $\angle api = 45°$ ∴ $pc = ac = 100$ mm

∴ coordinates of a are $(100-pi, 100)$ i.e. $(96.0715, 100)$

The equation of the line pa is $y = x + 3.9285$, since the slope is 1 and the intercept on the y-axis equals pi,

i.e. ap is the line $x - y + 3.9285 = 0$

To find the coordinates of a':

x-coordinate is $ic' = ij = im + mj = f \left(\tan \dfrac{\theta}{2} + \tan \angle mSj \right)$

But $\tan \angle mSj = \tan (\angle pSc - \angle pSn)$

$$= \frac{\tan \angle pSc - \tan \angle pSn}{1 + \tan \angle pSc \times \tan \angle pSn}$$

$$= \frac{\dfrac{pc}{ps} - \tan \theta}{1 - \dfrac{pc}{pS} \tan \theta}$$

$$= \frac{\dfrac{100}{150} - 0.05241}{1 - \dfrac{100}{150} \times 0.05241}$$

$$= 0.59352$$

∴ x-coordinate of a' is $150(\tan 1\frac{1}{2}° + 0.59352) = 92.9565$

and y-coordinate of a' is $a'c'$; but $\dfrac{a'c'}{ac} = \dfrac{ic'}{ic}$

$$\therefore \quad a'c' = \frac{ic' \times ac}{ic} = \frac{92 \cdot 9565 \times 100}{96 \cdot 0715} = 96 \cdot 7576$$

\therefore coordinates of a' are (92·9565, 96·7576)

Using the formula $\quad p = \dfrac{ax_1 + by_1 + c}{\sqrt{a^2 + b^2}}$

for the perpendicular distance from the point (x_1, y_1) on to the line $ax + by + c = 0$, we have

$$a'g = \frac{1 \times 92 \cdot 9565 - 1 \times 96 \cdot 7576 + 3 \cdot 9285}{\sqrt{1^2 + 1^2}} = 0 \cdot 1274 \, \text{mm}$$

Thus the error due to the radial line assumption is 0·1274 mm.

Height distortion is radial from the plumb point; but as we have corrected the position of a, we must also correct the position of n. If n' is the position of the image of N when the photograph is corrected for tilt, then $in' = ip = 3 \cdot 9285$, i.e. coordinates of n' are (3·9285, 0).

Let the homologue of a have a ground height of 75 m above datum; then if a'' is the height corrected position of a', a'' must lie on $n'a'$ in such a position that $n'a'' < n'a'$.

In Fig. 5.18 (iii),

$$\frac{a''a'}{BC} = \frac{f}{H} \; ; \quad \text{therefore} \quad a''a' = \frac{f}{H} \times BC = \frac{f}{H} \times h \tan \angle BTC$$

but $\quad \tan \angle BTC = \tan \angle n'Sa' = \dfrac{n'a'}{f}$

$$\therefore \quad a''a' = \frac{75}{3,000} \times n'a' = \frac{n'a'}{40}$$

$$\therefore \quad \frac{a''c''}{a'c'} = \frac{n'a''}{n'a'} = \frac{39}{40} \quad \text{(Fig. 5.18 (i))}$$

i.e. $\quad a''c'' = \dfrac{39 \, a'c'}{40} = \dfrac{39}{40} \times 96 \cdot 7576$

$$= 94 \cdot 3387$$

Similarly $\quad c''c' = \dfrac{1}{40} \times n'c' = \dfrac{92 \cdot 9565 - 3 \cdot 9285}{40} = 2 \cdot 2318$

$\therefore \quad ic'' = ic' - c''c' = 92 \cdot 9565 - 2 \cdot 2318 = 90 \cdot 7247$

\therefore coordinates of a'' are (90·7247, 94·3387)

$$\therefore \quad a''k = \frac{1 \times 90 \cdot 7247 - 1 \times 94 \cdot 3387 + 3 \cdot 9285}{\sqrt{1^2 + 1^2}} = 0 \cdot 3145 \text{ mm}$$

\therefore total position error of a due to the radial line assumption can be expected to be about 0·3 mm., which is barely plottable.

FURTHER READING

(i) Hart, pages 182–202.
(ii) Moffitt, Chapter 6.
(iii) *Admiralty Manual*, pages 267–80.
(iv) Trorey, pages 93–108.

(See Bibliography (page 346) for full titles.)

E

Measuring Heights and Contouring

The simplest method of contouring from levels taken in the field is to arrange the field stations in the form of a rectangular grid and then to use a linear interpolation between pairs of such points to locate the points at which the required contours cut the grid lines. In Fig. 6.1 the heights of A_5 and A_6 are given as 99·61 and 100·62

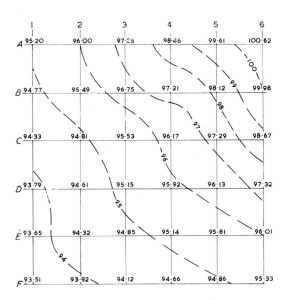

FIG. 6.1. CONTOURS INTERPOLATED FROM A GRID OF LEVELS

respectively, and it is obvious that the 100 m contour cuts the line joining A_5 and A_6. A_5 is only 0·39 m below 100 m, while A_6 is 0·62 above. The total difference in height between A_5 and A_6 is 1·01 m, and the distance A_5 to A_6 is 10 m. Therefore, the 100 m contour crosses the line A_5A_6 at a point $10 \times 0·39/1·01 = 3·86$ m from A_5. Similarly for all other cutting points. The contours are then sketched in by joining all cutting points representing the same contour.

When contouring is done from air photographs, the method used is basically the same. One of the photographs is gridded and the

height at each grid intersection point is determined. Contours are then interpolated between these points as for a ground survey. Sometimes an irregular pattern of points is used instead of a regular grid, heighting points being chosen at obvious changes of gradient.

PARALLAX EQUATIONS

In Chapter 3 and Fig. 3.24 we defined parallax in the sense understood by the photogrammetrist. We also stated that parallax was a

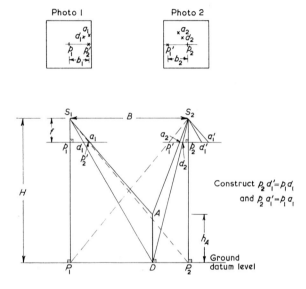

FIG. 6.2. PARALLAX OF A POINT—DIAGRAM FOR DETERMINATION OF PARALLAX
EQUATION
B = air base
H = flying height
h_A = height of A above datum
b = base line

measure of the height of a ground point. Let us extend this argument by reference to Fig. 6.2, where D is a point at datum level and vertically below the point of ground detail A. The sketches of photo 1 and photo 2, above the main figure, show the positions on the two photographs of the images of A and D. It will be noticed that while there is a big difference between the x-coordinates a_1 and a_2, yet the y-coordinates of these two points are almost equal. The same

may be said of the points d_1 and d_2. That is, there is relatively little y-parallax and the two photographs " correspond " fairly well.

In Fig. 6.2, $p_2d_1' = p_1d_1$ and $S_2d_1'\|S_1d_1$

Similarly $p_2a_1' = p_1a_1$ and $S_2a_1'\|S_1a_1$

But a_2a_1' represents the parallax of A, and d_2d_1' the parallax of D.

Triangles S_1DS_2 and $d_1'd_2S_2$ are similar.

Therefore $\dfrac{d_2d_1'}{S_1S_2} = \dfrac{\text{perpendicular height of triangle } d_1'd_2S_2}{\text{perpendicular height of triangle } S_1DS_2}$

That is $\dfrac{d_2d_1'}{B} = \dfrac{S_2p_2}{H} = \dfrac{f}{H}$

Therefore $d_2d_1' = fB/H$

or parallax of D, $p_D = fB/H$ (6i)

In this formula f will be expressed in millimetres, and the parallax will also be in millimetres. D is a particular point, being at datum level, but A is any general point at some height which we will call h_A above datum. If the parallax of A is written p_A, then from similar triangles $S_2a_2a_1'$ and AS_2S_1 we have—

$$\frac{a_2a_1'}{S_2S_1} = \frac{S_2p_2}{H - (AD)} = \frac{f}{H - h_A}$$

that is $\dfrac{p_A}{B} = \dfrac{f}{H - h_A}$ or $p_A = \dfrac{fB}{H - h_A}$. (6ii)

This is the general parallax equation, which expresses the parallax of a point in terms of the focal length of the lens, the length of the air base, the flying height, and the height of the point. The focal length will be recorded in the margin of the photograph; the parallax can actually be measured within limits as we shall see later; the air base and flying height can be estimated. The altimeter reading at the time of exposure is recorded in the margin of the photograph, but is not usually a sufficiently accurate value of H. The method used to determine H requires the existence of either four points of ground control on each photograph, or a minor control plot. For each photograph, four points are chosen so that, when opposite pairs of points are joined, the two lines intersect roughly at right angles and somewhere near the centre of the photograph. For instance, referring to Fig. 5.5, points a_3, f_3, e_3 and b_3 on photo 3 would be excellent. In this case the procedure would be to measure the distance a_3f_3, then to measure the distance AF on the slotted templet

plot. If the scale of the slotted templet plot were 1 in 10,000, then the scale of photo 3 along the line $a_3 f_3$ would be

$$\frac{a_3 f_3}{10,000 \times AF}$$

Suppose $a_3 f_3$ measured 284·1 mm and the distance AF measured 293·7 mm; then the scale along $a_3 f_3$ would be

$$\frac{284 \cdot 1}{10,000 \times 293 \cdot 7}$$

or 1 in 10,338 approximately. We then require to find the scale along $e_3 b_3$ by the same method, and the average of these two scales would then be accepted as the mean scale of the photograph. For good results, each of the four points A, F, E and B should be at, or near, the average height of the ground covered by the photograph. Since scale also equals $f/H - h$, then in the instance given

$$\frac{f}{H - h} = \frac{1}{10,338}$$

or $H - h = 0 \cdot 150 \times 10,338 = 1,551$ m, where the focal length is 150 mm. $H - h$ here represents the height of the aircraft above the mean level of the ground. h is determined as the mean height above datum of all the eight points used on the two photographs to determine the scales. However, an approximate value of h is often used.

The length of the air base, B, is represented by the base line on each photograph. If we measure the lengths of these base lines ($p_1 p_2'$ and $p_1' p_2$ in Fig. 6.2) and call the mean b (i.e. $b = \frac{1}{2}[p_1 p_2' + p_1' p_2]$), then the average scale along the base lines $= b/B$. This is the same thing as writing $f/H - h = b/B$ where h is the average height above datum of the ground line $P_1 P_2$.

If $\dfrac{f}{H - h} = \dfrac{b}{B}$, then $B = b \times \dfrac{H - h}{f}$ (6iii)

Thus we can determine the value of all the unknowns in the parallax equation, except h_A. So that we can write

$$p_A = \frac{fB}{H - h_A} \text{ as } H - h_A = \frac{fB}{p_A} \text{ or } h_A = H - \frac{fB}{p_A} \quad (6\text{iv})$$

and so find the value of $h_A = $ height of A above datum (AD in Fig. 6.2). This presupposes that we can find a value for B, which depends upon the value of

$$\frac{b(H - h)}{f}$$

(as in (6iii))

f is known accurately, b and H are estimated arbitrarily, but h depends upon our knowing the heights of p_1 and p_2 above datum—a most unlikely happening. h is therefore usually taken to be the average height of the ground above datum, and $(H - h)$ becomes the height of aircraft above mean ground level, which we are able to determine. Although this introduces an approximation, the error involved is negligible in practice.

Let us assume that we know the height of some ground point whose image falls in the overlap; let this point be E, and its height above datum be h_E. Then—

$$h_A = H - \frac{fB}{p_A} \qquad . \qquad . \qquad . \qquad . \qquad \text{(6iv)}$$

and
$$h_E = H - \frac{fB}{p_E} \qquad . \qquad . \qquad . \qquad . \qquad \text{(6v)}$$

Subtracting equation (6v) from equation (6iv)—

$$h_A - h_E = H - \frac{fB}{p_A} - H + \frac{fB}{p_E} = fB\left(\frac{1}{p_E} - \frac{1}{p_A}\right)$$

$$= fB\frac{p_A - p_E}{p_A \times p_E} \qquad . \qquad . \qquad \text{(6vi)}$$

It is usual to write $h_A - h_E$ as Δh_{AE}. This is purely conventional, Δ is a Greek letter, capital delta, often used to denote difference. By the same conventional notation $p_A - p_E$ would be written as Δp_{AE}. Thus—

$$\Delta h_{AE} = fB \times \frac{\Delta p_{AE}}{p_A \times p_E} = \frac{fB}{p_E} \times \frac{\Delta p_{AE}}{p_A}$$

But
$$p_E = \frac{fB}{H - h_E} \qquad \text{i.e.} \qquad \frac{fB}{p_E} = H - h_E$$

Therefore
$$\Delta h_{AE} = (H - h_E)\frac{\Delta p_{AE}}{p_A} \qquad . \qquad . \qquad \text{(6vii)}$$

Since E is the point of known height, this will usually be written as

$$\Delta h_{EA} = (H - h_E)\frac{\Delta p_{EA}}{p_A} \qquad . \qquad . \qquad . \qquad . \qquad \text{(6viii)}$$

This formula will enable us to find the difference in height between A and E, simply by measuring the parallax of both A and E, and estimating the value of H as explained earlier.

Measuring Parallax

We saw in Chapter 3 how, using a bar scale, we could actually measure the x-coordinates of the images on two overlapping photographs of the same ground point, and then by finding the algebraic difference between the coordinates we could determine the parallax of the ground point (see page 75).

FIG. 6.3. (i) DIAGRAMMATIC SKETCH OF A PARALLAX BAR
(ii) MICROMETER HEAD (ENLARGED)

This type of measurement might enable us to read to the nearest 0·5 mm, but we need a much closer reading than this if we are to obtain ground heights with sufficient accuracy. A special hand instrument has been produced for this purpose. This is known as the *parallax bar* or *stereometer*, and is illustrated in Figs. 6.3 and 3.17. The instrument consists of a bar to one end of which is rigidly attached the right-hand index-frame. The left-hand index-frame is free to move along the bar but can be clamped in any desired position on the bar. Each index-frame contains a dot (or cross) engraved on the underside of a piece of glass or Perspex. The right-hand dot can be moved relative to the bar in a direction parallel with the bar, in such a way that the amount of its movement is recorded on the micrometer head. Thus once the left-hand index-frame is clamped into position we can measure the magnitude of all changes in the spacing between the two dots.

The main micrometer scale, which reads longitudinally to the bar, is graduated in millimetres and half millimetres. The bar bearing this scale is cylindrical in section and fits inside the barrel-shaped

micrometer head (see Fig. 6.3 (ii)). It is by turning this head that the right-hand dot is moved in and out. The head itself also moves longitudinally in unison with the dot. One complete revolution of the head causes it to move one half-millimetre along the main scale. The leading edge of the head is equally divided into fifty parts so that the bar may be read directly to one-hundredth part of a millimetre.

If we place this instrument under a stereoscope so that the image of the left-hand dot is visible only to our left eye and the image of the right-hand dot only to our right eye, then by slightly adjusting the spacing of the dots we shall be able to fuse the images stereoscopically. We shall, in fact, see the fused dot floating in space; this is referred to as the *floating mark*. At the same time we must set up a pair of photographs for viewing stereoscopically under the parallax bar. The position now is that we have a view in the stereoscope of the floating mark superimposed on a three-dimensional image of the ground covered by the photographic overlap. Put in another way, we shall see two entirely separate stereoscopic models: one of the photographs, and the other of the dots.

To obtain these two images in satisfactory relationship with each other, base-line the pair of photographs and set them up under the stereoscope as in Chapter 3. Tape the photographs securely to the table, remove the stereoscope and, after bringing the micrometer of the parallax bar to the centre of its run, set the right-hand dot over a definite but very small point of detail on the right-hand photograph. (Some instruments read from zero to 13 mm; in such a case the reading should be set at 6·50 mm approx.) Let this be the image of the ground point Q. Slacken the clamp-screw on the left-hand index-frame and move the left-hand dot so that it falls over the left-hand photographic image of the same point of detail, Q. Tighten the clamp, making sure that the right-hand dot remains over the appropriate point of detail. This is known as *zeroing the bar*, and the clamp should subsequently remain tight throughout the heighting procedure on this pair of photographs.

Set the left-hand dot over a fairly clear area of ground, and keeping the bar parallel with the eye base, move the micrometer head in and out until fusion of the dots is obtained. Let the actual point chosen be the image of A. Now move the micrometer so that the right-hand dot moves inwards, that is to the left. Continue until fusion is lost, then move the micro-head back just enough to regain fusion. The dot should now appear to be floating above the model of the ground. Move the right-hand dot gradually outwards, and watch the floating mark gradually sink down to ground level. If you continue moving the right-hand dot outwards, the floating mark may appear to

penetrate the ground surface of the model, though such a pheno-
menon might be rejected by your subconscious as unnatural. In
the latter case fusion of the dots will be lost. At the time at which
the floating mark appears to be exactly at ground level, the spacing
of the dots is the same as the spacing of the pair of image points
a_1 and a_2 (see Fig. 6.4 (ii)). That is to say the parallax of the dots
is the same as that of the point of detail A.

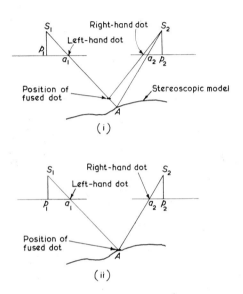

FIG. 6.4. VIEWING WITH A PARALLAX BAR UNDER THE STEREOSCOPE
(i) FUSED DOT APPEARS TO BE FLOATING ABOVE GROUND
(ii) FUSED DOT APPEARS TO BE AT GROUND LEVEL

The parallax bar reading is a measure of the parallax of the
point A. In some instruments the readings increase with the parallax,
but in others the readings increase when the parallax decreases.
One of the first requirements is to find out which type of bar you are
using; this can be done before zeroing, by turning the micrometer
head so that the readings are increasing slowly. During this move-
ment, watch the right-hand dot—if it is moving to the right the space
between the dots is increasing and the parallax, and therefore the
height of the floating mark, is decreasing. This instrument is then
of the inverse reading type. In a direct reading instrument the right-
hand dot would move to the left (decreasing separation) as the
readings increased.

Although the bar readings are a measure of the parallax of a point, they do not give the actual parallax.

In Fig. 6.5 the parallax of A, $p_A = x_{1A} + x_{2A} = K - X_A$.

But

$$X_A = L - m_A$$

Therefore

$$p_A = K - L + m_A \qquad . \qquad . \quad (6ix)$$

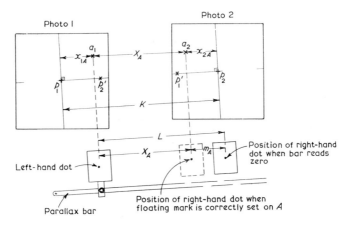

FIG. 6.5. DIAGRAM TO ILLUSTRATE THE RELATIONSHIP BETWEEN BAR READING DIFFERENCE AND PARALLAX DIFFERENCES
$K =$ constant spacing of photographs during heighting operations
$X_A =$ spacing of photo images A
$m_A =$ parallax bar reading when mark is set on A
$L =$ length of bar between dots after zeroing and when reading is reduced to zero.

Similarly it can be shown that for the ground point E,

$$p_E = K - L + m_E \qquad . \qquad . \qquad (6x)$$

Therefore subtracting equation (6x) from equation (6ix),

$$p_A - p_E = m_A - m_E . \qquad . \qquad (6xi)$$

That is to say that the *difference* in parallax between A and E is equal to the *difference* in the bar readings for the two points.

Example

We have a pair of vertical air photographs, both of which contain the image of the ground points A and E. We know the height of E above datum to be 38 m. The flying height has been estimated as 1,562 m, and the mean height of the ground above datum is 34 m. The base lines are 87·2 and 89·2 mm respectively. The focal length of

the camera is 152·4 mm and the parallax bar readings are 5·31 for A and 6·12 for E. Find the height of A above datum. The bar is such that an increased reading indicates an increase in parallax.

Solution

$$H = 1{,}562 \text{ m} \qquad m_A = 5{\cdot}31 \text{ mm} \qquad h_E = 38 \text{ m}$$

$$b = \frac{87{\cdot}2 + 89{\cdot}2}{2} = 88{\cdot}2 \text{ mm} \qquad m_E = 6{\cdot}12 \text{ mm}$$

$$f = 152{\cdot}4 \text{ mm} \qquad\qquad h = 34 \text{ m}$$

From the parallax equation (6ii)

$$p_E = \frac{fB}{H - h_E} \simeq \frac{b(H - h)}{H - h_E} = \frac{88{\cdot}2 \times (1{,}562 - 34)}{1{,}562 - 38}$$

$$= 88{\cdot}43 \text{ mm}$$

We have shown that

$$\Delta h_{EA} = (H - h_E)\frac{\Delta p_{EA}}{p_A} \qquad . \qquad . \qquad \text{(see eq. 6viii)}$$

But $\qquad \Delta p_{EA} = p_E - p_A = m_E - m_A \qquad .$ (see eq. 6xi)

$$= 6{\cdot}12 - 5{\cdot}31 = 0{\cdot}81 \text{ mm}$$

therefore $\qquad p_A = p_E - 0{\cdot}81 = 88{\cdot}43 - 0{\cdot}81 = 87{\cdot}62 \text{ mm}$

therefore $\qquad \Delta h_{EA} = (1{,}562 - 38)\dfrac{0{\cdot}81}{87{\cdot}62} \text{ m}$

i.e. $\qquad h_E - h_A = 1{,}524 \times \dfrac{81}{8{,}762} = 14 \text{ m}$

i.e. $\qquad 38 - h_A = 14 \text{ m}$

i.e. $\qquad h_A = 24 \text{ m}$

Answer: A is 24 m above datum.

This can be summarized in schedule form as follows—

Ground point	Bar readings	Difference in parallax in mm	Parallax in mm	Difference in height in m	Height above datum in m
E	6·12		88·43		38
A	5·31	− 0·81	87·62	14	24

Inaccuracies of Parallax Heighting

In this way the height of any point whose image appears on the overlap could theoretically be found, provided that we know the

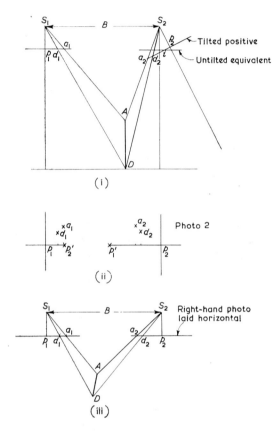

FIG. 6.6. EFFECT OF TILT OF MODEL AS RECONSTRUCTED UNDER A SIMPLE
STEREOSCOPE
 (i) Light rays at time of exposure. Left-hand photo untilted. AD is a
 vertical chimney.
 (ii) Plan view of photos.
 (iii) Model of AD as reconstructed under a simple stereoscope. Both
 photos are horizontal; thus the image is distorted because rays
 through the right-hand photograph are incorrectly reconstructed.

height of any other point on the overlap. However, there are many factors giving rise to errors in the parallax equation, and heights calculated as above are known as crude heights, because they need

adjusting in some way before they can be said to give even reasonable results. We have already seen that only an approximate value can be found for the flying height, and an even less accurate value for the length of the air base. In addition, the setting of the floating mark on a particular point of detail is a very skilled operation, and even the expert will require to take the mean of at least five separate readings for each point. Further, there will be errors in the position of the image on each photograph due to tilt, and also to displacements caused by the lens (see Chapter 9). It will be found in practice that the procedure just given will give grossly inaccurate results except for pairs of points which are very close together. Since tilt is the principal cause of these errors, let us examine what happens to the parallax equation when tilt is present in only one photograph of the pair, though we must remember that in practice both photographs are almost certain to be subject to some degree of tilt.

In Fig. 6.6, the diagram (i) is a correct reconstruction of conditions at the time of exposure, with the optical axis $S_2 p_2$ tilted in a fore and aft direction. The diagram (ii) shows the location of the images of the points A and D, and (iii) shows the reconstruction of the stereoscopic image which would actually take place under a mirror stereoscope. Note that under the stereoscope the photographs are necessarily mounted in a horizontal plane. Compare Fig. 6.6 (iii) with Fig. 6.2: a_2 and d_2 in Fig. 6.6 (iii) are displaced relative to their correct position as shown in Fig. 6.2, but $a_2 p_2$ in Fig. 6.6 (iii) is equal to the x-coordinate of a_2 in Fig. 6.6 (ii), and similarly for $d_2 p_2$. The result is that the three-dimensional image of AD is distorted—not only are the absolute depths below eye base ($S_1 S_2$) of the points A and D reduced, but the distance AD is reduced and the line AD is no longer vertical. Using exactly the same arguments as applied to Fig. 6.2, we can show that parallax of A in Fig. 6.6 (iii) is still $p_A = fB/H - h_A$, and that parallax of D is still $p_D = fB/H - h_D$. Thus, the equation

$$\Delta h_{EA} = \frac{(H - h_E)\Delta p_{EA}}{p_A}$$

still holds good, but the difference in height now relates to the erroneous model of Fig. 6.6 (iii), and not to the correct difference in height, nor even to the actual length AD.

HEIGHTING DRILL

Figure 6.6 obviously grossly exaggerates the errors, since a photo having the tilt of photo 2 in 6.6. (i) would certainly be rejected. However, the distortions of the model produced by an acceptable

photograph would be sufficient to make the parallax relationships completely unreliable, but there are several methods of correcting the heights derived from differences in parallax. The simplest of the drills involved, assumes that the errors are strictly linear in any direction. That this assumption is untrue will become apparent later, but some reasonable results have been achieved, and we will consider the way in which it has been used.

Suppose we know the heights of the two points A and E, whose images lie in the overlap between two vertical air photographs, then we can find the heights of points B, C and D lying on the straight line AE as follows: First find the crude height of B by parallax measurements and calculations as before, and using the known height of A. Repeat this for C, D and E. The crude height of E will differ from the true height, so that we may readily determine the correction required at E; the corrections required at B, C and D can then be calculated as proportional to their distances from A. For example, suppose the true heights of A and E are 30 and 37 m respectively, and that the crude heights of B, C, D and E are respectively 34, 29, 23 and 27 m. Let the measured distances on the map be $AB = 10$ mm, $AC = 20$ mm, $AD = 30$ mm and $AE = 40$ mm. Correction required at E is $+10$ m; therefore correction at B must be $10 \times 10/40 = +2{\cdot}5$ m, at C it is $10 \times 20/40 = 5$ m and at D it is $10 \times 30/40 = 7{\cdot}5$ m. Thus the corrected heights of the five points A, B, C, D and E would be 30, 36·5, 34, 30·5 and 37 m respectively.

L. G. Trorey in his book *Handbook of Aerial Mapping and Photogrammetry* described how he uses an adaptation of the above method for contouring. This method uses heighting drill only along lines perpendicular to the base line; i.e. points A, B, C, D and E of the above example must not only be collinear, but also lie on the same perpendicular to the base line. Considerable accuracy is claimed for this method, but the requirement of several pairs of points of known height, whose positions are so rigidly governed, must lead to considerable difficulty and inconvenience in the field. Although the heights of height control points will normally be obtained from barometric heighting, each control point has to be accurately recognized on ground and photograph, and has to be visited in the field.

More recently a theoretically sound method of heighting using a parallax bar has been developed. The corrections to be applied to the crude heights are a combination of a parabolic and a hyperbolic correction. A full investigation of the method is reported by Professor Thompson in the *Photogrammetric Record*, Vol. 1, No. 4

Expressed mathematically the method depends on a correction to any crude height of $a_0 + a_1x + a_2y + a_3xy + a_4x^2$, where x and y are the coordinates on the left-hand photograph of the image of the point being heighted, and a_0, a_1, etc. are constants which must be determined by experiment for each overlap. Since there are five unknown constants we must have five height control points per overlap. The solution simultaneously of the five resulting equations is the most tedious part of the drill, and the operation should be carried out according to a strict form of computation: one method is illustrated in Chapter 10, as part of a practical example of contouring.

Once the values of the constant coefficients are known, the appropriate correction at any other point may be ascertained by substituting the coordinates of the point for x and y in the equation

$$h' - h = a_0 + a_1x + a_2y + a_3xy + a_4x^2 \ . \qquad . \quad \text{(6xii)}$$

in which h' is the correct height and h the crude height.

The procedure is as follows. First base-line the photographs, choose the five control points and plot them on the left-hand photograph. Ideally these points should be located one in each corner of the overlap and one in the middle, but the rules to remember are that no four of these points should be in a straight line and no three of them should lie on the same perpendicular to the base line. The heights of these points must now be obtained by ground methods, usually by barometric heighting.

Now fix a transparency to the top edge of the left-hand photograph, and with this transparency folded down over the photograph draw in the X and Y axes as shown in Fig. 6.7. The centre of the base line is chosen as the origin, the X axis is drawn to overlie the base line, and the positive direction of the Y axis is downwards. A grid is now drawn on the overlay with lines at 20 mm intervals, and based on the new axes.

Coordinates of any photo-point can be read off the grid to the nearest 2 mm.

Carry out the heighting drill for each point in turn using say point No. 2 as datum; find the crude heights of the other four points. Now in equation (6xii) make substitutions for each of the control points in turn. $h' - h$ will be the difference between the crude height and the known correct height: in the case of point No. 2, this will be zero. In the right-hand side of the equation we must substitute the X-coordinate of the point for x, and the Y-coordinate for y. The solution of the five equations so formed gives us numerical values for a_0, a_1, a_2, a_3 and a_4.

To find the height of any other point q on the overlap, we must first carry out the heighting drill with the parallax bar, again using point No. 2 as datum; this gives us h in the correction equation. We then measure the coordinates of q and substitute these in the right-hand side of the equation, making a full numerical determination of this side of the equation. Thus we can find h', the corrected height of the point q.

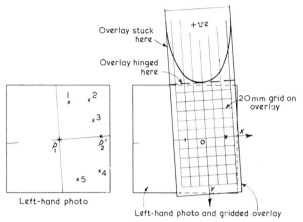

FIG. 6.7. HEIGHTING DRILL—THE GRIDDED OVERLAY

This drill could be followed to find the height of any point whose image falls on both the photographs under investigation; but the determination of contours calls for the heighting of so many points that it is usually advisable to draw two sets of graphs on to the overlay (see Fig. 6.7).

The parabolic graph at the top of the overlay is plotted by substituting a series of arbitary values for x in the equation $Y = a_4 x^2$, where the value of a_4 has already been calculated. Y is the parabolic correction to apply. and is represented by the ordinate of the graph.

The series of graphs across the face of the photograph (see Fig. 10.5) represent the hyperbolic correction and are obtained from the equation

$$Hyp = a_0 + a_1 x + a_2 y + a_3 xy$$

where a_0, a_1, a_2 and a_3 have already been determined. Hyp is the hyperbolic correction, and each separate curve is a rectangular hyperbola drawn through points having the same hyperbolic error.

If x remains constant, the right-hand side of the equation is linear in y, and if y remains constant that side of the equation is linear in x. Therefore we may adopt linear interpolations between the curves in directions parallel with either the X-axis or the Y-axis. The curves themselves can be very simply drawn in by finding mathematically the hyperbolic correction for the four corner points, and making successive linear interpolations between these four points.

The total correction to the crude height for each point will then be

$$Hyp + Y = a_0 + a_1x + a_2y + a_3xy + a_4x^2$$

as before. That is the sum of the parabolic and the hyperbolic corrections.

The network of points whose heights are required for interpolation of the contours is now plotted on the photograph. The crude height of each point is determined by parallax bar, and corrected heights are found by reading off the corrections from the graphs. The contours are finally drawn in on the photograph itself, using the stereoscopic model to help maintain correct contour heights between successive interpolated points.

Some Instrument Refinements

The main practical difficulties involved in using the parallax bar concern the maintenance of the bar parallel with the eye base and photo base, and also the bringing of the floating mark exactly to the " ground level " of the model.

A parallel guidance mechanism (see Fig. 6.8) solves the problem of parallelism. This mechanism consists of a base on which is mounted an x-carriage, free to move in only the x-direction. A y-carriage is mounted on this x-carriage, and is free to move only in the y-direction. The y-carriage carries both the stereoscope and the parallax bar, mounted parallel with each other and with the direction of movement of the x-carriage. The two prints are mounted on the base of the mechanism, and oriented so that, with the y-carriage clamped, the right-hand dot can be made to pass accurately along the base-lines of both photographs. The separation of the prints is set to give comfortable fusion.

The difficulty of fusing the dots when viewing points having appreciable wants of correspondence is reduced by making the left-hand stereometer dot adjustable in the y-direction.

Further help in reducing the floating mark to the model surface is obtained by viewing through a pair of magnifiers, which resemble field glasses, placed in front of the eye-pieces (see Fig. 3.17). One

effect of this attachment is to restrict the field of vision, which is often a severe disadvantage; but by making each image point and both dots appear bigger, more exact placing of the floating mark becomes possible. As experience is gained, magnification will allow a smaller dot (or other shape of reference mark) to be used, which will cover a smaller area of ground and so increase the accuracy of heighting.

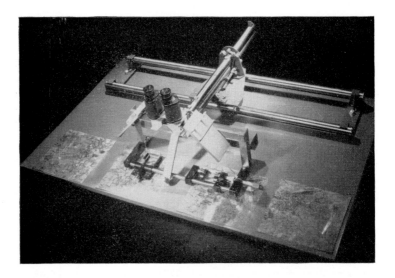

FIG. 6.8. PARALLAX BAR AND STEREOSCOPE WITH PARALLEL MECHANISM
(*C. F. Casella & Co. Ltd.*)

Since the magnifiers restrict vision to paraxial rays, the horizontal scale of the model will increase proportionally with the magnification. The effect on the vertical scale will depend upon the interpretation that the brain puts on the apparent enlargement of two flat pictures, both of which apparently remain at a great distance from the eyes—this will be complex, but will certainly not result in so great an increase in the vertical direction as in the horizontal. It is generally accepted that magnification decreases the impression of excessive gradients, though this is difficult to prove—it is probably almost entirely due to the greater apparent increase in horizontal relative to vertical scale.

In the Hilger and Watts folding mirror stereoscope, the reference marks of the parallax bar are replaced by two spots of light which are

introduced into the viewing system, and can be fused to form a floating mark in relation to the stereoscopic model formed from the pair of photographs. Want of correspondence can be removed by a y-adjustment of the left-hand spot. The separation of the spots, and therefore the apparent height of the floating mark, can be adjusted by an x-movement of the right-hand spot. This x-movement is

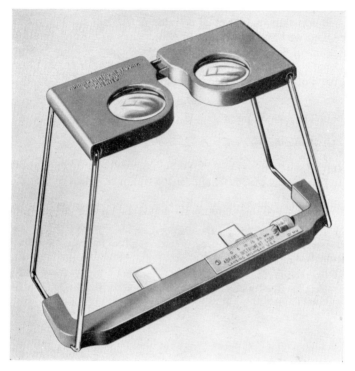

FIG. 6.9. ABRAMS HEIGHT FINDER ATTACHED TO POCKET STEREOSCOPE
(*Abrams Instr. Corp.*)

operated by a micrometer head, similar to the one illustrated in Fig. 6.3, which enables readings direct to 0·01 mm. The photographs are mounted on a carriage which is attached to the stereoscope by means of a pantograph type of parallel-guidance mechanism. Scanning is then carried out by a controlled movement of the photographs, thus avoiding the necessity for the operator to move his head. The brightness of the spots of light can be adjusted by a rheostat control, and the floating mark seems a little easier to bring to

"ground" level than does that of the parallax bar. However, the main advantage is that there are no bar frames to interrupt the view of the photographs or to damage the emulsion by physical contact.

The binocular unit gives a magnification of $4 \times$.

Figure 6.9 illustrates a pocket-size parallax bar which clips on to a stereoscope. It is especially useful for work in the field, including interpretation, and is shown attached to a pocket stereoscope.

In Fig. 6.2 we have seen that $p_D = fB/H$ (eq. 6i), so that if f remains constant, p_D varies directly as B/H. Fig. 3.13 is a similar figure, and we have shown that as H increases so the appreciation of variations in ground height decreases, whereas an increase in B has the effect of increasing depth perception. The B/H ratio is then a measure of the appreciation of stereoscopic depth.

FURTHER READING

 (i) *Admiralty Manual*, pages 285–98.
 (ii) Hart, pages 203–35.
 (iii) Moffitt, Chapter 8.
 (iv) Trorey, pages 56–92, and, using obliques, pages 37–55.

(See Bibliography (page 346) for full titles.)

The following articles in the *Photogrammetric Record* suggest that simple stereometer heighting accuracies can be increased by further refinements—

 1. "Corrections to *x*-parallaxes", by E. H. Thompson (October 1968).
 2. "Heights from parallax bar and computer", by B. D. F. Methey (April 1970).

CHAPTER 7

Plotting of Detail, Mosaics

If we have been following the chapters through in order, then at this stage we have a pair of photographs (on one of which the contours have actually been plotted) and a base grid on which is plotted the principal point traverses and copious points of minor control. Before sending the finished map for reproduction it is still necessary to plot the photographic detail and the contours on to the points of control. Generally speaking the base grid will be too large and too encumbered with construction lines to be used for plotting detail. A trace of the completed slotted templet plot is therefore made on to a suitable stable transparency. This is known as a compilation sheet. Each map sheet area is represented by a separate compilation sheet.

The profusion of detail on the face of the print makes the draughtsman's task difficult, and it is usual to prepare a separate photograph on which topographic and other required features are picked out in appropriately coloured inks or poster colours. This is known as interpreting a print and is the work of an expert. The fully interpreted photograph, together with a full specification of colours, conventional signs, names and other requirements, is delivered to the draughtsman or instrument operator.

Interpretation as a subject is dealt with in a later chapter.

THE PLOTTING OF DETAIL AND MAP REVISION

The most obvious advantage of making maps from vertical air photographs is in the plotting of detail. In chain surveying and traversing, the chain-lines form the control, and the offset and tie points are minor control points. The only guide to the shape of curved linear objects between such control is found in the sketches and notes in the margin of the field-book. Not only are these relatively crude sketches, but they were themselves made only after imperfect observation of the elevational view of the objects whose plan view we are plotting. Tacheometry provides only single points of detail and minor control. Even plane-tabling, where the detail is drawn up while the objects are in direct view, suffers from the fact that it is still only an elevational view on which the accuracy of the detail depends.

The vertical air photograph provides a detailed plan view which is accurate over short distances. For the same plan accuracy then,

far fewer minor control points are needed than would be required
for ground methods.

Maps from Obliques

In oblique photographs the shapes of objects depart from those of
the true plan view. Plotting detail from such photographs does not
therefore offer the same advantages as does plotting from verticals.
Nevertheless, if the ground is fairly flat, there are useful geometrical
relationships between the oblique view and the plan view, and plot-
ting by graphical methods may be undertaken from single obliques.

We have seen how the four-point method of transferring points
from photo to map can tolerate any degree of tilt. The method may
therefore be used for plotting single points of detail, or for increasing
control from an oblique photograph, though the strict limitations due
to variations in ground heights must be remembered.

If only a small amount of linear detail needs to be added to a map,
this can be done by choosing minor control points at close intervals
on these lines, transferring them by the paper-strip method, and then
sketching in the lines by eye using the m.c.ps. as guides. More
m.c.ps. would, of course, be needed than for use with vertical photo-
graphy.

If a new map is required, or a large amount of revision is neces-
sary, then a more systematic approach is needed. This will normally
call for the construction of some sort of grid, and the relationship
between the grid drawn on the map and that drawn on the photo-
graph will reflect the geometric properties of both. If the ground
is sufficiently flat to enable use to be made of the four-point method
of point transfer, then there will be very little height distortion and
we may assume that distortions are approximately radial from the
isocentre. Additionally, if on the map we draw a square grid, such
that the lines in one direction are all parallel with the homologue of
the principal line, then the corresponding lines on the photograph will
all meet in the vanishing point (see Fig. 2.23 and the associated text).

The principal point of an oblique may be found from the cali-
brating marks in the same way as for a vertical. If there are enough
buildings on the photograph, then there should be enough pairs of
lines, representing pairs of parallel horizontal lines on the ground,
for us to determine the position of the vanishing line or true horizon
on the photograph. This would enable the principal line to be drawn
in by dropping a perpendicular from the principal point on to the
true horizon. The method would be similar to that described for the
graphical determination of tilt.

Alternatively, on fairly high obliques, vertical lines may be very

much in evidence, and a good approximation to the position of the plumb point may be found relatively easily. The corners of buildings, telegraph poles, and the trunks of most tall trees are often sufficiently nearly vertical for this purpose. A transparency is securely mounted over the photograph. As many vertical lines as possible are chosen, and the construction shown in Fig. 7.1(i) is carried out. In practice all the lines will not normally meet in one point, but if the meeting points are reasonably consistent an approximate position of the plumb point may be found.

To continue the construction of Fig. 7.1(i), join the plumb point to the principal point, and extend this line beyond the principal point. This is the principal line.

The construction of Fig. 7.1(ii) could be superimposed on Fig. 7.1(i); but it is shown separately for clarity. In fact Fig. 7.1(i) is in the plane of the photograph, whereas Fig. 7.1(ii) lies in the principal plane. On 7.1(ii) pS is constructed perpendicular to the principal line, and of a length equal to the principal distance of the camera. Sn is the plumb line of the perspective diagram, so that the angle $pSn = \theta$, the angle of tilt. Determine the position of the isocentre, i, by bisecting the angle pSn, and find the position of the vanishing point, v, by making vS perpendicular to Sn. Check the position of the vanishing point by finding the vanishing line by the method indicated under the graphical determination of tilt.

If the plumb point lies too far off the photograph, or there are few prominent vertical lines in the photograph, it may be better to find the vanishing line first, and use the plumb point determination to check the figure.

Fig. 7.1(iii) is also drawn in the plane of the photograph, but the detail of Fig. 7.1(i) has been omitted, and only the principal line and the points v and i are retained. In the map plane (Fig. 7.1(iv)) the isocentre, I, would need to be resected from three, or preferably more, control points.

On Fig. 7.1(iii) the isometric parallel, ia, is drawn perpendicular to the principal line. a is any identifiable point of detail on the isometric parallel, and is transferred to A in the map plane by the paper-strip method. In Fig. 7.1(iv) AI is now the map representation of the isometric parallel, thus IN, perpendicular to AI, is the map representation of the principal line. Set up a square (say 10 mm) grid on these two lines.

The scale along ai is ai/AI of the map scale. Subdivide ia so that the length of the subdivisions $ji = JI \times ai/AI$. On Fig. 7.1(iii) join each of these points to v. The lines j_1v, j_2v, etc. then represent those map grid lines which are parallel with the line NI.

In the map plane draw a diagonal, *IL*, to the square grid. This line passes through successive grid intersections and with the principal line *IN* it subtends an angle of 45° at *I*. Since angles subtended at the isocentre are correct, the corresponding line on the photo plane will be at 45° in *in*, and will pass through those photo grid intersections corresponding to the map grid intersections, $L_1 L_2$ etc.

Those map grid lines parallel with *AI* will all be represented on the photograph by plate parallels and can be drawn in on Fig. 7.1(iii) by dropping perpendiculars on to *nv* from $l_1 l_2$, etc.

Detail can now be transferred from the photo to the map, square by square, as is done when a map is reduced in scale by the method of squares.

It will be appreciated that the scope of this method of making a map is limited not only by the terrain, but also by the fact that the greater the obliquity the less will be the amount of plottable detail, because the foreground detail will tend to obscure the background. In addition the angle of tilt must be such that the vanishing point and the isocentre do not fall too far outside the format of the photograph. In any case, the scale of photography on the horizon side of the principal point will be so small as to limit the plotting possibilities.

For low obliques it would be possible to find the principal line of the photograph and its angle of tilt by, say, the Anderson method of analysing tilt. The constructions of Fig. 7.1(ii) (iii) and (iv) could follow as above.

The Sketchmaster, described later, may be used to plot the detail from relatively low obliques; but a large amount of control would be needed.

Plotting and Map Revision from Verticals

Rectification is the technical term often used to describe the action of plotting correct planographic detail from an air photograph. The term is an unfortunate one, because photographic rectification is a method of producing a print free from tilt and having no distortions due to the lens. Height distortions remain, however, and can only be removed in a 3-dimensional model. In fact the only true rectifiers are the expensive plotting instruments such as the multiplex and the stereoscopic viewing type of instrument.

The simpler plotting instruments are not rectifiers in the true sense of the term, because in the words of Brigadier Hotine, " The use of an unlimited amount of control on vertical photographs enables the theoretical conditions of true rectification to be given up in favour of mechanical simplicity and more rapid setting." In an extreme

illustration of this principle, we may imagine that we have an existing map with a vertical air photograph of the same area. We require to revise the map, and find that only one block of houses is missing. All we need to draw are four straight lines in the form of a rectangle. This could be done with complete satisfaction by plotting the four corners in relation to other nearby features. Over such a small area the tilt would not normally cause any appreciable inaccuracy. In fact, if the map and photograph were to the same scale it would be possible to trace in the detail over an ordinary draughtsman's light table. Provided that the amount of revision is small, any of the normal methods of transferring detail from one map to another could be used, e.g. method of squares, transfer of lines parallel to them-

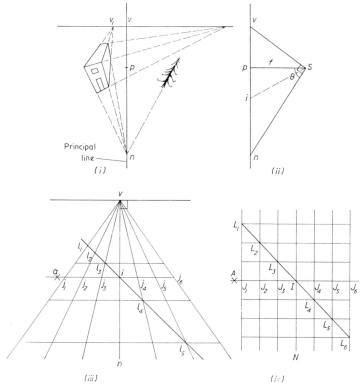

FIG. 7.1. PLOTTING FROM OBLIQUES—THE POLAR GRID
(i) In plane of photo
(ii) In principal plane of photo
(iii) Polar grid on photo
(iv) Square grid on map

selves, the use of a pantograph or proportional dividers. With all such methods, only small areas, up to about ten millimetres square of the photographic detail, should be transferred at one setting.

If there is a lot of revision required it would normally be advisable to trace the extant detail from the map on to a stable transparency, and then to locate the homologues of the principal points on this transparency. This would be done by the paper-strip method or by simple resection. Since the latter requires equality of angles, it must depend on the radial line assumption and can therefore be applied only for transferring the principal point. In order to allow for local height distortions the resection should be made from say five or six points by drawing radials through all these points instead of the usual three; in such a case only a mean fit of the rays to the map control will be possible.

If pairs of photographs are available, a principal point traverse can be drawn, minor control can be intersected and the detail may be plotted as described later for a new map. When only one photograph is available, radials are drawn at regular intervals through the principal points of both map and print. Each ray on the print should be checked to ensure that it passes through points homologous to those on the corresponding map ray. Curves can be drawn in the tangential direction by interpolation between close minor control. Pick a series of minor control points (m.c.p.s) each at about the same map distance from the map principal point. On the map and with its centre at the principal point, draw in an arc of radius equal to the mean distance of these m.c.p's. from the principal point. By interpolation between m.c.p's. on the print, mark points on the homologue of this arc and join these points with a smooth curve—this represents the arc as drawn on the map. (see Fig. 7.2). Repeat this process for a number of such arcs, until a fairly close curved grid is established. Detail may now be transferred in the same way as for the other grids.

Perhaps the most successful method is that of treating each detail line as a separate problem. Thus to plot a boundary line, m.c.p.'s would be plotted (by radial line or paper-strip methods) at all obvious changes in direction, and at regular intervals along the rest of the line. The boundary line would then be drawn in by eye, or by tracing short lengths at a time (cf. plotting a chain survey).

Where the area to be revised is large and little control remains, we approach conditions similar to those involved in making a new map, i.e. where we have traced the principal point traverse on to the compilation sheet and built up minor control to about 20 mm spacing. For this amount of revision and for plotting a new map, some

elementary plotting instrument is usually considered necessary, though 1/50,000 mapping is still carried out sometimes by purely graphical methods.

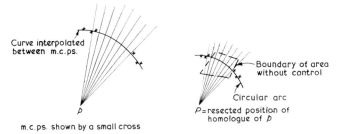

Curve interpolated
between m.c.ps.

p

m.c.ps. shown by a small cross

Boundary of area
without control

Circular arc

P = resected position of
homologue of p

FIG. 7.2. INTERPOLATING ONE OF THE CURVED GRID LINES IN THE "RADIAL GRID" METHOD
Left-hand side : print.
Right-hand side : map.

Simple Plotting Instruments

Most of this grade of instrument are based on the *camera lucida* principle. An ordinary camera used for taking photographs is a *camera obscura* or dark room—a compartment from which light is excluded. A camera lucida or *chambre claire* is a room or compartment into which light is flooded.

There are two main types of simple plotting instrument in photogrammetry: those which project the image, and those which reflect it. Perhaps the simplest instrument is one which can project the image of the photograph on to the map being revised. An epidiascope or an episcope could, with an adjustment to the lens, be used for this purpose. In such a case the map being revised would be secured to the screen and the photograph would be placed on the projecting table within the instrument. The image of the photograph is projected on to the map screen (see Fig. 7.3) and the object is to arrange matters so that four neighbouring image points appear exactly superimposed upon the four appropriate control points. The detail required within the figure formed by these four points can then be traced off on to the map. The setting is changed to four more points, and the procedure is repeated until all the required detail has been transferred. The adjustment to scale would be by altering the distance of the screen from the instrument and then refocusing. By altering the position of the photograph on the table, rotating it and tilting the screen about the ball and socket, the image of the photograph can be made to coincide with the relevant map detail over a very small area. New detail can be traced in directly

on to the screen. The procedure, though simple, is a great strain on the eyes and it is not advisable to work with the instrument for more than about half an hour at a stretch.

The reflecting type of instrument is that most used in simple plotting operations. Perhaps the best known representative is the Sketchmaster. Fig. 7.4 shows the Zeiss Aero-sketchmaster, the

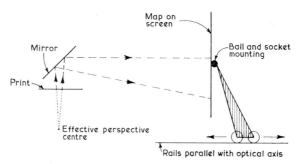

FIG. 7.3. EPIDIASCOPE ADAPTED FOR PLOTTING
(Lens and projective systems omitted)

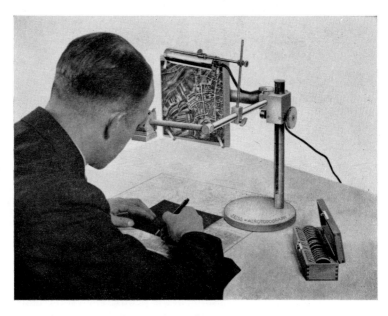

FIG. 7.4. ZEISS AERO-SKETCHMASTER
(*Zeiss Aerotopo*)

principle of which is illustrated in Fig. 7. 5. The eye-piece of this instrument contains a semi-transparent mirror, in which the photo image is reflected and through which the map image passes. The eyes therefore see the doubly reflected image of the photograph super-imposed on the doubly reflected image of the map. The photo-holder is ball and socket mounted.

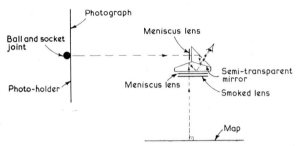

FIG. 7.5. PRINCIPLE OF THE SKETCHMASTER

If the ground covered is sufficiently flat, and the photo-plane and map plane are both correctly oriented with respect to the eye-piece, then the geometrical relationships of Chapter 2 are again set up between the photograph and map. It is therefore sometimes said that the instruments depend on anharmonic principles.

In fact, in order to maintain correct angular relationships between rays, the photo-plane should be fixed relative to the eye-piece (compare inner orientation of Chapter 11), and both tilt and scale should be corrected by movements only of the map plane; but the inconvenience of a moving map plane causes many manufacturers to ignore the theoretical niceties.

The drill for using the Zeiss Aero-sketchmaster is as follows—

1. Calculate the ratio between the photo scale and the map scale. Using the tables provided by the maker look up the appropriate lens-photo and lens-map distances and set these on the instrument. These distances could be approximately calculated by using the relationship—

$$\frac{\text{lens-photo distance}}{\text{lens-map distance}} = \frac{\text{photo scale}}{\text{map scale}}$$

In order to bring the two images into the same plane, and thus remove the effects of parallax, meniscus lenses are introduced in front of the eye-piece; the makers specify the correct lenses for the particular lens-photo and lens-map distances.

2. Mount the photograph with its principal point at the centre of the photo-holder, and by eye make the photo-holder vertical.

3. Secure the compilation sheet or map to the table so that the principal point traverse is more or less parallel with the operator's eyebase, and the homologue of the principal point is in the most convenient viewing position—probably about eight inches from the edge of the table.

4. Switch on the lamp to illuminate the photograph, and balance the strengths of the two images by inserting one of the range of smoked glasses in front of the stronger image.

5. Choose two points on the photograph in positions such as *a* and *b* in Fig. 7.6 so that the line *ab* is approximately horizontal and passes near to the principal point. Let *A* and *B* be the respective map positions of these points. Move the instrument stand until the photo line *ab* is superimposed on the map line *AB*. Now adjust the lens-map distance until *ab* is the same length as *AB*. Move the instrument again until *a* coincides with *A*, and *b* with *B*. This gives a correct mean scale for the line *ab*.

6. If *P* is the map position of *p*, and *P* is closer to *A* than *p* is to *a*, then the scale along *pa* is greater than along *PA*, i.e. the scale near *a* must be greater than that near *b*. Tilt the photo-holder about a vertical axis through *p*, bringing *b* closer to the eye-piece, until *a*, *p* and *b* coincide with *A*, *P* and *B* respectively.

7. Now choose two more minor control points on the photograph, in positions such as *c* and *d*, so that *cd* is approximately perpendicular to *ab* and passes near *p*. Repeat 6 above but using points *c* and *d* instead of *a* and *b*, and tilting about a roughly horizontal axis.

8. Repeat 6 and 7 above until the best mean fitting is obtained. Provided that *A*, *B*, *C* and *D* are points having similar ground heights, then the instrument will now be set for the approximate elimination of tilt. We say that we have completed the general setting, but it is rare that all or even many of the remaining m.c.p.s will be accurately superimposed on their map positions, and further detailed settings will be necessary.

9. Plot all detail nearer to the principal point than such points as *e*, *f*, *j* and *l*.

10. Check the setting of m.c.p.s *e*, *f*, *g* and *h* in Fig. 7.6. If necessary, and using movements similar to those of 6, 7 and 8 above, adjust the photo-holder to achieve coincidence of these points with their homologues. Plot all detail within this quadrilateral.

11. Repeat 10 for *fgkj*, then for *ghqr*, *grtk*, and *kjlm*, etc. until the whole quadrant has been plotted.

12. Repeat 6, 7, 8, 9, 10, and 11 for each of the other three quadrants in turn.

Note that if in any minor control quadrilateral coincidence of all four points is not possible, it means that the minor control is insufficient and further points should be added by intersections from the principal points.

Only a minimum area should be plotted from each photograph. For 20 per cent lateral overlap and 230 mm × 230 mm format this will average a little more than a rectangle 90 mm × 180 mm with the principal point at the centre.

Edge of format

FIG. 7.6. CHOICE OF M.C.P.'S FOR SKETCHMASTER CONTROL

Optical Rectifiers

A typical rectifier (see Fig. 7.7) consists of a projecting lamp and condenser which directs the rays of light through a negative or diapositive. These rays then pass through a lens which brings them to focus in the map plane. There are then three planes: the negative plane, the lens plane, and the map or image plane, and it is the relationships between these planes which particularly concern us.

The basic principles governing the design of an optical rectifier involve—

1. Correction for lens distortion.
2. Maintenance of a sharp image
 (a) at centre of projection.
 (b) over the whole projected image.
3. Correction for tilt distortion.

One method of correcting lens distortion is by projecting the negative image back through the lens which was actually used in the taking camera. Thus, in theory, each ray of light is made to travel backwards along the path which it took at the time of exposure. In practice it would be very inconvenient to use the same lens in the camera and in the rectifier, and the rectifier lens is usually a paired lens specially manufactured as nearly as possible the same as the camera lens. This is what is known as the Porro–Koppe principle. At one time rectification always involved recourse to the Porro

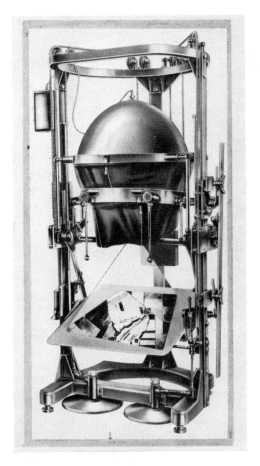

FIG. 7.7. AN OPTICAL RECTIFIER
(*Zeiss, Jena*)

principle, but nowadays many instruments use a glass correction plate instead. Some plotting instruments correct for lens distortion by mounting the viewing telescope on a specially made cam.

In the rectifier, the object is no longer at an infinite distance from the lens, as in Fig. 1.5; but the satisfaction of the lens condition

$$\frac{1}{U} + \frac{1}{V} = \frac{1}{f}$$

(see Fig. 7.8) ensures sharp focus of the image whatever the object distance (V).

Since the negative plane is not necessarily parallel with the lens plane, satisfaction of the lens condition along the optical axis does not ensure its satisfaction over the whole image area. For this reason

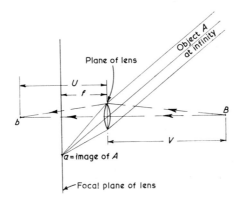

FIG. 7.8. FOCUSING A NEAR OBJECT
b is the image of B, an object at a finite distance V from the lens.
U is the image distance and f is the focal length of the lens.
Then the lens condition requires that $\dfrac{1}{U} + \dfrac{1}{V} = \dfrac{1}{f}$.

we must also satisfy the Scheimpflug condition which requires that the negative plane, the lens plane, and the image plane must all meet in one line. Proof that this satisfies the lens condition for every point is as follows: in Fig. 7.9, a is the image of point A, which lies at infinity. Drop aQ perpendicular to the lens plane; then $aQ = f$, the focal length of the rectifier lens.

Take any point b in the negative plane, with B its image in the map plane.

The ray aA passes through the optical centre O, and is parallel with RB; thus $aOQ = \beta$.

F

From similar triangles baO and bRB $\quad \dfrac{aO}{RB} = \dfrac{ab}{Rb}$

Drop perpendiculars bC and BD on to the lens plane, and let their lengths be U_b and V_B respectively; then

$$\frac{1}{U_b} + \frac{1}{V_B} = \frac{1}{Rb \sin \alpha} + \frac{1}{RB \sin \beta} = \frac{Ra}{f \times Rb} + \frac{aO}{f \times RB}$$

$$= \frac{1}{f} \times \frac{Ra + ab}{Rb} = \frac{1}{f}$$

i.e. the lens condition is satisfied for any image point.

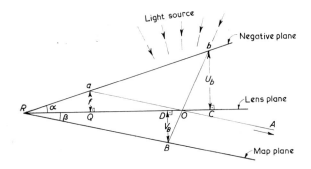

FIG. 7.9. THE OPTICAL RECTIFIER—PERSPECTIVE LINE DIAGRAM ILLUSTRATING PROOF OF THE SCHEIMPFLUG CONDITION

$O =$ optical centre of projecting lens,
$a =$ the homologue of a point at infinity,
$\therefore \quad aQ$ is focal length of lens

Theoretically the Scheimpflug condition must be satisfied in all cameras. In the air camera, the condition is only truly satisfied if the exposure is truly vertical, but the flying height is always sufficiently great to give " infinite focus " conditions over the whole of the format so that the whole picture will automatically be in focus.

An automatic rectifier is so constructed that, as the map plane is tilted, so one of the other planes tilts to maintain both the lens condition and the Scheimpflug condition.

The setting of the tilts in an automatic rectifier is achieved by making the projected images of four points of detail coincide with the plan positions of those points as plotted on the image plane. That is we require four points of control for each photograph in order to obtain rectification by this means. If the ground covered by the photograph were absolutely planar, three control points would do; the fourth is required since a tetrahedron is the rigid three-

dimensional figure in the same way that the triangle is the rigid
two-dimensional figure.

Just as we need five facts to fix a quadrilateral, so the rectifier
must be capable of five independent movements in order to be set to
the control quadrilateral. We say that the instrument has five
freedoms of movement, or just five freedoms. For example suppose
that the lens plane is fixed; then the first freedom might comprise an
adjustment of the lens to image plane distance; the lens to map plane
distance would now be determined by the lens condition and is
therefore not independent. The second freedom would entail

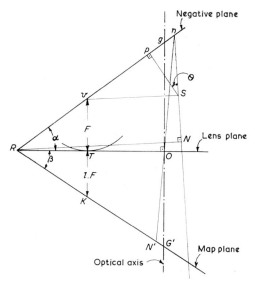

FIG. 7.10. OPTICAL RECTIFIER—CONSTRUCTION OF LINE DIAGRAM

rotation of the negative about a line in its plane, causing a change in
the angle α; the angle β is now fully controlled by the Scheimpflug
condition. The remaining three freedoms might involve one rota-
tional movement of the negative in its plane, and two lateral move-
ments of the negative in its plane and in directions at right angles to
one another; these would cause corresponding and dependent
movements of the map. The foregoing is intended merely as a simple
illustration of the idea of Five Freedoms—practical solutions of the
problem may be found elsewhere.

The following method of construction of Fig. 7.10 is given as
further explanation of the theory of optical rectifiers—

Draw pn to represent the negative plane, and produce. Set off $pS = f$ (the principal distance of the taking camera) and perpendicular to pn.

Join nS so that $\angle nSp = \theta$.

Draw vS perpendicular to nS and cutting pn in v.

Produce nS to N, so that $SN = H$, where

$$\frac{H}{f} = \frac{\text{map scale}}{\text{negative scale}} = l$$

Draw NR perpendicular to nN, cutting np in R.

With centre v describe an arc of radius F (the focal length of the rectifier lens).

Draw RT tangent to this arc and produce.

Join vT and produce to K so that $\dfrac{TK}{vT} = \dfrac{H}{f} = l.$ (7i)

Join RK and produce; mark N' in RK so that $RN' = RN$.

Join nN'. O, the optical centre, is the point in which nN' cuts RT.

When using a non-automatic rectifier the direction and amount of tilt are first calculated by methods similar to those suggested in Chapter 2. Further calculations might then be as follows.

In Fig. 7.10, a and β are the angles which the negative plane and the map plane respectively make with the lens plane. Sometimes it is the complements of these angles which are required.

By similar triangles ($vO \parallel RN'$, since v is point projected to infinity)

$$\frac{vO}{RN'} = \frac{nv}{nR} = \frac{vS}{RN} = \frac{vS}{RN'} \qquad \therefore \quad vO = vS$$

But $Rv = H \operatorname{cosec} \theta = lf \operatorname{cosec} \theta$

\therefore $\sin a = \dfrac{F}{lf \operatorname{cosec} \theta}$ and $\sin \beta = \dfrac{F}{vO} = \dfrac{F}{vS} = \dfrac{F}{f \operatorname{cosec} \theta}$

i.e. $\sin a = \dfrac{F \sin \theta}{lf}$ and $\sin \beta = \dfrac{F \sin \theta}{f}$ (7ii)

Let $gO = a$ and $OG' = b$; then applying the lens condition to the central ray—

$$\frac{1}{a} + \frac{1}{b} = \frac{1}{F}$$

but $\dfrac{b}{a} = l$ i.e. $b = al$

$$\therefore \qquad \frac{1}{a} + \frac{1}{al} = \frac{1}{F}$$

i.e. $\qquad a = F + \dfrac{F}{l} \quad$ and $\quad b = Fl + F \qquad$ (7iii)

The length pg can also be calculated, and it can be shown that when $l = 1$ the isocentre falls at g.

Automatic rectifiers incorporate a variety of link mechanisms for controlling the dependent movements. Fig. 7.11 is a line diagram

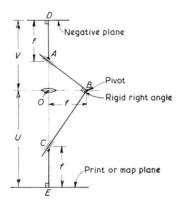

FIG. 7.11. PYTHAGOREAN INVERSER FOR MAINTAINING THE LENS
CONDITION

illustrating a simple Pythagorean inverser, whose function is to maintain the lens condition along the lens axis.

DA, *O* and *CE* are constrained to move only along the optical axis.

B is a rigid right-angle constrained in the plane of the lens.

Focus is varied by moving the lens up and down, thus causing rods *AB* and *CB* to pivot about *B* and slide in sleeves *A* and *C* respectively. So that if the map plane is fixed, then as the lens rises so the negative plane falls.

Triangles *ABO* and *BCO* are always similar;

$$\therefore \quad \frac{f}{OC} = \frac{AO}{f}, \quad \text{i.e.} \quad \frac{f}{U-f} = \frac{V-f}{f}$$

$$\text{or} \qquad f^2 = VU - fV - fU + f^2$$

$$\therefore \quad \frac{1}{f} = \frac{1}{V} + \frac{1}{U}$$

i.e. the lens condition is always satisfied.

Fig. 7.12 shows a Carpentier inverser for maintaining the Scheimpflug condition. In this case—
 DE is rigid and pivoted about a fixed point A.
 Both D and E are couplings hinged to DE.
 D can move only along DB and in the plane GD.
 E can move only along EC and in the plane EH.

BG, OA and CH are rigid and equal and constrained to move only along the optical axis.

Triangles BGD and K_1OB are similar;

$$\therefore \quad \frac{K_1O}{BO} = \frac{BG}{GD} \quad \text{i.e.} \quad K_1O = \frac{Vk}{V \tan \alpha} = \frac{k}{\tan \alpha}$$

Similarly $$K_2O = \frac{U.k}{U.\tan \alpha} = \frac{k}{\tan \alpha}$$

\therefore K_1 and K_2 coincide, and planes BK, OK and CK meet in one line, i.e. the Scheimpflug condition is satisfied.

An optical rectifier could be used for plotting detail by tracing the projected image with a pencil, directly on to the map plane. Since

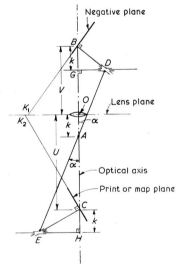

FIG. 7.12. CARPENTIER INVERSER FOR MAINTAINING THE SCHEIMPFLUG CONDITION

height distortion remains in the projected image, the plotting would require copious control and separate settings for each small area of the photograph, in much the same way as when using a simple reflecting plotter. An optical rectifier is usually large and expensive and is rarely preferred to the sketchmaster for this purpose.

When a rectified photograph is being prepared, the instrument is first set to the four points of control. The control plan is then removed, sensitized paper is put in its place, and the exposure is made.

Rectified prints are nominally free from tilt and lens distortions and are required in some plotting machines. They facilitate heighting by parallax bar and are necessary for making controlled mosaics. In very flat areas such a print would be so nearly equivalent to an orthogonal projection that it might be possible to produce a small scale map by actual tracing of detail.

Some Simple Stereoscopic Plotters

The slotted templet assembly incorporates corrections for tilt and height distortions within the limits of accuracy of the radial line assumption, but the sketchmaster and optical rectifier make no allowance for height distortion, except in so far as the area plotted at each setting of the instrument is strictly limited in extent. The radial-line plotter enables detail plotting to be carried out by radial line methods.

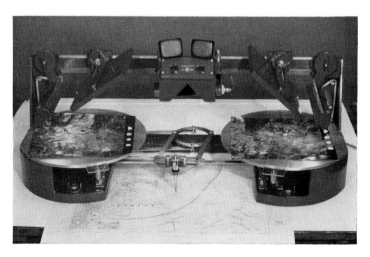

FIG. 7.13. RADIAL-LINE PLOTTER
(*Rank Precision Industries Ltd. (Hilger & Watts)*)

The radial-line plotter consists essentially of a stereoscope, similar to the normal mirror stereoscope (see Fig. 7.13). Plotting is therefore from a stereoscopic pair of photographs, which are first carefully base-lined and then mounted on the photo-tables with a weighted pin through the principal points. The pin for each photo also passes through a hole in the radial line engraved in the Perspex cursor and through a hole in the centre of the photo-table. Each

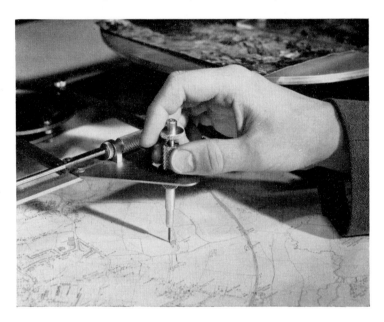

FIG. 7.14. PLOTTING A POINT WITH A RADIAL-LINE PLOTTER
(*Rank Precision Industries Ltd.* (*Hilger & Watts*))

photograph is now aligned so that the two base-lines are collinear, and then fixed to the table with masking tape. If the prints are viewed through the stereoscope the two radial lines can be rotated until each passes through the point of detail corresponding to the preselected ground point which it is required to plot. The linkage mechanism connects the two cursors together and to the pencil in such a way that the pencil point represents the map position of the point being plotted. The instrument rests on the map table itself, and any point may be plotted directly on to the map (see Fig. 7.14). By moving the pencil so that the point of intersection of the two radial lines moves along the line of detail being plotted, we can draw in

any, or all, detail. The plotting scale can be altered by adjusting the linkage mechanism, and the range of plotting scales is from half to twice photo-scale. The instrument is used for plotting detail between slotted templet control, and each model is oriented relative to the plotted positions of only the two principal points and the four pass points.

One drawback to the radial-line plotter is that, in common with

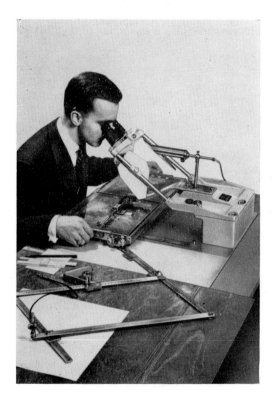

FIG. 7.15. THE STEREOPRET
(*Zeiss Aerotopo*)

all plotting by intersections based on the radial line assumption, the intersections near the base line will be very acute and consequently weak; this is overcome by the device of displacing the photographs by a fixed distance in the y–direction.

The stereoscope and parallax bar with parallel guidance mechanism (mentioned in Chapter 6) can have a drawing attachment fitted;

but this will only plot the detail direct from the left-hand photograph. It is therefore useful only for making small-scale sketch-maps, though accuracy can be increased by increasing the control, and it should give better results than say the pantograph because of the stereoscopic scanning. By fixing the stereometer reading and scanning lines of equal parallax, the instrument can be used to sketch in form-lines.

The Stereopret (see Fig. 7.15) is a handier version of the parallel guidance mechanism and drawing attachment. In this instrument the photographs are mounted on a carriage which is free to move only

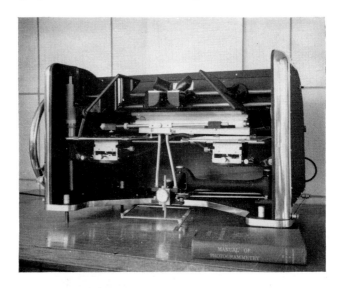

FIG. 7.16. THE K. E. K. PLOTTER
(*Philip B. Kail Associates*)

linearly in the x- and y-directions. The parallax bar is rigidly attached to the stereoscope. Movement of the photo carriage operates a pantograph type of plotting arm and sketching can be done at scales between 0·2 and 2·0 times the mean photo-scale.

The K.E.K. instrument (Fig. 7.16) has been a well-known simple plotter for many years. This instrument allows a limited amount of tilt to be imparted to the photographs, thus increasing the accuracy. The British-made Stereosketch is a similar type of instrument.

MOSAICS

Another type of map can be prepared from air photographs by.

piecing together parts of the prints themselves in the form of a photographic mosaic. Such a composite picture is sometimes known as a photo-map or photo-plan, but these terms are not considered so suitable as the name mosaic.

There are two main sub-divisions of mosaics: controlled and uncontrolled. The construction of a fully controlled mosaic is described in the following paragraphs.

First of all a base grid is prepared and a slotted templet control is plotted on to the grid. Then each of the photographs is rectified

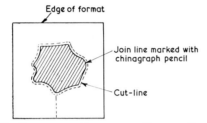

FIG. 7.17. CUTTING THE PRINT FOR A MOSAIC—FIRST PRINT

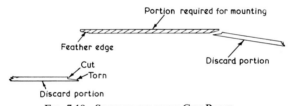

FIG. 7.18. SECTION THROUGH CUT PRINT

photographically thus producing a print equivalent to that which might have been produced directly had the air camera been truly vertical at the time of exposure.

When mosaics are being made the lateral overlap of the photographs must be increased to at least 30 per cent whilst fore and aft overlap can still be 60 per cent.

The central print for the area is taken first and the part required to be used on the mosaic is chosen. An area near the middle of the photograph will be preferred as this is the part having the least height displacement. The boundary of this area will be marked precisely using a chinagraph pencil (see Fig. 7.17). A cut-line is made with a sharp razor blade 3 mm outside the chinagraph line and in such a way that the blade penetrates to only about one-third of the thickness of the print. Now hold the centre portion of the print on the palm

of the left hand and tear down the discard portion with the right hand, leaving a feather edge as in Fig. 7.18.

Use a flour and water paste, and apply it thinly to the back of the photograph and to the face of the base grid. Stick fine needles through the photo control points and so orient the print on the base grid. The print can be stretched a little to fit the control merely by pulling it to shape. The print is now stuck down (see Fig. 7.19(i)) using a rubber roller to squeegee the paste from the centre outwards. Remove the surplus paste with a clean soft cloth.

The next print is now marked and trimmed in the same way as the first, except that the edge which will join with the already mounted print is cut to the exact join line, instead of 3 mm outside it. This is now pasted and oriented as before, taking care to match up the

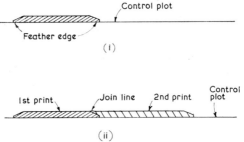

FIG. 7.19. MOUNTING THE CUT PRINTS
(i) FIRST PRINT MOUNTED
(ii) SECOND PRINT MOUNTED

detail along the common features where they join. Squeegee into position as in Fig. 7.19(ii).

The remaining prints are cut and mounted in succession until the mosaic extends beyond the required limits of the whole map (see Fig. 7.20). The surplus part of the mosaic is then cut away leaving the edges sharp and clean. Borders are now stuck on and the map is annotated as desired. Place names will be printed on paper strips and stuck on the face of the photo-map. If cleverly used, these name-strips can blot out some of the unwanted photographic detail. One of the drawbacks of a map of this description is that so much detail is shown that it becomes difficult to pick out the more important features. Figure 7.20 shows a mosaic under construction.

The map now contains ridges at the join lines, and after touching-up where necessary, it must be rephotographed to obtain the finished product. At this stage it is permissible to increase the scale of the map by up to $4\frac{1}{2}$ times the original photo scale, but in modern

practice it is more usual to maintain approximate mean photo scale throughout.

Cut-lines should be chosen so that the joins between successive pieces of photograph fall along irregular lines of dark detail—the shadow of the line of a hedge would be ideal. Straight lines would be more obvious in the finished map, and the darkness of the detail tends to conceal the shadow thrown by the overlapping edge of photo.

FIG. 7.20. A CONTROLLED MOSAIC UNDER CONSTRUCTION
Note the registration with underlying map at left-hand edge.
(*Hunting Surveys Ltd.*)

Even with rectified prints it will be difficult to make every small part of detail match exactly along the cut-line (see Fig. 7.21). A stretchable paper base for the print is therefore used, and the photos are pulled into shape as far as possible. Expansion of one print relative to its neighbour may be encouraged by adding more or less water to the paste according to the amount of expansion required. Differential stretching of a print is easier after it has been soaked in water but this softens the emulsion and makes it even more hazardous to handle.

An uncontrolled mosaic is one plotted without reference to any control points. Such a map would certainly not entail the use of rectified prints, but in other respects it would be similar to the controlled mosaic.

Mosaics can be compiled much more rapidly and more cheaply than any other type of map for large areas of land, particularly the uncontrolled variety. They are therefore very useful for reconnaissance. They show much more variety of detail than other types of map, but they are not so simple to understand, and some important

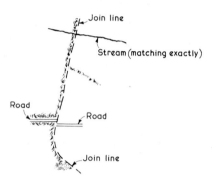

FIG. 7.21. LACK OF REGISTRATION AT MOSAIC JOIN-LINE
The right-hand print is to a slightly larger scale than the left-hand one, causing lack of registration of the two images of the road.

features might be hidden by overhanging trees. Contours may be added as for other maps, but this will partly offset the rapidity of of production. Inking in the streams and rivers in blue would help to convey a rapid impression of the configuration of the ground. It must be remembered, however, that distances cannot be accurately scaled from such a map because, however successful the rectification may be in removing tilt and lens distortions, it cannot remove the displacements due to the varying height of the ground.

A rough form of mosaic is sometimes made as a navigation map for flying for more accurate cover. In such a case skeleton cover would be flown first—probably only every third or fourth strip would be flown, and cross strips at 20 to 35 kilometre intervals. A rough mosaic could be made from these photos and navigational points could be chosen on this skeleton map. This procedure is sometimes necessary where an area is being mapped for the first time.

FURTHER READING

RECTIFICATION AND PLOTTING

(i) Schwidefsky, pages 56–9, 144–67, 174–95.
(ii) *Manual of Photogrammetry*, Vol. II, Chapter 16.
(iii) Hart, pages 236–74.
(iv) Moffitt, Chapter 10.
(v) Hallert, pages 103–19.
(vi) Lyon, Chapters 10 and 12 (cartography).
(vii) Zeller, pages 228–49.
 H.M.S.O., *Manual of Map Reading, Air Photo Reading and Field Sketching*, Part II, pages 11–17 on COPYING AND ENLARGING.

DETERMINATION OF TILT

(i) *Manual of Photogrammetry*, Vol. J, pages 33–45.
(ii) Hallert, pages 9–28.

PLOTTING FROM OBLIQUES

(i) *Manual of Photogrammetry*, Vol. II, Chapter 18.
(ii) Hart, pages 336–50.
(iii) Moffitt, Chapter 13.
(iv) Trorey, pages 7–36, especially 23–36 on perspective grid.

MOSAICS

(i) *Manual of Photogrammetry*, Vol. II, Chapter 17.
(ii) Moffitt, Chapter 11.

(See Bibliography (page 346) for the full titles.)

CHAPTER 8

Map and Plan Reproduction

After the detail and contours have been plotted the compilation sheet is taken into the field and checked for accuracy and completion. It is then passed on for the production of a number of copies of the finished map. The reproduction is carried out in the following stages—

1. Production of the fair drawing.
2. Preparation of the printing plates.
3. Machine printing, proofing (or proving).

Each of the three stages involves some form of printing.

Printing or the copying of a document can be done in four main ways—

1. Relief—Letterpress.
2. Intaglio—Gravure or Photogravure.
3. Lithography or Planographic Process.
4. Photographic Methods.

The first three all involve printing or proofing from a metal plate or stone surface. They differ in the methods of producing the plate, but since the proofing is similar for all three it is dealt with only under lithography.

LETTERPRESS

This is the method by which most modern books, newspapers and other periodicals are produced. It is particularly suitable for printing the written word. In this method, if it is required to print a line, the line will have to be produced standing proud on a metal plate. If a smooth roller is passed over the plate it will touch only the lines which are standing proud. If the roller is first rolled in ink and then applied to the surface of the plate, ink will stick to the lines but will not touch the other part of the plate. If a sheet of paper is now pressed in contact with the plate, it will receive an ink image of the raised lines. A little thought will determine that the picture on the face of the plate must be a mirror image of the final print.

This method is not used in map reproduction, except for incorporation on a page of newsprint. In such a case the mirror image would need to be drawn on to the surface of the metal plate with grease or some other acid-resistant substance. The plate would then be subjected to an etching process in which nitric acid would attack

and remove the surface of the unprotected metal and so leave the mirror-image standing proud.

INTAGLIO

Intaglio processes involve printing from a metal plate, or a stone plate, on which the image portion is incised into the surface of the plate. In this case, ink is applied to the surface so that it enters the incised lines, and is then wiped off the face of the plate. In this way the surface of the plate becomes clean but the image retains the ink and the paper may be printed by simply pressing it against the surface of the plate.

The plate can be prepared either by etching with nitric acid, after the background has been adequately covered with a protective film, or by engraving. The latter was the method whereby maps used to be produced. The engraving was on to stone, or more usually on to copper. The resulting map was an excellent reproduction. However, not only was the engraving skilled and laborious and therefore expensive, but the wiping of the plate after inking was tedious and did not lend itself to mechanization.

LITHOGRAPHY

Lithography means writing on stone. The basic principle is the mutual repellence of grease and water. Originally the idea was to write on a suitable stone using a greasy ink or crayon, then moisten the rest of the surface of the stone and roll with printers' ink which, being greasy, would be repelled by the moist surface and attracted by the greasy drawn lines. This again leaves us with a series of ink lines from which we can print on to a sheet of paper, but this time the lines of the image are neither raised above the remainder of the surface of the plate nor sunk into it. The process is therefore sometimes referred to as planographic.

When printing from stone, a special limestone is used and is carefully prepared to give a plane and slightly textured surface. A very smooth surface is undesirable as it would give no key for the ink, nor would the stone be able to absorb any water.

The image of the map can be transferred to the stone by drawing directly on to the surface, or by using a transfer paper. A transfer paper is a paper with a wax surface on one side. This paper is placed waxed side down on the stone and the map to be reproduced is placed over it. The detail on the map is then traced over using a steel or pencil point and applying sufficient pressure on the point to cause the wax to adhere to the stone below. This gives a wax impression of the map on the stone, but the original document will almost

certainly be ruined, and the resulting image will be erect and not reversed as in a mirror image. Ways can be devised for overcoming these difficulties but the method is cumbersome compared with the photographic methods of transferring the image which are considered later.

After the greasy outline has been impressed on to the stone, water is applied to the surface. A greasy ink is now rolled over the surface and will adhere to the greasy image, thus strengthening it and further protecting the stone underneath. The water content on the remaining surface will effectively repel the ink from this part of the stone. The whole surface is now treated with a very dilute solution of nitric acid, washed, and then given a thin coating of gum arabic. The gum arabic combines with the lime on the ungreased part of the surface, and helps to repel the greasy ink. Printing can then be carried out by rolling with ink and applying the paper as before.

Nowadays very similar processes are used, but the base is a metal plate instead of stone; the metals used are zinc and aluminium. In earlier years the more popular of these was zinc and for this reason the method has sometimes been referred to as zincography. The modern trend is towards the use of an anodized aluminium plate.

Stone was found to be too bulky for convenient storage, both before use and for final reference purposes. Metal plates are quite thin laminae, under 2 mm thick; they can therefore be bent for use on the cylindrical rollers of the most modern printing machines. In addition metal will usually work out to be the cheaper medium.

Zincography does not require as thick a plate as letterpress, and so is better for storage and initial cost. Also it is possible to remove the image from the zincographic plate and to use it all over again. The thinner plate is easier to wrap round a cylindrical surface and will give less distortion of the image when it is so wrapped.

Proofing the Plate

Proofing refers essentially to that stage of the reproduction processes during which a few impressions are taken from the plate on paper. These proofs are required for checking the strength of the image, sharpness of line, registration etc. (Registration refers to the accuracy with which the map detail is located relative to the sides of the paper; it is especially important when the map is printed in more than one colour.) The term proving is also often used to include the whole of the final machine printing processes, and it may be entirely by hand as described or it may be done in a press. The simplest presses are manually operated; the plate is placed face upwards,

and ink, or water and ink, is applied by a hand-operated nap roller. The paper is then laid on by hand and pressure is applied, either by capstan and vertical screw as in Caxton's original press, or using some other manually-operated mechanical device.

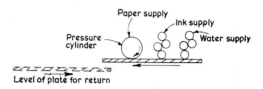

FIG. 8.1. LONGITUDINAL SECTION THROUGH A SIMPLIFIED FLAT-BED MACHINE

FIG. 8.2. A PROOFING PRESS
(*Sidney R. Littlejohn & Co. Ltd.*)

These methods would nowadays be termed " manual". The modern printing press may be one of two types—

1. the flat-bed,
2. the rotary press.

The flat-bed machines are similar to those last described, but they have been largely mechanized. This type is illustrated in Fig. 8.1. The plate is again laid flat and face upwards, and is made to travel backwards and forwards at different levels under three sets of rollers.

One set of rollers delivers the water, the next the ink and the third, which is a pressure roller, delivers the paper to the surface of the plate. Travelling forwards, the plate moves into contact with each of the rollers in turn, finally passing the printed paper off the end of the machine. In returning to its original position the plate is lowered a fraction of an inch so that it does not touch the rollers. In some machines the plate remains stationary, and the cylinder and roller system traverse the plate.

FIG. 8.3. ROTARY OFFSET MACHINE
(*Waite & Saville Ltd.*)

The rotary press has the plate attached face-upwards to the outside surface of a cylinder. Water and ink are fed on to the plate by two systems of rollers as before (see Figs. 8.3 and 8.4). The paper is delivered to another cylinder by a system of suction pads on an endless belt, and is removed by a further system of suction pads. The plate will take longer to fix securely to the cylinder than on to the flat-bed machine, but the speed of printing on the rotary press is much greater. A single run refers to the number of proofs printed (usually termed " the number of pulls ") while the same plate remains fixed in the press. For runs of up to about a thousand, the flat-bed

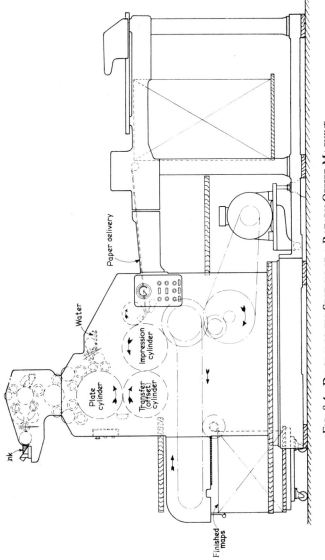

Ink

Water

Plate
cylinder

Transfer
(offset)
cylinder

Impression
cylinder

Paper delivery

Finished
maps

Fig. 8.4. Diagrammatic Section of a Rotary Offset Machine
(Waite & Saville Ltd.)

machine will probably be quicker. Longer runs would be more quickly dealt with on the rotary press. The precise dividing line will vary according to the performance of individual models. The proofing press (see Fig. 8.2) is an example of the flat-bed type of press and is especially suitable for taking a few preliminary pulls for inspection as it can be manually operated if desired.

So far we have considered that the paper is printed by direct contact with the plate, when the plate must bear a mirror image. Nowadays it is usual for the machines to contain a third and intermediate cylinder, called an offset cylinder (see Fig. 8.4). This cylinder has a special rubber blanket stretched tightly round it. The function of this blanket is to receive the image from the inked plate, and then pass it on to the paper. When offset printing is used, the image on the plate is erect and the image on the rubber blanket is reversed.

The advantages of offset proofing are that the rubber surface takes a better impression from the plate than the paper does because the rubber fits in to the slight unevennesses of the images. Because of its softness the rubber gives the plate an increased life. The rubber roller also fits into the corrugations of the paper better than the plate does; the main advantage is that a harder and coarser paper may be used. This type of paper gives better stability, i.e. expansion and contraction due to variations in temperature and humidity are reduced. Stability is the most important attribute of a paper, since any change in size means a change in scale of the map. Most litho papers are made from wood-pulp, but rag-litho is a very high quality paper (bank notes are printed on it) and is the type of paper on to which maps are normally printed. Even the coarser qualities of this paper are relatively unstable, and for special purposes (e.g. Cadastral plans) one or two impressions of the plate may be run off on Whatman's paper. Maps which are intended for outdoor use in all weathers (e.g. some military maps) are printed on " wet-strength " paper—a quality usually reserved for carrier bags, packaging, etc.

Where the map is being reproduced in colour, more than one plate is required, and each colour plate is printed on to the paper in turn. In such a case it is essential that changes in temperature and humidity should be kept to a minimum so that the rag-litho paper remains exactly the same size when each successive image is received. If there is any expansion or contraction of the paper between the two successive impressions, then corresponding lines in the two colours will not match up; such result is known as " lack of registration". Some modern machines are designed to print in four colours; the paper passes straight from one colour plate to the next and the ink dries instantaneously.

Correct registration requires that the plate should be accurately located on the cylinder. One way of achieving this is by punching slots in the edges of the plate, and fitting these slots exactly over lugs on the cylinder. Provided that the slots are located in exactly the same position on each plate, the registration should be correct.

PHOTOGRAPHIC COPYING

This can be done either by using a process camera or by contact printing methods.

FIG. 8.5. LONGITUDINAL SECTION THROUGH A SIMPLIFIED PROCESS CAMERA (GALLERY TYPE)

The Process Camera

The camera is necessary when it is required to change the scale of the document being copied, and for producing an erect negative. Until recent years the camera was also always required when an opaque original was being copied.

The copy camera is similar to the large studio portrait camera. It consists of the camera body and lens, mounted on rails, and a copyboard fixed vertically at one end of the rails. The simple system is illustrated in Fig. 8.5.

The map, or other document to be copied, is mounted on the copyboard. The cap of the camera is removed and a ground glass screen is placed in the position shown in Fig. 8.5. By moving the lens relative to the ground glass screen, the image of the map is brought into sharp focus on to the screen. The scale of the image is adjusted by moving the whole camera relative to the copyboard and then refocusing. Some cameras are made so that the image automatically remains in focus. The exact scale is achieved by drawing the frame lines of the map to correct scale on the ground glass screen and then making the images of these lines correspond exactly with the drawn representations.

The cap is now replaced, the ground glass screen is withdrawn, and a sensitized plate is inserted in its place. The exposure is made by

removing the cap for the predetermined time of exposure. Exposure times will normally be determined by trial and error. A wet collodion plate was often used in this process and was made on the premises (see Chapter 9) but dry-plates produced by various manufacturers are more convenient. Modern cameras are much more intricate, and are provided with a shutter.

FIG. 8.6. GALLERY-TYPE PROCESS CAMERA
(*Pictorial Machinery Ltd.*)

Cameras must be placed in positions which are subject to very little vibration, and mounted on absorption pads or springs to absorb any remaining vibrations (see Fig. 8.6). Modern developments of the camera include suspension from overhead rails to avoid any interruption to the movement across the floor. Another development is the dark-room camera (see Fig. 8.7) in which the plate holder is stationary within the dark-room wall, while the copyboard becomes moveable. The advantage of this camera over the older gallery type is that the plate can be loaded and unloaded from the darkroom, thus avoiding the use of opaque packing round the plate. A further tendency is toward the use of film cameras.

The camera produces a reversed negative copy, which is an "intermediate" in many processes of reproduction. An erect negative can be reproduced by photographing a reflection of the original map. The reflection may be obtained by using either a

FIG. 8.7. DARK-ROOM TYPE PROCESS CAMERA
(*Pictorial Machinery Ltd.*)

mirror or a prism. Modern copy cameras always incorporate a series of mirrors so that erect negatives are produced from an odd number of reflecting mirrors, and reversed negatives from an even number of reflections. Many smaller modern cameras are constructed with the copyboard laid flat and facing upwards while the plate is kept in a vertical position. In such cameras the reflecting mirrors or prisms effectively turn the image through a right-angle; such instruments are more compact than their forerunners.

The Vacuum Frame

Contact printing is done in a *vacuum frame*. The machine takes

many different forms but essentially it comprises a sheet of strong glass and a rubber blanket. The blanket is placed against the glass and all the air between the two surfaces is pumped out, so that the surfaces are held in intimate contact with one another by vacuum. See Figs. 8.8, 8.9 and 8.10.

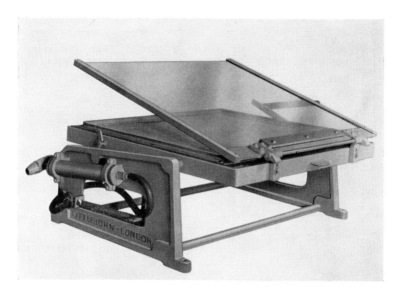

FIG. 8.8. SMALL VACUUM FRAME SHOWING HAND EXHAUST PUMP
(*Sidney R. Littlejohn & Co. Ltd.*)

Suppose that we want a positive print from an ordinary camera negative and we are using the machine in a " face-up " position, i.e. the glass and blanket are horizontal with the glass uppermost as in Fig. 8.10. The sensitized paper (or metal or plastic sheet) is laid facing upwards on the blanket and the negative is laid on top, emulsion side down. The glass is lowered into position and the air exhausted so that there can be no air-bubbles between the negative and paper as these would distort the image. The frame is now exposed under filament or, more usually, carbon-arc lamps. The print is then developed, washed, fixed, washed again and dried. The fixing prevents any further darkening of the print caused by exposure to light. This is essentially a method of copying from a transparent original or intermediate.

An adaptation of the vacuum frame principle, known as *reflex printing*, enables contact prints to be made from opaque originals.

When only one or two dozen copies of a map or plan are required —such as often happens in an engineering office—reproduction is usually most economically done photographically using a vacuum frame type of machine. Such machines are therefore found as part

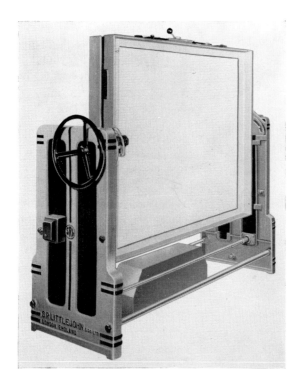

FIG. 8.9. UNIVERSAL VACUUM FRAME (CLOSED AND VERTICAL)
(*Sidney R. Littlejohn & Co. Ltd.*)

of the equipment of a drawing office, where drawings are usually made on transparent materials.

BLUE PRINTS. Perhaps the best known type of contact print is the blue print. This is a print from an original positive transparency on to a paper sensitized with a thin film of ferro-prussiate. Strong light decomposes the ferro-prussiate and the resulting compound turns blue when it is developed in water. The parts of the print under

the black detail lines will not be affected by light and will remain white after development. Thus the method gives a white picture on a blue background. It is this print which is called a blue print. If a negative transparency were used the result would be a blue picture on a white background. Until quite recent years the blue print was by far the most popular method of reproducing such documents as architectural or engineering working drawings.

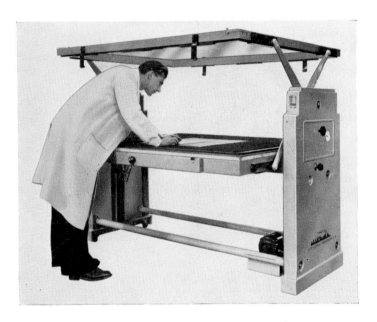

FIG. 8.10. LOADING A VACUUM FRAME
(*Pictorial Machinery Ltd.*)

FERRO-GALLIC. This is sometimes used instead of ferro-prussiate, using a positive transparency as the original. It usually gives a very dark brown picture on a very light brown background. It is often said to be little used, but those who do use it do not agree that it is inferior in any way to the blue print.

DYE-LINE PRINTS. In sunnier climes the product of this process is also known as a sun-print. The sensitizer is a diazo dye, a complex hydrocarbon which decomposes on exposure to light, resulting in a dense black line picture on a bright white background. If it is desired, other colorations can be achieved by a slight change in

composition of the sensitizer. The original is again a positive transparency. No dark room is needed, as the whole process can be carried out in daylight, though not in the direct rays of the sun. The exposure is made in a vacuum frame under carbon arcs or strong sunlight. The surface of the paper is yellow before exposure and afterwards a very faint shadow can be seen on the yellow surface. Developing is carried out in a machine in which the print passes between two rollers dampened with an ammonia solution.

Diazotype sensitizers first made their appearance in the 1920s, from which time they have rapidly increased in popularity. Since the 1940s most new drawing office installations have been of this type.

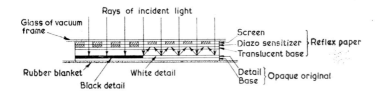

FIG. 8.11. REFLEX PRINTING—SECTION THROUGH VACUUM FRAME DURING EXPOSURE (GREATLY ENLARGED)

REFLEX PRINTING. It is often necessary to make contact prints from opaque originals. This is now possible by using a reflex method of printing similar to that first introduced by Van der Grinven as the Rétocé process. Again a type of vacuum frame is used, but this time if the machine is in the face-up position, the original document is placed face-up on the rubber blanket with the sensitized reflex paper over it (Fig. 8.11). The glass is then placed in position, the air is exhausted, and exposure is made. The top surface of the sensitizer comprises a very thin fine net screen which permits light to enter only through the holes. The base of the reflex paper is translucent; thus at the points at which light passes through the screen it decomposes the dye and then reaches the surface of the "copy." At this stage the layer of dye will be largely unaffected, but will have a network of small decomposed dots. Where the light meets black detail in the original it is absorbed, but it is reflected from the white image areas. This reflected light decomposes the rest of the dye in the areas in contact with the white portions. The screen is now peeled off and the print is developed. The result is a translucent positive in which the image is represented by grey lines. Copies can now be made by the normal dye-line printing methods.

A silver sensitizer could be used in copying documents but normally it would be too fast for convenience. Such sensitizers are used in outdoor photography, and are considered in some detail in Chapter 9.

PHOTO-LITHOGRAPHY

Photo-lithography, as its title infers, is a method of reproducing maps and plans in large numbers by a combination of the lithographic and photographic methods just described. In the following pages it will be assumed that a zinc plate is being used, but the procedure would be much the same if the metal were aluminium.

The process can be considered as comprising four stages—
1. Production of the fair drawing.
2. Preparation of the plate.
3. Transference of the image from the fair drawing to the plate.
4. Proofing.

The last stage has already been considered.

Production of the Fair Drawing

The fair drawing is usually produced photographically from the field sheet or compilation sheet. Suppose that the compilation sheet is not at the reproduction scale, then the usual modern procedure would be to use a process camera to obtain a photographic negative in which the scale was correct. Sometimes it is still considered necessary to make a fair drawing at about twice reproduction scale so that the subsequent reduction will give denser and cleaner linework than the cartographic draughtsman has achieved. This is perhaps the ideal method, but in commercial work it is considered to introduce unnecessary complications.

The base for the fair drawing must be of a very stable material. It will usually be of a dimensionally stable plastic material (such as "Astrafoil"), or of zinc (or aluminium) coated with white enamel. Such materials are known as *topographic bases*.

The surface of the base is then sensitized with ferro-prussiate sensitizer, and exposed in a vacuum frame under the correct scale negative. The developed image will be a positive in non-photographic blue on a white background. A photograph of this image taken through a blue filter would record none of the lines. Such an image is to serve as a guide or templet for the draughtsman, and is known as a *set-off* or sometimes an *off-set*. The cartographic draughtsman must ink in the lines which are to be reproduced, and add names, titling, border, etc. Black ink is used at this stage.

If the map is being reproduced in colour, then a separate fair

drawing is required for each colour plate. The same negative, which should be a glass plate to ensure maximum stability, is used to produce separate non-photographic blue images on each of the fair drawing bases. Each plate is clearly marked according to the colour in which it will be printed—black, blue, yellow or red. There are usually two black plates, one for detail and one for names, though on some maps the names are in blue.

The blue plate is inked up with black ink, but only the part requiring to be printed in blue is inked. Similarly the yellow plate is inked up in black, but only that part to be printed in yellow is inked up. So for each of the colours in turn. Thus there will be a separate fair drawing for each printing plate to be produced.

So that the final printing of each colour can be arranged to co-incide accurately with the images of the colours previously printed, registration marks are added at this stage. The Ordnance Survey use the four corners of the containing grid or frame for this purpose. Thus the frame must be drawn on the compilation sheet, so aiding the focusing to scale on the ground-glass screen of the process camera. A short length of the lines indicating the frame is then inked in in black on each of the fair drawings, and will therefore be printed in each colour in the proofing process.

Names and symbols are no longer printed manually on to the fair drawing, but are supplied as stick-on transparencies, sold under such trade names as Duraseal and Claritex. Larger map-making firms have their own machine for making these stick-ons by photo-graphic methods.

Where density maps are concerned, or layer-tinting of contours, it is often necessary to print in a large range of tones within one colour—for instance sea under six fathoms might be shown in a pale blue, that between six and twelve fathoms might be shown in a mid-blue, while deeper water might be indicated by a still darker blue. In such a case the shallow area would probably be indicated on the fair drawing by a pattern of very fine black dots, while the middle depths would be shown by slightly larger, but similarly spaced black dots, and the deeper parts by even bigger black dots. Thus with only one printing in a single colour a whole series of tones may be pro-duced. Lines can be used instead of dots, or in conjunction with them, and cross lines may be added. Again the dots or lines will be stick-on ready-made symbols, which besides being quicker to use give a more consistent density of colour and spacing than can be achieved manually. Incidentally the longer a draughtsman takes on a fair drawing the dirtier will it get, so a saving in time also results in a better finished article.

By overprinting one tone of one colour with another tone of a second colour, a further colour may be added. Thus if we print in four tones of each of three colours we can obtain at least sixty different shades in the finished map.

Colour separation processes are an alternative to the above method and are described at the end of the chapter. These methods require one fair drawing in full colour.

Manual tracing is tedious and the linework tends to be uneven, but in recent years a method of producing a good, clean and even-lined transparency by manual tracing has become popular. A sheet of some stable plastic transparency is coated with a thin coloured film. The plastic sheet remains fairly transparent and is placed over the compilation drawing. The draughtsman uses a sapphire pointed instrument to trace the detail on to the transparency. The detail is thus scribed into the coloured film, and can be seen as wholly transparent lines against the coloured background. At this stage we have a negative transparency. To make a positive transparency, special ink is carefully rubbed into the finished surface and the coloured film is then chemically removed leaving the ink detail on the transparency.

Preparation of the Zinc Plate

This includes the processes of (a) graining and (b) sensitizing the plate.

(a) GRAINING. The graining machine consists essentially of a horizontal rectangular tray, having vertical sides about 250 mm high. The dimensions of the tray must be greater than those of the largest plate. The plate is secured to the bottom of the tray and Carborundum powder or fine sand is poured over it and moistened until it forms a paste. Hundreds of glass, porcelain, steel, or wood marbles are introduced, and the tray is oscillated in a horizontal position, causing the marbles to roll about and push the sand particles over the surface of the plate. This action cleans the plate, removing traces of any previous work that may have been on the plate and imparts to the surface myriads of short fine scratches. This unevenness of surface is needed for several purposes including better adhesion of grease and greater water retention properties.

The marbles are of assorted sizes, and the maximum diameter varies according to the processes to be followed, but one firm would normally stick to one size and type—say up to 30 mm diameter glass marbles (steel balls are usually rather smaller). The marbles gradually wear away, but are retained in the machine until they begin to lose shape and bind together; new full-size marbles are added periodically to replace the misshapen ones.

Carborundum powder is often used instead of sand. It is the hardest suitable manufactured material, and is not unduly friable; the grain size can be closely governed, and it tends not to be rubbed into the metal surface.

(*b*) SENSITIZING THE PLATE. The grained plate is washed, dried and put into a special machine called a whirler (Fig. 8.12). This machine is completely enclosed and contains a horizontal table

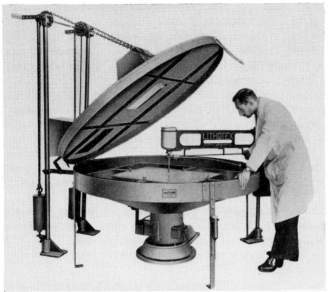

FIG. 8.12. WHIRLING MACHINE IN OPEN POSITION
(*Pictorial Machinery Ltd.*)

which rotates about a vertical spindle, much like the turntable of a gramophone. When the plate is on the turntable and rotating at the correct speed a measured amount of sensitizing solution is poured on to the plate. The motion spreads this evenly over the plate surface; the speed of revolution is then increased and the coating dried. The film should be as thin as possible consistent with complete coverage.

Transference of Image from Fair Drawing to Plate

There are many methods of making this transference photographically, but all are variations or adaptations of two main groups of processes—

(*a*) The *helio process* now more popularly known as the *albumen process*.

G

(*b*) The *Vandyke process* with its modern development the *gum-reversal process.*

(*a*) THE ALBUMEN PROCESS. In this process the plate is sensitized with bichromated egg albumen, on to which the image is transferred by contact printing from a negative copy of the fair drawing. In this case, then, the image areas themselves become light-hardened. A fairly hard developing ink is applied to the surface using a smooth nap roller, which is rolled carefully in all directions on the plate until a thin even hard film of ink is obtained.

The plate is then immersed in water and soaked for a minute or two. After this the image may be developed in running water by gently rubbing the surface with cotton wool which must be kept free from ink by continuous washing.

The unexposed soluble albumen is thus removed, leaving the image clean on the plate which now consists of a clear zinc background bearing a positive image. This image is composed of a strong film of greasy ink incorporated in, and superimposed on, the well-hardened albumen image. French chalk is dusted on and the background is " etched " with a dilute nitric acid. This is not of course a true etch, but is only a process evolved to increase the plate's attraction to water.

After washing again, the plate is ready for proving. For storage or during respites from proofing, the plate must be thoroughly cleaned with asphaltum solution, washed and dried. It is protected with a coat of gum arabic which must be removed before the plate is proved again.

The thin layer of albumen separating the ink image from the plate eventually breaks down on the run, which can therefore never exceed thirty thousand pulls.

(*b*) THE GUM-REVERSAL PROCESS. The first step in this method is to prepare a positive transparency, which needs to be reversed if proofing is to be on an offset machine. The grained plate is sensitized with bichromated gum arabic (the resin exuded by the acacia tree), and is exposed under the fair drawing in a vacuum frame. The fair drawing is placed face down on the sensitized plate, so that the image is in direct contact with the emulsion. The image therefore suffers inversion at this stage.

The effect of light on the bichromate is to harden it. Thus that part of the plate unprotected by the lines of the fair drawing will become light-hardened during exposure.

The plate is now dipped in an aniline dye—violet, scarlet and vermilion tints are the most popular. The effect is to give a vivid colouring to the face of the plate. Development of the image is

carried out in clean water. The unhardened part of the gum-arabic film is dissolved out with a lactic acid solution or washed away with a soft cloth, leaving the image visible as white metallic lines in a highly coloured background. The latter consists of the light-hardened relatively insoluble chromate which is now used as a stencil.

When dry this stencil can be touched up and strengthened using a solution of gum arabic.

A slight true etch (sometimes misleadingly called a deep etch) is now given to the line areas by applying a solution of iron perchloride and hydrochloric acid. The stencil protects the non-image areas, and the etch forms a key into which a rosin lacquer is rubbed. Lithographic ink is then rolled well in and the stencil is removed by light scrubbing in warm water.

After the removal of the stencil the plate is washed and treated briefly with a dilute solution of nitric acid to increase the water retentivity of the non-image part of the plate. This step is sometimes referred to as etching, though it does not result in a true etch.

Note that the image is still covered with a film of lithographic ink.

After washing, the plate is ready for proofing. When not in use the plate should be cleaned with asphaltum solution, dried and given a protective coat of gum arabic. This should be done even for pauses during a run.

The process is called reversal because it is the reverse of the albumen process in that in the latter the development of the image is done by washing away the non-image parts of the emulsion film, and the image is transferred from a negative fair drawing.

The original Vandyke process is essentially the same as the modern reversal process but the sensitizer is bichromated fish glue, no deep etch is given to the line areas, and the stencil is removed with an acid solution.

The original Vandyke process was the first to be used for commercial photo-lithography, but the albumen process replaced it and became the standard method for many years. Now the gum-reversal process has replaced the albumen process, mainly because it gives a greater strength of line and therefore a more durable image. However, for very long runs it has been found that, although the image remains intact, the graining of the plate itself begins to break down, causing loss of water retentivity. Thus for runs approaching a hundred thousand an anodized aluminium plate is necessary. In large commercial firms most work is now done on these plates; the process is very similar to the reversal process but the aluminium plate is grained and anodized by the manufacturers.

Half-tone Photography

So far we have spoken only of continuous-tone or line diagrams, but it might be necessary to reproduce a photograph, such as an air-photograph, by lithographic methods. This would be very likely to happen if it were required to reproduce a mosaic in large numbers. Such a document is composed of many tones of grey, with black and white as the extreme limits. This problem is dealt with by introducing a cross-line screen in the camera when the negative is being produced. The effect of this is to split the image up into a regular pattern of dots; the size of the dots varies with the depth of tone to be recorded.

A plate produced by this method is known as a half-tone plate or block. The cross-line screen consists of two plates of glass, each of which has been ruled on one face with a series of fine parallel straight lines such that the black lines and the clear spacing between are of equal thickness. The two glass plates are then cemented together so that the lined surfaces are in contact and one set of lines is perpendicular to the other. There are usually between 4 and 5 lines per mm depending on the type of work being done.

The screen is placed in the camera just in front of the focal plane. In the negative, light tones of the original will be represented by white dots on a black background, and dark tones by black dots on a white background, the background dominating; the effect will be reversed on the print. If a newspaper photograph is examined closely the texture described above can be observed; the pattern is much more obvious when looking in some directions than in others.

Colour Separation Processes

These can be used to produce separate colour plates from one fair drawing in full colour, i.e. from a map containing large *areas* of colour. Most modern maps are composed mainly of lines and individual symbols, and can therefore be readily transferred to a series of fair drawings by the normal methods described earlier.

Colour separation is usually achieved by a subtractive process. The subtractive primaries are primrose, blue-green, and magenta, and it is useful to think of them as minus-blue, minus-red, and minus-green respectively. The effect of applying e.g. primrose ink to white paper is to prevent the paper from reflecting blue light. Areas printed in primrose and magenta will therefore appear red, and areas printed in all three primaries will appear black.

A separate negative is first obtained for each colour plate by photographing the single fair drawing through a particular colour

filter or cut-out. These filters must be of as fine a quality as the lens in order that register is not disturbed. Tri-colour work is normal and the filters used are blue, red and green. Each filter is used separately and passes all light which it is desired *not* to print so that the clearer portions of the film are a record of the " heldback " colour. A blue filter is needed for the primrose printing plate, a green filter for the magenta plate and a red filter for the blue-green plate (see Fig. 8.13). A light green-yellow filter is used for the black or grey plate. Tone values for each colour are produced by the use of a cross-line screen.

Filter	Negative			Diapositive			Plate			Printing Ink
	blues	greens	reds	blues	greens	reds	blues	greens	reds	
Blue	▨				▨	▨		▨	▨	primrose
Green		▨		▨		▨	▨		▨	magenta
Red			▨	▨	▨		▨	▨		blue-green

Hatching indicates opaque areas | Hatching indicates dark areas | Hatching indicates image areas

Areas printed in all three colours will be black
A separate plate is needed for the black detail.
N.B. Strictly each diapositive and plate will also record the no colour (or black) areas

FIG. 8.13. COLOUR SEPARATION BY A SUBTRACTIVE PROCESS

The cross-line screen and the filter may be used in the camera at the same time to produce the negative in one operation, but some firms prefer to obtain a normal photographic colour-separate negative first, and use the cross-line screen in rephotographing a contact print of this negative.

A half-tone positive transparency is produced by contact printing, and this is used to produce a printing plate by the gum-reversal process.

Revision of Plate

A lithographic printing plate may be revised by removing obsolete detail with a scribing tool and putting in new detail by direct drawing using chalk or sawdust as offset guide lines. Such revision is easier to carry out on the erect-image plates used in offset printing methods.

The main difficulty is in making areas which were previously line areas attractive to water, and in large commercial concerns it is

unusual to carry out revision on the plate. It is normally much easier to revise the fair drawing and make an entirely new plate. This is especially true when anodized aluminium plates are used.

FURTHER READING

Map reproduction is very poorly documented but there are books dealing with PHOTOLITHOGRAPHY.

References to " Photo-mechanical Processes " should not be overlooked, since the term means much the same as " Photo-lithography."

Ilford Ltd., have produced a booklet entitled *Document Copying with Ilford Materials* which is a useful reference for purely PHOTOGRAPHIC COPYING methods.

See Trorey, Appendix I, for a drill for fair drawing and a helpful system of checking.

(See Bibliography (page 346) for the full titles.)

CHAPTER 9

Characteristics of Film and Camera

In Chapter 1 we have seen how the main attributes of an air photograph depend upon the resolution and distortion of both the negative and print itself. We must now consider in more detail, the factors governing these characteristics.

Resolution or definition refers to the clarity of the image and is measured in terms of resolving power, which indicates the power of an optical system to separate the images of a pair of neighbouring points or lines. A resolving power of s lines per mm means that the smallest separation of a pair of lines which can be discerned is $1/s$ mm (see Fig. 9.1).

It will usually be necessary to examine an air photograph under magnification in order to appreciate its limit of resolution.

In testing for resolving power it is usual to photograph test targets similar to the one illustrated in Fig. 9.1. One such target is photographed many times on to different portions of the negative, so that the resolving power of every part of the lens is known.

Distortion of an image indicates the amount by which that image is displaced from its true position. If measurable distortion is present, measurements from the photograph will be in error. Distortions due to tilt and height differences are inherent in an air photograph (see Chapter 2), but there are other distortions caused by defects in the photographic instruments, materials or processing. Distortion of the image due to negative or positive materials is almost confined to that due to temporary or permanent instability of the base (see Chapter 1), since expansion and contraction of the emulsion is entirely in a direction perpendicular to the surface of the negative or print.

PROCESSING THE NEGATIVE

The film in an air camera is commonly about 270 mm wide and some sixty metres long. It is most important that the processing does not subject the film to scratching or to undue stresses, particularly in the longitudinal direction. Therefore processing, which includes development, washing and fixing, takes place in specially designed tanks. Each tank is of sufficient size to take two spools side by side (see Fig. 9.2) and the film is wound alternately from one spool to the

other, in such a way that each layer of film is always cushioned from the next layer by a small amount of whatever liquid it is being treated with at the time. The alternation from one spool to the other

FIG. 9.1. SKETCH OF PART OF A TYPICAL TEST TARGET
s = separation of lines

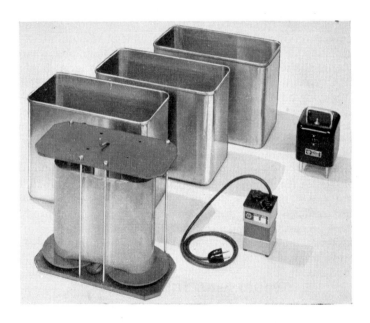

FIG. 9.2. TANK DEVELOPING EQUIPMENT
(*Wild Heerbrugg Ltd.*)

ensures that fresh liquid is continually being brought into contact with each portion of the film. However, if the length of the film being processed is long, the developer remains undisturbed on the face of

the film for too long without renewal. This cannot be counteracted by increasing the speed of winding indefinitely since eventually the initial acceleration and final deceleration would be so great that it would apply undue stresses to the film. Probably about 35 m of film is the greatest length which should be treated in a tank at any one time.

Longer lengths of film are developed by the continuous process as shown in Fig. 9.3. The film is passed continuously through the

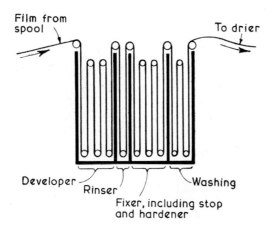

FIG. 9.3. APPARATUS USED IN CONTINUOUS PROCESSING
The size of each compartment depends on the time required for each process.

series of tanks and is dried by lightly blown air. The process is only economical for bigger organizations as the tank capacities are larger than those of the individual tanks and more developer and fixer need to be made up at one time.

The drying process presents a bigger problem in that the film must be laid out to dry in such a way that its weight is supported throughout its length, without scratching taking place. A series of soft-wood slats, which are often arranged round a circular drum, usually serve this purpose (see Fig. 9.4). During this stage care must be taken to keep the air, and therefore the surface of the film, clean. The difficulties of drying are increased by the fact that during processing the film doubles its weight due to the moisture absorption.

The Developer

This is a chemical solution which actually causes the chemical changes in the sensitizer and so makes the latent image visible. All

developers are reducing agents, and those normally used in air photography are benzene derivatives or aniline dyes; therefore they are nearly all by-products of coal-tar. There are many such agents, but by far the most popular are metol and hydroquinone (quinol).

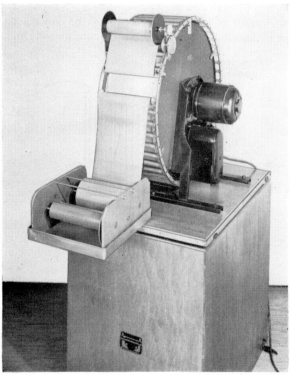

FIG. 9.4. DRYING MACHINE
(*Wild Heerbrugg Ltd.*)

Metol is more vigorous in action than quinol, but usually results in a " softer " image, in which the lights and shades do not contrast as vividly as if quinol were used. Many of the most popular developers contain a mixture of metol and hydroquinone known as M.Q. Hydroquinone alone is very suitable for developing process camera negatives.

Pyrogallol is also used for developing negatives, but it has a tendency to leave a yellowish stain which makes it unsuitable for use with positives.

These three developers are the only ones in general use for air photography.

Temperature has a direct and marked effect on the speed of development and must be kept at between 18° and 21°C. Lower temperatures will give slower reactions and loss of contrast; and higher temperatures may cause too rapid a reaction, blistering of the emulsion and decomposition of the developer.

The developer itself is readily oxidized, i.e. it will reduce the silver halides to metallic silver, and thus develop the image. However, action is accelerated by the addition of an alkali; sodium carbonate is the commonest accelerator, but there are many alternatives, and it is the degree of alkalinity which determines the rate of development. Degree of alkalinity or acidity of a solution is known as its pH value. A pH value of 7 is neither acid nor alkaline; as the alkalinity increases so the pH value increases from this number and a pH value of 9 is ten times as alkaline as one of 8; pH values of less than 7 indicate acidity.

The developer and accelerator together would result in the immediate oxidation of the developer, which would then have lost its power for developing the image. To prevent this, a preservative (usually sodium sulphite) must be added. The preservative prevents oxidation until the developer comes in contact with the sensitized emulsion.

With these three constituents only, the development would be very rapid and would tend also to blacken the areas of emulsion which had not been exposed to the light, so causing " fogging " of the negative. Fogging is reduced because the developer absorbs some of the potassium bromide from the emulsion, but to offset completely the objectionable effects of fogging, potassium or sodium bromide must also be added to the developer. The bromide is known as a *retarding agent*. The additional potassium bromide absorbed from the emulsion will further slow down the reaction—thus speed of development rapidly decreases, especially as the oxidation process set up on first use of the developer may continue after the removal of the negative.

Development begins at the surface of the emulsion and gradually penetrates to the deeper parts so that the developer in the vicinity of the emulsion becomes exhausted before the lower part of the emulsion has been developed. To offset this, the developer must be agitated continuously to replenish the liquid on the emulsion surface. The emulsion film should be as thin as possible consistent with full and even coverage, as the silver image should penetrate the full depth of the emulsion and because a thick emulsion is more prone to

halation. The latter is a phenomenon due to reflection of bright light from the base of the plate or film causing blurring of the image (see Fig. 9.5). It can be reduced by applying an anti-halation coat to the film base, before spreading the sensitized emulsion.

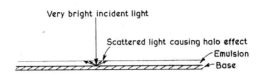

FIG. 9.5. HALATION
(Greatly enlarged section through negative)

Fixing

When development is complete, the film should be rinsed and then subjected to a stop bath in the form of a solution of sodium bisulphate and chrome alum. The sodium bisulphate has the effect of stopping development by neutralizing the alkali of the developer and the chrome alum hardens the emulsion.

This is normally followed by the fixing process proper, using a solution of sodium thiosulphate (hypo), but for air photographs, fixing, stopping and hardening are usually included in one process.

The purpose of fixing is to remove the unused parts of the sensitizing chemicals. Hypo dissolves silver chloride very readily and silver bromide readily, but silver iodide is dissolved only slowly. Since the anti-halation layer often contains silver iodide and must be completely removed during fixation, ample time must be given for the hypo to do its work.

When air film is processed, both the stopper and the hardener are usually included in the fixing solution, as it is considered that this reduces the tendency for the chemical stopping reaction to damage the emulsion film by blistering.

Washing

The negative must be washed absolutely free of all processing chemicals. Thorough washing entails running clean water over the negatives for at least twenty minutes and preferably for half an hour. If hypo is left on the face of the negative it tends to turn the image areas brown; other salts cause staining of the clear areas.

Drying

Only after washing has been completed is the processed film removed from the tank. It is then dried by blowing slightly warmed

air over it. The atmosphere must be kept scrupulously clean and the air introduced must be filtered.

Summarizing, it can be said that, after exposure to the light when the latent image has been formed, the film is removed from the camera and placed in the developing tank where it is subjected to—

1. *Development* by chemical reduction of the light-affected part of the silver halides to form a metallic silver image.
2. *Rinsing* to remove surplus developer.
3. (a) *Stopping* to neutralize any remaining alkali.
 (b) *Fixing* to remove the unused sensitizing halides by solution.
 (c) *Hardening* the gelatine to render it more stable. Sometimes hardening is carried out after washing.
4. *Washing.*
5. *Drying.*

CHARACTERISTICS OF AN EMULSION

On a black and white photograph detail can only be recognized by a difference in grey tone values. Thus in spite of its distinctive shape a church spire could not be distinguished from its background if the latter consisted of cloud represented on the print by exactly the same tone value as the spire. No outline could be distinguished unless its background had a different tone value. The greater the difference in tone between object and background, the more readily can the object be distinguished. The depth of tone of any part of a print depends upon the opacity of the corresponding portion of the negative.

The emulsion is composed of a large number of very small crystals suspended in gelatine. The largest of these grains is of the order of one micron in diameter.

At exposure, light makes a certain proportion of these grains developable (the latent image) and during development each light-affected grain is made to deposit its load of silver. The quantity of silver deposited at any particular point governs the opacity of the negative at that point.

Opacity is a measure of the proportion of incident light which is prevented from passing through the negative. An opacity of 10 denotes that $\frac{1}{10}$th of the incident light will pass through, whereas an opacity of 100 indicates that only $\frac{1}{100}$th of the light will pass. Density is the logarithm of the opacity and is the term usually applied when discussing the tone value of the silver image. Thus tone varies over the face of the negative according to the amount of light which came to a focus at that point.

Exposure is the unit of measurement for the amount of light admitted to the sensitized film and is the product of the intensity of illumination and the time for which that illumination is admitted to the film.

For any particular emulsion the final negative density will be increased by increasing the exposure, and it is instructive to examine this relationship. Consider a series of experiments in each of which the camera is focused on to a constant light source, and different parts

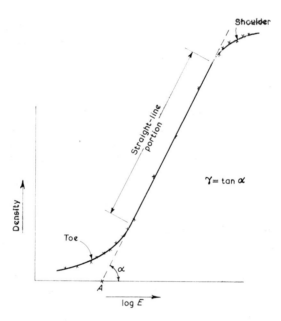

FIG. 9.6. THE CHARACTERISTIC CURVE OF AN EMULSION
Graph is interpolated between results of separate experiments plotted thus ×.

of the same film are exposed for varying lengths of time. For each of these experiments the resulting density is measured and plotted on a graph against the logarithm of the exposure (log E, on Fig. 9.6). Numerous such points are plotted, and then a smooth curve is drawn through the mean positions. The resulting graph is known as the *characteristic curve* for that particular emulsion, and will be of the form shown in Fig. 9.6.

It will be noted that as log E increases, so the density increases, slowly at first, but at an increasing speed until it reaches the foot of the

straight-line portion of the graph. Within this portion the increase of density with increase in log E remains constant. Finally as the density begins to reach its maximum values so the increase in its value relative to log E slows down.

That part of the curve below the straight-line portion is known as the toe and that above as the shoulder.

In the above experiments we were concerned with a series of photographs each of which consisted of only one tone value. In an air photograph we have seen that the tone value varies continuously over the face of the negative. This is due to the varying intensity of light received from each of the objects within the field of view. Thus for any one photograph the time of exposure applies to the whole of the negative but variations in exposure (and therefore in log E) occur because of the differences of illumination by the individual objects whose images are reproduced.

If the time of exposure in the air camera had been very short, then only for the brightest objects would log E be sufficiently great for the density to register on the characteristic curve at all. If a somewhat longer time of exposure had been given, the brightest objects might have achieved sufficient density for log E of their image to be carried to the foot of the straight-line portion of the graph whilst the dullest objects might be registering at the lower end of the toe. In this case the density range is seen to be small, i.e. there is little difference in tone between the densest part of the negative, which represents the highlights, and the most transparent parts representing the shadows. The ratio between the density of the highlight and that of the shadow parts is known as the *contrast*: the greater the contrast, the greater the range of tone. A negative exposed so that even the highlights are represented on the toe of the characteristic curve is said to " lack contrast " due to under-exposure.

As more time is given to the exposure so log E increases, bringing more and more of the image on to the straight-line portion of the graph and increasing the contrast. When the time of exposure is long enough for the whole of the view to register on the straight-line portion, then the contrast will be at its maximum. The aim is to expose so that log E for every part of the negative image falls within the log E range of the straight-line portion of the characteristic curve.

It is apparent, therefore, that the slope of the straight-line portion of the graph is a measure of the potential contrast of an emulsion, and this slope is known as the *gradation gamma* (or just γ) of the emulsion, where $\gamma = \tan \alpha$ as in Fig. 9.6.

So far in our discussion of the characteristic curve we have

assumed that development was carried to completion. Now we must consider the effect of changes in time of development.

As development proceeds so each of the light-affected grains gradually deposits its silver. In the highlight areas there is a greater proportion of grains which have been light-affected so the image builds up more quickly in these areas. Thus as time of development increases so gradation increases. Figure 9.7 represents the stages through which the overall density of the image passes in terms of

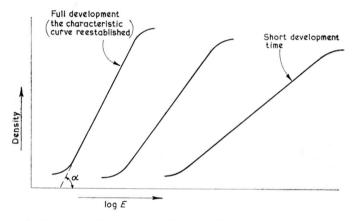

FIG. 9.7. CHANGES IN DEVELOPMENT TIME IN TERMS OF THE CHARACTERISTIC CURVE

the characteristic curve. The curve on the right represents the density built up over the full range of tone values for only a short development time. The middle curve represents the position after a longer period of development and the left-hand curve illustrates complete development and is a repetition of the characteristic curve of the emulsion. Thus contrast increases with the time of development until the full potential contrast for the emulsion and exposure is achieved. If development were continued appreciably beyond this point there would be a tendency for the developer to attack the non-affected grains, with a consequent fogging effect and loss of contrast.

Some emulsions require more exposure than others for a latent image to be formed. Those requiring less light are said to be more sensitive or faster than the others. The faster the emulsion, the further to the left will its characteristic curve appear—in fact the point A in Fig. 9.6 has sometimes been used to denote the speed of the film. Various units are used to denote speed, among them Din, Weston and ASA.

Since the same amount of light is required to affect a grain whatever its size, the fast emulsions will usually comprise a comparatively large proportion of bigger grains. On the other hand, a contrasty emulsion is usually composed of smaller and more evenly graded grains; this is unfortunate since both qualities are needed in an air film.

The characteristic curve of an emulsion can be amended by changing the composition of the developer, or altering the development technique, e.g. hydroquinone is included in the normal developer because it gives greater contrast than metol.

The quality of the positive print depends on that of the negative but the contrast may be increased by using a printing paper having a " hard " or contrasty emulsion and reduced by the use of a " soft " paper. In addition, there are now electronic dodging contact printers available, which automatically correct for unevenness of illumination in the negative.

Sensitivity to Different Wavelengths

Ordinary silver halides sensitizer is sensitive only to the ultraviolet and blue rays (see Fig. 9.8). The resulting negative would record only those objects which reflect light of lower wavelength. The result is that many of the objects which we normally see would be represented by a very faint image, quite out of keeping with their normal tone values—in fact, reds and greens would be represented by transparent parts of the negative. The first improvement to this ordinary silver halides film, was known as *orthochromatic*, in which the addition of certain dyes to the sensitizer increased the range of sensitivity to include most of the green division of the spectrum. Nowadays, nearly all film is panchromatic, which by incorporating additional dyes, even further rectifies the silver halides in respect of their sensitivity to different ranges of the spectrum. From Fig. 9.8 it will be seen that this type of film can be processed only in the dark, as it is sensitive to all colours of the spectrum, but even panchromatic film is not fully sensitive to red light.

A special *infra-red film* is also produced; this is especially useful for piercing haze since the longer infra-red waves are not so easily deflected from their course. Haze conditions are caused by light being deflected from its course on meeting minute dust particles. The more such particles there are the more scattered the rays become, so that the view becomes blurred and obscured. Infra-red film is sometimes used in aerial photography since it allows photographs to be taken in otherwise unsuitable conditions. The tone contrasts of infra-red film are very different from those of pan but

the result is not so bad as a glance at Fig. 9.8 might suggest, since green vegetation usually reflects a lot of infra-red light as well.

Wavelength	0·40	0·50	0·60	0·70 microns	
	Ultra-violet	Blue-violet	Green	Red	Infra-red
Silver halides	///////	///////			
Orthochromatic	///////	///////	///////		
Panchromatic	///////	///////	///////	///////	
Infra-red	///////	///////	//		///////

FIG. 9.8. SENSITIVITY OF EMULSIONS
Hatching indicates the range of sensitivity.

FILTERS

The most serious drawback of panchromatic film is that it is over-sensitive to blue light and it becomes necessary to hold back some of the blue light before it enters the camera. This is done by placing a *minus-blue filter* in front of the camera lens. Filters generally transmit light of their own colour and hold back or absorb the other colours. There are three main types: those consisting of a thin coloured gelatine film which is very fragile; those consisting of a gelatine film between two plates of optical glass; and coloured optical glass. The last type is the only one suitable for use with an air camera and the filter must have an optical quality not inferior to that of the lens. Green, yellow-green and yellow filters are often used in cameras but with pan film in an air camera a deep-yellow filter is always used. The latter is a minus-blue filter and it reduces the quantity of blue and violet light admitted to the emulsion and so helps to correct the oversensitivity of pan film to light of the lower wavelengths; this in turn reduces the effect of haze. However, the best penetration of haze is achieved by using infra-red film with a deep red filter.

CHARACTERISTICS OF A CAMERA LENS

In Chapters 1 and 2 we considered that the objects being photographed were sufficiently far away from the camera for the beam of light rays from them to be considered as consisting of parallel rays. In air photography for topographic surveying purposes this will

always be so and the camera can be set for infinite focus. In a process camera, however, the objects may be very near and the incident rays will be convergent. As the constant of refraction will remain the same, the tendency will be for the rays to be brought into focus at a greater distance behind the lens. Figure 9.9 shows light from objects O_1, O_2 and O_3 on the optical axis brought to focus at I_1, I_2 and I_3 respectively. Thus if O_2 were brought into clear focus, O_1 and O_3 would have slightly fuzzy images. If the three

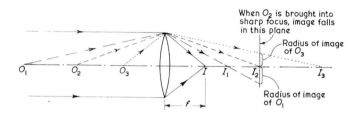

FIG. 9.9. DEPTH OF FOCUS
I = sharp image of object at " infinite " distance
I_1 = sharp image of object at O_1
I_2 = sharp image of object at O_2
I_3 = sharp image of object at O_3

objects were considered as point sources of light, I_2 would be a point but I_1 and I_3 would appear as discs having a definite magnitude. These are known as discs (or disks) of confusion, and if they are 0·25 mm or less in diameter they will appear to the human eye as dots. If an enlarged print is to be made at say twice the scale, then a disc of more than 0·125 mm on the negative will be visible in the enlargement.

In process work the objects usually lie in one plane surface so that with a theoretically perfect lens there will be zero depth of focus. However, the halo-forming aberrations or lens faults which are considered later in this chapter will all be accompanied by discs of confusion not all of which will be circular in shape.

The Angle of View

The angle of view or width of angle of a lens is the angle subtended at the rear node by the diameter of the circle defining the limit of satisfactory image. Since the whole of an air photograph is required to be satisfactory it follows that the diameter of such a circle cannot be less than the diagonal of the format. A normal angle

lens has a width of angle up to 75°. If the angle lies between 75° and 95° the lens is usually described as *wide-angle*, but an angle of over 95° would be described as *ultra-wide-angle* or *super-wide-angle*. With a given focal length lens and flying at a fixed height, the wider the angle of view the larger the area of ground covered with one exposure and the fewer exposures required for a given area of ground. The

FIG. 9.10. ANGLE OF VIEW (152·4 MM LENS AND 230 MM × 230 MM FORMAT)
B = back node AC = diagonal of format
BD = principal distance $\angle ABC$ = angle of view

$$\tan \angle ABD = \frac{\frac{1}{2} \times 230\sqrt{2}}{152\cdot4}$$

$$\therefore \ \angle ABD = 46°52'$$

i.e. angle of view $\simeq 93\frac{1}{2}°$

most common types of air camera have lenses 152·4 mm focal length and a 230 mm × 230 mm format size. Thus the diagonal of the format is 230√2 mm long, and this can be regarded as the diameter of the circle defining the limit of satisfactory image. From Fig. 9.10 it will be seen that the angle of view of such a lens is approximately 93½°. This is by no means the widest angle lens in use: lenses with angles of up to at least 120° can be made today but unfortunately both definition and illumination tend to fall away from the axis. Improvements in the manufacture of lenses have largely overcome this defect but the wider-angle lenses are more expensive.

Relative Aperture

The diaphragm consists of a set of thin metal plates arranged in the form of an adjustable iris as in Fig. 9.11. At the time of exposure, the hole or aperture in the centre of the diaphragm forms the only access for light into the camera.

The leaves can be turned on pivots to vary the size of the central hole although there are definite upper and lower limits to the size of this aperture. The action of reducing the size of the aperture is known as *stopping down*. The stop is the method of controlling the amount of light entering the camera—the wider the aperture the

greater the illumination of the image, but opening up the stop in-
creases the depth of focus. If you were to point a hand camera at
three persons A, B and C such that A was nearer to the camera than
B who was in turn nearer than C, then focusing on B with the lens
stopped right down you might find that A and C were also in focus
(compare O_1, O_2 and O_3 in Fig. 9.9). If we now increase the aperture

(i) (ii)

FIG. 9.11. AN IRIS DIAPHRAGM
(i) SMALL APERTURE
(ii) OPEN APERTURE

size, at the same time keeping B in focus, we find that A and C
gradually lose definition by going out of focus. In an air camera the
depth of focus is of little importance as the distance of the camera
from the ground objects is very great compared both with the
equivalent focal length and with the differences in ground heights.

Relative aperture is usually denoted as the ratio of the focal
length to the diameter of the stop. That is, relative aperture
$= f/D$ where D is the diameter of the stop. A relative aperture of 8
is expressed as $f/8$ and this is sometimes called the f number. For
example, if the focal length of a lens were 152 mm and the diameter
of the aperture 19 mm, then the relative aperture $= 152 \div 19 = 8$,
i.e. relative aperture of $f/8$.

In British practice, camera stop adjustments are usually marked
with the following f numbers: 2, 2·8, 4, 5·6, 8, 11, 16, 22, etc.—
each higher number is $\sqrt{2}$ times the number next preceding it.

Illumination of Image

In theory we may consider a particular field object to be self-
illuminated and to lie in a plane perpendicular to the optical axis
of the lens. Let us assume too that this object is very small, having
an area of A, and that it lies on the optical axis of the lens. Let the
light per unit area of the source be I. Then the total light emanating

from the source is $I \times A$, and the total amount of light passing through the stop is proportional to $\dfrac{I \times A \times d^2}{l^2}$ (see Fig. 9.12).

If now we consider a second similar source of light in the same

FIG. 9.12. ILLUMINATION OF AXIAL IMAGE

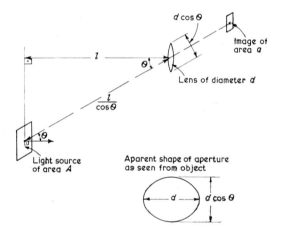

FIG. 9.13. ILLUMINATION OF NON-AXIAL IMAGE

plane as the first but situated off the lens axis in such a position that the angle of incidence for the light rays at the lens is θ, then the rays of light from the object leave the surface of the object at an angle of θ with the normal, and the intensity of illumination will fall to $I \cos \theta$. The apparent area of the lens aperture as viewed from the object will be reduced to an ellipse whose major axis is still d but whose minor axis is reduced to $d \cos \theta$. The distance of the object

from the lens is now increased to $l/\cos\theta$ (see Fig. 9.13). Thus the amount of light passing the stop is now proportional to

$$\frac{I \times \cos\theta \times A \times d^2 \times \cos\theta}{\left(\dfrac{l}{\cos\theta}\right)^2} = \frac{I \times A \times d^2}{l^2} \times \cos^4\theta$$

The illumination has then decreased from that of the axial image proportionally with $\cos^4\theta$. This is known as the \cos^4 law, and it represents a decrease in illumination per unit area since the area of the image remains the same.

Illumination from all sources is subjected to further losses of light when the light rays pass from one medium to another. Loss of illumination when the rays pass from air to glass or from glass to air is approximately four per cent. Thus the transmission of light through a single lens is not greater than $(0{\cdot}96)^2$, and through a lens with eight air-glass intersurfaces it is not greater than $(0{\cdot}96)^8$. These losses may be reduced by coating the lens surfaces with a very thin anti-reflecting film. The latter helps by reducing flare-light (see the section on lens mount and cone, page 16).

In addition to the above losses, the glass itself will absorb some of the light.

Thus from the point of view of illumination, the thickness of the lens should be reduced as far as possible, and the number of air-glass interfaces should be kept to a minimum.

Chromatic Aberration

In focusing a particular object a lens acts similarly to a prism in that it brings different wavelengths of light impulses to focus at different distances from the lens. A simple lens, as illustrated in Fig. 9.14 (i), refracts the blue-violet rays more strongly than the red rays. Thus if the focal plane is taken to be the plane through V, the image point would appear to be of blue-violet light with a halo of green and red. The photograph would be such that the whole image of the point would be replaced by a blurred disc, since all light would be represented by tones of black and white.

Chromatic aberration can occur with oblique rays of light, when it is known as *lateral chromatic aberration*. In such a case the true position of the point is no longer central within the blur (see Fig. 9.14(ii)).

By stopping down the aperture the rays of light passing through the outer areas of the lens can be eliminated and chromatic aberration can be virtually cured if this stopping-down is carried to

extremes. However, stopping-down cannot be used to any great extent in an air camera because the resulting loss of illumination would increase the necessary time of exposure. Until recent years there were only two main types of optical glass: *crown* and *flint* which have different refractive effects on the spectrum. By using a combination of one of each of these types of glass the lens can be made to focus two parts of the spectrum in the same plane: thus either the green and red rays or the green and blue-violet rays will be brought to the same focus. Such a combined lens is called *achromatic*.

FIG. 9.14. CHROMATIC ABERRATION
(i) AXIAL
(ii) LATERAL
$V =$ violet image $R =$ red image

An *apochromatic* lens consists of three separate lenses combining to bring three parts of the visible spectrum to the same focus.

Spherical Aberration

Because of the shape of the simple lens, parallel rays of light are refracted more at the outer areas of the lens than at the centre, so that the image cannot be brought to focus in one plane, and a point will appear as a disc (see Fig. 9.15(i)).

If we use a combination of two lenses in such a way that the thickness of the lens is the same throughout (see Fig. 9.15(ii)), then theoretically we shall remove the cause of spherical aberration. Unfortunately such a lens would cease to refract at all and there would be no focused image. If one lens is of crown and the other of flint glass the ability to focus is restored but so also is some aberration. A lens of this type is known as aplanar.

Spherical aberration can also be reduced by stopping down the aperture, or by using *aspheric* lenses, i.e. lenses with a surface which is other than spherical. They are more difficult to grind to shape and therefore more expensive than the more usual spherical lenses.

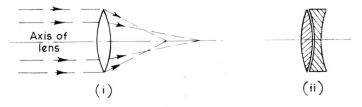

FIG. 9.15. SPHERICAL ABERRATION
(i) AXIAL RAYS
(ii) COMPOUND LENS OF UNIFORM THICKNESS

FIG. 9.16. COMA

Coma

Coma is spherical aberration of oblique rays (see Fig. 9.16), and results in a blurred image which takes on a comet-like shape—hence the term coma.

Astigmatism

This is an aberration of rays oblique to the axis of the lens. A point appears in the image as two mutually perpendicular straight lines at different distances from the lens: one of these lines will be radial from the centre of symmetry which should lie at the principal point.

Curvature of the Field

Curvature of the field indicates that the focal " plane " is no longer planar, but a curved surface. Curvature concave towards the lens is known as positive curvature. Where curvature exists the plane of the

negative at the time of exposure must be adjusted so that it takes up a mean position relative to the curve of correct focus (see Fig. 9.17).

Where astigmatism exists, the radial line images form in a different curved surface from the tangential line images. The curvature of field is then said to be the mean of these two curved surfaces.

An *anastigmat* is a lens so compounded as to eliminate both astigmatism and curvature of field over a large part of the photograph.

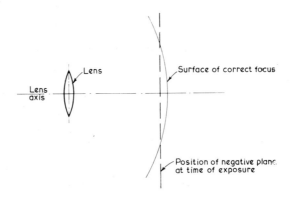

FIG. 9.17. CURVATURE OF FIELD—LONGITUDINAL SECTION THROUGH THE OPTICAL AXIS

Distortion

This implies a displacement of an image point from its true geometrical position; it therefore directly affects the accuracy of measurements made on the face of a photograph. It is the oblique rays of light which will give rise to distortion, so that the point at which the optical axis meets the plane of the negative should be free from distortion. Distortions at other points can be thought of as radial from or tangential to this point which is known as the *centre of symmetry* or *conformal point*. The lens is symmetrically constructed about its optical axis and distortions will therefore tend to vary with the distance of the image from the centre of symmetry.

If the centre of symmetry lies at the principal point, then linear distortion will be radial from the principal point and will not invalidate the radial-line assumption. It becomes important therefore to ensure that principal point and centre of symmetry coincide. Tangential distortion is measured on the face of the photograph in a direction perpendicular to the radials from the principal point,

which for the present purpose is assumed to fall at the centre of symmetry. This displacement of the image is small and will cause a slight curving of straight lines. The effect of tangential distortion will be at a maximum along one radial and it will be almost non-existent along another radial perpendicular to the first.

Where distortion is such that it causes the sides of a square symmetrical about the principal point to become concave outwards, it is known as *positive* or *pincushion distortion*. Where these lines become convex outwards, this is evidence of *negative* or *barrel distortion* (see Fig. 9.18).

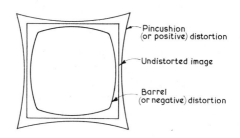

FIG. 9.18. PINCUSHION AND BARREL DISTORTION

Variation in the resolving power of a lens causes a variation in the ease with which a particular point can be accurately located, and in this way it affects indirectly the accuracy of measurements made on the face of the photograph.

Resolving power of the emulsion has been considered earlier, but the resolving power of the lens and the separately determined resolving power of the emulsion will be no guide to their combined resolving power. Thus an emulsion should be tested with the lens with which it will be used.

CAMERA CALIBRATION

Calibration is required to determine not only the camera constants (i.e. focal length, width of angle of lens, principal distance, format size, and location of principal point in the camera), but also the quality and efficiency of all parts of the camera.

The lens is usually tested for distortion and resolution in the laboratory although it is now realized that this will give very different results from those applying in practice, and more realistic field tests are being applied.

Such calibration is the responsibility of an expert, but the surveyor himself might need to check the camera in the field to determine whether it has retained its principal distance and whether the collimating marks still indicate correctly the principal point. If an appreciable discrepancy is found, the camera should be returned to the maker.

These field checks are similar to the full outdoor calibration, and they will be described because it will help with the theory of the camera.

Set up the camera on its side on a firm stand such that the optical axis is truly horizontal and two sides of the format are also horizontal. Choose three field points within the field of view of the camera and at a distance of five hundred metres or more. The points chosen should be in approximately the same horizontal plane as the optical axis, and one should be in a fairly central position and the others at between a quarter and a third of the format width from either edge of the format.

In the case of full calibration at least five points will be required; the extra ones will be used as checks and also for the determination of the centre of symmetry.

After the field points have been adequately marked, an exposure is made. Such an exposure is best made on a glass plate. The camera is now rotated about its optical axis through 90° and set up again in exactly the same position as before but with the other two sides of the format horizontal. A second plate is now exposed.

A theodolite is set up in the place of the camera. It does not affect the test if the theodolite is slightly displaced in the vertical direction, but the plan position of the theodolite must exactly duplicate the plan position of the lens. The theodolite is required to measure the angles between the rays from the three field objects. The plates are now developed. Let the field points be A, B and C and their image positions a, b and c. Then if m and n are collimating marks in the middle of the vertical sides of the first plate, the line mn will pass through a, b and c, and the distances ma, mb and mc are measured in millimetres. The true principal distance pO in Fig. 9.19 can now be computed, as we shall see in the next chapter, and the length mp can also be found.

The same procedure and computations are carried out for the second plate so that the true position of p, the principal point, is now known and can be checked against the marked position.

Lens calibration is a subject for the expert, but a word must be said concerning the measurement of lens distortions. The distortion of any point is usually considered as the error in its positional

displacement from the principal point as measured on the face of the photograph. The principal point is here considered as the centre of symmetry. The correct position of an image point a is at a distance of $f \tan \theta$ from the principal point, where f is the principal distance

FIG. 9.19. CALIBRATION DIAGRAM
mn is a line joining a pair of collimating marks.
O represents the perspective centre or rear node and therefore in the field diagram *O* is the camera station.
a, *b* and *c* are the images of the targets.
p is the principal point.

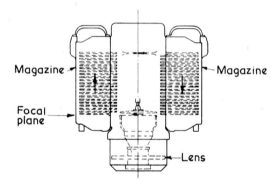

FIG. 9.20. SECTION THROUGH A WILD PLATE CAMERA SHOWING THE PLATE TRANSPORT SYSTEM

of the camera and θ is the angle of incidence of the appropriate ray. If the measured distance from the principal point is x, then the distortion is $\dfrac{x - f \tan \theta}{x}$. There are practical difficulties in using this formula and it is becoming more usual to express distortion as a variation in focal length by putting $f = \dfrac{x}{\tan \theta}$ when f will vary according to the distortion element in the measured distance x.

Modern air camera lenses are often described as distortion free, e.g. the Wild range which includes the normal-angle Aviotar, the wide-angle Aviogon, and the Infragon (for use in infra-red work) lenses, each of which have distortions within ± 0.01 mm.

PLATE CAMERAS

A corresponding improvement in base stability of the negative is achieved by the use of glass plates. The Wild RC 7 plate camera (see Figs. 4.10(i) and (ii)) is fully automatic; the plates are loaded into the camera in two detachable magazines. The plate transfer system is illustrated in Fig. 9.20.

FURTHER READING

BROCK, G. C., *Physical Aspects of Air Photography*, 2nd ed. (Longmans).
 (i) Schwidefsky, pages 34–54 (lens), pages 74–90 (photography).
 (ii) *Manual of Photogrammetry*, Vol. I, Chapter 6.
 (iii) Moffitt, Chapter 2 (cameras).
 (iv) Hallert, pages 28–52.
 (v) Lyon, Chapter 14.
 (vi) Zeller, pages 105–14 (cameras).
 BROCK, G. C., *Image Evaluation for Aerial Photography* (Focal Press).

Further information concerning PHOTOGRAPHIC PROCESSES can be found in the recognized books on that subject, e.g.—

 CLERC, L. P., *Photography—Theory and Practice* (Focal Press).
 Ilford Manual of Photography.

A good guide to PHOTOGRAPHIC TERMS is the *Dictionary of Photography* published by The Fountain Press.

(See Bibliography (page 346) for the full titles.)

CHAPTER 10

Designing a Project

In order to demonstrate the principles put forward in the previous chapters, and to introduce some of the mathematics and computations required of the photogrammetrist, we are going to assume that we have been asked to undertake a particular project.

The project involves the making of a 1/25,000 scale topographic map series with a vertical interval of 15 m. The terrain comprises an area roughly 80 km by 60 km. The ground is undulating, wooded in parts, and includes one medium-sized town and several small towns and villages. It is estimated that the average ground height is 135 m above sea level, and that the whole area lies between 60 and 210 m above sea level. No existing maps are available. 10,000 copies of each map are required in the first instance.

Office equipment includes mirror stereoscopes and parallax bars, sketchmasters, full slotted templet equipment, and the usual drawing office instruments and equipment together with a process camera and vacuum frame.

Outdoor equipment includes a suitable aircraft capable of a cruising speed of 320 km/h and adapted for the air camera. The only available camera has a 230 mm × 230 mm format and 152·4 mm focal length lens interchangeable with a 305 mm focal length lens, referred to below as 150 mm and 300 mm lenses respectively.

DESIGN OF SERIES

We will assume, to simplify matters, that the projection is to be the Transverse Mercator and that the conventional signs and general design of each sheet are to be similar to the current edition of Ordance Survey 1/25,000 sheets of Great Britain.

FLYING FOR COVER

Our first problem is to determine which of the two lenses we should use for the project. For mapping to a scale of 1/25,000 using only simple apparatus, the mean scale of photography should lie between about 1 and $2\frac{1}{4}$ times the reproduction scale, though it is sometimes convenient to operate outside these limits. It is often preferable to work at scales approximating to reproduction scale throughout and the 300 mm lens would preferably be flown at between 6,000 and

9,000 m above the average height of the ground. For the same scale range, the 150 mm lens could be flown at any height between 3,000 and 4,500 m above mean ground height.

Choice of Lens

The scale of the 150 mm exposure at 3,000 m is 1/20,000 and is equal to the scale of the 300 mm exposure at 6,000 m. The areas of ground covered would therefore be equal as the format size is the same in both cases. This means that the same number of exposures would be required to cover the whole area whether we were photographing at 6,000 m with a 300 mm lens or at 3,000 m with a 150 mm lens. There is therefore nothing to choose between the two lenses on this score, but the lower flying height required for the 150 mm lens makes this the more economical proposition and gives a bigger B/H ratio.

Figure 10.1(i) represents the perspective diagram for the 150 mm

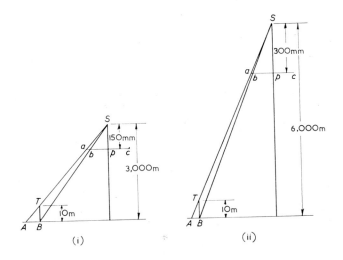

Fig. 10.1. Dead Ground Caused by Vertical Objects
(i) Using a Wide-angle Lens
(ii) Using a Normal-angle Lens

lens at the time of exposure such that ac is one of the diagonals of the format of a theoretical truly vertical photograph. The corresponding diagram for the 300 mm lens is shown in Fig. 10.1(ii). Sa is then one of the most oblique rays and A is the ground point whose image falls at a. Assume that TB is a 10 m high vertical wall,

whose bottom B lies in the same horizontal plane as A and whose top T lies on the ray Sa. $ac = 230\sqrt{2}$ mm $\therefore ap = \frac{1}{2} \times 230\sqrt{2}$ mm. But triangles Sap and TAB are similar since all three sides are parallel;

$$\therefore \quad \frac{AB}{TB} = \frac{ap}{Sp} \quad \text{i.e.} \quad AB = \frac{ap \times TB}{Sp}$$

In Fig. 10.1(i) $AB = \dfrac{\frac{1}{2} \times 230\sqrt{2} \times 10}{150} = 10 \cdot 8$ m

In Fig. 10.1(ii) $AB = \dfrac{\frac{1}{2} \times 230\sqrt{2} \times 10}{300} = 5 \cdot 4$ m

Thus such a wall might completely obscure a narrow street in the first case. In central areas of large and even middle-sized towns, where buildings are much higher than 10 m a very large amount of important detail may be completely lost. The 300 mm lens is much better in this respect and in a predominantly urban area there would be a preference for a longer focal length lens, but in rural areas there are very few vertical features of the type just considered and there would be no objection to the 150 mm lens on these grounds.

The longer focus lens would normally give better resolution but this is offset by the greater thickness of haze which must be penetrated due to the greater flying height.

So far we have considered factors which give only a general guide to the choice of lens, but variations in the height of the terrain and heighting requirements demand respectively definite lower and upper limits to the flying height.

If the range in ground heights exceeds 8 per cent (sometimes up to 10 per cent is quoted) of the flying height, the radial line assumption becomes insupportable. In the case under consideration, the maximum variation in ground height from the mean is 75 m; therefore the flying height must be at least $75 \times \frac{100}{8}$ m, or say $75 \times 12 = 900$ m. Either of the lenses would comply with this requirement.

It is, of course, desirable that the plan displacement of contours from their true position shall be as small as possible. The usual criterion, however, relates only to heighting accuracy and is such that on the reproduced map 90 per cent of the points on any contour shall be in error by less than half the vertical interval. In order to achieve this at topographic scales, the accuracy of heighting should be such as to give an error not exceeding a mean value of one-quarter of the vertical interval. (For production scales larger than 1 in 10,000, V.I./10 should be taken.) In the present case $3 \cdot 75$ m would be taken. Let us also assume that parallax differences can be determined to within $0 \cdot 075$ mm. We must now determine the flying

H

height for which a change of 0·075 mm of parallax would represent a 3·75 m difference in ground height, i.e. a rate of change of h relative to p of 3·75 m per 0·075 mm or 50 m/mm.

The parallax equation $p = fB/H - h$ is sometimes known as the absolute parallax equation.

Using calculus and differentiating with respect to h we obtain the differential parallax equation—

$$\frac{dp}{dh} = \frac{fB}{(H - h)^2}$$

which is usually expressed as—

$$\frac{dh}{dp} = \frac{(H - h)^2}{fB}$$

This equation is sometimes also known as the slope equation or parallax scale.

But
$$B = b \times \frac{H - h}{f}$$

where b = the mean length of both base lines of the overlap, and h = the mean height of the base line above datum (in this case datum is taken as mean ground height, or 135 m above sea level).

Substituting in the slope formula we have—

$$\frac{dh}{dp} \simeq \frac{(H - h^2)}{f \times b \times \dfrac{H - h}{f}} = \frac{H - h}{b}$$

The approximation is due to the fact that in the slope formula itself h = the height of one of the points whose heights are being compared.

$\dfrac{dh}{dp}$ represents the rate of change of h compared with p, and we have already seen that this is 50 m/mm.

$$b \simeq 230 \times \frac{40}{100} \text{ mm} = \frac{230 \times 4}{10} = 92 \text{ mm}$$

Substituting these values in the equation $\dfrac{dh}{dp} = \dfrac{H - h}{b}$ we have—

$$50 \simeq \frac{H - 135}{92}$$

i.e. $H - 135 \simeq 50 \times 92 = 4{,}600$ m
 i.e. $H \simeq 4{,}735$ m

Thus the flying height for the project should not be more than 4,735 m above our datum, so that the 300 mm lens could not be used. We shall assume that we have chosen to fly at 3,135 m with the 150 mm lens for a mean photo scale of 1 : 20,000.

Field Calibration of Camera

The camera should normally be checked at regular intervals to ensure that the principal distance remains as specified, and also to check the position of the principal point as indicated by the camera calibrating marks. The aircraft and camera will normally return to base at frequent intervals and such checks would be carried out then.

The procedure is the same as for field calibration in the last chapter but only three field stations need be marked.

All lettering refers to the figure on the computation form shown in Table 2.

$$bO = \frac{k \sin \phi}{\sin \alpha} = \frac{l \sin \psi}{\sin \beta} \quad \therefore \quad \frac{\sin \phi}{\sin \psi} = \frac{l \sin \alpha}{k \sin \beta}$$

Put
$$\tan \theta = \frac{\sin \phi}{\sin \psi} = \frac{l \sin \alpha}{k \sin \beta} \qquad . \qquad . \qquad . \qquad \text{(i)}$$

But
$$\frac{\sin \phi}{\sin \psi} = \frac{cO}{aO}$$

$$\therefore \quad \frac{cO - aO}{cO + aO} = \frac{\sin \phi - \sin \psi}{\sin \phi + \sin \psi}$$

$$= \frac{\dfrac{\sin \phi}{\sin \psi} - 1}{\dfrac{\sin \phi}{\sin \psi} + 1}$$

$$= \frac{\tan \theta - 1}{\tan \theta + 1}$$

$$= \tan (\theta - 45°)$$

$$\therefore \quad \tan(\theta - 45°) = \frac{\sin \phi - \sin \psi}{\sin \phi + \sin \psi} = \frac{2 \cos \frac{1}{2}(\phi + \psi) \sin \frac{1}{2}(\phi - \psi)}{2 \sin \frac{1}{2}(\phi + \psi) \cos \frac{1}{2}(\phi - \psi)}$$

$$= \frac{\tan \frac{1}{2}(\phi - \psi)}{\tan \frac{1}{2}(\phi + \psi)}$$

$$\therefore \quad \tan \frac{\phi - \psi}{2} = \tan (\theta - 45°) \tan \frac{\phi + \psi}{2} \qquad . \qquad . \qquad \text{(ii)}$$

θ may be found from eq. (i) since k, l, α and β are known; ϕ and ψ may be found from eq. (ii) since θ has been calculated and —

$$\frac{\phi + \psi}{2} = \frac{180 - (\alpha + \beta)}{2}$$

Thence γ and bO may be found, so enabling pO and pb to be determined.

The working is usually set out in the form of a computation so that the actual arithmetic is standardized and can be done and

Table 2
CALIBRATION COMPUTATION

Camera No.

Date:

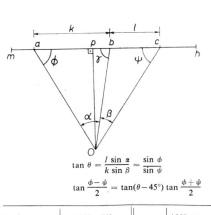

angle $\alpha = 30°\ 08'\ 38''$
angle $\beta = 22°\ 59'\ 23''$

$\alpha + \beta = 53°\ 08'\ 01''$

Point	Plate measurement along mn	
m	0·00 mm	
a	37·98 mm	$ma = 37·98$
b	123·51 mm	$k = 85·53$
c	190·74 mm	$l = 67·23$
n	227·91 mm	$k+l = 152·76$

$$\tan\theta = \frac{l\sin\alpha}{k\sin\beta} = \frac{\sin\phi}{\sin\psi}$$

$$\tan\frac{\phi - \psi}{2} = \tan(\theta - 45°)\tan\frac{\phi + \psi}{2}$$

$$bO = \frac{k\sin\phi}{\sin\alpha} = \frac{l\sin\psi}{\sin\beta}$$

log l	1·827 563	
log sin α	$\bar{1}$·700 853	
colog k	$\bar{2}$·067 882	
log cosec β	0·408 305	
log tan θ	0·004 603	
θ	45° 18′ 13″	
$\theta - 45°$	00° 18′ 13″	
log tan$(\theta - 45)$	$\bar{3}$·724 199	
log tan $\frac{\phi + \psi}{2}$	+0·300 999	
log tan $\frac{\phi - \psi}{2}$	$\bar{2}$·025 198	
$\frac{\phi - \psi}{2}$	00° 36′ 26″	
$\frac{\phi + \psi}{2}$	63° 26′ 00″	
ϕ	64° 02′ 26″	
ψ	62° 49′ 34″	

$\gamma =$	$180° - (\alpha + \phi)$	
α	30° 08′ 38″	
β	+ 22° 59′ 23″	
	− 53° 08′ 01″	
	+180° 00′ 00″	
$\frac{\phi + \psi}{2}$	126° 51′ 59″	
$\frac{\phi + \psi}{2}$	63° 26′ 00″	
α	30° 08′ 38″	
ϕ	+ 64° 02′ 26″	
	− 94° 11′ 04″	
	+180° 00′ 00″	
γ	85° 48′ 56″*	
β	22° 59′ 23″	
ψ	+ 62° 49′ 34″	
γ	85° 48′ 57″*	

log k	1·932 118	
log cosec α	0·299 147	
log sin ϕ	$\bar{1}$·953 810	
log bO	2·185 075†	
log l	1·827 563	
log cosec β	0·408 305	
log sin ψ	$\bar{1}$·949 207	
log bO	2·185 075†	
log cos γ	+ $\bar{2}$·863 129	
log bp	1·048 204	
bp	− 11·17 mm	
mb	123·51 mm	
mp	112·34 mm	
log bO	2·185 074	
log sin γ	$\bar{1}$·998 841	
log pO	2·183 916	
$pO = f =$	152·73 mm	

checked more quickly. A suitable form of computation is set out in Table 2 and an example is actually worked on it. There will be two such computations for every field calibration: one for each of the two exposures. The mean value of the two principal distances will be taken and the two values of *mp* will give the two coordinates of the principal point.

One of the most important functions of a computation form is to cut out all unnecessary operations. In the field it is assumed that calculating machines are not available and the form is arranged for use with log tables. + and − signs in a formula necessitate at least one extra antilog, and should therefore be avoided if possible. The ideal would be a single formula for the whole computation with no addition or subtraction signs. A table of cologs would make it possible to evaluate any fraction in one operation involving only an addition of a whole series of logs. The formula used and the actual forms of computation would be drawn up according to the machines and tables available for the particular project. As the design of calculating machines is gradually improved, so the most suitable formula and form of computation will change. Notice that a system of checks on the working has been contrived.

In the example we see that if the coordinates of the marked position of *p* are not such that *mp* = 112·34, then there is either an error in the marked position of *p*, or the negative plane is not parallel with the lens plane.

Overlaps

Fore and aft overlap is always specified as 60 per cent and lateral as 30 per cent if a mosaic is required. When the photographs are not required for making a mosaic, 20 per cent lateral overlap would suffice although for general purposes 25 per cent is often required. The latter seems wasteful and we shall specify 60 per cent and 20 per cent respectively.

The need for 60 per cent fore and aft overlap arises from the fact that not only must the whole area be covered stereoscopically, but the image at the principal point of one photograph must appear well within the format of both the preceding and succeeding photographs. Let us examine the situation should two consecutive photographs each be tilted away from the other by the maximum permissible tilt of 3°. (Note that even if the maximum tilt of 3° were present it would require excessive coincidence for the principal line of even one of the photographs to coincide with the base line.) Figure 10.2 illustrates such a case. The ground is considered to be flat and to lie in the datum plane.

For 60 per cent fore and aft overlap, base line $b \simeq \dfrac{40}{100} \times 230$ mm

\therefore

$$B \simeq \frac{4}{10} \times 230 \times 20{,}000 \text{ mm}$$

$$= 1{,}840 \text{ m}$$

i.e. $N_1 N_2 \simeq 1{,}840$ m

But $P_1 N_1 = H \tan 3° \simeq 3{,}000 \times 0{\cdot}0524 \simeq 160$ m

\therefore $P_1 N_2 \simeq 2{,}000$ m

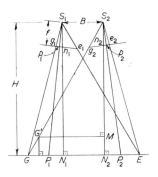

FIG. 10.2. EFFECT OF TILT ON OVERLAP
The tilt is assumed to be wholly in the fore and aft direction. e_1 is a point on the edge of the format of photo 1 and g_2 a point on the edge of photo 2: both lie on their respective base lines.

Now $GN_2 = H \tan \angle\, GS_2 N_2 = H \tan (\angle\, g_2 S_2 p_2 - 3°)$

$$= \frac{H(\tan \angle\, g_2 S_2 p_2 - \tan 3°)}{1 + \tan \angle\, g_2 S_2 p_2 . \tan 3°}$$

$$= H \times \frac{\frac{115}{150} - 0{\cdot}05}{1 + \frac{115}{150} \times 0{\cdot}05}$$

$$= 3{,}000 \times \frac{107{\cdot}5}{155{\cdot}75}$$

$$\simeq 2{,}070 \text{ m}$$

Thus the image of P_1 would have appeared on photo 2 in spite of the excessively bad conditions assumed.

Let us see what is the actual percentage overlap. The overlap on

photo 1 is represented by g_1e_1, and the percentage overlap on this photograph will be $\frac{g_1e_1}{230} \times 100$ per cent.

$$g_1e_1 = g_1p_1 + p_1e_1 = g_1p_1 + 115 \text{ mm}$$

But $\quad g_1p_1 = f \tan \angle g_1S_1p_1 = f \tan (\angle GS_1N_1 - \angle p_1S_1n_1)$

$$= 150 \times \frac{\tan \angle GS_1N_1 - \tan 3°}{1 + \tan \angle GS_1N_1 . \tan 3°}$$

$$\tan \angle GS_1N_1 = \frac{GN_1}{H} = \frac{GN_2 - N_1N_2}{H} = \frac{2{,}070 - 1{,}840}{3{,}000} = 0{\cdot}0767$$

$$\therefore \qquad g_1p_1 = 150 \times \frac{0{\cdot}0767 - 0{\cdot}0524}{1 + 0{\cdot}0040} = 3{\cdot}6$$

$$\therefore \qquad\qquad g_1e_1 = 3{\cdot}6 + 115 = 118{\cdot}6$$

$\therefore \quad$ overlap of photo 1 is $\dfrac{118{\cdot}6}{230} \times 100 = 51$ per cent.

Suppose now that the image at g is the top of a hill, G' in the figure, and let G' be 75 m above datum, i.e. in figure, $MN_2 = 75$ m

$$\therefore \quad S_2M = H - 75 = 2{,}925 \text{ m}$$

But $G'M = S_2M \tan \angle G'S_2N_2 = 2{,}925 \times \dfrac{107{\cdot}5}{155{\cdot}75} \simeq 2{,}020$ m

P_1N_2 is still approximately 2,000 m, if P_1 is at datum level so that the image of P_1 is still to be found on photo 2, but only just. Our specification will require that relative tilt between any two consecutive photographs shall not exceed 5°. Our example has assumed 6°.

The lateral overlaps can be similarly examined against tilt and height distortions, but a further factor enters into consideration: that of deviation from course. With modern aids and sufficient recognizable ground points a good pilot reckons to be able to keep within 20 m of his correct course, i.e. the ground plumb point will not be more than 20 m away from the pre-determined ground position of the line of flight. Even if we were to allow for an error of 60 m in this respect, it can be seen that at this scale of photography it is almost negligible compared with the ground distance of the overlap which is approximately

$$\frac{20}{100} \times 230 \times \frac{20{,}000}{1{,}000} = 920 \text{ m}$$

Number of Photographs

Flying will take place in directions parallel with the two longest

sides, so that each strip requires to cover a length of approximately 80 km of unsurveyed ground.

In the first strip each overlap covers only

$$40\% \text{ of } \frac{230 \times 20,000}{1,000 \times 1,000} = 1\cdot84 \text{ km of new ground.}$$

\therefore No. of overlaps per strip is $80 \div 1\cdot84 = 43\cdot48$, i.e. 44.

\therefore No of photographs per strip is 45.

It is usual to add one more photograph to make sure that the stereoscopic cover extends on to land outside the area of the survey at both ends of the strip. Thus we require 46 photographs per strip.

The second strip gains only 80 per cent of its own width, of new coverage, so that the effective width of second and subsequent strips

$$\text{is } \frac{80}{100} \times \frac{230 \times 20,000}{1,000 \times 1,000} = 3\cdot68 \text{ km}$$

\therefore No. of strips required is $60 \div 3\cdot68 = 16\cdot3$

i.e. 17 strips are required.

But for the same reasons that we allowed one extra photograph per strip, it is usual to allow one extra strip of photography.

\therefore we shall specify 18 strips, each containing 46 photographs, or $18 \times 46 = 828$ photographs in all.

Specification for Air Cover

The preparation and reproduction of a map series may often be let out to contract; alternatively any part of the work may be so let out. When this happens it becomes necessary to enter into an agreement with the firm concerned. The most usual part of the work to be let out to contract is that concerned with flying and processing the photographs. Supposing that in this case it has been decided to call in a specialist firm to perform this part of the work, then it would become necessary to draw up an agreement: the main, and possibly the only, contract documents would be the Conditions of Contract and the Specification.

The Conditions of Contract are drawn up in legal terms rather than technical. This document defines the extent of the contract, stating precisely and in non-technical language what it is that the contractor is expected to do.

The Specification, on the other hand, is of a highly technical

character and must be drawn up afresh for each contract. Every aspect of the work should be specified accurately so that there can be no doubt in the mind of the contractor of the intentions of the employer. The wording itself must be as concise as is compatible with clarity. As an illustration the following might be included in some particular specification:

The camera shall be properly calibrated and be fitted with 150 mm nominal focal length wide-angle lens, with 230 mm × 230 mm format.

The film shall be of panchromatic emulsion on topo-base, and a deep yellow optical quality filter shall be placed in front of the camera lens.

The flying altitude shall be 3,135 m above mean sea level. A variation of more than 5 per cent above or below this altitude shall be sufficient cause for rejection of the photographs.

The flight lines shall comply with the attached flight-plan, and flying shall be within 60 m of these lines.

Fore and aft overlap shall average 60 per cent of the side of the format. No overlap shall be less than 55 per cent or more than 65 per cent of the side of the format in length.

Lateral overlap shall average 20 per cent of the side of the format.

The principal point of the first and last photograph of each strip shall fall outside the area to be mapped.

No sequence of two or more photographs shall be crabbed in excess of 5°.

Tilt of any individual photograph shall not exceed 3°. No two consecutive photographs shall be tilted, the one relative to the other, by more than 5°. The average tilt of all the photographs in the sortie shall not exceed 1°.

The photography shall not be undertaken when the leaves are on the deciduous trees (this is not a usual requirement), nor when snow is lying on the ground. The altitude of the sun shall be between 30° and 70° at the time of each exposure.

The negatives shall be of uniform density and clear and sharp in detail; they shall have a resolving power of not less than 30 lines per millimetre and shall be free from all defects which might interfere with their suitability for making a topographical map.

The prints shall be semi-matt on double-weight paper. They shall be free from all stains, blemishes and other defects which might interfere with their suitability for making a topographical map.

The above is by no means exhaustive and even the points included are not of universal application. They are given here mainly to make the meaning of the term " specification " clearer.

Flying the Sortie

The pilot will normally be accompanied by a navigator who is responsible for the operation of the camera, and for most other aspects of the flight peculiar to flying for photographic purposes. The navigator or pilot needs to carry a plot of the land over which they are to fly. Such a plot must indicate flight lines and show sufficient recognizable ground points to enable the pilot to maintain his course. For this purpose, at normal flying heights and assuming visual flying only, the requirement is that recognizable points shall be spaced at from 25 to 30 kilometre intervals along the line of flight.

FIG. 10.3. FLIGHT LINES FOR NAVIGATION STRIPS

In the present case no map or plan exists, and a preliminary set of photographs will be flown, so that a rough mosaic may be produced. Such navigation strips are flown according to a pattern similar to that shown in Fig. 10.3. Overlapping photographs are taken throughout such a preliminary sortie, and these are used to produce a partial mosaic of the area. The main strips are tied in by photographs taken during the flight along the cross strips. Navigational control points are marked on this mosaic and a copy of the photographs is issued to the pilot.

Having checked his instruments and flight plot the navigator loads all his equipment into the plane and stows it correctly. The sortie proper is now ready to begin.

When the altimeter registers the correct flying height, the pilot turns to make his first run. The pilot guides the plane in accordance with his flight plot, and the navigator using the view-finder checks the accuracy of his track by watching the progress of the principal point

over the ground. He then removes crabbing by changing the drift ring setting until the flight line on the ground appears to move along the base line as marked in the viewfinder. The movement of the principal point over the ground can be used to calculate the ground speed. Let this be 300 km/h, and the intervalometer will be set in accordance with the calculations set out in Chapter 4. The camera must now be trimmed for level by adjusting the gimbal mounting to bring the bubbles in the spirit levels on the camera to the centres of their runs.

If the combined resolving power of lens and emulsion is 30 lines per mm, then the shutter speed is calculated as follows.

Image movement during exposure must not be such as to reduce resolution and therefore must not exceed 1/30 mm.

\therefore when scale of photography is 1 in 20,000, movement of the plane relative to the ground must not exceed

$$\frac{1}{30} \times \frac{20,000}{1,000 \times 1,000} \text{ km}$$

But ground speed of plane is 300 km/h

\therefore plane moves $\dfrac{1}{30} \times \dfrac{20,000}{1,000 \times 1,000}$ km in

$$\frac{1}{30} \times \frac{20,000}{1,000 \times 1,000} \times \frac{3,600}{300} \text{ second}$$

$$= \frac{1}{125} \text{ second.}$$

Thus the shutter speed must not be slower than 1/125 second. The shutter speed calculation will not actually be made in the air as (unless the shutter is synchronized with a modern view-finder) a set of tables would be carried.

A skilled crew will be able to arrange a reasonable length of run-in to each flight line so that the above adjustments can all be carried out before the first photograph is exposed. The adjustment procedure must be repeated in full for the second strip which is flown in the opposite direction; full checks must be made at the beginning of each subsequent strip.

When the sortie is complete the film is processed, and the contact prints are run off. A key photographic map is then made to a small scale, and the relative position of each photograph (or alternate photos) of the sortie is plotted on to it. This affords a ready check on

the adequacy of the cover and the approximate amount of crabbing and also forms a convenient method of reference for choosing the photographs required to study any particular portion of the area.

The photographic prints must be checked to ensure that the quality is up to specification.

GROUND CONTROL

The reproduced map is usually required to be of an accuracy within $\pm\,0\cdot5$ mm; thus the compilation scale accuracy should be to

$$\pm\,\frac{5}{10}\times\frac{25,000}{20,000}=\pm\,0\cdot625 \text{ mm.}$$

\therefore in the empirical formula of Chapter 5,

where $c = t\left(\dfrac{0\cdot16}{e}\right)^{2}$, $e = 0\cdot625$ and $t = 828$

so that $c = 828 \times \left(\dfrac{0\cdot16}{0\cdot625}\right)^{2} = 55.$

We require 55 ground control points which should be fairly evenly spaced over the whole of the area to be plotted, but chosen in detail on the lines set out in Chapter 5. These approximate locations of points are marked on a set of photographs which are issued to the ground surveyors. The exact positions of the stations are chosen in the field in such a manner that every point can be accurately and certainly pin-pointed on the photograph. In this connexion, whilst a post in the line of a fence might form a suitable point, the intersection of the root line of two hedge boundaries would not do.

The field survey will nearly always be carried out in the form of a series of third-order traverses between existing control. In most circumstances the Tellurometer would appear to be ideal for this type of work.

Height Control

The number of height control points can be considered to be five per overlap, although the number could be expected to be considerably reduced by reason of the fact that many would be able to be used on two or more overlaps and even in adjacent strips. A reasonable allowance would be three new points for each overlap, i.e. $3 \times (828-18) = 2,430$ height control points. These may include some of the ground control points, but otherwise, provided that the field surveyor can pin-point them on the photographs, they

need not be surveyed for planimetric position. In choosing the points for any overlap, the surveyor must bear in mind requirements of the particular heighting drill to be used. We are using the parabolic hyperboloid corrections to parallax bar heights, and must therefore see that for any single overlap no four points are collinear and no three points have the same x-coordinate.

The heighting will be by barometer.

SLOTTED TEMPLET PLOT

The base grid is now prepared, and the ground control points are plotted on it. This is only a moderately sized assembly of area

$$\frac{60 \times 80}{(20,000)^2} \times (1,000)^2 = 12 \text{ m}^2$$

but there would be some difficulty in obtaining a suitable base material in sheets of this size, and the grid would probably be plotted on pieces of 5-ply butt-jointed and sprayed with white enamel. The mean scale of the photographs approximates to 1 in 20,000, so the scale of the grid would be made exactly 1 in 20,000. The slotted templet assembly is prepared, and the minor control plotted as in Chapter 5.

A noticeable error due to the inaccuracy of the radial line assumption is very rare—so rare that if buckling takes place in a slotted templet assembly, the cause is almost always found to be inaccuracies in draughtsmanship or cutting. If a check reveals no such inaccuracies then one of the photographs will almost certainly be found to fall outside the specification regarding tilt or ground height variation or both. In such a case it might be necessary to make an optically rectified copy of the offending photograph.

When the templets have been removed, and all the minor control points have been systematically numbered, the principal points of each strip are joined by a series of straight lines to form a principal point traverse.

Further points of control are now plotted by using the radial line assumption that angles subtended at the principal point are true. The chosen points are plotted by intersections based on the principal point traverses. The number of points is gradually increased until the desired density is reached. This density will vary according to the scale and quality of photography and with the density of detail on the ground, but it will often be found to be such that there are control points of one sort or another at intervals of about 20 mm over the whole of the area to be plotted.

COMPILATION

The base grid is now divided into map sheet areas, and a piece of transparent stable plastic is chosen to represent each map sheet. This transparency is to become the compilation sheet, and all the control points are traced on to it from the base grid. Each photograph is now suitably interpreted and the detail is plotted on to the compilation sheet under a Sketchmaster or other simple reflecting plotter. Only the central part of each photograph is used. If the surveyor himself, or some other thoroughly experienced person, is to do the plotting the marking of the photographs during interpretation will probably be omitted.

CONTOURING

As soon as the slotted templet assembly is completed, contouring can begin. We shall use the method outlined at the end of Chapter 6. The basic equation of this method is—

$$h' - h = a_0 + a_1 x + a_2 y + a_3 xy + a_4 x^2$$

where h' is the known height, and h is the height determined by parallax bar heighting.

The other equation which we need to use is the one derived in Chapter 6 (6viii) from which

$$\Delta h_{ab} = (H - h_a) \frac{\Delta p_{ab}}{p_b}$$

In this equation h_a is the known height, p_{ab} and p_b will be determined during the heighting procedure, but H the flying height must be separately determined. For this purpose we must choose four points a, b, c and d on photo 1, such that the lines ab and cd are as long as possible and intersect approximately at right angles in a point near the principal point. The four points should be plotted by radial line methods on to the base grid, and the lengths ab, cd on the photograph should be measured and also the lengths AB, CD on the base grid. Similarly four points q, r, s, t must be chosen on photo 2. These measurements are recorded in Table 3.

The scale of the base grid is 1 in 20,000

$$\therefore \text{ mean scale of the overlap} = \frac{839 \cdot 0}{851 \cdot 2 \times 20,000} = \frac{1}{20,291}$$

But the mean height of the eight ground points is found to be 117 m above datum,

$$\therefore \quad \text{scale} = \frac{f}{H - h} = \frac{150}{H - 117} = \frac{1}{20,291}$$

i.e. $H - 117 = 3,044$ and $H = 3,161$ m

As the approximate ground height of each of the eight points should be known, it would be convenient if height control points could be used.

The five height control points for this overlap are chosen as in Fig. 10.4, and their coordinates are read from the 20-mm grid on the overlay which must now be prepared.

A minute but easily recognizable point of detail is chosen on the base line, A in Fig. 10.4, and its parallax is accurately measured using

Fig. 10.4. CHOOSING SUITABLE HEIGHT CONTROL POINTS
Photo 1 is the left-hand photo of the pair
O is the mid-point of p_1p_2'
Coordinates of the points
1—(− 1·1, − 3·9) 2—(+ 2·5, − 1·9)
3—(− 0·5, + 0·5) 4—(− 2·1, + 4·1)
 5—(+ 1·4, + 4·7)

dividers and a diagonal scale reading to $\frac{1}{10}$ mm. The parallax of A is found to be 91·6 mm.

Parallax bar heighting is now carried out in respect of these six points and the bar readings are recorded as in Table 4.

A mean of at least five readings is required for each point. Obviously erroneous readings such as the first reading for point 5 and the second reading for A are ignored. The readings should normally agree to within 0·03 or 0·04 mm. Point 1 in this case has yielded very poor results, largely because photo 2 is poorly illuminated in the neighbourhood of this point.

The parallax bar being used gives increasing readings as the separation of the dots increases, but increasing height and increasing parallax are accompanied by decreasing the spacing of the dots. Thus the bar reading of 6·31 for point 1 indicates that the height and therefore the parallax of point 1 is greater than that for point A

whose bar reading was 6·98. Δp in Table 4 indicates the difference of parallax between A and the points 1, 2, 3, 4 and 5 respectively, A being assumed datum.

Table 3

Line	Photo Distance in mm	Grid Distance in mm	
AB	210·1	212·1	} photo 1
CD	176·3	177·8	
QR	229·3	234·3	} photo 2
ST	223·3	227·0	
Sum	839·0	851·2	

Table 4

SCHEDULE OF PARALLAX BAR READINGS

Reading	A	Pt 1.	Pt 2.	Pt 3.	Pt 4.	Pt 5.
1st	6·985	6·34	5·55	7·80	8·73	10·72*
2nd	7·08*	6·27	5·58	7·81	8·74	10·00
3rd	6·99	6·34	5·53	7·82	8·73	10·04
4th	6·98	6·31	5·51	7·83	8·70	10·00
5th	6·985	6·29	5·55	7·79	8·72	10·00
6th	6·96	6·26				10·03
7th	6·98	6·33				
8th						
Total		44·14	27·72	39·05	43·62	50·07
Mean	6·98	6·31	5·54	7·81	8·72	10·01
Δp	0	0·67	1·44	− 0·83	− 1·74	− 3·03

*Discarded

The form in Table 5 is that used for recording the main steps in calculating $h' - h$, the error in crude height for the five points with which we are concerned. Column 7 indicates the previously determined barometric heights of the five points, and this column is

entered up straight away. Column 4 records the actual parallax of each point; that for point A has already been measured and must now be entered.

Next, differences in parallax Δp are copied from Table 4 into Column 2 of Table 5.

The remaining parallaxes are entered in Column 4, e.g. for point 1 : $91 \cdot 6 + 0 \cdot 67 = 92 \cdot 27$.

Point 3 is chosen as datum and the difference of parallax in Column 3 is entered as zero; the other entries in this column are the

Table 5
FORM FOR COMPUTING THE HEIGHT CORRECTION, $h' - h$

Col. 1	Col. 2	Col. 3	Col. 4	Col. 5	Col.6	Col. 7	Col. 8
Point	Δp	$\Delta'p$	p	Δh	h	h'	$h'-h$
A	0		91·6				
1	+ 0·67	+ 1·50	92.27	+49·5	156·5	123	− 33·5
2	+ 1·44	+ 2·27	93·04	+74·5	181·5	169·5	−12
3	− 0·83	0	90·77	0	107	107	0
4	− 1·74	− 0·91	89·86	− 31	76	59·5	−16·5
5	− 3·03	− 2·20	88·57	− 76	31	101	+70

Figures in bold type are those which have been previously determined.

differences of parallax related to the parallax of 3. It is the value of $\Delta'p$ recorded in Column 3 which is required for substitution in the formula

$$\Delta h_{ab} = (H - h_a) \frac{\Delta p_{ab}}{p_b} \text{ as follows—}$$

$$H - h_a = 3,161 - 107 = 3,054$$

$$\therefore \quad \Delta h_{31} = 3,054 \times \frac{+ 1 \cdot 50}{+ 92 \cdot 27} = + 49 \cdot 5 \quad . \quad \text{Point 1}$$

$$\therefore \quad \Delta h_{32} = 3,054 \times \frac{+ 2 \cdot 27}{93 \cdot 04} = + 74 \cdot 5 \quad . \quad \text{Point 2}$$

$$\therefore \quad \Delta h_{34} = 3,054 \times \frac{- 0 \cdot 91}{89 \cdot 86} = - 31 \quad . \quad \text{Point 4}$$

$$\therefore \quad \Delta h_{35} = 3,054 \times \frac{- 2 \cdot 20}{88 \cdot 57} = - 76 \quad . \quad \text{Point 5}$$

These results are entered as Δh in Column 5.

Column 6 is now calculated by adding the appropriate figure in Column 5 to the datum height of 107 m. Thus the crude height h entered for Point 1 is $107 + 49 \cdot 5 = 156 \cdot 5$.

Column 8 is then the difference between Column 5 and Column 7, and represents the correction to be applied to the crude height of Column 6.

Now in the equation

$$a_0 + a_1 x + a_2 y + a_3 xy + a_4 x^2 = h' - h$$

we substitute the coordinates of Point 1 for x and y, and we put $h' - h = -33 \cdot 5$. We have—

$$a_0 + (-1 \cdot 1)a_1 + (-3 \cdot 9)a_2 + 4 \cdot 29a_3 + 1 \cdot 21a_4 = -33 \cdot 5 \quad \text{(i)}$$

This is one of the five equations in the unknown constants; the others are—

$$a_0 + 2 \cdot 5a_1 - 1 \cdot 9a_2 - 4 \cdot 75a_3 + 6 \cdot 25a_4 = -12 \text{- - - (ii)}$$
$$a_0 - 0 \cdot 5a_1 + 0 \cdot 5a_2 - 0 \cdot 25a_3 + 0 \cdot 25a_4 = 0. \text{ - - - - (iii)}$$
$$a_0 - 2 \cdot 1a_1 + 4 \cdot 1a_2 - 8 \cdot 61a_3 + 4 \cdot 41a_4 = -16 \cdot 5 \text{ - - (iv)}$$
$$a_0 + 1 \cdot 4a_1 + 4 \cdot 7a_2 + 6 \cdot 58a_3 + 1 \cdot 96a_4 = +70 \text{ - - (v)}$$

These five equations are solved simultaneously in Table 6. The form of computation is arranged mainly for convenience in the explanation. The same form could be used in practice, but it would be more convenient to rearrange matters so that the final back substitutions could be made in the lines following the equations to which they refer. Thus, rearranged, line 38 would actually have followed line 1, line 37 would have followed line 2 and so on. That is, in the original setting out, the second, fourth, sixth, etc. lines would have been left blank and would have been filled in only at the time of making the back substitutions.

The correction equation becomes—

$$h' - h = 2 \cdot 2 + 10 \cdot 6x + 8 \cdot 44y + 2 \cdot 61xy - 1 \cdot 96x^2$$

We can now find the corrected height for any point on the overlap. Suppose that we wish to find the spot height at Point 6 $(-1 \cdot 7, -1 \cdot 8)$, for which the mean bar reading was $4 \cdot 86$, then—

$$\Delta' p_{36} = 7 \cdot 81 - 4 \cdot 86 = +2 \cdot 95$$
$$p_6 = 90 \cdot 77 + 2 \cdot 95 = 93 \cdot 72$$
$$\Delta h_{36} = (H - h_3)\frac{\Delta' p_{36}}{p_6} = 3{,}054 \times \frac{2 \cdot 95}{93 \cdot 72} = 96$$

$\therefore \quad h_6 = 107 + 96 = 203$

$h'_6 = h_6 + 2 \cdot 2 + 10 \cdot 6x + 8 \cdot 44y + 2 \cdot 61xy - 1 \cdot 96x^2$

$\quad = 203 + 2 \cdot 2 + 10 \cdot 6 \, (-1 \cdot 7) + 8 \cdot 44 \, (-1 \cdot 8)$

$\qquad \qquad + 2 \cdot 61 \, (-1 \cdot 7) \, (-1 \cdot 8) - 1 \cdot 96 \, (-1 \cdot 7)^2$

$\quad = 180 \text{ m}$

i.e. height of Point 6 is 180 m.

The graphs are now drawn on the overlay as follows—

Let the parabolic correction be q, and the hyperbolic correction be r; then

$h' - h = r + q$, and

$q = -1 \cdot 96x^2$

$r = 2 \cdot 2 + 10 \cdot 6x + 8 \cdot 44y + 2 \cdot 61xy$

Figure 10.5 shows the graph of the parabolic correction plotted as q against x. The plot is made by assuming a series of values for x between $+3$ and -3, plotting the corresponding value for q and joining as a smooth curve. In this case all values of q are negative.

The hyperbolic correction is plotted by first determining the values for r at each of the four corner points $(-3, -5)$, $(+3, -5)$, $(+3, +5)$ and $(-3, +5)$, and plotting them on the overlay—

For Point $(-3, -5)$

$2 \cdot 2 + 10 \cdot 6 \, (-3) + 8 \cdot 44 \, (-5) + 2 \cdot 61 \, (-3) \, (-5) = -32.6$

For Point $(+3, -5)$

$2 \cdot 2 + 10 \cdot 6 \, (+3) + 8 \cdot 44 \, (-5) + 2 \cdot 61 \, (+3) \, (-5) = -47 \cdot 4$

For Point $(+3, +5)$

$2 \cdot 2 + 10 \cdot 6 \, (+3) + 8 \cdot 44 \, (+5) + 2 \cdot 61 \, (+3) \, (+5) = +115.4$

For Point $(-3, +5)$

$2 \cdot 2 + 10 \cdot 6 \, (-3) + 8 \cdot 44 \, (+5) + 2 \cdot 61 \, (-3) \, (+5) = -26.6$

The corrections at points $(-2, -5)$, $(-1, -5)$, $(0, -5)$, $(+1, -5)$ and $(+2, -5)$ are interpolated between the values for points $(-3, -5)$ and $(+3, -5)$ as $-35 \cdot 1$, $-37 \cdot 6$, -40.05, $-42 \cdot 5$ and $-45 \cdot 0$ respectively. These values are now entered on the overlay as shown. Similarly the corrections at points $(-2, +5)$, $(-1, +5)$, $(0, +5)$, $(+1, +5)$ and $(+2, +5)$ are determined and entered.

We must now interpolate between points $(-3, -5)$ and $(-3, +5)$ for the corrections at $(-3, -4)$, $(-3, -3)$, $(-3, -2)$, $(-3, -1)$, $(-3, 0)$, $(-3 +1)$, $(-3, +2)$, $(-3, +3)$, $(-3, +4)$; similarly between points $(-2, -5)$ and $(-2, +5)$ for the values at the nine grid intersections along the line $x = -2$. We

Table 6

SOLUTION OF THE FIVE EQUATIONS

		a_0	a_1	a_2
Solutions		2·2	+10·6	+8·44
	1	+1	− 1·1	− 3·9
	2	+1	+ 2·5	− 1·9
	3	+1	− 0·5	+ 0·5
	4	+1	− 2·1	+41
	5	+1	+ 1·4	− 4·7
(1)−(3)	6		− 0·6	− 4·4
(2)−(3)	7		+ 3·0	− 2·4
(4)−(3)	8		− 1·6	+ 3·6
(5)−(3)	9		+ 1·9	+ 4·2
(6)÷[−0·6]	10		+ 1	+ 7·333
(7)÷[+3·0]	11		+ 1	− 0·8
(8)÷[−1·6]	12		+ 1	− 2·25
(9)÷[+1·9]	13		+ 1	+ 2·210
(10)−(13)	14			+ 5·123
(11)−(13)	15			− 3·010
(12)−(13)	16			− 4·46
(14)÷[+5·123]	17			+ 1
(15)÷[−3·01]	18			+ 1
(16)÷[−4·46]	19			+ 1
(17)−(19)	20			
(18)−(19)	21			
(20)÷[−1·814]	22			
(21)÷[+2·058]	23			
(22)−(23)	24			
Substitute for—				
a_4 in (23)	25			
a_4 in (22)	26			
a_3 in (19)	27			+ 1
a_3 in (18)	28			+ 1
a_3 in (17)	29			+ 1
a_2 in (13)	30		+ 1	+18·652
a_2 in (12)	31		+ 1	−18·990
a_2 in (11)	32		+ 1	− 6·752
a_2 in (10)	33		+ 1	+61·891
a_1 in (5)	34	+1	+14·84	+39·668
a_1 in (4)	35	+1	−22·26	+34·604
a_1 in (3)	36	+1	− 5·3	+ 4·22
a_1 in (2)	37	+1	+26·5	−16·036
a_1 in (1)	38	+1	−11·66	−32·916

Table 6—(continued)

a_3	a_4	$h'-h$	Σ	Solutions
+ 2·61	− 1·96			
+ 4·29	+ 1·21	− 33·5	− 32·00	
− 4·75	+ 6·25	− 12	− 8·90	
− 0·25	+ 0·25	0	+ 1·00	
− 8·61	+ 4·41	− 16·5	− 17·70	
+ 6·58	+ 1·96	+ 70	+ 85·64	
+ 4·54	+ 0·96	− 33·5	− 33·00	
− 4·50	+ 6·00	− 12	− 9·9	
− 8·36	+ 4·16	− 16·5	− 18·7	
+ 6·83	+ 1·71	+ 70	+ 84·64	
− 7·567	− 1·6	+ 55·833	+ 55	
− 1·5	+ 2·00	− 4	− 3·3	
+ 5·225	− 2·6	+ 10·312	+ 11·687	
+ 3·595	+ 0·9	+ 36·842	+ 44·547	
− 11·162	− 2·5	+ 18·991	+ 10·453	
− 5·095	+ 1·1	− 40·842	− 47·847	
+ 1·630	− 3·5	− 26·530	− 32·860	
− 2·177	− 0·488	+ 3·707	+ 2·040	
+ 1·693	− 0·365	+ 13·569	+ 15·896	
− 0·365	+ 0·785	+ 5·948	+ 7·368	
− 1·814	− 1·273	− 2·241	− 5·328	
+ 2·058	− 1·150	+ 7·621	+ 8·528	
+ 1	+ 0·701	+ 1·235	+ 2·937	
+ 1	− 0·559	+ 3·703	+ 4·144	
	+ 1·260	− 2·468	− 1·207	$a_4 = -1·959$
+ 1	+ 1·096	+ 3·703		$a_3 = +2·607$
+ 1	− 1·374	+ 1·235		$a_3 = +2·609$
− 0·953	− 1·539	+ 5·948		$a_2 = +8·440$
+ 4·419	+ 0·715	+ 13·569		$a_2 = +8·435$
− 5·687	+ 0·956	+ 3·707		$a_2 = +8·438$
+ 9·383	− 1·764	+ 36·842		$a_1 = +10·764$
+ 13·637	+ 5·096	+ 10·312		$a_1 = +10·569$
− 3·915	− 3·920	− 4·000		$a_1 = +10·587$
− 19·750	+ 3·136	+ 55·833		$a_1 = +10·556$
+ 17·174	− 3·842	+ 70		$a_0 = +2·16$
− 22·472	− 8·644	− 16·5		$a_0 = +2·272$
− 0·652	− 0·49	0		$a_0 = +2·222$
− 12·397	− 12·25	− 12		$a_0 = +2·183$
+ 11·197	− 2·372	− 33·5		$a_0 = +2·25$

The column headed Σ is a check only. It records the sum of all the other columns for each line. The check consists in carrying out, in respect of this column, the instructions given in the first column.

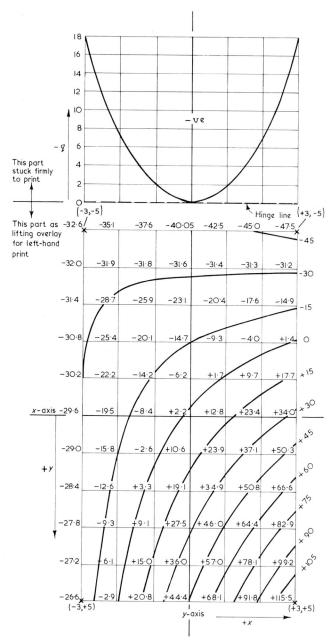

FIG. 10.5. THE PARABOLIC AND HYPERBOLIC CURVES PLOTTED ON THE GRIDDED
OVERLAY
These curves represent corrections to parallax bar heighting.

then find the corrections at all grid intersections on the line $x = -1$, and so on until corrections have been determined for all the grid intersections. A family of hyperbolas are now drawn in by interpolation. These curves represent lines along which the value of r remains constant. Interpolation in this case is exactly the same as when drawing in contours between points of known height.

We are now ready to begin work on the prints themselves. A number of evenly spaced points are chosen over the face of the overlap together with further points at all obvious changes of slope. The exact spacing of points will vary with the steepness of the gradients encountered, and after the first set of points has been heighted it might be necessary to add further points to help determine the exact topography. Each of the chosen points is ringed on the photograph, and heighting drill is carried out. The crude height is adjusted by reading off the corrections from the two graphs. For example, the crude height for the points $(+1·5, +3·9)$ is found to be 72 m. From the graph on Fig. 10.5 the parabolic correction for a point whose x-coordinate is $+1·5$ is found to be $-4·5$, and the hyperbolic correction for point $(+1·5, +3·9)$ is read as $+67$. Thus the correct height of this point is $72 - 4·5 + 67 = 134·5$ m. The hyperbolic correction is obtained from the graph by interpolating parallel to either the x- or the y-axis.

When the heights of all the chosen points have been found, we mark a series of points on the face of the left-hand photograph found by interpolation to fall on say the 90 m contour. Points lying on each of the other contours represented in the overlap are now marked. The stereoscope is used to enable the relief to be seen while each contour is sketched in on the face of the left-hand photograph.

The contours are transferred to the compilation sheet by tracing from the photograph under the Sketchmaster.

FIELD CHECK

As soon as the compilation is complete, probably whilst the contouring drill is being carried out (though it is better to wait until the contours themselves have been included on the compilation), a field check will be carried out. The field surveyors will take out photographic copies of the compilation and a set of photographs. The main purpose of this check is to note omissions from the detail, especially such items as have been hidden from photographic view by say overhanging foliage. At the same time note will be taken of gross inaccuracies which may have arisen, and local names and boundaries of districts, etc. will be added.

REPRODUCTION

After the field check, fair drawings are produced as in Chapter 8, and the map is reproduced by the gum reversal (or albumen process, if it is certain that not more than 30,000 copies will ever be pulled) and rotary offset printing processes. The fair drawings themselves must pass a rigorous test for density, evenness and fineness of line, square-cut ends of lines, accuracy of colour tone, conventional signs especially with regard to the bounding lines, and accuracy of registration marks. The rotary machines are stopped after the first few pulls so that the latter may be checked for registration, accuracy of tonal representation, and clarity of line.

When printing is complete for each plate it will be cleaned in asphaltum solution and given a thin coat of gum arabic before being filed away.

FURTHER READING

(i) *Manual of Photogrammetry*, Vol. I, Chapter 7.
(ii) Hammond.

The following deal with the GROUND SURVEY—
(i) *Manual of Photogrammetry*, Vol. I, Chapter 8.
(ii) Lyon, Chapter 11.
(iii) Moffitt, Chapter 5.

(See Bibliography (page 346) for full titles.)

CHAPTER 11

An Introduction to Machine Plotting

So far we have considered only simple methods of plotting from air photographs, in particular those based on the slotted templet method of increasing control, the simple mirror stereoscope and parallax bar for calculating heights, and the Sketchmaster for the final plotting of detail. In the past these methods have been used for making topographic maps, and there is no reason why they should not continue to be used for map revision and for making maps of scales between 1 in 100,000 and 1 in 25,000. Even at such small scales it would be economic to employ these simple methods only for relatively small projects or where the work is of a periodic nature. Most organizations dealing with map-making from air photographs would nowadays employ machine plotters of some sort.

The simple reflecting plotters make no attempt to correct lens distortions, and it is only possible to cope with height distortion by local adjustments. On the other hand, the simple mirror stereoscope does not correct for either lens or tilt distortion. We have seen in Chapter 7 how the radial-line plotter makes it possible to plot a map from the model formed in an ordinary mirror stereoscope, but this solution is only accurate within the limits of the radial line assumption.

SIMPLE CONCEPT OF PLOTTING INSTRUMENTS

In order to simplify the subject as much as possible we might consider all plotting instruments as derived from—

1. the simple mirror stereoscope,
2. the simple reflecting plotter,
3. the optical rectifier.

1. The basic instrument of this group is the simple mirror stereoscope with parallel mechanism, parallax bar and plotting attachment. In all such instruments the model is imaginary and not theoretically correct. The warping of the model may be corrected—

(*a*) approximately as in the radial-line plotter (see Fig. 7.13);
(*b*) mathematically as in the Zeiss Stereotope;
(*c*) mechanically as in the Santoni Stereomicrometer (see Fig. 11.11.)

2. In this type of instrument a theoretically correct imaginary

239

model is set up. The plotting pencil is attached to a floating mark which is moved across the model and in contact with the model surface.

If we consider viewing two Sketchmaster photo-images simultaneously, one with each eye, then the theory of this type of plotter becomes apparent. One of the simplest instruments of this type is the S.O.M. Stereoflex (see Fig. 11.12).

3. In this type of instrument a pair of photographs is projected from two optical rectifiers and viewed either

(a) Stereoscopically as in the Zeiss Stereoplanigraph (see Fig. 11.14), or

(b) anaglyphically as in the multiplex type of instrument (see Fig. 11.1.)

Although by no means the most accurate instrument, the multiplex is perhaps the simplest of the larger instruments, and is therefore treated in some detail below.

The foregoing is intended only as an introduction to instrumentation and not as a classification.

Aerotriangulation

In common with the simple methods of plotting, machine plotters require control points in order that the models may be correctly set up. Each overlap will require at least two ground control points and three height control points. This would entail a very large amount of ground work. For medium and smaller scales the slotted templet assembly could be used in order to increase the control, but this mechanical adjustment cannot help with height control. Some instruments, including the multiplex, are capable of breaking down major control to form minor control. The process involved is comparable with ground methods of triangulation, and is known as aerotriangulation.

THE MULTIPLEX

These instruments have been made by most firms whose activities include the manufacture of large photogrammetric instruments, and all are similar in principle and design. The one described here is produced by the Williamson Manufacturing Co. Ltd, of London.

The basic idea is that of the anaglyph, which from time to time has been a popular feature of picture magazines. Two slightly different views of the same object are illustrated, one depicted in green and the other in red. The two images are superimposed on the page but are so arranged that one is slightly displaced to left or right of the other, the whole forming a rather blurred image. This

page is viewed through a pair of spectacles, of which one eye-piece is a green and the other a red filter, so that one image is seen with one eye and the other with the other eye; thus a three-dimensional impression is conveyed to the brain.

In the multiplex the image of one photograph is projected in red on to a plain white surface, and the image of its overlapping pair is projected in blue-green on to the same surface. These reflected

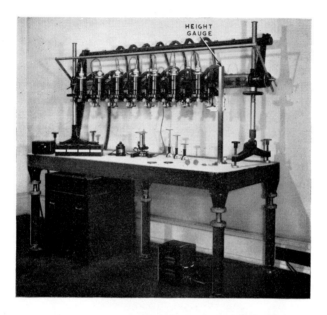

FIG. 11.1 (i) THE MULTIPLEX 7-PROJECTOR ASSEMBLY WITH ILLUMINATION
CONTROL UNIT
(*Williamson Manufacturing Co. Ltd.*)

images are viewed with red and blue-green spectacles and a three-dimensional anaglyphic model is seen (Fig. 11.2). Since it is a positive image which is projected, the reflected image of the left-hand photograph in Fig. 11.2 will consist of blue highlights on black shadow; thus no light will pass a red filter, so that no image would be received by the right eye.

The general appearance of the instrument may be seen from Figs. 11.1(i) and (ii).

The apparatus consists essentially of the following parts—

1. A range of projectors, each of which is made to represent a particular camera station.

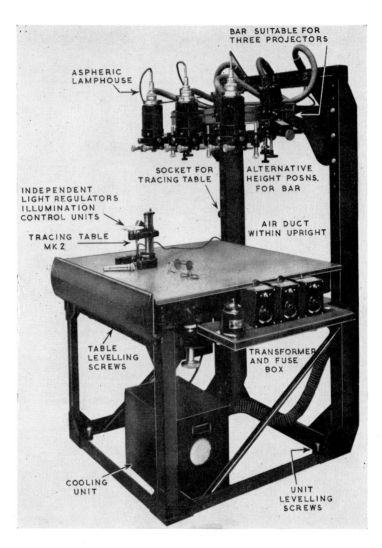

BAR SUITABLE FOR
THREE PROJECTORS

ASPHERIC
LAMPHOUSE

SOCKET FOR
TRACING TABLE

ALTERNATIVE
HEIGHT POSNS.
FOR BAR

INDEPENDENT
LIGHT REGULATORS
ILLUMINATION
CONTROL UNITS

AIR DUCT
WITHIN UPRIGHT

TRACING TABLE
MK 2

TABLE
LEVELLING
SCREWS

TRANSFORMER
AND FUSE
BOX

COOLING
UNIT

UNIT
LEVELLING
SCREWS

FIG. 11.1 (ii) MULTIPLEX 3-PROJECTOR ASSEMBLY TYPE A.P.U. MARK 2
(*Williamson Manufacturing Co. Ltd.*)

2. A horizontal map table on to which the map is eventually plotted.

3. A bar which supports the projectors, and which on some models is capable of rotation about its axis (Fig. 11.1(i)) and of being " tipped " in the fore and aft direction.

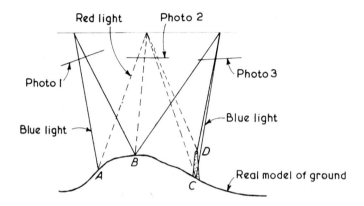

FIG. 11.2. FORMATION OF THE REAL MODEL IN THE MULTIPLEX

4. A tracing table (see Fig. 11.4) which forms the reflecting surface on which the coloured images of the two photographs are viewed. In the centre of the plane surface of the tracing table is the floating mark formed by a point source of light. The table itself is carried on a stand which can be moved over the surface of the map table. Vertically below the floating mark is a pencil which can be raised or lowered on to the map plane, and so can trace the plan route of the floating mark. The tracing table surface can be raised and lowered so that the floating mark can be kept in contact with the model surface. Variations in height of the floating mark can be read on the glass scale which will normally be graduated in milli-metres, and therefore a graph will need to be constructed so that the readings can be converted to feet or metres at the model scale. A specially divided glass scale can be obtained to read directly in feet or metres if the amount of work to be done at any particular scale warrants such expenditure.

Each projector (see Fig. 11.3) consists of three main parts—body, condenser housing and lamphead, and is provided with an inter-changeable red or blue-green filter and a projector bulb. The body is a small-scale reproduction of the taking camera, approximately

114 mm diameter and 62 mm high, mounted so that it may be rotated about, and translated along, three mutually perpendicular axes (see Fig. 11.5). Figure 11.3 is annotated to show the method of effecting these movements.

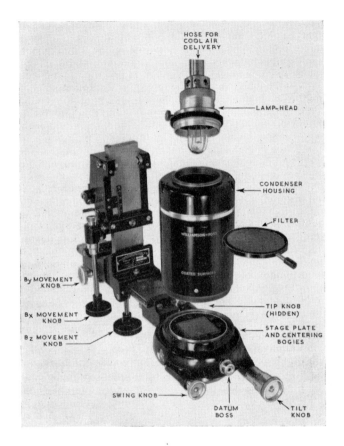

FIG. 11.3. MULTIPLEX PROJECTOR MARK 2
(Williamson Manufacturing Co. Ltd.)

Since the lamphead is small and the power of the bulb is high the projector must be cooled by pumping in air through ducts. This will prevent the emulsion on the diapositive from melting, and prolong the life of the bulb.

The diapositive is reduced in size to about 62·5 mm × 62·5 mm. It is obtained from the negative by projecting the original negative on to a sensitized glass plate in a reduction printer.

Although similar to an optical rectifier, the reduction printer

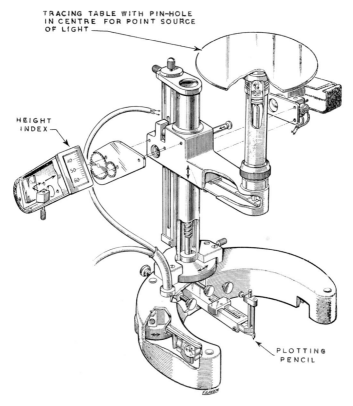

TRACING TABLE WITH PIN–HOLE
IN CENTRE FOR POINT SOURCE
OF LIGHT

HEIGHT
INDEX

PLOTTING
PENCIL

FIG. 11.4. MULTIPLEX TRACING TABLE MARK 2
(*Williamson Manufacturing Co. Ltd.*)

makes no attempt to remove tilt distortion, but lens distortions are greatly reduced by matching the projector lens in the reduction printer against the camera and multiplex projector lenses.

Once the instrument is properly set up, the plotting of detail and contours is a straightforward operation of the tracing table and pencil, but the process of setting up the instrument, usually known as orientation, is complex, and is carried out in the following stages—

1. *Inner orientation* which entails the re-establishment of the central perspective for each projector in turn. The projecting lamp must be centralized and focused, and the diapositive must be brought into its correct plane, i.e. that plane which simulates the focal plane in the taking camera. The diapositive must also be centralized by making the principal point lie on the axis of projection. In addition to making provision for the reduction of distortions, steps must be

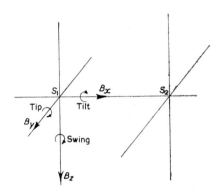

FIG. 11.5. THE MOVEMENTS OF A MULTIPLEX PROJECTOR

taken to satisfy the lens condition. The Scheimpflug condition does not apply as the lens plane and diapositive plane remain parallel as in the taking camera.

2. *Outer orientation* which replaces the four-point setting of the rectifier and comprises—

(*a*) *Relative orientation* of one projector with respect to another in order that a correct model may be reconstructed.

(*b*) *Absolute orientation* in which the model is oriented correctly in relation to the map plane by—

(i) *Scaling*, i.e. setting the horizontal scale of the model to agree with the compilation scale by increasing or decreasing the spacing of the projectors.

(ii) *Horizontalizing* the model. This might be done by altering the slope of the model as a whole by movements of the bar, or by tilting the map plane to agree with the general slope of the model. In some models (see Fig. 11.1(ii)) the bar is not adjustable, and horizontalizing is carried out by reciprocal movements of individual projectors.

Before beginning the drill for orientation of a particular strip of

photography, the map plane should be horizontalized using the spirit level in accordance with the manufacturer's instructions. The map plane should then be covered with a flat sheet of white paper.

Inner Orientation

Figure 11.3 illustrates the various parts and movements of one projector. Turn on the air cooling system and then the lamp of the first projector. Move this projector so that the whole of the illuminated area falls on the map plane. Focus the lamp by moving the axial adjustment screw until the maximum intensity of light is obtained. Now move each of the two lamp centering screws in turn until there is a clear white square of light on the map plane. Sometimes it might be necessary to leave the corners of this square of light slightly rounded by a reddish-orange band. Turn off the lamp.

We are now ready to insert the diapositive. Remove the condenser housing and lightly but thoroughly dust the surfaces of the diapositive and the glass stage plate with a camel-hair brush. Hold the diapositive with the emulsion side down; orient so that the image appears as you wish it to be projected; now rotate the diapositive through 180° in swing and place it gently on the stage-plate. Release the two idling spring-loaded centering bogies which will hold the diapositive firmly in contact with the plate. Check that the diapositive moves linearly when the centering screws are rotated. Replace the condenser housing.

Turn on the lamp again. In the middle of the projected image on the map plane there should be a small black dot which is the projected image of a dot engraved at the centre of the stage plate. Nearby will be seen the projected image of the principal point cross which must now be made to coincide with the dot by movements of the two diapositive centering screws.

Each of the remaining projectors is similarly oriented. Inner orientation is now completed by zeroing the heighting scale on the tracing table in order to satisfy the lens condition approximately.

There is a limited range of focus for these projectors, and the optimum conditions are obtained when the vertical distance from the centre of projection to the tracing table is 360 mm. For the whole model to be sufficiently sharp this distance must be between 270 and 450 mm when viewing any point on the model. This projection distance Z represents the flying height in the model; thus—

$$Z = H \times (\text{scale of the model})$$

If $H = 3{,}000$ m $= 3{,}000{,}000$ mm then the scale of the model

J

should approximate to $\dfrac{360}{3,000,000}$ or 1 in 8,333. Let us assume that we have decided to plot at a scale of 1 in 8,000, then

$$Z = 3,000,000 \times \frac{1}{8,000} = 375 \text{ mm}$$

Set the floating mark 381 mm below the projector datum boss, using the height gauge provided (see Fig. 11.1(i)). Release the glass scale clamp, and adjust the scale so that it reads exactly 50 mm. It is now in the centre of its run.

Overlap between Photos 1 and 2

FIG. 11.6. LOCATION OF CONTROL FOR RELATIVE ORIENTATION

Outer Orientation

As shown in Fig. 11.5, each projector is capable of six movements—

 1. Linear, horizontal, and parallel with the bar; known as B_x.
 2. Linear, horizontal, and perpendicular to the bar; known as B_y.
 3. Linear and vertical; known as B_z.
 4. Rotation about the x-axis, or tilt; known as ω.
 5. Rotation about the y-axis, or tip; known as ϕ.
 6. Rotation about the z-axis, or swing; known as κ.
4 and 5 are sometimes also called *roll* and *pitch* respectively.

It will be noted that the x and y-axes correspond to those for the heighting drill at the end of Chapter 10.

Both of the first two projectors are set so that their distances in the y-direction from the bar are equal. Their heights above the map plane must also be equalized, and the B_y and B_z scales should be near the centres of their runs. The three rotational movements should be set so that the projectors are approximately horizontalized.

The separation of the projectors is now wholly in the x-direction and will govern the scale of the model.

If B is the horizontal distance between the two projectors, then when the scale is correct

$$B = b \times \frac{\text{model scale}}{\text{photo scale}}$$

where b is the mean length of the two photo base lines.

If we are using projectors 1 and 2 (numbering from left to right) of the three-projector instrument, then projector No. 2 is now brought to a central position on the bar, using the B_x-movement. Adjust projector 1 in the B_x-direction so that the distance between the two projectors is equal to the calculated value of B.

Put a red filter in projector 1 and a blue filter in projector 2, switch on the cooling system, and check that it is working properly. Now switch on both projectors.

If the photographs had both been truly vertical then a true to scale real model could now be seen by viewing through the spectacles provided. The presence of tilt, however, means that pairs of rays representing any particular ground point will probably not intersect at all (i.e. they will be skew lines). Thus, no matter how we alter the height of the floating mark, the two images of any point A cannot be made to coincide on the platen of the tracing table. Looking at the surface of the platen without using the spectacles we can see the red image and the blue image separately; raising and lowering the floating mark causes these two images to move towards or away from each other in the x-direction. If we view a particular point A, and by raising and lowering the floating mark we equate the x-coordinates of the red and blue images of this point, then the separation of the two image points is now wholly in the y-direction, and is known as want of correspondence or K. It is by systematically eliminating K at all points that relative orientation is achieved and the correct model becomes visible. In detecting small amounts of K it is usually considered better to use a small black cross drawn on the platen rather than the floating mark itself.

RELATIVE ORIENTATION. Choose six readily discernible image points approximately in the positions shown in Fig. 11.6 where 1 and 2 are near the principal points of projections 1 and 2 respectively.

Now eliminate K at each of these points in turn as follows, keeping the x-coordinates equal by appropriate z-movements of the floating mark—

 (*a*) At point 1 by swing of projector 2.
 (*b*) At point 2 by swing of projector 1.
Repeat (*a*) and (*b*) until positions 1 and 2 are free of K.
 (*c*) At position 6 by tip of projector 1.

(*d*) At position 4 by tilt of projector 1; overtilt by imparting about three times the amount of tilt required to eliminate *K*.

Repeat above until points 1, 2, 4 and 6 are free of *K*.

(*e*) At position 5 by tip of projector 2. Check for *K* at position 3, and repeat all movements until *K* is eliminated from all six points.

At this stage the model is correctly set up but it still requires horizontalizing, i.e. it needs tilting as a whole relative to the map plane. In addition, the model will be only approximately true to scale.

ABSOLUTE ORIENTATION. This consists in setting the model to the correct scale and in making it horizontal. The former requires at least two ground control points and the latter at least three height control points. They need not be the same points, but it is desirable to have them so, as this provides a cross-check and simplifies identification.

Scaling. None of the above movements has involved a B_y- or a B_z-change in either projector so that the scale can still be adjusted by a B_x-movement of either projector, without reintroducing *K*.

Using the floating mark in the normal way, plot the positions of the two control points and measure the distance apart using a diagonal scale; let this be say 99·1 mm. If the correct distance should have been 98·3 mm, then by B_x-movement of projector 1, reduce the *x*-separation of the projectors in the proportion 98·3 to 99·1 (i.e. make the new distance $= 229 \times \dfrac{98\cdot3}{99\cdot1}$ where 229 mm was the originally calculated separation). Check again, and repeat until correct.

Horizontalizing. Where the bar is adjustable, by systematic tipping and tilting of the bar itself, the errors in the heights of the three height control points recorded on the glass scale of the tracing table can be equalized. The glass scale is adjusted to eliminate this error, and the tracing table index will now record correct elevations.

When horizontalizing by use of the projectors only, care must be taken to ensure that the relative orientation is not affected. Thus when one projector is tipped or tilted the other must be tipped or tilted by the same amount and in the same direction.

In Fig. 11.7, *A*, *B* and *C* are the positions of the three height control points as plotted from the scaled model on to the map plane. Their coordinates relative to p_1p_2 as the *x*-axis and O_y as the *y*-axis, where *O* is the mid-point of p_1p_2, are $(-53\cdot2, -5\cdot7)$, $(-9\cdot8, +49\cdot5)$ and $(+29\cdot7, -23\cdot2)$ respectively.

After taking height readings on the tracing table scale for each of these three points, determine the errors in height by comparing with the known height of each point. Let these height errors be

$$A - 5\cdot4 \text{ mm} \qquad B - 9\cdot8 \text{ mm} \qquad C + 6\cdot2 \text{ mm}$$

Note that these errors could have been converted to metres but it is usually more convenient to work in terms of units on the heighting

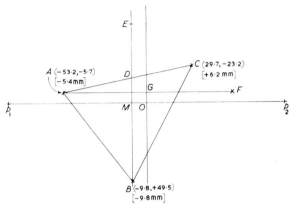

FIG. 11.7. ABSOLUTE ORIENTATION—HEIGHT CONTROL FOR HORIZONTALIZING MODEL

scale—having first converted the known heights to these units at the scale of the model. Draw $AF = 2AG$ and parallel with p_1p_2.

Draw BD perpendicular to p_1p_2, cutting AC in D and p_1p_2 in M.
Produce BD to E so that $EM = MB$.

Then coordinates of E are $(-9\cdot8, -49\cdot5)$ and the x-coordinate of D is $-9\cdot8$.

$$\therefore \quad y\text{-coordinate of } D \text{ is } -5\cdot7 - \left[(23\cdot2 - 5\cdot7) \times \frac{53\cdot2 - 9\cdot8}{53\cdot2 + 29\cdot7}\right]$$
$$= -14\cdot9$$

i.e. D is the point $(-9\cdot8, -14\cdot9)$

\therefore by interpolation between errors at A and C, error at D will be approximately

$$-5\cdot4 + (5\cdot4 + 6\cdot2) \times \frac{53\cdot2 - 9\cdot8}{53\cdot2 + 29\cdot7} = -5\cdot4 + 11\cdot6 \times \frac{43\cdot4}{82\cdot9}$$

By extrapolation from B and D, the error at E is approximately

$$-9\cdot8 + \left(9\cdot8 - 5\cdot4 + 11\cdot6 \times \frac{43\cdot4}{82\cdot9}\right)\frac{49\cdot5 + 49\cdot5}{49\cdot5 + 14\cdot9}$$

Now the model must be tilted so that the errors at B and E are equal. This must be done by estimating the tilt required, then tilting one projector by that amount, removing K by tilting the other projector, and repeating this until the errors are equal. In practice experience will decide the amount of tilt to apply but

$$\tan \omega \simeq \frac{\frac{1}{2}(\text{difference between errors at } B \text{ and } E)}{y\text{-coordinate of } B}$$

The tip is corrected in a somewhat similar manner. The floating mark is set at ground level at O, and one projector is then tipped by an estimated amount. The other projector is then tipped in the same direction until the image of a point near O is at the same height as before the tipping took place. Again experience will normally decide the amount of tip and it may be necessary to repeat these tip movements after checking the heights at A and C.

The amount of tip can also be estimated by calculation—

$$\tan \phi \simeq \frac{\frac{1}{2}(\text{error at } A - \text{error at } F)}{x\text{-coordinate of } A}$$

A small amount of K will probably have been reintroduced at points off the base line, and this should be removed by B_z-movement of projector 1, which may make a slight B_y-movement also necessary.

It now remains to check the scale and adjust in B_x if necessary, then carry out the whole of the orientation again as a check, repeating until no errors remain. Finally the glass scale on the tracing table should again be zeroed, this time on one of the height control points.

Projectors 1 and 2 are now correctly oriented, and plotting may begin on to topographic base secured in the map plane. If the third projector is required, this can be oriented relative to projector 2, which will not be altered throughout the whole procedure. Projector 3 must be adjusted in inner orientation, and then oriented relative to projector 2 as follows; projector 3 will have a red filter, and no absolute orientation will be necessary—

The points numbered 1 to 6 are arranged now in the overlap between projectors 2 and 3, again in positions shown in Fig. 11.6.

Eliminate K by movements of projector 3 as follows—

(a) At position 2 by B_y } repeat until free of K.
(b) At position 1 by swing }
(c) At position 6 by B_z.
(d) At position 4 by tilt, overtilting by tilting approximately 3 times amount required to remove K.

(e) At position 2 by B_y.

Repeat (c) (d) (e) as necessary.

(f) At position 1 by swing.

(g) At position 3 by tip.

Check for K at position 5 and repeat all steps until no K remains. All three projectors are now oriented, and in an instrument having more projectors, each of these may be oriented in turn by orienting 4 on 3, then 5 on 4 and so on. This is called a cantilever, and errors will increase as further projectors are added. At least two ground control points and three height control points should appear in the last overlap, and the error should be spread evenly over the intervening overlaps; this is known as bridging. Normally some additional control is required near the middle of the bridge. This is aerotriangulation by which control for each overlap is built up from relatively sparse ground control.

The multiplex is a universal plotter as it is capable of aerial triangulation as well as plotting detail and contours. Although the model as seen is imaginary, plotting is from a real model formed by a purely optical process. The models are true perspective diagrams in so far as the camera lens distortions are balanced by the reduction printer lens and the final projection lens. Each instrument of this type is designed for use with a particular range of cameras: the Williamson models they designed for use with the Eagle IX which has a 152·4 mm focal length lens and a 230 × 230 mm format. The reason why the range of projection distances is limited is because the focal length of the projector is almost fixed and the sharpness of the image is relatively poor. Other drawbacks are low resolution due to the reduction in scale of the diapositive, and insufficient illumination. However, the multiplex is capable of a plan accuracy of about ± 0·5 mm and a heighting accuracy of about 1/1000 of the flying height. Its simplicity and the theoretical accuracy of its solution of the problem of re-forming the model of the ground, make it suitable for small- and medium-scale mapping.

The Kelsh type of instrument (see Fig. 11.8) is the result of an attempt to remedy the main defects of the multiplex. The diapositive is full-size, and a system of rods attaches the tracing table to each lamp. These rods direct the lamp towards that part of its diapositive which is being viewed. Such an instrument is not much more complicated than the multiplex itself, and is capable of greatly increased plotting accuracy. The Balplex (see Fig. 11.9) is a further variant of the multiplex principle, and is also available with a bank of eight projectors.

Viewing in colour accounts for some loss of illumination, and

experiments have been made with polarized light, but a number of firms have produced instruments of both multiplex and Kelsh types incorporating " blink " viewing apparatus (see Fig. 11.10). Rotating shutters in each eye-piece are synchronized with similar

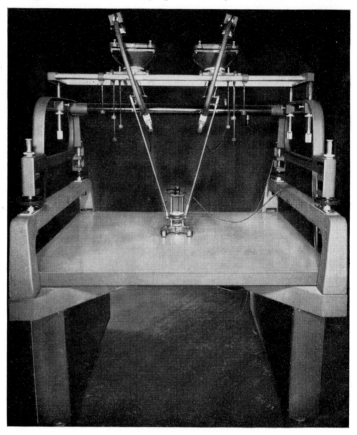

FIG. 11.8. THE KELSH PLOTTER
(*The Kelsh Instrument Co. Inc.*)

shutters attached to the respective projectors. Thus when the left eye-piece shutter is open, so is the left-hand projector shutter, and the left eye obtains an uninterrupted view of the left-hand dia-positive—at this moment the two right-hand shutters are closed. As the two left-hand shutters close so the two right-hand ones open. In this way first one image is seen and then the other in rapid

succession so enabling the brain to reconstruct a three-dimensional model.

When viewing the coloured images only a part of the spectrum is utilized; when using the blink apparatus illumination is wasted by

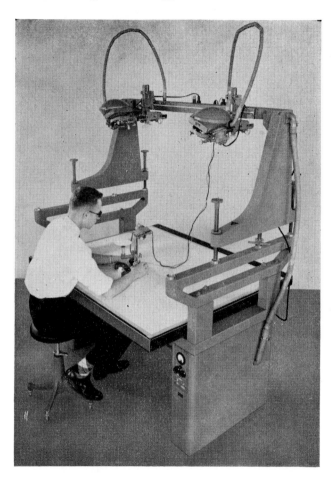

FIG. 11.9. THE BALPLEX PLOTTER
(Bausch and Lomb Optical Co.)

discontinuity in time; even with polarized light only a proportion of the light vibrations can be used. There is then always some loss of illumination with these methods of viewing which is not shared when the viewing is stereoscopic.

INSTRUMENTS BASED ON THE SIMPLE
MIRROR STEREOSCOPE

Use of the mirror stereoscope involves no inner orientation; relative orientation is represented only by the swing correction carried out when making the base lines collinear, and some scale control is achieved by adjusting the x-separation of the prints for ease of fusion.

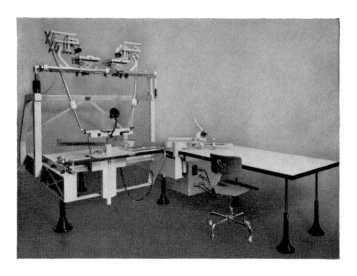

FIG. 11.10. PG1 STEREO RESTITUTION INSTRUMENT (BLINK TYPE)
(*Kern and Co. Ltd.*)

The radial-line plotter does require a measure of inner orientation, in that the principal point is automatically centralized. A measure of absolute orientation is also involved in setting the model to control before plotting begins. This instrument incorporates a linkage mechanism by which the movement of the plotting pencil is approximately corrected for the errors inherent in the model.

In other instruments under this heading, a theoretically exact correction is made to the movement of the pencil.

The Stereotope is a development of the Stereopret (see Fig. 7.15). The pencil movement is corrected mathematically by two computers incorporated in the instrument itself. This instrument is simple in operation and the makers claim results comparable with those of the multiplex.

In instruments which use an imaginary model, one floating mark is formed by fusing two similar marks, one in front of each eye; these are sometimes called half-marks.

In the Stereomicrometer (see Fig. 11.11) the half-marks are placed axially in each eye-piece, and might therefore be expected to remain fused in a floating mark which will appear to stay at a constant height.

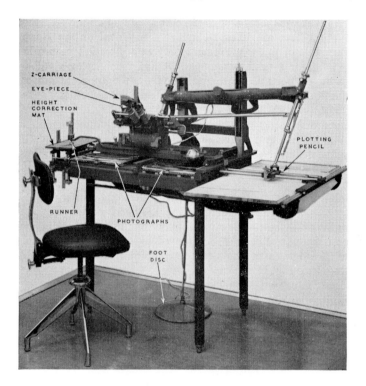

FIG. 11.11. THE STEREOMICROMETER
(*Officine Galileo*)

However, the floating mark is brought on to the " ground " surface by apparent x-movements of the two photographs, and since the model of the ground will seem more realistic to our brain, it will usually be the floating mark which seems to rise and fall rather than the model. In the Stereomicrometer the heighting knob operates the reading on the heighting scale, and at the same time varies the x-separation of the objectives of the viewing system, so that after

the initial setting there is no further x-movement of the photographs themselves.

This instrument incorporates basic eye-piece and plotting pencil movements similar to those of many of the larger machines. A rigid horizontal frame is mounted over the photograph table, and is capable of movement only in the y-direction; it is therefore known as the y-carriage. The x-carriage is another rigid horizontal frame carrying the eye-pieces and capable of moving over the y-carriage in only the x-direction. The z-carriage is mounted on the x-carriage and capable of linear movement only in a direction perpendicular to that of the x- and y-carriages. A link mechanism, similar to a more or less vertical pantograph, conveys the apparent movement of the floating mark to the plotting pencil—it is actually the joint movements of the objectives which control the plotting arm.

Inner orientation is represented in the Stereomicrometer by a mechanical change in the link mechanism to accommodate the principal distance of the photographs, and by focusing the objectives and eye-pieces to obtain sharp images of the photographs and the half-marks respectively.

Relative orientation includes swing corrections similar to those of the multiplex; B_x movement of the left-hand photograph is used to make the height scale read zero when the right-hand principal point is being scanned; K is removed by B_y-movement of the left-hand photograph at the time each point is being heighted and plotted. (See Fig. 11.5.)

Scaling is carried out by setting to two control points as for the multiplex, but it is achieved by an alteration of the link mechanism and does not therefore affect the model.

When these stages of orientation have been carried out the instrument is capable of plotting a sketch map.

The model is warped due to lack of ϕ- and ω-rotations of the two photographs. Correction of the pencil movement is effected by systematic distortion of the surface of the mat on the height corrector. When this surface is set, movement of the viewing system causes the runner to move over the mat in such a way that its position on the mat represents the position on the overlap of the point being observed. As the mat is traversed, the rise and fall of the runner operates a system of levers which effect the necessary corrections to the height gauge and the plotting pencil.

The mat comprises a series of metal rods arranged parallel with the y-axis; thus corrections remain linear in the y-direction. The mat is capable of rotational movements in ϕ and ω and of up to three further warping movements. For complete setting of the mat,

then, at least six height control points are required; the mat is systematically warped until the height gauge reads correctly for each of these points.

Oriented in this way the Stereomicrometer is considered to be of about the same accuracy as the multiplex.

INSTRUMENTS BASED ON THE SKETCHMASTER PRINCIPLE

Perhaps the simplest method of plotting from a theoretically correct stereoscopic model is that used in the Stereoflex (see Fig. 11.12). If we consider viewing two Sketchmaster photo images simultaneously then the theory of this plotter becomes apparent (see Fig. 11.13).

In the Stereoflex the model can be traced out point by point, using a floating mark and tracing table similar to those of the multiplex. With this instrument as with the Kelsh, a wider range of scale can be obtained by using the pantograph-type linkage for the plotting pencil.

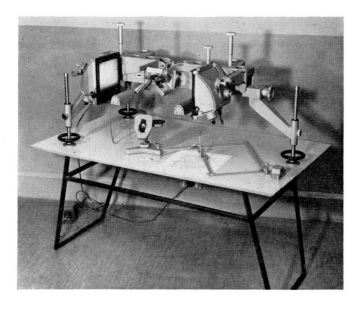

FIG. 11.12. THE STEREOFLEX
(*S.O.M., Paris*)

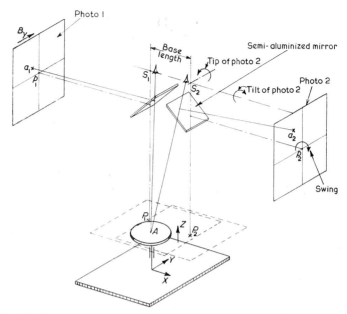

FIG. 11.13 LINE DIAGRAM SHOWING THE PRINCIPLES OF THE STEREOFLEX
The swing is by a movement of the photograph itself.
Tip and tilt are by movements of the relevant mirror system about two
horizontal but mutually perpendicular axes through S.
(S.O.M., Paris.)

The photographs can themselves be rotated in swing. The scale adjustments, as with the Sketchmaster, are made by altering the eye-piece to photo and eye-piece to map distances. As these scale movements are carried out independently for each photo, they simulate the inclination of the air-base. Tip and tilt of each photo is dealt with by combined movements of eye-piece and photo-carrier.

The foregoing instruments are intended for map revision and for plotting detail at relatively small scales, and between previously plotted and fairly dense control. However some, notably the multiplex, can be used for aerotriangulation. Consideration of the more complex, rigorous solution instruments is deferred until the next chapter.

BRIDGING WITH THE MULTIPLEX

It has been seen that, given two ground control and three height control points for an overlapping pair of photographs, the appropriate diapositives can be mounted in two adjacent multiplex

succession so enabling the brain to reconstruct a three-dimensional model.

When viewing the coloured images only a part of the spectrum is utilized; when using the blink apparatus illumination is wasted by

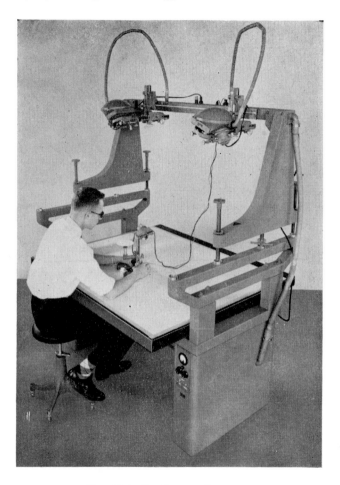

FIG. 11.9. THE BALPLEX PLOTTER
(Bausch and Lomb Optical Co.)

discontinuity in time; even with polarized light only a proportion of the light vibrations can be used. There is then always some loss of illumination with these methods of viewing which is not shared when the viewing is stereoscopic.

INSTRUMENTS BASED ON THE SIMPLE
MIRROR STEREOSCOPE

Use of the mirror stereoscope involves no inner orientation; relative orientation is represented only by the swing correction carried out when making the base lines collinear, and some scale control is achieved by adjusting the x-separation of the prints for ease of fusion.

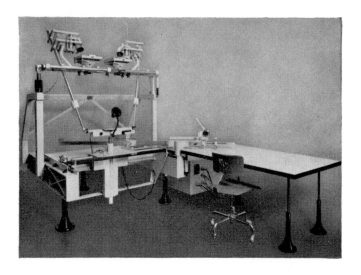

FIG. 11.10. PG1 STEREO RESTITUTION INSTRUMENT (BLINK TYPE)
(*Kern and Co. Ltd.*)

The radial-line plotter does require a measure of inner orientation, in that the principal point is automatically centralized. A measure of absolute orientation is also involved in setting the model to control before plotting begins. This instrument incorporates a linkage mechanism by which the movement of the plotting pencil is approximately corrected for the errors inherent in the model.

In other instruments under this heading, a theoretically exact correction is made to the movement of the pencil.

The Stereotope is a development of the Stereopret (see Fig. 7.15). The pencil movement is corrected mathematically by two computers incorporated in the instrument itself. This instrument is simple in operation and the makers claim results comparable with those of the multiplex.

In instruments which use an imaginary model, one floating mark is formed by fusing two similar marks, one in front of each eye; these are sometimes called half-marks.

In the Stereomicrometer (see Fig. 11.11) the half-marks are placed axially in each eye-piece, and might therefore be expected to remain fused in a floating mark which will appear to stay at a constant height.

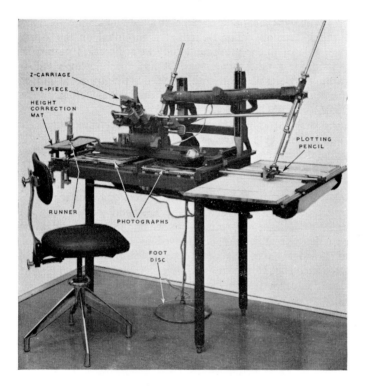

FIG. 11.11. THE STEREOMICROMETER
(*Officine Galileo*)

However, the floating mark is brought on to the " ground " surface by apparent x-movements of the two photographs, and since the model of the ground will seem more realistic to our brain, it will usually be the floating mark which seems to rise and fall rather than the model. In the Stereomicrometer the heighting knob operates the reading on the heighting scale, and at the same time varies the x-separation of the objectives of the viewing system, so that after

the initial setting there is no further x-movement of the photographs themselves.

This instrument incorporates basic eye-piece and plotting pencil movements similar to those of many of the larger machines. A rigid horizontal frame is mounted over the photograph table, and is capable of movement only in the y-direction; it is therefore known as the y-carriage. The x-carriage is another rigid horizontal frame carrying the eye-pieces and capable of moving over the y-carriage in only the x-direction. The z-carriage is mounted on the x-carriage and capable of linear movement only in a direction perpendicular to that of the x- and y-carriages. A link mechanism, similar to a more or less vertical pantograph, conveys the apparent movement of the floating mark to the plotting pencil—it is actually the joint movements of the objectives which control the plotting arm.

Inner orientation is represented in the Stereomicrometer by a mechanical change in the link mechanism to accommodate the principal distance of the photographs, and by focusing the objectives and eye-pieces to obtain sharp images of the photographs and the half-marks respectively.

Relative orientation includes swing corrections similar to those of the multiplex; B_x movement of the left-hand photograph is used to make the height scale read zero when the right-hand principal point is being scanned; K is removed by B_y-movement of the left-hand photograph at the time each point is being heighted and plotted. (See Fig. 11.5.)

Scaling is carried out by setting to two control points as for the multiplex, but it is achieved by an alteration of the link mechanism and does not therefore affect the model.

When these stages of orientation have been carried out the instrument is capable of plotting a sketch map.

The model is warped due to lack of ϕ- and ω-rotations of the two photographs. Correction of the pencil movement is effected by systematic distortion of the surface of the mat on the height corrector. When this surface is set, movement of the viewing system causes the runner to move over the mat in such a way that its position on the mat represents the position on the overlap of the point being observed. As the mat is traversed, the rise and fall of the runner operates a system of levers which effect the necessary corrections to the height gauge and the plotting pencil.

The mat comprises a series of metal rods arranged parallel with the y-axis; thus corrections remain linear in the y-direction. The mat is capable of rotational movements in ϕ and ω and of up to three further warping movements. For complete setting of the mat,

then, at least six height control points are required; the mat is systematically warped until the height gauge reads correctly for each of these points.

Oriented in this way the Stereomicrometer is considered to be of about the same accuracy as the multiplex.

INSTRUMENTS BASED ON THE SKETCHMASTER PRINCIPLE

Perhaps the simplest method of plotting from a theoretically correct stereoscopic model is that used in the Stereoflex (see Fig. 11.12). If we consider viewing two Sketchmaster photo images simultaneously then the theory of this plotter becomes apparent (see Fig. 11.13).

In the Stereoflex the model can be traced out point by point, using a floating mark and tracing table similar to those of the multiplex. With this instrument as with the Kelsh, a wider range of scale can be obtained by using the pantograph-type linkage for the plotting pencil.

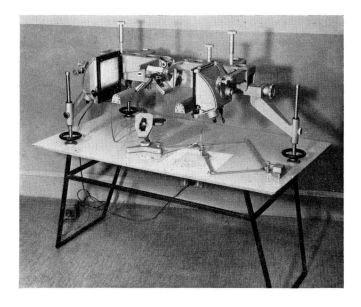

FIG. 11.12. THE STEREOFLEX
(*S.O.M., Paris*)

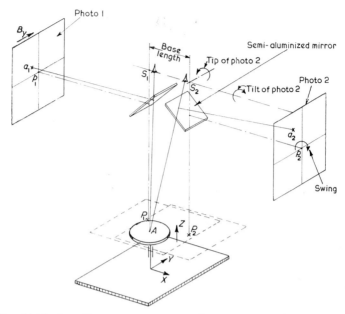

FIG. 11.13 LINE DIAGRAM SHOWING THE PRINCIPLES OF THE STEREOFLEX
The swing is by a movement of the photograph itself.
Tip and tilt are by movements of the relevant mirror system about two
horizontal but mutually perpendicular axes through S.
(*S.O.M., Paris.*)

The photographs can themselves be rotated in swing. The scale adjustments, as with the Sketchmaster, are made by altering the eye-piece to photo and eye-piece to map distances. As these scale movements are carried out independently for each photo, they simulate the inclination of the air-base. Tip and tilt of each photo is dealt with by combined movements of eye-piece and photo-carrier.

The foregoing instruments are intended for map revision and for plotting detail at relatively small scales, and between previously plotted and fairly dense control. However some, notably the multiplex, can be used for aerotriangulation. Consideration of the more complex, rigorous solution instruments is deferred until the next chapter.

BRIDGING WITH THE MULTIPLEX

It has been seen that, given two ground control and three height control points for an overlapping pair of photographs, the appropriate diapositives can be mounted in two adjacent multiplex

projectors and oriented so that a correct scale model is set up in space. Using the tracing table pencil, any point on the model surface can be projected orthogonally on to the base-grid lying on the plotting surface of the instrument, and a topographic map can be plotted. Similar kinds of procedure enable the other instruments mentioned in this chapter to plot maps from pairs of photographs. The amount of ground control required for plotting a complete block of photography in this way involves long and relatively costly field operations.

Using a multi-projector instrument similar to that shown in Fig. 11.1, a complete strip of photographs can be oriented in such a manner that the angular relationships between the individual projectors are exactly the same as were the angular relationships in space between the camera in its successive air station positions. Some instruments can be used to assemble up to 15 projectors.

When a strip is set up in this way, so that it starts from a fully controlled single model and finishes at another controlled model, the assembly is known as a multiplex bridge, and from it sufficient horizontal and vertical control can be obtained to enable each intervening stereo-model in the strip to be set up independently— e.g. on a two-projector instrument.

The usually accepted absolute minimum amount of ground control necessary for setting up a multiplex bridge is three height and two horizontal control points on the first overlap of the strip, two height and one horizontal control points on the last overlap, and two height control points on a central overlap of the strip. These control points should as far as possible be in the lateral overlaps, i.e. in positions similar to those of pass points or of points 3, 4, 5 and 6 in Fig. 11.6.

The bridging drill will begin with the construction of a base-grid on which the ground control is plotted. In Fig. 11.14 (i) *B* represents one of the horizontal control points in the first overlap, and *L* represents the ground control point in the last overlap. The control plot is laid on the plotting surface of the instrument, the diapositives are mounted in the appropriate projectors, and inner orientation is carried out. The next step involves setting up the first two projectors in relative and absolute orientation, there being full control for this overlap.

The second model of the strip is formed by setting the third projector in relative orientation with projector 2. In practice the scale may not be exactly the same for both models, and the second model may not occur at the same level as the first. This can be corrected as follows—

Choose a point d which occurs in both models 1 and 2; view the point as produced in model 1 and bring the tracing table height to ground level at this point; now turn off projector 1 and turn on projector 3; do not alter the height of the tracing table but bring the image point d back to ground level by an x- (i.e. scale) movement of projector 3. Check the relative orientation of model 2, and readjust if necessary using the same

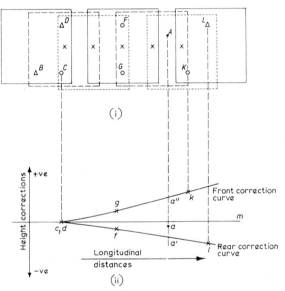

Δ Horizontal and height control
o Height control
x Passing-through points

FIG. 11.14. GROUND CONTROL AND HEIGHT CORRECTION GRAPHS
B, C, G and K are in front lateral overlap. D, F and L are in rear lateral overlap.

movements as before. To remove K completely it may also be necessary to carry out slight y- and z-translations of projector 3. This drill is often referred to as " passing through ".

The point d should be near the flight path, have an easily recognizable and precise image, and be located in an area in which the tracing table can be brought to ground level without ambiguity. Projector 4 is now oriented relative to projector 3, and the " passing through "

drill is performed as above. In this way each successive model of the strip is set up.

If B' and L' are respectively the multiplex-plotted positions of the points B and L, then the bridge scale will be determined by measuring $B'L'$ and comparing this length with BL. The x-separation of each pair of projectors is then increased (or decreased) to a distance equal to $BL/B'L'$ multiplied by the original spacing. This adjustment is carried out by moving projector 2 first, followed in succession by projectors 3, 4, 5 and so on to the end of the strip. There is no easy way of measuring the x-separation accurately, so that this scale adjustment is usually done by calculating the correct tracing table height readings for each passing-through point in turn.

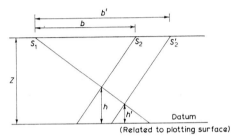

FIG. 11.15. CALCULATING TRACING TABLE HEIGHTS FOR SCALING BRIDGE

Actually it is the corrections which are calculated since these will be cumulative throughout the strip.

In Fig. 11.15—

h' = existing height of tracing table above datum
h = correct height of tracing table above datam
Z = distance of centres of projection above datum
b' = existing separation of projectors
b = correct separation of projectors
Scale ratio, $BL/B'L' = b/b'$
By similar triangles: $(Z - h)/b = (Z - h')/b'$
i.e. $Z - h = (Z - h') \times b/b' = (Z - h') \times BL/B'L'$
or $h = Z - (Z - h') \times BL/B'L'$
Thus, correction $= h - h' = Z - h' - (Z - h') \times BL/B'L'$
$= (Z - h')(B'L' - BL)/B'L'$
so that the corrected heights of tracing table are
Model 1 $h_1 = Z - (Z - h_1') \times BL/B'L'$
Model 2 $h_2 = h_1 - (Z - h_2') \times (B'L' - BL)/B'L'$
Model 3 $h_3 = h_2 - (Z - h_3') \times (B'L' - BL)/B'L'$
and so on.

When this procedure has been completed the length $B'L'$ should be the same as BL, so that the overall scale is now correct.

If the control plot is moved until B coincides with B', and L with L', then it might be expected that the bridge would be fully oriented and that plotting from each model could take place. However, even at this stage it is unlikely that the heights at the two final height control points or at the two centre height control points would be correct. The graphical adjustments which may be used are fairly intricate and only a simplified version is given.

Fig. 11.14 (ii) shows a graph in which cm is the x-axis. The height errors of the model at G and K would be determined and the required corrections plotted as ordinates on the graph (at g and k respectively); C and D were used in the orientation of model 1; they have no error, and are therefore represented by the point c, d on the x-axis. A ruler or straight-edge is made to stand on its edge, and bent until the edge passes through c, g and k; a curve is drawn by moving a pencil point along this edge—this is a spline curve, and represents the height correction at each point along the strip having similar y-co-ordinates to C, G and K. A similar curve afl is drawn through the plotted positions of A, F and L. Corrections for model heights may be read off the graph for any point within the bridge— e.g. the correction at A, midway between the flight line and the near lateral line of control, will be read off the graph as the ordinate of a, which is one-quarter of the distance from a' to a'' on the relevant correction curves.

Using a 3-projector Instrument

Bridging is possible with a 3-projector instrument. The first two models are set up in the usual way, then the first projector is removed and the second and third projectors are translated in x to the left. The second model is re-established by moving one of the two projectors in x until the height of the passing-through point is again correct. Scale errors may be detected by checking against points plotted during the initial setting. Projector 1 is remounted to the right of projector 3, and a diapositive of the fourth photograph of the strip is inserted. After inner orientation, projector 1 is adjusted relative to projector 3, and model 3 is scaled using a passing-through point whose height has been determined from model 2. By moving the projectors in rotation the bridge can be completed. The overall scale error is measured as before, and scale corrections are calculated in terms of tracing table heights for each model. Final height corrections and plotting can be carried out as before.

Using a 2-projector Instrument

In a 2-projector instrument exactly the same procedure is possible provided that the height of the right-hand projector above the plotting surface can be accurately re-established after it is translated to the left. A special height gauge (see Fig. 11.1) can be obtained which will enable this distance to be measured easily and accurately.

Bridging is carried out on other 2-camera instruments by comparable procedures; though those specially designed for bridging, such as the Wild A7, are constructed in such a way that the second model is set up with photo 2 still in the right-hand projector. In this case each alternate model is formed from the right-hand side of the right-hand photograph and the left-hand side of the left-hand photograph. This is the base-out position of the base-in, base-out procedure.

The Inclinometer

After the bridging operation has been completed, the requisite horizontal control plotted and the height control recorded, the plotting of detail will be carried out from the individual models. For this purpose it would normally be necessary to repeat the whole of the relative orientation drill for each model in turn. However, with the use of an inclinometer the angular settings of the projectors can be measured and recorded during the bridging, and then reset when the particular overlap is to be plotted. An inclinometer consists simply of a pair of spirit bubbles mounted at right angles to one another, and attached to the projector in such a way that two micrometer screws can be used to bring the bubbles to the centres of their runs, and so to determine the tilts of the projector.

Block Adjustment

These procedures would enable plotting to be carried out from successive overlaps of each strip in a block of photographs; but there may still be noticeable discrepancies between two adjacent strips. The slotted templet assembly is the simplest method of removing discrepancies in plan; but no height adjustment is involved, so that vertical discrepancies remain.

There are several ways in which improvements have been made to the simple slotted templet method—by using spring-loaded studs, and stereo-templet pairs; but the more mathematically based Jerie analogue computer can also be used in a slightly different form to perform a height adjustment. Some improvement in

matching adjacent strips can also be made by running some cross-strips and carrying out bridging drill on these.

However, complete block adjustment can be carried out mathematically, by comparing three-dimensional coordinates established on the ground with similar coordinates of the same points as read from the plotting machines or from a stereocomparator. Equations can then be deduced which can be used to determine corrections to apply to three-dimensional machine coordinates of any other point.

FURTHER READING

There is an immense amount of literature dealing with this aspect of the subject, and an advanced student must read very widely; especially must he keep up to date with articles appearing in the periodical journals such as those listed in the bibliography (page 346).

STEREOSCOPIC PLOTTING
 (i) Schwidefsky, pages 158–73, 196–205.
 (ii) *Manual of Photogrammetry*, Vol, II, Chapter 13.
 (iii) Hart, pages 275–326.
 (iv) Moffitt, pages 305–60.
 (v) Hallert, pages 119–76.
 (vi) Lyon, Chapters 6 and 7.
 (vii) Zeller, pages 62–79, 126–38.

AEROTRIANGULATION
 (i) Schwidefsky, pages 248–76.
 (ii) Hallert, pages 184–206.
 (iii) *Manual of Photogrammetry*, Vol. I, Chapter 9.

ORIENTATION AND THE MATHEMATICS OF PLOTTING
 (i) Hallert, pages 247–86 (theory of errors).
 (ii) Lyon, Chapter 3, pages 38–43 and Chapter 5.
 (iii) Zeller, pages 138–204.
 (iv) Merritt, pages 133–53.

ANALYTICAL PHOTOGRAMMETRY
 (i) *Manual of Photogrammetry*, Vol. I, Chapter 10.

INSTRUMENTS
 (ii) Cimerman and Tomasegovic.

EXAMPLES
 (i) Hallert, pages 287–330 (Appendix C).

(See Bibliography (page 346) for the full titles.)

Some more Instruments

This book has so far been mainly concerned with imparting an understanding of the theory of making maps from air photographs; but in this chapter we intend to introduce the reader to some of those plotting instruments which he might expect to encounter in large-scale commercial production.

One method of grouping machines is by reference to the traditional land-surveying criterion of accuracy of work. Planimetric accuracy might be a useful measure with regard to planimetric plotting alone but other factors must be considered in a general classification. Schwidefsky classifies as first order, only those instruments which are capable of both detail plotting and aerotriangulation. Such instruments are often known as universal, though this term sometimes implies that the instrument is also capable of plotting from oblique or ground overlapping photographs. Although universal in the former sense, the multiplex is only a second-order machine since it lacks the necessary accuracy. The Stereoflex and Stereotope would be classified as third-order machines.

One of the oldest of photogrammetric instruments is the stereo-comparator (see Fig. 12.1). In its simplest form this instrument consists essentially of a mirror stereoscope and magnifiers, incorporating a pair of half-marks or grids. The spatial coordinates of the floating mark can be accurately read. Corrections for model distortion must be computed, a procedure which was formerly extremely tedious. The instrument can thus be used to increase the amount of control mathematically, i.e. to achieve an "analytical" aerotriangulation. Analysis of the distortions in the base materials is assisted if a réseau is incorporated in the taking camera. It can also be used for non-cartographic photogrammetric analysis; but it is not a plotting instrument.

Plotting instruments also may be linked with electronic computers, and a point may be plotted and its coordinates enumerated at the same time.

Most of the major manufacturers produce at least one model which can be considered as first order. In Britain perhaps the best-known first-order machine is the Zeiss Stereoplanigraph (see Fig.

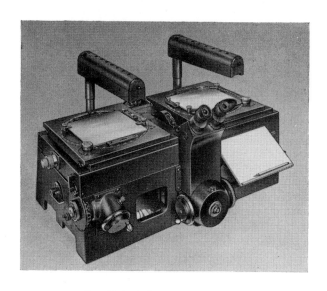

FIG. 12.1. A STEREOCOMPARATOR
(*Zeiss Jena*)

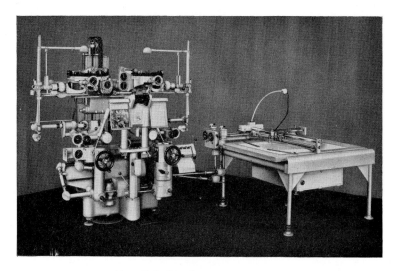

FIG. 12.2. THE STEREOPLANIGRAPH
(*Zeiss Aerotopo*)

12.2), while the best-known range comprises the Wild A7 (see Fig. 12.3), A8 (see Fig. 12.4), A9 (see Fig. 12.5), A10 (see Fig. 12.6) and B8 (see Fig. 12.7).

In considering the order of an instrument, we have spoken of accuracy, by which we mean position accuracy and heighting accuracy. The latter is usually considered in terms of the C-factor, where $C = \dfrac{H - h}{V}$, V being the minimum contour interval attainable in the given circumstances.

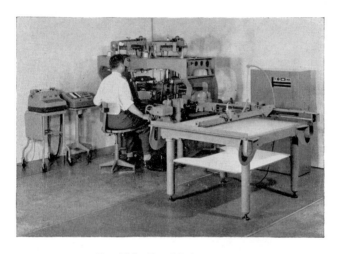

FIG. 12.3. THE A7 AUTOGRAPH
(*Wild Heerbrugg Ltd.*)

Referring back to the calculation for maximum flying height in a previous chapter, we found that for a 15 m V.I. the maximum flying height was 4,735 m. Since the mean height of the ground above datum was 135 m, the C-factor for those simple methods would be approximately $\dfrac{4,735 - 135}{15} \simeq 300.$

The classification for each plotting instrument includes an assessment for C-factor, but too much importance must not be attached to this factor since many extraneous circumstances may affect the heighting accuracy, e.g. after a series of tests two equally experienced operators may allot quite different C-factors to the same instrument, and in testing two different types of machine A and B,

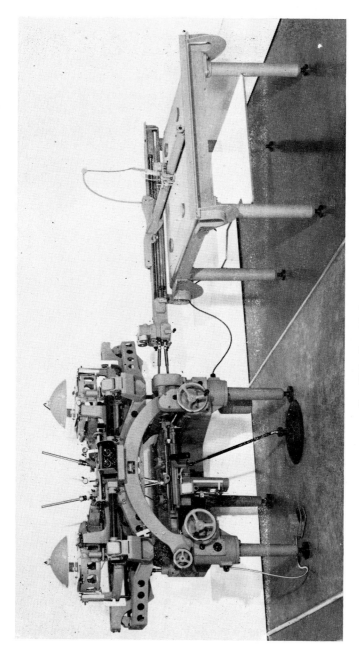

FIG. 12.4. THE A8 AUTOGRAPH
(*Wild Heerbrugg Ltd.*)

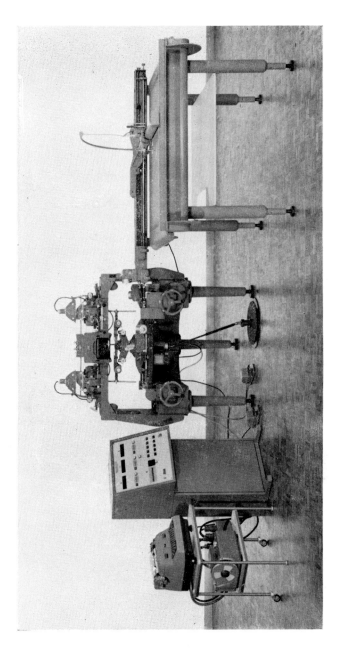

FIG. 12.5. THE A9 WIDE-ANGLE AUTOGRAPH WITH EK8 COORDINATE PRINTER, IBM TYPEWRITER (INPUT/OUTPUT WRITER) AND SL15 TAPE PUNCH (*Wild Heerbrugg Ltd.*)

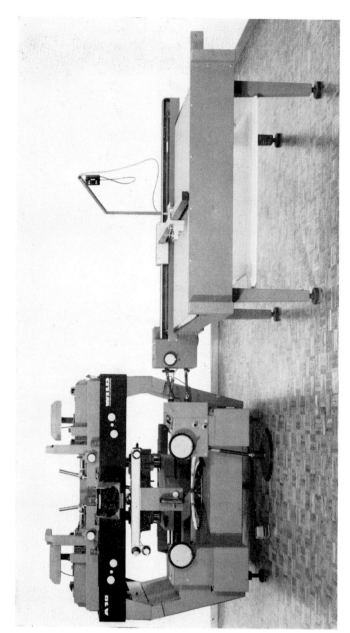

Fig. 12.6. The A10 Autograph
(*Wild Heerbrugg Ltd.*)

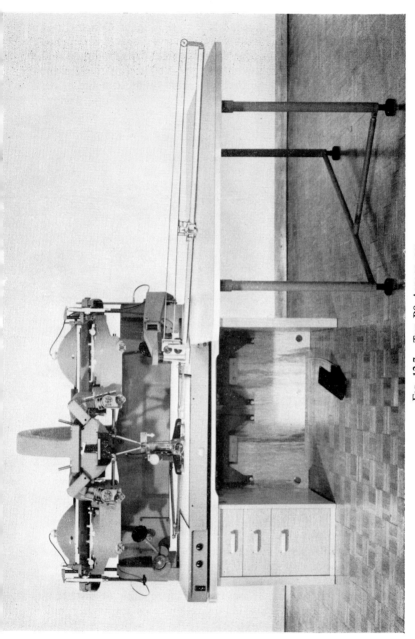

FIG. 12.7. THE B8 AVIOGRAPH
(*Wild Heerbrugg Ltd.*)

the first operator might allot machine *A* the higher *C*-factor, while the second operator might allot the higher factor to instrument *B*. This difficulty is brought out by the fact that *C*-factors allotted to the multiplex vary at least between 600 and 1,000. This range is incidentally barely higher than that attainable by most of the modern third-order instruments. The Balplex 525 has a working *C*-factor of 800–1,500.

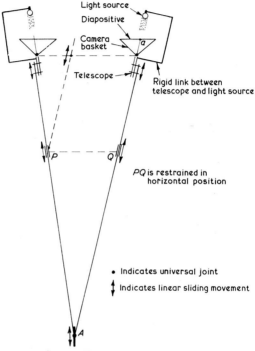

FIG. 12.8. SIMPLIFIED SKETCH DIAGRAM TO SHOW THE MOVEMENT OF A SYSTEM OF SPACE RODS

The *C*-factor is not usually applied to simple methods involving the parallax bar.

The Stereoplanigraph is often said to be representative of the purely optical group of instruments in which images from the diapositives are projected and the reflected images are viewed stereoscopically. It is sometimes also called a Porro–Koppe type of instrument, although the lens distortion is now removed by a glass correction plate; a separate plate is used to " pair " with each range of taking cameras.

The Wild Autographs are similarly said to be representative of the optical-mechanical group of instruments in which prints or diapositives are viewed stereoscopically through a pair of telescopes. Each telescope pivots about a mechanical centre which takes the place of the optical centre of the viewing " camera basket," and is linked with a rod whose movements therefore follow those of the

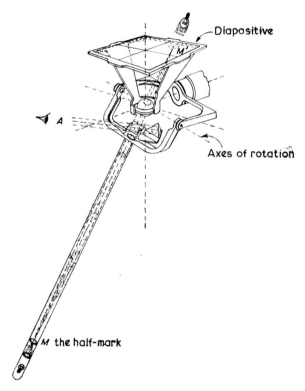

FIG. 12.9. THE VIEWING SYSTEM IN THE NISTRI
PHOTOSTEREOGRAPH MODEL BETA/2
(*Ottica Meccanica Italiana*)

half-mark. These are the space rods, which in the simplest conception (see Fig. 12.8) can be considered as intersecting in the space position A, of the floating mark. The pencil at A is so far below the camera baskets that the resulting instrument would be excessively tall. The mechanism shown by the broken lines in Fig. 12.8 would shift the effective plotting point to pencil P. This is sometimes

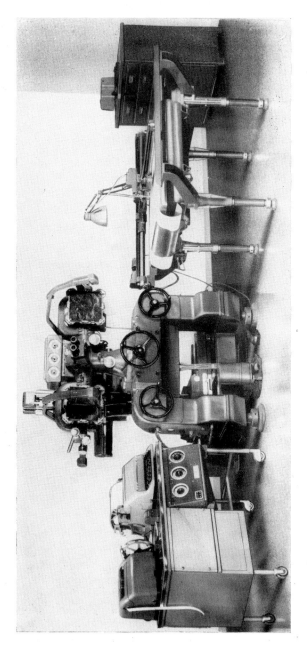

Fig. 12.10. The Photostereograph (Beta/2) Coupled with Coordinate Computer on the Left and Plotting Table and Coordinate Plotter on the Right

(Ottica Meccanica Italiana)

known as the Zeiss parallelogram. The plotting scale would be reduced but the pencil at P could be replaced by a horizontal pantograph.

Figure 12.9 shows the way in which the images of photo and half-mark are viewed in the first-order Nistri machine shown, in Fig. 12.10, set up between a coordinate recorder on the left, and an electric coordinatograph and plotting table on the right.

The Thompson-Watts plotter, a British machine, is one of the most accurate instruments for numerical aerial triangulation and plotting, but is no longer produced.

In both the A7 and A8, the model is correctly re-formed, but the A7 is first-order, and the A8 is second-order because, although little less accurate than the A7, it is not universal.

THE WILD RANGE OF PLOTTING INSTRUMENTS

The A8 Autograph

Basically the A8 (Figs. 12.4 and 12.11) comprises two camera-lucidas into which a pair of diapositives are inserted, and viewed stereoscopically. The cameras are oriented as would be the corresponding pair of multiplex projectors. The sight-lines are represented by a pair of space-rods rotating about perspective centres S_1 and S_2, and meeting in a point A (Fig. 12.11) which is free to trace out the spacial model formed by the points being viewed. The horizontal position of A is conveyed to an adjacent plotting table by a system of linkages, and the relative height of A can be read out on a height scale similar to that of the multiplex.

For ease of description we will consider the A8 as comprising the the following parts (see Fig. 12.11)—

A. the sub-structure with
 1. the X-, Y- and Z-carriages
 2. the space rods
B. the superstructure with
 3. the camera complex
 4. the lazy-tongs linking the telescopes' movements with those of the space-rods
 5. the viewing telescopes and the optical trains
C. the plotting table with
 6. the plotting pencil
 7. the linkage between carriage complex and plotting table.

Where there are similar right-hand and left-hand units, it will normally be the right-hand unit which is described.

The substructure is the rigid base of the instrument, which is carried on three adjustable legs. The rigid arched portion (Fig. 12.4) is known as the yoke and is supported by the flat tabular part to which the carriage complex is also attached.

1. The *X-* *Y-* and *Z*-carriages. Right in the middle of the instrument, and just above the knees of the operator, is the carriage complex, similar in purpose to that of the Stereomicrometer.

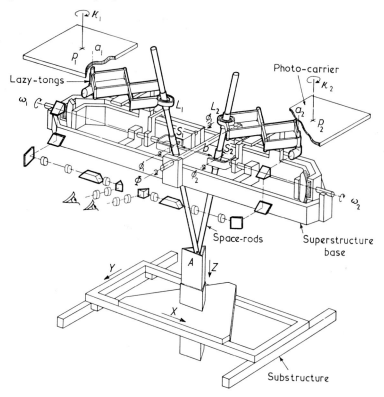

FIG. 12.11. A8 AUTOGRAPH SPACE-ROD DIAGRAM
(*Wild, Heerbrugg Ltd.*)

The *Y*-carriage is mounted on rails which are rigidly attached to the substructure. It is free to move only in the *Y*-direction, that is in the front-to-back direction of the instrument, which will later be seen to be the lateral direction of the line of flight of the observed model. The carriage is moved along its rails by turning the large right-hand handwheel (Fig. 12.4).

The X-carriage is mounted on rails attached to the Y-carriage. It is free to move relative to the Y-carriage only in the X-direction, that is in a horizontal direction perpendicular to the Y-direction. This is the fore-and-aft direction of the model, and the movement is operated by the large left-hand handwheel.

Mounted in the X-carriage, and free to move only in the Z, or up-and-down, direction is the Z-carriage. This carriage is moved by rotating the foot-disc (see Fig. 12.4) with the right foot.

The foot of each space-rod is attached to the Z-carriage by a universal joint, A in Fig. 12.11. A is thus free to be moved in three perpendicular directions.

There is an X-scale, a Y-scale and a Z-scale, which indicate the movements of the three carriages, and enable a visual readout of the three spacial coordinates of A. The Z-scale is the height-scale or -index; it is similar to that of the multiplex tracing table, and for wide-angle photography it has a range of from 175 to 280 mm. The height-index actually forms part of the X-carriage, and so does not itself move up and down.

Just above and to the front of the top of the foot-disc spindle is a grip-release handle (seen black in Fig. 12.4). When the handle is gripped a lever is depressed, and this releases the X- and Y-carriages so that they may be moved freely without using the handwheels. When the grip is relaxed these carriages are again moveable only by the handwheels.

2. The space-rods represent the lines of the perspective rays in space, and as they meet at A, which traces out the three-dimensional model of the ground surface, then A also represents the point which is under observation at any particular moment. Each rod is free to slide through a sleeve which in turn is free to rotate in its universal joint at S_1 or S_2 (Fig. 12.11). These two points represent the per-spective centres and the distance between them, b, can be varied to set the scale of the model before plotting begins. There is a second sleeve on each rod which is free to rotate about L_1 or L_2. These points are the centres of universal joints attaching the rods to the lazytongs.

The superstructure is carried on a base-frame, and comprises that part of the instrument which carries the cameras. It is so constructed as to enable the cameras each to rotate about its ϕ-, ω- and κ-axes, to rotate jointly about the Φ-axis, and to be capable of an adjustment to accommodate a range of different principal distances. The frame itself is seen in Fig. 12.11; it is the part which extends beyond the substructure at both sides in Fig. 12.4. The Φ-axle rotates on the apex of the yoke, and this movement is controlled by the small left-hand handwheel (Fig. 12.4).

K

3. The camera complex (Fig. 12.12) contains a camera lucida which is flooded with light from above by means of a 35-watt lamp in a parabolic reflector housing. The diapositive, or negative, is mounted on to a detachable picture carrier, which is inserted into the camera

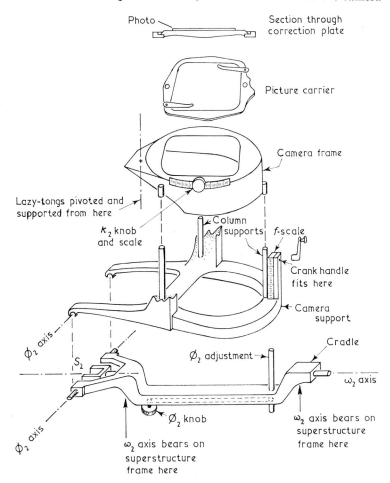

FIG. 12.12. WILD A 8 CAMERA COMPLEX D

frame and is rotatable in swing by means of the knob at the top front of the frame. The picture carrier consists of a metal frame surrounding a sheet of optical-quality glass on which calibrating marks are engraved. For greater accuracy this glass may be replaced by a

glass correction plate, shown in section in Fig. 12.12(i). The correction plate is optically designed and ground to offset the lens distortions of the taking camera, and if desired may also include a correction for earth curvature. It may be designed to balance the distortions of one particular lens or to be complementary to a range of lenses. The camera frame is mounted on the camera support by means of three variable columns. The angular relationship between the frame and the support is constant; but the "vertical" distance between the two can be varied by adjusting the height of the column supports. The movement of these columns is linked, so that rotation of the detachable crank-handle causes all three to be raised or lowered simultaneously and by the same amount. This is the way in which the focal length is set.

The camera support is mounted in the cradle so that it rotates about the ϕ_2-axis of the cradle. This movement is achieved by turning the ϕ_2-knob (see Fig. 12.12). The camera cradle is a rigid framework of which the ω_2-axis of Fig. 12.11 forms a part. It is free to be rotated about this ω_2-axis by means of a knob which may be found above the eye-piece and in front of the space-rods.

4. The lazy-tongs (Fig. 12.11) are sometimes called the scissors, double scissors or double rhomboids, and are supported in a horizontal position at their central pivot by the camera frame. They carry the telescope, a_2, at one end, and the universal joint, L_2, at the other. This ensures that the lazy-tongs and telescope move only in a plane parallel with the plane of the diapositive, and allows the axis of the telescope to be maintained perpendicular to the plane of the diapositive. The central pivot remains stationary relative to the diapositive, whilst the movements of the telescope are the reciprocal of those of the point L_2. As L_2 moves towards the operator so the telescope moves away by an equal amount, and as L_2 moves to the left so the telescope moves to the right. This means that as the distance between the two telescopes, a_1 and a_2, increases so the distance between L_1 and L_2 decreases and the position of A is lowered. If we look again at Fig. 6.2 we shall see that as the parallax increases, so the model height increases, thus A is rising and falling in sympathy with the visual model.

It can now be seen that the focal length adjustment has the effect of raising and lowering the diapositive, together with the lazy-tongs and L_2, relative to the camera support. The vertical distance between L_2 and S_2 is therefore altered, and this distance represents the principal distance in the space-rod perspective diagram.

The viewing telescope contains the half-mark, and the images of the diapositive and the half-mark are together conveyed by a

flexible optical train (shown in Fig. 12.11) from the telescope to the eye-piece in the centre front of the instrument. The diapositives are thus viewed from below; but since they are placed emulsion side down on the picture carriers and are arranged with their common overlap nearest to the instrument centre-line (the Φ-axis), the model conveyed to the eyes will be erect as it is in the mirror stereoscope.

The operator can therefore sit facing the instrument, and look through the eye-piece at the three-dimensional model of the ground. By moving the X- and Y-handwheels he can scan the whole overlap, and by adjusting the foot-disc he can raise and lower the apparent position of the fused dot so that it lies at ground level on the model.

The plotting-table is essentially a flat horizontal ground-glass surface, usually one metre square. The plotting surface must be maintained level by adjusting the length of the legs to bring the two bubbles of a cross-level to the centres of their runs. The base-grid is mounted on the table surface, and plotting is done by a coordinatograph whose pencil can be raised and lowered by means of the left-foot pedal (see Fig. 12.4).

The coordinatograph consists of a straight cantilever arm mounted at right angles to a straight rail, along which the supporting end of the cantilever moves. The pencil is mounted on the cantilever arm along which it is free to run. Thus the pencil is free to move in two mutually perpendicular directions, which represent the coordinate directions of the instrument.

A series of spindles, worms, gears and splines are assembled to drive the pencil in the X- and Y-directions in sympathy with the horizontal movements of the universal joint, A. A range of 7 gear ratios are fitted so that the movements of the pencil may be set to any of a series of 15 magnifications relative to the space-rod model, ranging from 1:4 to 4:1. A profiloscope may be fitted to the plotting point to enable the operator to see, by reflection, the plotting table in the vicinity of the plotting pencil, without moving his position relative to the instrument.

The Operation of the Instrument

The A8 is a precision instrument and must be installed in a stable position free from vibrations of all kinds. A solid ground floor would be considered essential. It must be maintained free from dust, and the moving parts must be regularly lubricated in accordance with the maker's instructions. The X- and Y-carriages must be kept perfectly horizontal by adjustment of the three legs.

A mapping project with the A8 must be planned in the same way as any other such project. The manufacturers suggest that a mean

photo scale should be calculated in accordance with the following equation—

$$m_B = c\sqrt{m_K}$$

where m_B is the reciprocal of the photo scale, m_K the reciprocal of the required map scale, and c is a constant which varies between 200 and 300 according to the severity of the demands for accuracy, the lower figure being chosen for the severest demands. Thus suppose that the required mapping scale was 1/2,500, and the demands for accuracy were moderate, then

$$m_B = 250 \times 50 = 12,500$$

The scale of the photography should then be 1/12,500 and the flying height for a 150 mm lens would be $\dfrac{150 \times 12,500}{1,000} = 1,875$ m.

Choice of Instrument Scale

When plotting is about to begin a choice must be made regarding the glass scale to be inserted in the height index, and the appropriate gear-ratio for connexon with the plotting table. There are three separate scales with which we are concerned—the scale of the photographs, the map (or plotting) scale, and the scale of the instrument model. We have seen how, in the multiplex, the scale of the model is set by the X-separation of the projectors; this separation represents the base-length, S_1S_2. Similarly the scale of the space-rod model of the A8 can be set by adjusting the base-length (b in Fig. 12.11). This separation of S_1 and S_2 can be altered by rotating a handle, which can be seen in Fig. 12.4 at the right-hand end of the horizontal shaft behind the eye-piece. Since the relationship between the instrument scale and the map scale must equate to one or other of the gear-ratios provided, it is this b-adjustment which must be used to remove any residual error between the instrument scale and the photo scale.

The height scale sets the instrument model scale, and we have a choice of 15 different glass scales which enable a read-out of heights in metres. To save calculation, the manufacturers produce tables which enable the choice to be made without actual calculation (see Table 7). Thus, choosing the largest scale consistent with a flying height of 1,750 m, we see that we need the 1/7,500 glass scale, and for plotting at 1/2,500 from a 1/7,500 model we need a gear-ratio of 1:3.

Orienting the Instrument

Inner orientation. As with the multiplex, the purpose of inner orientation is to re-establish the same relationship between lens and photo plane as existed at the time of exposure.

Table 7

WILD A8: EXTRACT FROM SCHEDULE OF GLASS SCALES

(*Wild Heerbrugg Ltd.*)

Flying height above ground wide angle max.	min.	Glass scale 1/	Plotting scale 1/1000	1500	2000	2500	3000	4000	5000	6000
840	530	3000	1:3	1:2	2:3	5:6	1:1	4:3	5:3	2:1
1050	650	3750		2:5		2:3	4:5		4:3	8:5
1120	700	4000	1:4	3:8	1:2	5:8	3:4	1:1	5:4	3:2
1400	880	5000		3:10	2:5	1:2	3:5	4:5	1:1	6:5
1680	1050	6000		1:4	1:3		1:2	2:3	5:6	1:1
2100	1300	7500				1:3	2:5		2:3	4:5
2240	1400	8000			1:4		3:8	1:2	5:8	3:4
2800	1750	10000				1:4	3:10	2:5	1:2	3:5
3350	2100	12000					1:4	1:3		1:2
3500	2200	12500							2:5	
3700	2350	13333						3:10	3:8	
4200	2650	15000							1:3	2:5
4650	2900	16667							3:10	
5600	3500	20000							1:4	3:10
7000	4400	25000								
8400	5300	30000								
10500	6500	37500								
11200	7000	40000								

Heights in metres Gear

Table 7—(continued)

7500	8000	10000	12000	12500	15000	18000	20000	24000	25000	50000
5:2	8:3	10:3	4:1							
2:1		8:3		10:3	4:1					
	2:1	5:2	3:1							
3:2	8:5	2:1		5:2	3:1		4:1			
5:4	4:3	5:3	2:1		5:2	3:1	10:3	4:1		
1:1		4:3	8:5	5:3	2:1		8:3		10:3	
	1:1	5:4	3:2				5:2	3:1		
3:4	4:5	1:1	6:5	5:4	3:2		2:1		5:2	
5:8	2:3	5:6	1:1		5:4	3:2	5:3	2:1		
3:5		4:5		1:1	6:5		8:5		2:1	4:1
	3:5	3:4					3:2			
1:2		2:3	4:5	5:6	1:1	6:5	4:3	8:5	5:3	10:3
		3:5		3:4			6:5		3:2	3:1
3:8	2:5	1:2	3:5		3:4		1:1	6:5	5:4	5:2
3:10		2:5		1:2	3:5		4:5		1:1	2:1
1:4		1:3			1:2		2:3		5:6	5:3
				1:3	2:5				2:3	4:3
		1:4			3:8		1:2		5:8	5:4

Ratio

The calibrated focal length of the taking camera is set on both plotter cameras. The picture carriers are removed and the diapositives are placed emulsion side down on their respective carriers, on which they are carefully centred by bringing the collimating marks into exact coincidence with the marks engraved on the picture carriers. This centring is done on a specially manufactured light box, and under magnification. The picture carriers are now carefully replaced in their respective camera frames and with their common overlap correctly oriented towards the central Φ-axis. For more exacting work, correction plates are mounted in the picture carriers in place of the ordinary glass plates.

A negative may be used instead of the diapositive; but in this case the negative is mounted emulsion side upwards, and is held flat with a glass covering plate.

Outer orientation is concerned with setting up a space-rod model, correctly oriented within itself and with the plotting table, and at the scale required by the combination of map scale and gear-ratio.

Relative orientation may be carried out by systematically removing K at six suitably placed points (Fig. 11.6) in much the same way as with the multiplex. The manufacturers do suggest a particular procedure, but warn that it was actually designed for use with photographs of flat terrain. It differs only in detail from the drill described for the multiplex.

With reference to Fig 11.6, K is removed

at point 1 by swing of photo 2

at point 2 by swing of photo 1

at point 5 by tilt of photo 1

at point 3 half by tilt of photo 1, and half by tip of photo 2

at point 6 by tilt of photo 1

at point 4 half by tilt of photo 1, and half by tip of photo 1

at point 6 (or 1) by tilt of photo 1

at point 2 (or 3) overcorrect n-times by tilt of photo 1

Repeat all steps until the model is free from K.

In fairly flat country an approximate value for the overcorrection factor would be

$$n = f^2/a^2$$

where a = image ordinate of point 2 (or 3).

In cases where several repetitions of this drill do not result in reducing K, then more sophisticated calculations for determining the overcorrection factor are called for, though a suitable value for n may be found fairly easily by trial and error.

ABSOLUTE ORIENTATION

We shall assume for the moment that we wish to plot the detail from a single overlap on to a base-grid on which adequate control is available, say as in Fig. 11.7, where A and C are also horizontal control points.

Scaling. The base-grid is placed on the plotting table and oriented so that the pencil positions representing two well-separated control points (say A and C in Fig 11.7) lie along the line joining the plotted positions of these points. The correct scale of the instrument model is obtained by adjusting the base-length, $S_1 S_2$, until the length of the plotted line AC equals its length on the base-grid. The corrected length of $S_1 S_2$ can be calculated by proportion in the same way as for the multiplex.

Horizontalizing. This is simpler than as described for the multiplex, as the whole superstructure may be rotated about the central Φ-axis. If a pair of height control points are located on the photographs at nearly equal distances on either side of the right-bisector of the base-line (A and F on Fig. 11.7), then the glass scale should be set to give the correct height-index reading at say the left-hand point, and the height error at the other point should be eliminated half by adjusting the glass scale and half by using the Φ-rotation and the X-, Y- and Z-scanning movements. This drill may need repeating until no error remains. If necessary the height error at one of the two points, say at F, may be estimated in the same way as it was for the multiplex; i.e. by interpolation between the errors at C and B and then by extrapolation.

The same procedure may be followed for an Ω-orientation, using simultaneous and equal ω_1- and ω_2-movements to adjust between a pair of height-control points placed symmetrically about the Ω-axis.

Finally the scale is checked and the glass scale is again adjusted to give the correct height-index readings, and plotting can begin.

Aerotriangulation with the A8

The A8 is not designed for bridging; but this can be achieved with a cross-level, which is an inclinometer similar to that used with the multiplex. After the first model has been fully oriented, the cross-level is fixed to the right-hand picture carrier, and the inclination measured in two perpendicular directions. The first diapositive is now removed. The second diapositive in its picture carrier and with the cross-level still attached, is placed in the left-hand camera. The diapositive of photo 3 is now mounted on another picture

carrier and inserted in the right-hand camera. Relative orientation is carried out, and photo 2 (now on the left-hand camera) is given the same orientation as before by bringing the two cross-level bubbles to the centres of their runs with ω_1- and Φ-movements. Eliminate K with ω_2 and carry out the scaling adjustment between two points already plotted from the previous model, i.e. between two points in the double overlap. Similarly at a previously heighted point (again in the double overlap) set the heighting scale so that it reads correctly. Both the horizontal scale and height-index readings should be checked against other points from the previous model.

Another cross-level is attached to the photo-carrier holding photo 3 and the bubbles are brought to the centres of their runs. Photo 3, again with photo carrier and cross-level attached, is removed to the left-hand camera and the third overlap is oriented in the same way as was the second.

A complete bridging operation can be carried out in this way, and adjustment to the bridge may be completed using techniques similar to those used for the multiplex; but in practice it will normally be performed by analogue or digital computer. The latter techniques are almost wholly automatic, since the coordinates of points are automatically recorded in print and on punched tape by linking the A8 with an electric coordinate printer and a tape punch machine. The tape is then fed into a computer, previously programmed to carry out the whole computation and fed with appropriate control information. The result will be sufficient control to enable each overlap in turn to be set up in the machine for plotting.

The manufacturers hope that an ortho-photo attachment for standard A8s will be available in 1972.

The A7 Autograph

The A7 and A8 have basically similar carriage complexes, together with similar rotational movement of the cameras; but in some fundamental respects there are important differences. The A7 is more rigid and massive than the A8, the base distance (b in Fig. 12.13) is not adjustable, and there is no common Φ-movement in the A7. However, the A7 rods are attached to the Z-carriage in such a way that there are separate translatory adjustments in b_y and b_z for each rod (see Fig. 12.13), which has the effect of altering the relative positions of S_1 and S_2 in the Y- and Z-directions, i.e. altering the bearing and inclination of the air-base in the space-rod model. The effective distance between S_1 and S_2, and therefore the scale

of the model, is adjustable by a joint b_x-movement of the lower ends of the rods relative to the Z-carriage.

The upper end of an A7 space-rod moves the viewing telescope over the face of the diapositive in such a way that the telescope is not only always perpendicular to the face of the diapositive but also vertically above the end of the space-rod. Thus when the space rods are vertical the respective principal points are being viewed, so that when the overlap portion of the photos is between the two

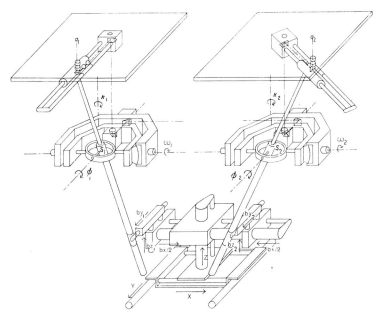

FIG. 12.13. WILD A7 AUTOGRAPH SPACE-ROD DIAGRAM
(*Wild, Heerbrugg Ltd.*)

principal points (i.e. in the normal position), the upper ends of the rods will be closer together than the lower ends. The point of intersection of the lines of the space-rods would then be above the plane of the diapositives, and as the parallax decreases so the lower ends of the rods approach one another and the Z-carriage falls— there is therefore no need for the rod motions to be reversed by lazy-tongs as with the A8.

The A7 is a more expensive instrument than the A8; but the essential difference is that the A7 is specifically designed for aero-triangulation as well as for plotting. Besides the ability to simulate a

B_y-movement of each perspective centre, it is possible to switch the viewing system so that the image of the right-hand picture is brought to the left eye, and the image of the left-hand photo to the right eye. This cross-over position of the viewed images is known as the base-out position because it is the outside part of the diapositives which are being viewed. The normal position is then referred to as base-in. Thus the first two diapositives are mounted with the instrument in the base-in position, photo 1 in the left-hand camera and photo 2 in the right. Relative orientation similar to that for the A8 is completed, photo 1 is replaced by photo 3, and the optical train is switched to its base-out position. The orientation of photo 2 is not altered in any way; but the left-hand camera, holding photo 3, is oriented relative to photo 2 in a way similar to that used for 7-projector multiplex bridging, the b_y- and b_z-movements of the foot of the left-hand space-rod relative to the carriage system being used to simulate B_y- and B_z-movements of the left-hand perspective centre. In effect this enables the left-hand photo base-line to be made collinear with the right-hand base-line, and for the correct inclination of the air-base to be set in the space-rod model.

The A8 is incapable of any differential Y-movement between the two cameras, so that the fact that on photo 2 the base-line of the second overlap is most unlikely to be collinear with the base-line of the first overlap (see Fig. 5.4) presents a problem which could only be solved by a rotational movement about the plumb line; but the swing rotation is, of course, about the principal axis of the camera. We have just seen that the b_y-movements of the rods relative to the Z-carriage enable the A7 to overcome this difficulty.

The manufacturers state that the A7 is designed to perform the following tasks—

1. Preparation of large-scale plans between 1/500 and 1/2,500 for technical projects, cadastral purposes, reallotment schemes, and town surveys.

2. Photogrammetric preparation of numerical cadastral surveys.

3. Photogrammetric measurement of profiles and cross-sections for planning railways and highways.

4. Increasing the density of the ground control network by bridging at large scales for providing coordinated points for map revision, instead of fixing such points by lower-order triangulation and traversing.

5. Photogrammetric determination of positional coordinates and elevations for medium and small scales by the method of aerial triangulation.

6. Preparing large-scale contour plans from small photograph scales for preliminary technical investigations.

7. Preparing maps at all medium and small scales when no simpler plotting instruments are available.

8. Plotting from terrestrial photo-theodolite photographs.

9. Of much lesser importance: plotting from less-frequently encountered types of photography such as obliques and convergent photography; and aerial triangulation from convergent photographs with large convergent angles.

This is the picture of a fully versatile instrument, truly universal by any criterion.

The A8 can be used for all items from 1 to 7. It would normally be used for item 7 and probably also for 3 and for much of 1.

The picture carriers with cross-levels attached are interchangeable between the A7 and A8, and one of the more important tasks of the A7 is to feed a group of three or four A8s with control and oriented picture carriers, so that the A8s may be used for plotting detail, the purpose for which they were mainly intended. Auxiliary equipment, such as the plotting tables, profiloscope, the electronic co-ordinate printer and the card punch and tape punch machines can be used with either the A7 or the A8. It is estimated that for plotting at medium scales, one A7 and four A8s are able to produce twice as much work in a given time as could three A7s alone. This serves to underline the need for a range of instruments, in that, however many tasks a particular machine *can* perform, it is most economically employed for its own specialization.

The B8 Aviograph

The B8 is a smaller and simpler instrument than either the A7 or the A8, but it still maintains a rigorous geometrical solution of the space model. Fig. 12.14 shows the space-rods in diagrammatic form. It will be seen that the perspective centres are above the universal joints which control the movements of the viewing telescopes, so that the space-rod arrangement directly simulates the perspective rays (cf. Fig. 6.2). The instrument is basically intended for map revision and plotting at medium scales from wide-angle and ultra-wide-angle photography; but it can also be used for large and small scales.

Each camera is supported by an interchangeable camera carrier, which sets the focal length. Camera carriers are available with five different focal lengths: 152, 125, 115, 100, and 88·5 mm, and each is fitted with a micrometer adjustment which can vary the focal length by up to 3 mm either way. Note that on the A7 and A8 the focal length is continuously adjustable over a considerable range.

Plotting may be done on the supporting table top, in a manner similar to that of the multiplex; but it is possible to plot on a separate plotting table, in a way reminiscent of the Autographs, but using a linear pantograph instead of a coordinatograph.

By reason of its relative simplicity of construction and operation, and the rigorous solution, the B8 is particularly suitable for photogrammetric investigation for engineering and scientific purposes. An expert in a particular science can use the B8 without a long period of training, which would be necessary for a more complex instrument—this gives him direct access to a rigorously correct model of the land or object under investigation.

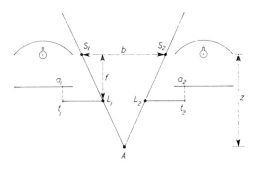

FIG. 12.14. WILD B 8 AVIOGRAPH SPACE-ROD DIAGRAM

The A9 Autograph and The B9 Aviograph

The A9 (Fig. 12.5) and B9 are designed for use with photography taken by the Wild RC9 super-wide-angle camera, but they will also accept wide-angle photography. Both use diapositives reduced to half the size of the negative. Because of the reduction in the number of photographs and the consequent saving in flying time and more especially the saving in ground control, super-wide-angle photography is normally preferred for small-scale mapping projects—that is, for scales of 1/50,000 or less.

Instruments designed for limited ranges of work can be simpler than the more universal machines, and they will therefore be less costly, quicker to orient and usually easier to operate. The A9 is universal in the sense that it is intended for aerotriangulation. It is very similar to the A7, but is simpler and smaller. The B9 is a smaller version of the B8, but is designed to plot the detail from the diapositives previously triangulated on the A9. Special diapositive printers are required for use with these instruments. Besides making

the required reduction in scale, the printers incorporate a correction for lens distortion of the camera being used and, where needed, a further correction for earth curvature and mean atmospheric refraction according to the flying height.

The A10 Autograph

Change is continuous, and the B9 is being discontinued, whilst the latest addition to the Wild range is the A10 (Fig. 12.6), which is described as being intermediate between the A7 and the A8. The A10 is suitable for aerotriangulation, coordinate recording, and for plotting vertical photographs having angular views of up to 120°. By an interchange of the drives to the Y- and Z-carriages, it is also capable of plotting from terrestrial photographs.

It is recommended that the A10 and B8 should be used in harness, just as the A7 and A8 are paired; thus for the highest precision, largest scales and closest contour intervals the A7 will triangulate and the A8 will plot, while for the less demanding work the A10 will triangulate and the B8 will plot the detail. It is in fact anticipated that the B8 will overtake the A8 as the most popular instrument.

The A40 Autograph

The A40 (Fig. 12.15) is designed for plotting from pairs of terrestrial photographs, taken with either specially designed stereo-cameras, or from pairs of photo-theodolite pictures. This is sometimes known as close-range or short-range photogrammetry. Photographs taken with specially designed stereo-cameras are known as fixed-base or short-base photographs. Some uses to which such photography may be put are mentioned in the next chapter.

Wild have produced the P30 photo-theodolite, with a 165 mm focal length and 100 mm × 150 mm format. This is being replaced by the P31, a completely new design, which will probably be available in 1972. In addition the company are producing the P32, which is a camera designed for attachment to any standard Wild T2 theodolite. The P32 will have a 65 mm × 90 mm plate format and a focal length of about 64 mm; it will also be possible to use this camera without the theodolite.

Wild also produce a range of three stereometric cameras: the C120 and C40 each consist of a pair of wide-angle cameras separated by a stable rigid bar or base, mounted on a tripod, the base-lengths being respectively 1·2 m and 0·4 m; the C12 has normal-angle cameras with a 1·2 m base. These cameras are capable of taking certain inclined shots as well as horizontal photography.

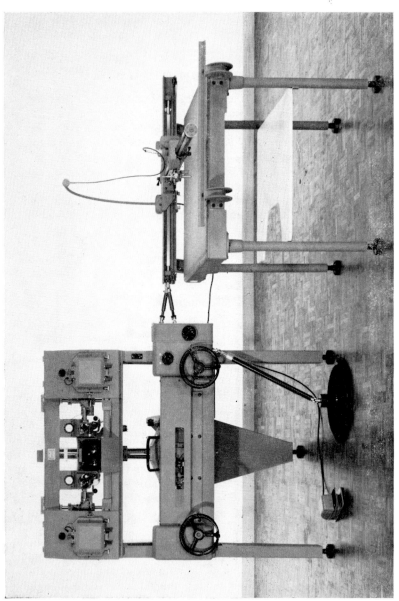

Fig. 12.15. The A40 Autograph
(*Wild Heerbrugg Ltd.*)

The RC7a, RC8, RC9, and RC10 Air Cameras

There is a range of four Wild air cameras likely to be encountered in current commercial use.

The RC7a, successor to the RC7, is a plate camera with 140 mm × 140 mm format and has two interchangeable lenses—a normal-angle and a wide-angle lens, with 170 mm and 100 mm focal lengths respectively. Fig. 4.10 shows the RC7 and Fig. 9.20 shows the way in which the plates are stored in the magazine and fed into the exposure position. Plate photographs are especially suitable for producing enlarged prints for mosaic making.

The RC8 is a film camera with vacuum-frame type of film-flattening device, and intended for wide-angle photography with a 152 mm focal length lens and a 230 mm × 230 mm format. The photographs are suitable for plotting in any of the Wild instruments described above (except the A40), and most other major instruments.

When fitted with the Wild Universal-Aviogon $f/5\cdot6$ wide-angle lens cone, and the appropriate filters, the RC8 can be used with panchromatic, infra-red, colour, or infra-red colour film. The magazine holds 60 m of film having an overall width of 240 mm. The viewfinder is of the type illustrated in Fig. 4.9 (upper photo). It has been estimated that wide-angle cameras with 152 mm focal lengths account for 80 to 85 per cent of all vertical air photography, and Wild believe the RC8 to be the most popular camera in the world.

The RC9 is a specialist film camera, designed for super-wide-angle photography for making small- and medium-scale maps and for aerotriangulation in the A9, or A10. It has an $f/5\cdot6$ Super-Aviogon lens, with a focal length of $88\cdot5$ mm (format 230 mm × 230 mm). Very little air photography is done with cameras with lenses of focal length other than 152 mm or $88\cdot5$ mm.

The RC10 (Fig. 1.7) is the latest Wild air camera. It is a film camera incorporating new design elements and is intended to supersede both the RC8 and RC9, which are already out of production (March 1971). This camera has a 230 mm × 230 mm format, but is more compact than its predecessors, and has interchangeable lenses—one wide-angle with 152 mm focal length and one super-wide-angle with $88\cdot5$ mm focal length. A narrow-angle, 305 mm focal length lens is expected to be added later.

In addition to cameras and plotting instruments Wild produce almost all items of photogrammetric equipment and accessories, including: a camera mount, horizon camera, registering statoscope, stereocomparator, enlarger, rectifier (or rectifier-enlarger), a range of diapositive printers, processing equipment (Figs. 9.2 and 9.4),

various stereoscopes and a point-transfer device. The PUG3 and PUG4 point-transfer-device instruments are designed for easy stereoscopic transfer of image points from one photograph to another, and for marking them. Points can even be transferred between photographs of different scales.

THE CHOICE OF INSTRUMENTS

Classification according to "order", degree of precision and C-factor only takes into consideration a limited range of characteristics. Another perhaps broader classification might be as follows—

1. Universal and precise—e.g. A7, Stereoplanigraph, Photostereo-graph
2. Precise and designed for aerotriangualtion—e.g. A9
3. Precise plotters—e.g. A8
4. Exact solution but lower precision—e.g. B8, PG2
5. Anaglyphic instruments—e.g. multiplex, Balplex
6. Approximate solution instruments:
 (a) so-called 3rd order—e.g. Stereomicrometer, Stereotope
 (b) sketching only—e.g. Sketchmaster, Radial-line plotter

This would be some help in discussing the attributes of instruments; but in making a practical choice, it would be necessary to pose certain questions, and it seems appropriate to conclude this chapter with a suggestion as to what some of these would be. It is assumed that we would be using vertical black and white photography.

Each instrument possesses certain attributes which help to determine its suitability for any particular purpose. Perhaps the most important of these are—

1. The order of the work for which the instrument is intended (first, second, third order or only sketching or minor revision).
2. Position accuracy of which it is capable.
3. The ratio between flying height and heighting accuracy—the C-factor takes care of this.
4. The range of plotting scale to photo-scale ratio, including the z-scale range (i.e. projector to floating mark distance on the multiplex).
5. The quality of the stereoscopic model and ease of operation.
6. Average time required for orientation.

In choosing an instrument for a particular project, the following factors are important—

(a) What is the purpose of the survey? Is a plan, relief, or numerical information required?
(b) Scale of the plot required relative to the scale of photography.

(*c*) Position accuracy required and amount of control available.

(*d*) Heighting or contouring accuracy required, and amount of height control available.

(*e*) The quality of photography, including B/H ratio.

(*f*) The availability of machines.

FURTHER READING

(i) Schwidefsky, pages 205–52.

(ii) Moffitt, pages 360–96.

(iii) *Manual of Photogrammetry*, Vol. II, Chapters 14 and 15.

CONVERGENT PHOTOGRAMMETRY

(i) Moffitt, pages 439–45.

(See Bibliography (page 346) for full titles.)

Applications of Photography and Photogrammetry in Civil Engineering and Allied Fields

This chapter is an edited version of a correspondence course paper originally written by the author for the College of Estate Management.

The term "civil engineering" was originally used to distinguish between engineering activities dealing with civil matters on the one hand and those dealing with military matters on the other—military engineering being the preserve of the Corps of Royal Engineers. Thus originally civil engineering included mechanical, electrical, structural and all other types of engineering; but nowadays the civil engineer is one who deals with such things as the design and construction of railways, highways, and sewerage systems; land drainage, water supply, hydro-electric and irrigation schemes; dams of all kinds, tunnelling, airfields, harbours, canals, river control and coastal protection. His sphere of interest extends to town planning, estate development, mining, and under-water construction of all kinds. In other countries the dividing line between engineering and its associated professions differs from the above concept, and the term is sometimes considered to include surveying.

Within this wide range of interest, photography and photogrammetry are playing rapidly increasing roles. Before trying to outline the way in which photography in its widest sense may be used to solve the civil engineer's problems, it is necessary to present a résumé of the techniques which may be brought to bear.

THE USES OF DIFFERENT TYPES OF PHOTOGRAPH

The great advantages of photography are that it is the best means of recording a lot of separate items or movements at a given moment of time, and that the photographs can always be studied in comfort and at leisure; in addition, cine photography enables continuous

movement to be studied under laboratory conditions—the film can be " played back " as often as is required, stopped at a critical point, slowed down to capture a natural movement too fast for the eye and brain, or speeded up so that the significance of a very slow movement (such as the growth of a flower) can be appreciated.

A single photograph can be an ordinary snapshot taken with an ordinary everyday camera, or it can be almost distortion-free as are those taken with a modern air survey camera. Even the simple snapshot can be used to record facts, to illustrate the text of a report, or to convince a client or a committee on some factual point. On the other hand the use of modern high-speed digital computers has greatly extended the usefulness of photogrammetric techniques, as in highway route-finding and design.

Air Photographs

Air photographs extend the usefulness of photography for recording facts by enabling a number of photographs, collectively covering a very large area of ground, to be taken within a very short space of time. Thus the extent of a major flood can be recorded at or near the moment of maximum inundation; or a land-use record of a whole county can be made on the same day.

Air photographs also give views of objects and of the ground generally that are not otherwise available for study, and in particular they will often indicate areas where the ground has previously been disturbed. This will show up partly because of differences in the compaction of the soil, differences in the types of natural vegetation or in the lushness of crops. Thus existing sewers or other conduits may be discovered before excavation operations damage such services, or unique archaeological remains may be discovered before they are finally obliterated by engineering works.

Oblique Photography

Oblique photography from the air or from the ground will give a different view again. Often an aerial oblique will be more persuasive than its vertical counterpart because the layman can more readily distinguish objects with whose ground view only he is familiar. This type of photograph can also be taken from a captive balloon, or from an elevated ground station such as a tower or crane.

Fixed-base Stereo-photographs

Pulfrich's original stereocomparator was designed for use with a pair of photographs taken with the optical axes parallel with one another, and perpendicular to the camera base. This type of overlap

is important in fixed-base work where two identical cameras are rigidly fixed at either end of a rigid bar of stable material.

Fixed-base photography is important for plotting and recording architectural features, sculpture and models of say intricate factory layouts. Such methods involve vertical, oblique or horizontal photography, and are particularly useful where access is difficult or the time factor precludes other methods, e.g. where ancient monuments are about to be submerged due to the construction of a dam. The method is becoming widely used by the police, principally in obtaining records and plots of accidents where prolonged ground measurements might impede the flow of traffic. Plotting is greatly simplified because relative orientation is already known, and some firms produce special plotting machines in which the relative orientation is already set for use with a particular pair of short-base cameras.

Telescopic and Microscopic Views

Photographs can also be taken through telescopes and microscopes. In the latter case a single-lens reflex camera with a special close-up lens is desirable—in this type of camera the shutter would normally be in the focal plane so that the viewfinder could receive its image of the object by reflection of light rays entering through the taking lens. Such photographs could be used for recording bacteria in water samples, or perhaps for studying and making records of flaws in materials. When photographs are taken through telescopes, the telescope eyepiece is omitted and the image is brought to a focus in the negative plane. The most important use for this type of photograph is in astronomy.

Photographic Materials

Each of the above types of photograph can be taken on a variety of photographic materials, whose special characteristics can be used to bring out detail which could not otherwise be observed satisfactorily. If we wish to see the image as nearly as possible similar in appearance to the object itself, we would use normal colour film and view stereoscopically. For photography in poor light, for economy and ease of control and of processing, or where colour is unimportant, panchromatic film would be used; whereas infra-red will enable photographs to be taken through a hazy atmosphere. Infra-red could also be used to investigate changes which do not affect the visible spectrum—e.g. it would show clearly the division between sea-water and tidal flats or sand much more clearly than ordinary pan film; whilst a radar picture can be taken in the dark,

and some substances are differentially sensitive to heat variations. If it is wished to emphasize particular aspects of a subject, it may be possible to evolve a false-colour process—e.g. Kodak produced Ektachrome infra-red film for piercing war-time camouflage. This film contains three layers of emulsion sensitive respectively to green, red and infra-red light; and it is processed so that the green-sensitive layer appears yellow, the red layer appears magenta, and the infra-red layer blue. Such a film is also useful to forestry experts because an air photograph of forest areas would show up as bright magenta, but the diseased or dead trees would appear bright green.

In addition, the base for the photographic emulsions can be either transparent or opaque, whilst photogrammetric measurement demands the use of special dimensionally stable materials. Where plotting on to the photograph in the field is necessary, a double-weight paper base is probably best; a matt finish would provide a satisfactory plotting surface. A glossy finish gives greater re-flectivity and is usually preferred for stereo-viewing; but semi-matt could be specified when the same photographs may be used under a stereoscope and for plotting. For some outdoor uses a water-proof base may be needed. Where colour slides are required, positive transparencies are usually produced direct from the camera.

Recording Instantaneous Events

As previously stated, cine processes are invaluable for recording continuous movement; but the technique may also be used to obtain a photograph of a particular instantaneous event which could not previously be sufficiently accurately forecast. Such a procedure would sometimes be exceedingly wasteful of film, and there are ways in which the camera can be tripped to make the exposure at the required moment, or the shutter may be held open in a darkened room and the exposure made by instantaneous flash.

Typical methods of tripping the shutter are the make-and-break variety, where the breaking (or alternatively the making) of an electrical circuit causes the shutter to make the exposure. Perhaps the simplest illustration would be in testing an ordinary concrete test-cube to destruction under compression. In such a case a very fine wire could be placed tautly around the block being tested in such a way that the first " give " in the block would break the wire. If the shutter were wired to operate when an electric current was broken, then the device could be used to obtain a photograph at the moment of failure.

Photoelectric cells, which operate when something or somebody crosses an emitted ray, can also be used; and photographs of bullets

or other projectiles travelling at speed can be obtained by causing electricity to build up at one of a pair of electrodes until a very brief but intense spark crosses the gap and casts a shadow of the projectile. High-speed photography has become virtually a subject in its own right.

Photographs compared with Maps and Plans

Another aspect which needs examination is the relative use of maps and plans on the one hand, and photographs, especially air photographs, on the other. From the point of view of quantitative analysis and general appearance of the objects portrayed, it is important to remember that a photograph is a perspective projection whereas a plan is an orthogonal projection; i.e. height distortion is not strictly an error. However, there are other contrasts which may need noting here—a map or plan is made for a particular purpose and the objects which are shown are carefully chosen with an overall objective in mind; much information is therefore deliberately omitted, with the result that the information specifically required is shown free from unnecessary detail and is therefore very easy to pick out. In contrast, the photograph shows every item of detail which is visible from the lens. The photograph is therefore not only cluttered up with a massive amount of detail, it is also incomplete in that some objects will be hidden by other possibly less important objects. However, the very profusion of detail gives rise to an important group of uses for air photographs. If a geologist wishes to plot the limit of an outcrop which he can recognize on the ground, he may actually be able to see this on the photograph as well; but in any case there is so much detail already visible on the photograph that he will probably be able to recognize photo-points on the ground at frequent intervals along the line that he wants to plot; he can then draw the required line on the photograph in relation to these points. The line can later be transferred to a map by photogrammetric methods if desired. A physical (e.g. chain, plane-table or tacheometric) survey of the line would have been needed if it were to be plotted directly on the map or plan.

Orthophotos

The term " orthophoto " refers to air photographs from which height distortion has been removed, and they are therefore especially useful for plotting in the field since it is possible to measure horizontal distances from such a photograph. Orthophotos can be produced by spacial orientation of a pair of air photographs and then making a rectified print of the overlap systematically point by point. For

example, in a projection plotter of the Kelsh type the sensitized surface would be on the tracing table which would be brought to the correct height for each point in turn—all other points being masked at the instant of exposure. It takes very much less time to produce an orthophoto than it does to produce a map, and it seems likely that variations of this kind of photograph will tend to be used instead of maps, though positional accuracy is not yet up to the specifications required of plans. Wild have under manufacture an attachment which will enable orthophotos to be produced on the A8.

Micro-features

The Americans use terms such as " micro-features " and " micro-relief ". The latter refers to relatively small changes in slopes which occur between contours, and which are not therefore shown on a map. Micro-features are described as minor details of the earth's surface, seen on air photographs but too small or too subtle to be noted in normal mapping practice. Instances of such features are changes in tone value which reveal minor changes in the shape of drainage and vegetation patterns. Micro-features play an important part in feeding the deductive processes required to interpret such things as soil changes and the geological structure of an area, or in picking out diseased trees from an otherwise healthy forest. Acute powers of perception and careful training of the co-ordination of the eyes and brain are needed in order to pick out micro-features. We are looking for signs and signals whose shape and tone values we do not know, so that we can expect no automatic reaction of the brain to help us isolate the first of a particular batch of such features.

Ecology is the science concerned with geographical distributions of plants and animals and their interaction with their habitat. Ecological counts of items which can be distinguished on air photographs concern us here, as the dominance of certain plants is evidence of the soil conditions and geological structure. It is very much easier to organize systematic counts of populations on an air photograph than it would be to perform the same task directly on the ground.

AVAILABILITY OF AIR PHOTOGRAPHY

The Department of the Environment (Air Photo Officer) holds air cover of virtually the whole of the United Kingdom. This photography was flown mainly on training flights, and therefore although relatively very cheap it is of variable quality and scale, and is intended

for general local authority and educational use. For nearly all civil engineering (including local authority) and cadastral purposes commercially flown photographs are necessary.

One of the main reasons why air photography is not used for objectives for which it is eminently suitable is the high initial cost of the photography. On a large mapping project this cost is much more than counterbalanced by the saving in the cost of the ground survey. However, much of the expense is incurred in getting the aircraft to the required spot and at the required height, and in maintaining aircraft and crew during the periods of waiting for suitable weather conditions. The cost per photograph of a sortie containing only a small number of photographs is therefore very high compared with similar costs for a large project. However, most survey companies help to provide air photography of small areas economically by accepting orders over a period of time, and arranging for the actual sorties to be flown only when they have a suitable aircraft in the vicinity and there are a number of projects which can be photographed during the same sortie. Alternatively the client could enter into a contract with the survey company whereby the photography of a relatively large area of land would be flown at one time, and the bank of photographs would then be drawn upon by the company over a period of years to provide plans of separate small areas as and when the client needed them. A system similar to the latter has been operated by Hunting Surveys in the area of one of the New Towns.

The following are the main commercial sources of air photography and photogrammetric mapping—

Aerofilms Ltd., 4 Albemarle Street, London W1X 4HR.
B.K.S. Air Survey Ltd., Cleeve Road, Leatherhead, Surrey.
Cartographical Services (Southampton) Ltd., Waterworks Road, Worcester, and at Landford Manor, Salisbury, Wilts.
Fairey Surveys Ltd., Reform Road, Maidenhead, Berkshire.
Hunting Surveys Ltd., 6 Elstree Way, Boreham Wood, Herts.
Meridian Airmaps Ltd., Commerce Way, Lancing, Sussex.
J. A. Story and Partners, 8 Laurence Pountney Hill, Cannon Street, London, E.C.4.

Huntings provide mapping Services and specially flown photography and their associate firm, Aerofilms Ltd., specialize in maintaining a library of photographs to illustrate "all kinds of places and features from Ox Bows to Oxford." Photographs may be inspected at Albemarle Street, or ordered by post on a sale or return basis. As an example of the cost of this type of photography,

prints of up to 250×200 mm (Dec. 1970) cost 75p for first print (50p others) plus 9p postage.

The other firms specialize in surveying, and therefore in photogrammetric work. Where fairly large areas of land are concerned, these firms normally prefer to be consulted in the earlier stages of the project, so that they may advise on the most satisfactory and economic methods. Many of them provide a wide range of services auxiliary to mapping, such as model making or geophysical surveying. Such firms are naturally reluctant to quote a price for photogrammetric work until the actual location is known; but B.K.S. do give "budget guidance" figures (Jan. 1971), which they qualify as subject to a minimum charge of the order of £100, as follows—

(*a*) Land open in nature, approx. £22 to £25 per hectare

(*b*) Modern-type development, approx. £46 to £52 per hectare

(*c*) Dense central areas, approx. £68 to £74 per hectare

These figures are given in the context of 1/500 scale and 0·3 m vertical interval survey work.

B.K.S. also maintain a photographic library, mainly of 1/2,500 to 1/12,000 scale black-and-white vertical photography of the United Kingdom. The prices (April 1969) range from £1·06 for a single print (£1·07 for 2 prints) to 26p each when over 100 are ordered. Specially flown photography would be much more expensive, and present minimum charges would probably be £50 to £60 for vertical photography and £25–£40 for obliques.

Meridian too, offer the full range of services and they have a library of more than half a million vertical (scales from 1/1,200 to 1/25,000) and oblique aerial negatives.

Fairey Surveys use photogrammetric methods for mapping areas as small as 10 acres, especially when there is a lot of contouring required; though on flat areas they prefer ground survey methods as being cheaper and quicker. Fairey also maintain a library of photogrammetric quality air cover at scales ranging from 1/3,000 to 1/50,000. Cartographical Services too have a limited amount of air cover available for sale or loan, and this firm advertise 24-month mapping contracts, whereby they undertake to carry out all the client's survey requirements for two years at a fixed rate. Although J. A. Story do not maintain a library of photographs, they do, like the other firms, offer a purpose-flown photographic service.

USE OF AIR SURVEY IN CADASTRE

Cadastre deals essentially with the recording of details of land tenure; in particular, with the exact physical and legal boundaries

of plots or parcels of land. It is therefore concerned with accurate large-scale planimetry.

Air photographs can be used to record the position of pre-marked boundary stones, and in theory there is no limit to the scale at which this can be plotted on to maps and plans. Plans can easily be made from air photographs, without significant error, at a scale of 1/500; and in areas of sparse development or with little vegetation, the boundary marks can be picked out on the photographs. The only criterion to bear in mind here is the size of the boundary mark, which should be just big enough to be visible at the scale of the photography intended, and it must not be completely covered by the floating mark of the plotting instrument; but it must not be so big as to leave room for argument as to the precise point intended on the ground.

For this type of work the sequence of events would normally be for the land-owners and occupiers and tenants to agree to the boundaries on the ground, and for the surveyor then to mark these boundaries, preferably by erecting permanent marks such as stones or concrete posts and rendering these visible from the air, e.g. by painting or whitewashing. Air photographs are then taken and maps made, though in many instances the air photographs themselves would, by reason of the profusion of detail, be more suitable if a lost or moved boundary stone needed to be re-located.

By assisting in determining land utilization and soil conditions, the photographs would also help in establishing the relative values of parcels of land.

The limits of use of air survey in cadastre are legal—where the accuracy requirements are stated in a way which precludes economical use of air survey methods, and physical — where tree cover or other vegetation obscures the ground effectively over large areas. In addition, the agreement of the boundaries by the interested parties may take so long that relatively few marks need to be plotted in an area at any one time, and the individual projects cease to be large enough to give the cost advantage to air survey methods. However, it should often be possible for the surveyor to identify the agreed boundary marks on previously flown air cover.

PHOTOGRAPHY AND PHOTOGRAMMETRY AT DIFFERENT STAGES OF AN ENGINEERING PROJECT

The following is an attempt to point out the uses which can be made of photography and photogrammetry during the preparation and progress of a typical civil engineering project.

Reconnaissance and Site Investigation

At this stage photographic techniques are important mainly in determining best location for the project, and in investigating the economic and technological viability of a particular site, by—

1. Making maps—probably to a small scale (say 1/10,000 to 1/100,000). In this country the 1/25,000, 1/63,360 and 1/10,560 or 1/10,000 scale Ordance Survey sheets are already available, though perhaps not sufficiently up to date.

2. Instead of maps—stereoscopic air photography and especially orthophotos are particularly useful when plotting information in the field, as the copious detail allows more accurate and quicker location of, for example, geological factors, boundaries of all kinds, and trial-hole positions.

3. A stereo-model is the best way of seeing at a glance the shape of the whole area under review; e.g. in estate development the shape of the ground over the whole of a fairly large estate can be seen at one viewing from 1/10,000 scale prints. This is rarely possible from the ground and even when it is the perspective prevents a true assessment. Viewing directly from an aircraft does not give the advantages of an extended eye-base, so that the differences in height are not as readily appreciated. Since the configuration of the ground should normally suggest the layout of a new estate and indicate the natural drainage pattern, the value of the stereo-model can hardly be exaggerated. The ease with which the drainage pattern can be picked out makes the stereo-view invaluable in studying the catchment areas of reservoirs and water conservation generally.

4. The field data required by the engineer can in many cases be gathered more rapidly and mainly under office conditions, by interpretation from a single air photograph or from stereoscopic pairs. The sort of information which would interest the engineer at this stage would be concerned with: geology and soil conditions; land use and quantities of such use; natural drainage patterns and watersheds; made ground; previous excavations including those which may indicate buried pipe-lines or cables and archaeological remains.

5. Quantities of excavation and fill, and haulage figures, can be measured from the photographs and analysed by computer. This approach will be of particular use in highway location and design, for assessing the storage capacities of potential reservoirs and the probable run-off from the catchment areas. It is this aspect

of the subject which gives rise to some of the more spectacular uses of photogrammetry, and more will be said about this later.

6. Investigations of moving or changing objects can be made much more easily by the use of photography. For example, when it is proposed to discharge sewage effluent, treated or untreated, into coastal waters, the water currents at different depths may be studied and the speeds measured by photographing various coloured floats at successive intervals of time from the air, or from elevated ground positions. The floats are designed so that they are propelled by currents at various significant depths. If strips of overlapping photographs were flown during such an experiment, the positional changes of a float would show up as changes of parallax (x and y) between successive exposures, and a continuous record at short time intervals could thus be maintained.

Coastal erosion, littoral movement of materials, the progress of sand-dunes, and even the inexorably slow movement of a glacier could be measured by, for instance, using a known, fixed and elevated camera station for taking exposures at suitable intervals of time. It is also possible by similar methods to discern the diffusion of pollution in a stream, because the oxygen deficiency shows up on panchromatic film when a blue filter is used.

7. A record of the area may be made before the siteworks begin, by taking stereoscopic pairs of photographs from ground stations or from the air, or preferably by a combination of both. The record may be required purely for historical purposes, for legal evidence in case of subsequent dispute, or even to enable a building to be re-constructed elsewhere. A complete photographic record was made of many of the historic monuments in the area flooded by the Aswan High Dam, and there is a detailed description of the application of photogrammetric techniques prior to the restoration of Castle Howard in Yorkshire in the *Photogrammetric Record* of October, 1962. This country mansion was severely damaged by fire in 1940, and the only photographs available were random and not taken for photogrammetric purposes.

8. Offshore and under-water information may often be obtained. United States Coast and Geodetic Survey use colour film to locate deep channels, shoals, rocks awash or slightly submerged, and small inlets that shift and change with storms.

Provided that wave action and turbidity are not too great, the depth of a water body can be read off in a stereo-photogrammetric plotter. The apparent depth will be affected by the refractive index of the water and the angle of observation within the stereo-

model, and a correction factor must be applied. A change in the separation of the photographs forming the stereogram will alter the correction factor; but under good conditions an expert can calculate the positions of sub-aqueous contours.

Preliminary Report

At the preliminary report and any subsequent stage, photographs may be used to illustrate the report and for publicity. Photographs are often more persuasive than maps or plans, especially to laymen councillors, promoters, owners, or the public generally. The effect is even more marked if mosaics are used, or particularly if a three-dimensional model is made. Many items which have distinctive shapes are difficult to describe, and yet may be fully defined by photographs.

Design Stage

At this stage there will be a need for large-scale plans, probably at a scale of 1/500, and a new set of low-flown photographs may be necessary. Ordance Survey maps are not normally available at this scale, so that for engineering works a fresh survey and plot will be needed, probably involving photogrammetric methods.

It is not very easy to add design detail to the stereogram, and it may well be worth while to make a physical model. This would be made by forming the hills and valleys, probably by superimposing successive laminae of thickness equal to the known contour interval (at the scale required—often 10 times the horizontal scale), filling the ledges with some plastic material, smoothing this down and superimposing a mosaic of air photographs, stretched to fit the known points of control. The photographic detail will locate the objects which it is desired to place on the model. The design can be carried on this model, and viewed in various ways, some of which will simulate natural views of the completed scheme. This approach is especially useful for designing large high-rise estates and in examining the aesthetics and visual safety of a proposed highway.

A model is not easy to transport, and at any stage of the design it may be necessary to obtain plans. This is easy to do by using a systematic photographic converage similar to the normal vertical air cover, but on a very much reduced scale; it would involve plotting from a series of short fixed-base pairs of photographs. Alternatively the photographs could themselves be used instead of a plan. In cases where comparable plans at various stages in the design process are required, it will often be desirable to set up a permanent grid of elevated camera stations; e.g. at the intersections of a series of parallel horizontal rods with another similar

series at right angles to the first. Any physical model can be treated in this way, and the lighting may in many cases be arranged to simulate natural lighting.

Progress of the Actual Works

Photographs form the quickest way of recording information, and the whole of one photograph will relate to the same moment of time. Rarely will the cost of successive air photographic sorties be justified as a method of recording the progress of the works; but it will sometimes be possible to take successive ground photographs (or photographs from elevated camera stations such as gantries or cranes) which will adequately record this progress. These photographic records will usually need to be accompanied by a written statement dealing with items not readily visible on the photographs themselves. A good example of this sort of record occurs in the assessment of stocks of coal and coke at power stations and gasworks throughout the United Kingdom. Similar techniques could be used for accurate measurement of quarries and open-cast workings, spoil tips, and stockpiles of such things as timber, bricks, sand and gravel.

Sometimes too it will be desirable to make photographs of parts of the works which will be hidden when the structure is complete. This may help in analysing the subsequent behaviour of a structure, or as evidence in a court of law. Such photographs will have even more use if they are of photogrammetric quality.

Maintenance Period

During the maintenance period it may often be necessary to record and measure changes which are not directly observable but may be easily seen on successive photographs. Examples of this are the settlement of buildings, roadways and even bridge abutments; the movement of tall structures under varying wind conditions; analysis of the movements of various parts of a suspension bridge or other structure under varying load conditions; investigation of the deterioration of materials, such as wear in engine parts or wear of road surfaces.

Research

Much of the foregoing is equally applicable to research, which may be considered as similar to long-term reconnaissance or investigation, though the latter is usually concerned with a single project and there is likely to be a time limit. In research the investigation is likely to continue until the problem is solved, and the

results are not usually required for a particular job of work; however, the dividing line is very poorly defined. The ways in which photography and photogrammetry may help in research programmes include the following—

1. Recording successive stages in the physical development of an experiment, such as a model simulating the evolution of a river bed or the simulated formation of an offshore bar, or perhaps the colour changes taking place in a chemical experiment.

2. Examining the deterioration of materials under varying conditions of load, such as the testing of materials to destruction where the shutter would be tripped to expose at the moment of fracture.

3. Recording microscope work, or stress patterns set up by photo-elastic experiments.

4. Investigating under-water phenomena, such as the determination of the cause of a wreck.

SOME OUTSTANDING ILLUSTRATIONS

Land Utilization

Land utilization and the quality of the soil may be determined from vertical overlapping air photographs. This will help in a valuation of the land concerned; but such information would probably only be really useful for engineering purposes in under-developed countries. Messrs. Hunting Surveys report that much of the 6 years' work of investigation for the Lower Indus Report was carried out by air survey methods. The report was required by the Water and Power Development Authority for a development plan for the whole region. The plan envisaged a capital outlay of £600 M during a 25-year period, with the object of increasing the agricultural production of the region, though only a small proportion of the expenditure is directly concerned with agriculture. The report contains detailed studies of the river itself, the climate, soils, population, agriculture, irrigation, drainage, groundwater, and reclamation.

The first requirement in such a project would be for relatively small-scale (say 1/20,000 or 1/25,000) vertical air cover; partly for map-making, but also to enable an assessment of the overall problems to be made, so that the detailed investigation could be planned. Although a generalized land-use pattern will be easily determined by the surveyor's normal methods of interpretation, more detail can be obtained less directly from the photography by

L

using an expert in, for example, ecology or geology. Interpretation of the same photographs, particularly ecological interpretation, would help in locating geological outcrops and ground-water conditions; and certain items, such as saline deposits, could be exactly located. This same photography could then be used for plotting the field information.

As with the Lower Indus project, the purpose of such an investigation is normally to enable a development plan to be drawn up. This would almost certainly lead to engineering works such as dams, canals or highways, and a second more limited but larger-scale (say 1/5,000 or 1/10,000) set of vertical photographs would be needed for exact location and design of each of these projects. In the case of a reservoir, for example, these photographs would probably suffice for locational purposes and assessment of run-off; but large-scale photography (say 1/2,500 to 1/4,000) would be required in the vicinity of the dam itself.

Photogrammetry in Road Design

Several routines for using air photography, photogrammetric plotters and electronic digital computers for routing a new highway have been evolved. The following is a résumé of a method used by Hunting Surveys Ltd. (the complete artical is by J. W. Simmons and K. M. Keir in *Hunting Group Review* No. 64).

This method begins when the area of interest has already been reduced to a band which may be covered by a single strip of overlapping aerial photographs, at a relatively small scale, probably 1/10,000 or less. The photography is flown and processed and a suitably contoured strip map is prepared. At the same time a thorough geological investigation, including seismic and resistivity techniques, is made from which a longitudinal section is drawn, bedrock is isolated, and a report is drawn up.

The engineer is now able to select a more precise location for the centre-line, which he will define entirely in terms of straights and circular curves. Hunting's horizontal alignment computer programme will fit appropriate transitional curves for any specified road design speed, and National Grid co-ordinates are calculated (by the computer) for centre-line stations at any regular interval specified by the engineer. These co-ordinates are punched on tape, by which a co-ordinatograph is controlled to plot the centre-line together with normal cross-section lines at each station, and the plotter automatically records the centre-line chainage at each of these stations.

New low-level (say 1/2,500) air photography enables large-scale

contoured plans to be prepared, incorporating the centre-line plot. The plotter, for example a Wild A7, will, at the press of a button, also tape-record heights along each cross-section in turn. The centre-line ground profile is plotted automatically. The engineer provides information concerning the vertical alignment of the road and the lengths of the vertical transition curves. The computer will calculate and record centre-line chainage to all vertical tangent points, sags and summits, and the longitudinal grade profile is superimposed on the ground profile.

Further design information is now needed from the engineer in the form of simplified required cross-sections, and preliminary calculations of cut and fill are made. The programme can cope with various types of road cross-section, and will present the results in tabular form, recording soft cut, rock cut, fill, and running totals for each successive cross-section. Savings in the cost of earth moving by making small shifts of centre-line, either horizontally or vertically, can be investigated at this stage.

This procedure may be applied to alternative routes, so that a choice may be made.

The final calculation of earthworks quantities is made using full design information and more sophisticated computer programmes. Such a programme would take account of both camber and superelevation, and deal with differences in natural support (e.g. cut and fill) even to half-widths of the road. Quantities for stripping top-soil and subsequent re-spreading and seeding will also be recorded, and even bulking and compaction factors can be taken into account. Full drawings can be made automatically, but the setting out on the site must still be carried out manually.

Archaeological Sites

The presence of important archaeological sites must play a part in the making of decisions relating to the location of engineering works, and even when the chosen location violates such a site, every effort should be made to facilitate a complete survey of the site before its destruction. Air photographs are invaluable in finding such sites, and in many cases the photographs themselves will form a fairly complete record of the plan outline of the objects or constructions.

In this country, the discoveries would relate to anything from prehistoric burial mounds, iron-age hill forts, and Romano-British settlements and routes, to lost medieval villages. The last would be revealed by discoveries of changes in tone resembling the shape of the old strips of cultivation; in fact these patterns would be a

fairly complete record of plough marks and ridge and furrow, which are the result of continuous ploughing in one direction within the limits of the strip. In some cases the street pattern of the village, the house plots, and even the foundations of the houses themselves might be distinguishable. Although digging on the site would be necessary to elucidate some matters and to prove the deductions, the air photographs reveal remarkable detail which may not be visible on the site even when the location has been disclosed by the photographs.

During the progress of the " dig " it is necessary to map the position of finds almost as soon as they occur. This can be done from ground photographs, from photography taken from elevated platforms, or from scaffolding similar to that used in underwater mapping off Yassi Ada (p. 316).

Because it reveals former street patterns, and because subsequent archaeological investigation may reveal much of the social pattern of the former inhabitants, air survey can be considered as an important tool for research into the continuous interaction between society and its environment, which is often considered to be the basis of town planning theory.

Town Planning

This is one of the fields within civil engineering in which the advantages of air photography were first recognized. The operation of the Town and Country Planning Act, 1947, called for up-to-date maps, which the Ordnance Survey could not supply in time, though they did produce mosaics in lieu of the 1/10,560 sheets in areas where large-scale development was imminent. The then Ministry of Town and Country Planning set up a bank of R.A.F. air cover, from which the planning authorities could draw. These photographs enabled the planning authorities to bring the Ordnance sheets up to date by simple graphical methods. Having obtained the cover or having borrowed it from the regional offices of the Ministry, the planning authorities began to find other uses for this photography, such as in the survey for land use. It is the only method of making a record of uses over a whole county within one, or a few, days. Such photography could be very important where, in development control disputes, it is necessary to prove the use of a particular parcel of land at a particular date, or where it is important to know the extent of gravel workings at a certain date. If regular photography were considered economically viable, then much of the tedious work of inspection for contraventions of the planning code would become unnecessary.

Estate Development

This is an aspect of town planning and engineering which illustrates the versatility of air photography in providing information. For instance, the initial choice of site may be made from vertical photographs without the prior necessity of making a map, though in accordance with normal interpretation procedure, site visits will be necessary. The relevant factors concerned with such a choice are: the relationship of the individual site to other development and to the appropriate means of transport, whether road, rail, canal, harbour or airport; the amount of traffic on the existing roads; the natural drainage pattern and the water-table; soil and geology; the shape of the site on plan and in three dimensions; the vegetation; and the availability of facilities such as open spaces and schools. Nearly all this information can be deduced at least in part from air photographs; though the availability of gas, electricity and sewerage, together with legal and Development Plan restrictions, will need separate investigations.

The next stage involves the detailed investigation and planning of the chosen site. Air photography will be no help in determining the type of people for whom any residential development is intended; but it will help in allocating the flatter areas to industrial use, and to use for playing fields and schools; it will help in deciding the parts of the site unsuitable for construction projects by reason of poor bearing capacity, or liability to flood. The same photographs may be used to solve many of the problems arising at this stage, for instance: the presence of workable minerals will have to be established, especially surface deposits which may need to be extracted before development takes place; the best routes for through roads may be determined; and the shape of the land surface may be studied in order to help in defining the groupings of buildings, e.g. a concave surface is unifying, whereas a convex surface would tend to be divisive and would be preferred when choosing the boundaries of individual cells of development and of environmental areas. The micro-relief, so readily discernible in a stereo-model, is invaluable here, and in previously open areas the surface shape will probably be the most important factor in deciding the detailed layout of streets and sewers.

In addition, photographs can be used to illustrate each stage of report, for record purposes at intervals during the construction period, and perhaps even to assist in assessing progress. Sales publicity might well be illustrated with oblique views of the completed scheme, or of the design model. The entire design may

be carried out on a model, from which the final plans may be made by photogrammetric methods.

Making Plans from Models

One instance of this relates to a method of making working drawings for pipe systems in new or modified I.C.I. installations. The systems were so complicated that it became absolutely necessary to use a three-dimensional model for design purposes. The model was constructed using coloured pipes; pairs of short fixed-base coloured photographs were taken, and a purpose-made simplified plotter was used to plot the required plans.

Investigating Under-sea Phenomena

One of the most interesting uses of photogrammetry was reported in an article in the September, 1968, issue of the *National Geographic Magazine*. The article was by George F. Bass, who was investigating the wreck of a Roman argosy off Yassi Ada, a Turkish island in the Mediterranean. He describes an under-water photogrammetric system which was used to record precisely and speedily the relative positions of the various artifacts. A comprehensive scaffolding of angle iron was erected to cover the whole area of the wreck, and vertical photographs were taken from a tower which could be attached to any part of the scaffolding. The expedition later used a highly manoeuvrable two-man submarine which could dive to 180 m, and was fitted with a pair of aerial survey cameras with special under-water lenses.

Low Altitude Photography

The first air photographs were taken from balloons, and in more recent years captive balloons have been used, to a limited extent, for low-level photography; but these methods suffer from grave disadvantages. A fat cigar-shaped balloon about 6 m long is only just capable of lifting a 35 mm automatic camera. Something even of this size needs a lot of handling when it is in the air, and it is not easy to transport unless it is brought down and preferably dis-inflated. Disinflation is very tedious and costly, the helium gas itself is very expensive, and hydrogen is too inflammable for normal use.

It is possible to elevate a camera mechanically from a moving platform or vehicle but this method does not seem to have been used to any great extent.

Fairey Surveys Ltd. announce that they have succeeded in insulating the camera from the aircraft sufficiently to take successful

vibration-free exposures from a helicopter. Flying safety regulations allow helicopters to fly much lower than conventional aircraft, so that considerably larger-scale photography may be possible in the future. Fairey's claim that tests show a heighting accuracy of about 12 mm from a flying height of 75 m. Such a development would not only enable larger-scale (and small area) plans to be made, but would increase the amount of micro-detail available to all photo-interpreters.

The Department of the Environment has now extended its services by forming a Central Register of Air Photography of England and Wales, not only for O.S. and R.A.F. cover but also for other photography. The Register is advisory and intermediary. Enquiries about cover of a specified point or area should be addressed to: The Air Photographs Officer, Central Register of Air Photography, Department of the Environment, Whitehall, London S.W.1.

A similar Register for Scotland is operated by the Scottish Development Department, York Buildings, Queen Street, Edinburgh EH2 1HY.

FURTHER READING

1. ST. JOSEPH, J. K. S. (ED.), *The Uses of Air Photography* (John Baker Publications).
2. BERESFORD, M. W. and ST. JOSEPH, J. K. S., *Medieval England—an Aerial Survey* (Cambridge University Press).
3. *Aerofilms Book of Aerial Photographs.*
4. KUDRITSKII, D. M., POPOV, I. V. and ROMANOVA, E. A., *Hydrographic Interpretation of Aerial Photographs* (The Israel Program for Scientific Translations).
5. ALLUM, J. A. E., *Photogeology and Regional Mapping* (Pergamon).

(i) *Manual of Photographic Interpretation* (American Society of Photogrammetry).
(ii) Schwidefsky, pages 277–308.
(iii) Hart, pages 43–89.
(iv) Hallert, pages 224–41.

See also the trade literature of the firms mentioned in this chapter, and periodicals including those listed under Bibliography (page 346), e.g.—

"Precision photogrammetry at close ranges with simple cameras", by K. Schwidefsky, *Phot. Rec.*, Oct. 1970.

(See Bibliography (page 346) for the full titles.)

CHAPTER 14

Some Notes on Interpretation

As we have seen, most air photographs are overlapping verticals flown specially for map-making. For interpretation, however, there would be some benefits from using obliques, which cover a greater area of land per exposure; but the falling off in scale towards the horizon and the tendency, especially in high obliques, for the foreground detail to obscure other detail usually more than offsets the advantages of seeing a more natural elevational view. Foreshortened elevational views of objects can be seen near the edges of vertical photographs, e.g. the side elevation of the wall *TB* in Fig. 10.1. This phenomenon is sometimes referred to as the "leaning effect". Fig. 10.1 also shows that the greater the angle of view, the greater the leaning effect, so that there is some advantage, besides economy, in using super-wide-angle photography. With systematic vertical air cover it is often possible to see a limited elevational view of an object from more than one direction; with random obliques this is unlikely to occur, but obliques may also be flown systematically either by using convergent photography, or by other multi-camera methods. Tri-camera, or tri-metrogon (from the name of the lens) systems were once very popular in the U.S.A. and Canada. This method involved a vertically mounted camera, flanked by two obliquely mounted ones, and flown to produce strips of horizon-to-horizon photography.

INTERPRETATION OF BLACK AND WHITE VERTICALS

Besides the marking-up of photographs for the normal map-making procedure, the term includes interpretation for other purposes such as archaeological or other scientific investigations of an area. Interpretation of verticals is an art involving the recognition of objects which are familiar on the ground, from the unfamiliar vertical aspect. Many objects can be recognized directly by a study of a single photograph, but stereoscopic vision is used for the bulk of this work.

Good interpretation is mainly a matter of experience, and only a person regularly engaged in this work can be classified as expert. In addition, the interpreter for engineering purposes needs to be an

expert in engineering: the interpreter for agricultural purposes needs to be an expert in agriculture: the land surveyor needs to have a wide knowledge of topographic form, particularly of the area under consideration. It is usually necessary for the surveyor to spend a lot of time in the type of country being interpreted, comparing the actual ground with a stereoscopic model of the area. This is the type of work for which pocket stereoscopes are designed. The interpreter will also require a parallax bar for comparing heights of objects.

A good interpreter can recognize, from good stereoscopic photographs at a scale of say 1/10,000, most objects which he would normally recognize within about a half-mile range on the ground.

The following factors may be said to aid identification: tone, shape, size, pattern, shadow, texture, flare marks and location relative to other features.

We depend on the differences of tone in order to be able to appreciate any of the other factors, but it must be remembered that colour changes will show only as tonal changes. It was seen in Chapter 9 that the apparent brightness of a colour to our eyes may not be fairly represented by the tone on the photograph. Again the tone of a particular object will be affected by its texture. A very coarse texture will normally give rise to a lot of internal shadow and therefore to a dark tone, though if the camera and the sun's rays are in about the same direction, the shadows will be hidden and a much lighter tone will be apparent.

We cannot expect to recognize objects by their tonal values alone but if we take the other listed characteristics into account as well, then we can begin to get on with the job. As an example, roads could be of almost any tone but they are one of the easiest features to recognize by their shape and pattern. Again, regularly-shaped objects are likely to be man-made. Rectangular shapes indicate buildings of some sort, and houses can usually be distinguished by their size and location relative to the road pattern. Farm buildings and barns will usually be distinguishable by their pattern. Churches can be picked out by their size, shape and shadow. Gasometers again are easily recognized because of their distinctive shape and shadow.

The importance of shadow is that it gives a clue to the vertical or elevational shape of the object; thus it is the main guide as to how the object would look to us on the ground. If the position of the camera is changed, an object may be depicted quite differently, e.g. on two adjacent strips.

To illustrate the type of information which can be gleaned from

air photographs, and to give an idea of the problems of interpretation, let us consider the photographs from the point of view of their value in particular fields of study.

The agriculturist can pick up farm buildings as above; field boundaries will usually be obvious by their shadows. Pasture land will normally be distinguishable from arable. Grass has a high degree of reflectivity, and will therefore usually appear as light in tone, but there are many varieties of grass and the tone will also change with the stage of growth. Long grass will normally give a lighter tone than short grass as the individual blades will tend to bend over and form a better reflecting surface. Corn crops will expose a coarser texture and will therefore usually be darker than grass, except when they are ripening. Root crops might be distinguished by their pattern and rougher texture. These facts entail some knowledge of agricultural methods, and with a greater knowledge of the subject more information might be deduced: healthy crops might be distinguishable from those damaged by storm or even by insect pests. For complete investigation, the time of day and date should be known. For instance, if we recognized a field with the centre in one tone and a regular straight side border in another tone, then in late July and August the harvesting of some corn crop would be implied, but in June it would almost certainly be hay.

Woods and hedgerow trees could normally be easily distinguished. Areas containing trees arranged in straight rows, both rectangularly and diagonally, would either be orchards or forestry plantations. Orchards would normally be formed of smaller trees, and be of lesser extent, but the real distinction might be that orchards would normally appear in close association with a house or farm buildings, except in certain well-defined fruit-growing areas.

Photographs taken in winter will enable the leafless deciduous trees to be recognized, and at the same period of the year an elementary knowledge of forestry may enable certain species to be distinguished by their branch formation. Long well-defined shadows may help to determine the species. Certain species have peculiarities which may help in picking them out: elms are generally only found in hedgerows and their shadow is usually unmistakable; a single large tree in the middle of a field will almost certainly be an oak as this is the only forest tree which does not stifle the undergrowth, including grass; a smaller tree in a similar situation would probably be hawthorn; willows have an affinity for wet marshy places. The list of such characteristics is probably endless.

The geologist can recognize bedding planes by changes in rock structure, soil and vegetation. He can obtain some idea of the

direction and dip of particular strata, and so deduce the position of anticlines. He can obtain a fairly accurate idea of the location of fault lines and of the type of rock outcropping at different points. Many air survey companies include a special geophysical section and the aircraft carry magnetometers and other instruments to supply geological data which can then be elaborated by photo-interpretation and plotted on prints.

The archaeologist can pick out patterns of buried foundations and earthworks from air photographs. This is particularly remarkable, as in many cases there is no visible sign of the presence of such features when the area is examined from ground level. Once soil has been disturbed by trenching or similar working it will always retain a changed tonal value when viewed from the air. Of course the marks can be hidden by further excavation in the neighbourhood, and it is not every air photograph of the area that will reveal the tell-tale marks. These marks may show up to varying degrees according to the moisture content of the soil, the condition of the overlying vegetation, or the intensity and direction of the sun's rays at the time of exposure. The flying height and the type of film may also alter the photographic image of such a site.

"Flare marks" is the term used to describe small and apparently random differences in tone, Such marks can often be the first indication that there is something needing investigation. In rural areas a flare mark may be the only indication of a gate or break in a hedge—in this case the mark will probably have been caused by the concentration of animal or human feet changing the quality of the grass or other vegetative cover, or just causing greater compaction of the soil.

The topographer needs some knowledge of many different sciences. When interpreting the photographs for map production, he would usually start by marking in the roads, probably in yellow. He would follow this by picking out the watercourses in blue; this part of the proceedings would actually be facilitated by working on the contoured photographs, though the contours might tend to obscure some of the detail. Remaining water surfaces should also be picked out, though this may not be so easy, as not only is a water surface exceedingly variable in tone, but the edges tend to be obscured by overhanging trees. It might be difficult at first to distinguish between a canal and a road, but the presence of locks, causing sudden changes of level distinguish the canal. Other items of detail would now be marked up: houses, hedges and other boundaries, trees, footpaths, etc.

Interpretation involves full use of our power of deduction, but we

must be careful not to deduce too much. To take an extreme example, it would be in order to deduce that a smoking chimney indicated that a house was occupied; but the absence of smoke could not be taken to mean that the house was unoccupied.

Unfortunately overhanging trees may obscure much detail, and even overhanging eaves may prevent exact location of the ground-level plan of a building.

Topography and Land Use

Recognition of roads is generally easy except where hidden by overhang or the leaning effect; but the air photograph offers no direct evidence relating to the classification, though the width of the carriageway and the number of vehicles using it on a normal week-day are some indication of the road's importance. Modern design criteria may also be of some help in that the more important the road the greater the radius of its curves and the fewer the junctions with other roads. The road pattern itself may give some indication of focal points in an area, and the intensity of the traffic may be a measure of the importance of some of these points, e.g. the range over which fairly dense traffic is approaching a town centre on a market day may provide some evidence relating to the sphere of influence of the town or of its market.

Natural drainage patterns are readily discerned under stereoscopic viewing conditions; but some useful hints may be deduced from a single photograph. For instance, tonal variations may be due to differences in moisture content of the soil, and some types of vegetation (e.g. willows, osiers and reeds) will normally indicate a good supply of water and probably a low-lying area. Shadow will sometimes disclose a steep slope, and it may occasionally be worth while to remember that shadows will be foreshortened on a south-facing slope and elongated on a north-facing one, though it will be rare to find suitable objects to give the necessary guide to scale. Routes of roads and footpaths may be some guide as to steepness of slope, and where it is practised contour ploughing will help; but the location of any water surfaces will probably provide the best evidence.

Stereoscopic viewing reveals the exact shape of the ground; the lines of valleys, spurs and ridges may be found and the direction of surface drainage may be deduced for any spot. Actual variations in height may be measured by parallax bar, or read off the height index of, say the B8. On a single photograph it may be difficult to differentiate between a river and a canal, but viewed under a stereoscope the latter can be seen to follow the contours except where sudden changes in level indicate the presence of locks.

Legal and administrative boundaries are not seen on an air photograph, and their location needs investigation on site or on maps. Place, and other names need the same treatment. Physical boundaries are readily seen and fences may be distinguished from hedges by their shadow, straightness and thickness.

The regularity, straight lines and smooth curves of man-made objects will stand out against a background of the random arrangements of nature. In the more traditional residential layouts in suburbia and in rural areas, the fact that a building is a house will be revealed by reason of its relationship to a road, its garden, footpath and even garage. In more central areas, two- and three-storey terrace houses will be more difficult to differentiate from shops, offices and warehouses, though the items seen to be deposited in the backyards will be indicative of the use to which the building is put. We must remember, however, that we are only dealing with deductions and probabilities, and that even a garden will not necessarily indicate a house—perhaps there is a flat above a shop, or the garden is being cared for by a small shopkeeper, by a warehouse caretaker or even by the local authority. A large number of people in the street may suggest the presence of a shop or shops, which will also often have a wider pavement in front. Thus to achieve any certainty, the interpretation of building uses, especially in an urban area, would almost certainly need to be aided by sample site visits, though low-flown photos might reveal much from the elevations disclosed by the leaning effect, and obliques would probably show even more in this way. Shadow and elevation would normally give an indication of the height of a building and enable a bungalow, a two-storey house, or a block of three- or four-storey flats or maisonettes to be differentiated. This would, of course, be much easier using a stereoscopic view.

Industrial property poses similar problems. Cooling towers are unmistakable even in most plan views. Tall chimneys would probably indicate a manufacturing industry. The presence of a wharf or railway sidings would suggest the transport of coal or oil fuels, or of heavy raw materials or finished goods. Further pointers might be found in the kind of material stacked in the open round the building, and the type of transport in the vicinity, e.g. parked tankers or car-transporters. A glimpse of one elevation and clues as to the construction of the buildings would be a further help.

If the times of exposure are accurately recorded in the margin of the photograph, then the time interval between exposures can be deduced. By measuring the distance, relative to static objects, which any object has moved between successive exposures, an

estimate of the speed of movement can be made. For fast-moving objects, knowing the duration of the exposure might make it possible to deduce a crude estimate of the speed; but to notice any blur due to the normal movement of a car in a built-up area it would be necessary to subject a 1/2500-scale print to some 12 × magnification. There are sometimes ways of assessing relative speeds from single photographs, e.g. the frequency and shape of a ship's bow wave is an indication of speed through the water.

Aids to Interpretation

There are certain instruments or other adjuncts which can be used to aid interpretation. The most essential of all these is an ordinary hand magnifying glass, sometimes known as a reading glass. Those in most common use have up to about 6 × magnification; but more powerful lenses may sometimes be useful, and it would help to be able to obtain magnification up to the limit of resolution, i.e. until any further increase in magnification would produce a fuzzy image and no further increase in the amount of detail that would become discernable. An increase in magnification results in a decrease in the field of view, so that the photographs should normally be viewed with as little magnification as possible consistent with the need for easy visibility of the images being sought and studied. For this reason it is best to have available a range of glasses, with varying magnifications.

A linear millimetre scale is needed for comparing the sizes of objects, and even for obtaining an approximate measure of actual sizes. It is also advisable to have a pair of dividers available for use with this scale. There are several patterns of scale available, from the ordinary boxwood or those with black subdivisions on a brilliant white background, to the transparent variety. The last-named might be thought to have the advantage, in that photo detail on both sides of the line being measured can still be seen. However, the grey background of the black and white photograph tends to obscure the subdivisions, unless these are engraved in some bright colour, such as red or orange. A millimetre scale is to be preferred because it is unlikely that the scale of the photograph will be exactly that of any of the representative fractions for which scales are normally made. For special work it might be worth while having a scale subdivided with more precision than 1 mm, since under a magnifying glass the scale itself as well as the photographic image will be magnified. Lengths of horizontal objects can be measured directly in this way, but if reasonably prominent shadows are apparent an estimate of the height of an object can be made by com-

paring the length of its shadow with that of the shadow of another object of known height. Care must be taken to see that the shadow used falls on flat ground, or at least that the top of the shadow falls on ground which is at the same level as that at the bottom. The calculation required is a simple proportion, thus—

$$h_a = h_b \times \frac{l_a}{l_b}$$

where h_a = height of object a
h_b = known height of object b
l_a = length of shadow of object a
l_b = length of shadow of object b

Shadow is also a guide to bearing. In the northern hemisphere, the shadow at midday points to true north and it moves through approximately 15° in every hour, so that provided that the time of exposure is known, the direction of true north can be calculated with the accuracy normally associated with a desk protractor and a small prismatic compass, say to about the nearest degree. Thus a transparent protractor is also desirable, making it possible to measure approximate bearings. Unfortunately photographs do not always have suitable shadows, sometimes because of the high angle of the sun, or because a veiled sky has dimmed the sun. Electronic printers tend to even out the shadows, and it might often be desirable to have a second print made, on which the shadow is fairly dense.

A useful combined tool is a pocket-size measuring magnifier, which contains both eye-piece lens and field lens, and incorporates a linear scale reading to 0·1 mm and an angular scale reading to 2°. The one illustrated in Fig. 14.1 has a magnification of 5 ×, and the plastic body is translucent to allow adequate illumination of the field of view, since the bottom of the instrument rests on the table when in use. A grey scale is an adjunct which is often said to be useful in interpretation for measuring the tone of an image and comparing it with that of an already interpreted image; but this exercise is of very limited value because of the wide variety of tones which may apply to any one object, due to the conditions of lighting relative to the direction of the object from the camera lens. One of the best illustrations of these difficulties can be seen in a body of water, in which the tone may vary from black to white according to the conditions of light and wind.

A grey scale (Fig. 14.2) is made in a dark-room, using a strip of sensitized paper about 20 mm wide. The strip is laid face-up under an ordinary photographic enlarger, and covered with a sheet of

stiff paper, which is arranged so as to leave a length of, say 10 mm uncovered. The enlarger lamp is then switched on for a very brief period. The covering paper is moved along so that about 20 mm is now uncovered and another exposure equal to the first is made. A further 10 mm length is then exposed, and the process is continued until only the last 10 mm remains covered. At this stage the first 10 mm will have been exposed, say 10 times (i.e. length of strip is 110 mm), the second 10 mm will have been exposed 9 times, and so on, while the last 10 mm will still be unexposed. The strip is

FIG. 14.1. MEASURING MAGNIFIER (SECTION)
(*Rank Precision Industries* (*Hilger and Watts*))

FIG. 14.2. GREY SCALE

then processed. If the total exposure for the first 10 mm is just enough to make this area black, then we shall have a tone scale ranging, in 11 equal steps, from black to white.

Sometimes it is worth while to make a density scale, again using a strip of paper about 20 mm wide and subdivided into a series of say 10 mm lengths (for 1/2500 scale this would mean that the strip was divided into a series of rectangles each representing 1/8 of a hectare). The first space will be left blank, the second will contain scale images of, say 5 of the objects whose numbers are being estimated, the third

will contain, say 10 such images and so on. To estimate the density of the objects on any part of the photograph, the density scale is compared with the photographic image, and the rectangle whose density most nearly compares with the photo density is found. The appropriate figure is then read off the scale. A density scale would be particularly useful in estimating the number of animals in a herd of wild animals, and in other ecological counts.

Using a similar strip of paper, we may make sketches or tracings of patterns or shapes found to be indicative of particular ground features, so that they may be compared with other image areas on the print being interpreted. Particular crops may perhaps be identified in this way. Specimens actually cut from similar photographs would be preferred to sketches; they would be mounted on the end of a paper strip on which their identification would be recorded. Alternatively a series of such specimens of similar image patterns may be mounted side-by-side along one edge of the paper strip. It is convenient to refer to these aids as "identity scales".

Experience in interpreting for a particular purpose will enable the operator to build up a set of adjuncts and techniques specially adapted to those needs; but in virtually all cases stereoscopic viewing will be advantageous. When using the mirror stereoscope, the photographs will be set for viewing as stereograms in accordance with the drill given on page 71; though an approximate setting without marking the print is to be preferred. It is usually much better to set up the stereogram initially without the use of the magnifiers as the restricted view will be a disadvantage; when the magnifiers are subsequently brought into play a further adjustment to the setting will often be necessary.

The advantages of the pocket stereoscope are its low price and portability; but the uncut pair of prints can usually be viewed only by lapping one of them over the other. First lap the left over the right and then the right over the left; even then there will be part of the overlap which cannot be viewed at all without bending and damaging at least one of the prints, though arching one or both of the photographs may help a bit. Once the surface of the emulsion is cracked its usefulness for interpretation will be reduced, and great care should be taken of the prints. Often it will be desirable to have two sets of photographs, one for use in the field, for marking up during interpretation or for cutting into strips to facilitate viewing under a pocket stereoscope. With care the strips can be cut and mounted on to a backing sheet in such a way that each narrow strip can be viewed stereoscopically by lifting alternate edges. Wild have now produced a pocket mirror stereoscope (the TSP.1), which, although

portable and moderately priced, can present a three-dimensional view of the whole overlap of a pair of 230 mm × 230 mm prints.

For comprehensive and intricate interpretational tasks it would often be worth while to use one of the main range of plotting instruments if more remunerative work is not claiming it. In certain circumstances it might even be desirable to retain, say a B8 or a stereocomparator specially for this work.

Steps in an Interpretational Exercise

If the area of land concerned is extensive, a key map should first be drawn, showing the availability of photography over the whole area, and the purpose of the exercise should be fully investigated and understood. The photographs should then themselves be studied in a general way, both by direct vision and stereoscopically. The idea is to get to know the area and the qualities of the photography, so that an appraisal of the interpretational problems can be made.

Suitability of the photography will depend on the purpose of the investigation. The date of exposure may not matter for, say an archaeological investigation, when as many different sets of photographs of the area as possible might well be the main requirement. In the case of topographic interpretation for map revision, the photography needs to be as recent as possible. The appropriateness of the scale will vary according to the size of item under investigation as well as the purpose. Thus small-scale photography might be best for determining the extent of soil erosion or flooding, or for counts of large objects such as buildings; whereas large-scale photographs would be needed for counts of small objects such as individual plants or small animals, and for investigating land use in urban areas. For economy both in cost of photography and in time and convenience of interpretation, the smaller the scale consistent with the necessary requirements the better. The minimum scale will normally be that which under maximum magnification will just allow the necessary images to be identified.

In theory the next stage would be to base-line all the prints; but this inevitably destroys some detail, and is not normally necessary to the interpretation process. Without the base-line the interpreter is deprived of the usual reference system, and he will probably use the edge of the image areas as axes. If this is done it is considered safer to orient a particular photograph, either with the marginal lettering upright or with the southern edge nearest to the interpreter, and then to give six-figure references; the first three

digits would indicate the perpendicular distance in millimetres of the image under reference from the left-hand edge, and the last three digits the perpendicular distance in millimetres from the lower edge of the print. Other conventions apply in different offices.

By this time many of the problems of interpretation will have been isolated, and the prints will be taken into the field. As many items as possible will there be identified, and probably noted on transparent overlays. The photograph can be oriented in the field in much the same way as a map. At a scale of 1/10,000 or more it will usually be possible to recognize a fairly precise observer's position, so that it will often be possible to align the print on one prominent ground object. Otherwise linear items such as roads and railways on the print can be aligned parallel with the ground objects which they represent. If there are adequate shadows on both photo and ground, these can be correlated by applying the $15° = 1$ hour rule.

A limited amount of interpretation data may be determined from a map without visiting the site. For instance the scale can be found with greater accuracy than is given by the marginal information on the photograph, by comparing a fairly long photo distance with the corresponding distance on the map; but there are a few pitfalls. Firstly the base material of most maps is subject to a good deal of expansion and contraction (far more than for air photos), and bar scales drawn on the map itself should be preferred to representative fractions or to the token scales (i.e. to the scales quoted on the map in words). Secondly items shown by conventional signs should normally be avoided as they are not precise locations; boundary intersections away from roads are often best, but these must be exactly identifiable on the photographs where hedge intersections are often woolly. Ordnance Survey maps would enable the direction of true north, magnetic north and National Grid north to be found on the print. Information concerning road classifications, administrative boundaries and other conventionally marked detail might also be useful. Correlation between certain patterns on the photos and, say osier beds on the map, may enable the extent of osier beds to be interpreted on the photographs.

If part of the object of the exercise is to find all locations of, say item A, then the photographs will need to be scanned systematically, using the appropriate magnification and an identity scale if this is necessary. It will probably be possible to say with some certainty that item A could not occur in certain parts of the area; for instance we would not look for a stream on a convex slope, or for domestic poultry in a swamp. With a good knowledge of item A, the area of search can often be significantly reduced before scanning begins.

Where population counts (e.g. the number of coniferous trees per hectare in an area of mixed woodland) are required to be made the photograph under investigation may be divided into a succession of narrow parallel strips, and one strip at a time scanned carefully from left to right. When an estimate rather than a complete count is wanted, the rules of sampling may be applied to determine which strips need to be investigated. In such a case it would probably be better to divide the area into a series of squares, when statistical methods and random samples should be used to enable a good estimate of the numbers to be made by counting only within relatively few of the squares.

Records of the interpreted data must be meticulously kept, probably by sketching on an overlay or marking up a spare photograph, or by drawing up a schedule on which the image point is identified by the serial number of the print followed by a six-figure grid reference.

The availability of maps and oblique photographs will aid the interpretation of verticals, and complete knowledge of an area would require site visits including scientific site investigation, use of maps of various scales and a range of oblique and vertical photographs taken at different times and under varying conditions.

In colour photography the appearance of the stereoscopic model from vertical photography will differ from the natural view of the ground almost only in that the objects will be smaller and will be seen from the unfamiliar vertical direction, so that shadow will be the best guide to its better-known shape, just as it is with panchromatic air prints. Colour and false-colour photography is in demand for interpretation; but the main demand for air photography comes from map-makers, who want wide-angle photography on a 230 mm × 230 mm format. Such photographs are subject to serious doubts concerning the fidelity of the colour, and are still very expensive to process. Narrower-angle lenses give better results, and L. W. Tarling reports in the *Photogrammetric Record* that smaller 70 mm cameras are being used in the U.S. for aerial colour photography, and he recommends such cameras for use in groups of four alongside a 150 mm survey camera. The idea is to provide a 25% (by area) sample, to aid the interpretation of the 150 mm black-and-white photography.

C. F. Casella & Co. Ltd., market two Air Photo Packs, which have been developed as teaching aids by the Geographical Association. One deals with different types of developed areas, and the other with Lake District landscapes. Each pack comprises pairs or runs of stereo prints together with explanatory notes and key

transparencies. A pocket stereoscope is available with each pack
if required.

FURTHER READING

 (i) *Manual of Photographic Interpretation.*
 (ii) Trorey, Appendix I.
 LUEDER, D. R., *Aerial Photographic Interpretation*, (McGraw-
 Hill).
 H.M.S.O., *Manual of Map Reading, Air Photo Reading and
 Field Sketching*, Part II.
 *Aerial Stereo Photographs for Stereoscope Viewing in Geology,
 Geography, Conservation, Forestry, Surveying* (Hubbard Press).
 BOYER, R. E. and SNYDER, P. B., *Aerial Stereo Studies* (exercises
 to supplement *Aerial Stereo Photographs for Stereo Viewing*,
 above) (Hubbard Press).
 "Photo-interpretation and topographic mapping", by D. A. TAIT,
 Phot. Rec., April 1970.

COLOUR AND FALSE COLOUR
 (i) *Manual of Color Aerial Photography*
 Articles in the *Photogrammetric Record* of April, 1970—
 (*a*) "The truth about false colour film", by M. L. Benson,
 W. G. Sims, G. Hilderbrandt and H. Kenneweg.
 (*b*) "Some observations and recommendations for the future of
 aerial colour photography", by L. W. Tarling.

(See Bibliography (page 346) for the full title.)

Questions

The questions which follow are intended to be attempted at the end of each chapter as indicated. The purpose of the questions is to give the reader the opportunity to find out whether he has assimilated the text of each chapter in turn and, from time to time, to try to establish whether revision is needed.

Numerical answers are given at the end, but it must be appreciated that some questions may have several slightly different answers according to the method adopted, or to the assumptions made.

The answers section is also used to give some guidance on verbal answers, information on which the reader may not readily find in the rest of the book.

Where a question is not original, its source is acknowledged by a reference in brackets at the end of the question. The following abbreviated references have been used—

> I.C.E. The Part II Examination of the Institution of Civil Engineers: Surveying Paper.
>
> N.E.L.P. The North East London Polytechnic examinations for the B.Sc. (CNAA) degree in Land Surveying Sciences, Part II: Photogrammetry Paper.
>
> Read. U. The University of Reading First Examination for the B.Sc. degree in Estate Management: Surveying Paper.
>
> R.I.C.S.—I. The Royal Institution of Chartered Surveyors Intermediate Examination, Land Surveying Section: Topographical Surveying Paper.
>
> R.I.C.S.—F. The Royal Institution of Chartered Surveyors Final Examination, Land Surveying Section: Topographical Surveying Papers.
>
> Shef. U. The University of Sheffield First Examination for the Degree of B.Eng.: Surveying Paper.
>
> W.F. The Waltham Forest Technical College (now part of the N.E. London Polytechnic) Sessional examinations for Land Surveyors.

Chapter 1

Q.1. An air camera has a 230 mm × 230 mm format. If the slot in the focal plane shutter is 1 mm wide, calculate the speed (in mm/sec) at which the slot must move across the focal plane to give an exposure time of 1/250 sec. What period of time elapses between the exposure at one edge of the format and that at the other?

How high would a plane have to fly before the light reflected from a ground object would take as much as 1/3,000 sec to reach it?

Explain what is meant by the efficiency of a shutter.

Q.2. Explain the function of each part of a typical basic air camera and its mountings.

Q.3. Explain why it is that the most popular air cameras incorporate (i) a vacuum type of film-flattening device and (ii) a rotating-disc shutter.

Q.4. The perspective diagram of Chapter 2 is basically the same as the diagram of light rays which cause the image formation on the rear wall (negative plane) of the pin-hole camera. Explain briefly why, in spite of the use of complex lenses, this diagram may be taken to represent the theoretical paths of rays entering an air camera. Why would the pin-hole camera be useless in air survey?

Chapter 2

Q.1. (a) With reference to such factors as scale, tilt and height variations discuss the statement "A vertical air photograph is not a map".

(b) Define principal point, photo plumb point, isocentre and perspective centre. An air photograph of 3° lateral tilt was taken with a camera of 152·0 mm focal length; determine the distance from the perspective centre to the plumb point, and give the distances on the photograph—

(i) From the principal point to the plumb point.

(ii) From the principal point to the isocentre.

(iii) From the plumb point to the isocentre.

<div align="center">(R.I.C.S.—I., Mar. 1966, Q.1.)</div>

Q.2. Show that the scale along the isometric parallel of a tilted photograph is constant and equal to the scale of a truly vertical photograph taken at the same air station. Diagrammatically or otherwise show that when a square grid is projected perspectively on to a plane non-parallel to the grid surface, the resulting graticule is one in which there is a convergence of one or both sets of parallel grid lines.

Prove that the lines joining the upper corners of buildings to their corresponding ground line corners on an aerial photograph pass through the nadir point. Of what significance is this for other points on the photograph?

<div align="center">(W.F.—3rd year, Feb. 1969)</div>

Q.3. Explain the theory behind the paper strip method of plotting single points of detail or minor control points.

Suggest the main factor limiting the use of this method of plotting single points.

Q.4. Using a high oblique as an example, show in detail how the scale varies across the format of a tilted aerial photograph of flat ground.

Points A, B, C and D in the ground plane produce image points a, b, c and d in the photo image plane of a camera with a focal length of 150 mm. At the moment of exposure the camera axis was vertical and the image points then formed a perfect square, symmetrical about the principal point and with a diagonal length of 200·00 mm. What would the lengths of the diagonals have been if the camera axis had been tilted through an angle of 2° in the direction of the line AC at the moment of exposure?

<div align="center">(R.I.C.S.—F., Pt. I, Mar. 1969)</div>

Q.5. Using a camera with 150 mm focal length lens, photographs were taken of a hilly area of land from a flying height of 3,000 m A.O.D. The camera axis was truly vertical at the time of exposure. Calculate the smallest and largest local scales if the ground heights varied from sea level along the foreshore to a height of 97·42 m.

Chapter 3

Q.1. A pair of ground photographs are taken of a particular view containing two points A and B, the height of A being 37·41 m A.O.D. The two photo-theodolite stations O_1 and O_2 (Fig. 3.4) are 100 m apart, and the lens has a focal length of 165 mm. The angles $p_1O_1O_2$ and $p_2O_2O_1$ were measured as $59°37'$ and $51°25'$ respectively, and the axis was horizontal at both stations.

The co-ordinates in millimetres of the images of A and B are—

On photo 1 a_1 ($-31·72$; $+22·34$)

b_1 ($+07·36$; $+19·79$)

On photo 2 a_2 ($-11·47$; $-18·63$)

b_2 ($+29·58$; $-22·46$)

Calculate the height of the camera at O_1 and O_2, and the ground height of the point B.

Q.2. Explain what is meant by (i) base-line, (ii) parallax, (iii) want of correspondence, in relation to a pair of air photographs.

Q.3. Explain the purpose of a simple stereoscope, and the effect of using lenses in the eyepieces. What is the apparent effect of magnification?

Consider the relative advantages and disadvantages of a pocket stereoscope and a mirror stereoscope.

Q.4. Describe the method of base-lining a pair of air photographs by successive approximations, and explain how you would check the base-line. Discuss the merits of this method relative to those of base-lining under a stereoscope.

Chapter 4

Q.1. What is the significance of the *isocentre* and the *photo plumb point* in aerial photographs, and how are these points located?

Deduce an expression to show how the scale varies along the principal line of a "vertical" photograph containing tilt distortion and negligible height distortion.

What is meant by *crabbing* in aerial surveying, what effect does it have on the work, and how is it *corrected*?

(*I.C.E., Apr.* 1968, *Q*7)

Q.2. 1/10,000-scale photographs with 230 mm × 230 mm format are taken of a fairly level area of land. If the average fore and aft overlap is 60 per cent calculate the minimum number of photographs required to give stereoscopic cover of a strip of land 21·763km long.

Q.3. Explain why the heights of buildings, trees, etc. appear to be exaggerated when a pair of vertical photographs is viewed stereoscopically.

A factory chimney 400 ft. high appears at the principal point of a truly vertical photograph. On the next photograph, taken shortly after, and also truly vertical,

the base of the chimney is on the x axis and 3·30 in. to the left of the principal point. Each of the photographs is 8 in. × 8 in. Given that the flying height of the aircraft above the ground was 2,600 ft, and that the focal length of the camera lens was 5 in., determine—

(a) the distance of the top of the chimney from the y axis on the second photograph,

(b) the percentage overlap between the two photographs.

(*I.C.E.*, *Apr.* 1967, *Q*1)

Note: Use metric equivalents as follows: 400 ft = 122 m; 3·30 in. = 83·82 mm; 8 in. = 203 mm; 2,600 ft = 792·5 m; 5 in. = 127 mm.

Q.4. (a) You are asked to prepare a flight plan for an area of photography at 1/20,000 scale.
Camera focal length is 152 mm.
Format is 23 × 23 cm.
Ground height varies from 100 m to 500 m.
Fore and aft overlap is to be 60 per cent.

Calculate—

(i) Aircraft flying height,

(ii) The length of the airbase between photographs,

(iii) Image movement if shutter speed is 1/200 sec and aircraft speed is 300 km per hour.

(b) Give three factors which could affect your choice of flying direction for an area of photography, and explain their importance.

(*R.I.C.S.—I.*, *Mar.* 1970, *Q*3)

Chapter 5

Q.1. (i) What are the basic principles of the slotted template laydown method of providing minor control?

(ii) You are responsible for executing a slotted template laydown. Describe how you would do this up to the stage of obtaining positions of the minor control points.

(*R.I.C.S.—I.*, *Mar.* 1970, *Q*7)

Q.2. Define the terms "principal point", "minor control point" and "ground control point" as applied to vertical air photographs.

Minor control points are marked on three consecutive vertical photographs forming part of a strip of photography. Two ground control points are identified on the photographs from information from a ground control survey and also marked on them.

A map showing the relative positions of the principal points, and the ground control points is to be prepared to a scale of $1\frac{1}{2}$ times that of the photography. Describe the procedure to be followed in producing and checking such a control map.

(*I.C.E.*, *Apr.* 1968, *Q*6)

Note: The term "minor control points" in the second paragraph of this question is used in the same sense that this book uses the term "passpoints".

M

Q.3. What is the immediate objective of a slotted templet assembly, and for what purpose is the completed plot used?

Discuss the relative advantages of the slotted templet method of increasing control, and the purely graphical radial-line method.

Chapter 6

Q.1. Define the term "parallax" when it applies to the images of a certain ground point that are seen on a pair of overlapping vertical photographs.

A certain point on a cliff-top is clearly visible on two truly vertical overlapping air photographs. Similarly a marker on the sea-shore close to the water's edge is also clearly visible on both photographs. Describe how you would determine the height of the point on the cliff-top above sea-level from the two photographs and state what further information you would require. Prove any formulae used.

(I.C.E., Oct. 1965, Q6)

Q.2. (a) Prove that the displacements of air photo images due to tilt in a near-vertical photograph are radial from the isocentre.

(b) Describe how you would establish vertical control for contouring a stereoscopic overlap by linear methods using a parallax bar, quoting any formula you would use. Assuming that eight vertical control points are available to start with, how should these points be positioned for the best results?

(R.I.C.S.—I., Mar. 1966, Q6)

Q.3. Explain why it is necessary to use stereoscopic viewing to measure the differences in *x*-coordinates of a point on two successive air photographs, when such measurements are required for determining differences in ground heights.

Suggest criteria for selecting photo points to act as heighted points between which contours may be interpolated.

Q.4. Explain the practical advantages and disadvantages of using a correction equation for adjusting the heights of minor height control points between which it is intended to interpolate contours.

Comment on the possibility of using an Ordance Survey map or plan to provide major height control for a simple photogrammetric contouring project.

Describe the operation of contouring by interpolating between points of known height.

Chapter 7

Q.1. You are asked to "field complete" a 1:25,000 map compilation which has been plotted from aerial photography with the minimum amount of ground control and no reliable existing map material.

List the items you would expect to have to supply, describe how you would collect and record them.

(R.I.C.S.—F., Mar. 1966, Pt.I, Q7)

Q.2. Compare the merits and demerits of "vertical" air photographs with those of obliques as a medium for map and plan compilation.

Q.3. In map revision, the quantity of new detail to be plotted in any part of a map may range from a single house to a large estate. Explain carefully how such detail may be plotted from: (a) random air photography, (b) purpose-flown overlapping vertical photography. Only graphical methods are to be used.

Q.4. The Sketchmaster is one of the simplest instruments used for plotting map detail; but an optical rectifier may also be used for this purpose. Compare and contrast the operation and accuracy of these two instruments.

Q.5. In emergency, mosaics have been issued in place of Ordnance maps. Explain the reasons why mosaics are rarely produced for sale to the public in this way, and point out the reasons why such an issue might have been worth while.

Chapter 8

Q.1. A three-colour map with new-style lettering and information is to be produced from an outdated black and white original incorporating revision detail and contours. Detail the procedure necessary to produce plates for rotary offset printing.

What advantage is there in compiling map data in reverse image form?

(W.F.—3rd year, Feb. 1969)

Q.2. Explain the following cartographic terms: (*a*) Half tone, (*b*) photo-mechanical lettering, (*c*) presensitized plates, (*d*) specification, (*e*) tone, (*f*) registration.

(W.F.—2nd year, Feb. 1970, Q3, part only)

Q.3. Name three light-sensitive substances which are used in map reproduction. Explain the process in which each is used, and the reasons for this segregation of function.

Q.4. (i) Basically both the process camera and the lithopress are reprographic machines. Briefly explain their differing roles.

(ii) Both the air camera and the process camera are precision instruments, basically similar in construction. Point out the main physical differences and the reasons for these.

Chapter 9

Q.1. (*a*) Discuss factors which militate against the procurement of quality survey photography and the means adopted to minimize their effect.

(*b*) Summarize the characteristics of black and white emulsions used in aerial photography.

(W.F.—3rd year, Feb. 1969)

Q.2. Discuss the relative advantages and disadvantages of panchromatic and infra-red emulsions in aerial survey work.

(R.I.C.S.—F., Mar. 1966, Pt.I, Q4)

Q.3. Explain the purpose of each of the stages of processing an aerial film, noting precautions which need to be taken to maintain the quality of the negative.

Q.4. What is the importance of resolving power, and how may it be measured?

List and explain briefly those attributes of an emulsion, film-base, or lens which may cause displacement of the image in an aerial photograph.

Chapter 10

Q.1. A block of 1:25,000, 23 cm format wide-angle photography is flown to cover an area 100 kilometres square with 60 per cent and 25 per cent forward and lateral overlaps respectively. Determine the amount of film required and estimate the amount and distribution of ground control for a photo scale slotted template assembly for compilations at

(a) 1:25,000

(b) 1:40,000

What differences would result in the use of 23 cm format 88·5 mm focal length super-wide-angle photography for this project if

(c) the same flying height were used?

(d) the same photo scale were used?

(*W.F.—3rd year, Feb.* 1969)

Q.2. (a) Discuss the requirements for a suitable ground control point for a photographic survey at a scale of 1:10,000. What kind of equipment would you recommend for the ground control survey?

(b) Photographs 230 mm square are taken vertically (without tilt) from a height of 1,500 m above a fairly level site using a camera of 150 mm focal length. On a stereo-pair the principal points are marked and found to be a mean distance of 93·50 mm apart. Calculate the percentage overlap and the length of the air base.

(c) Calculate, as accurately as possible, the difference in level between two points for which the mean parallax bar readings are 17·85 and 18·62 mm respectively and state the permitted tolerance in flying height if this difference is to be known within ±0·2 m.

(*Shef. U., June* 1971)

Q.3. Give an account of the factors that influence the choice of focal length and photographic scale for a specific mapping project.

List and briefly explain the other technical factors you would expect to find in a comprehensive specification for an aerial photography contract.

(*N.E.L.P.—Part II, June* 1971)

Q.4. Calculate the flying height, number of photographs per strip and number of strips for the following conditions, allowing a fore and aft overlap of 60 per cent and a lateral overlap of 30 per cent—

(a) 1:5,000 contact scale photography when using a 180 mm × 180 mm format camera with a 210 mm focal length lens. A rectangular area of 105 km × 16 km is to be covered. Ground heights vary from 50 m to 150 m above m.s.l.

(b) 1:25,000 contact scale photography when using a 230 mm × 230 mm format camera with a 150 mm focal length lens. A rectangular area of 273 km × 32 km is to be covered. Ground heights vary from 200 m to 700 m above m.s.l.

(*Based on a question from the R.I.C.S. Autumn* 1958 *examination*)

Q.5. The Town and Country Planning Authority are producing a "Regional Plan" for an area some 1,250 km² in extent, and need up-to-date topographic maps to work on. A 1/25,000 scale map series with 10 m V.I. contours exists for the whole area. These maps would be suitable, but they are out of date, mainly

owing to new development. The latter consists chiefly of individual buildings and small groups of houses and the accompanying access roads; but there are also a few large residential estates which are missing.

There is full recent overlapping vertical air cover at approximately 1/24,000 scale over most of the area; the remainder is also covered but only by random air photographs.

You have been sent to advise the Chief Planning Officer, who tells you that he has very limited capital resources but is willing to buy a few simple instruments if necessary. He also tells you that he has a very good team of draughtsmen, who have been doing some cartographic work, but have no experience of plotting from air photographs.

Briefly outline the initial advice you would give.

Chapter 11

Q.1. State what is meant by the real model and the visual model in relation to multiplex plotting, and explain why it is the real model from which the measurements and plottings are made.

Q.2. The co-ordinates of three points A, B and C on the plotting table of the multiplex equipment are as follows—

$$A \quad -11\cdot2\,\text{cm} \quad X, \quad +23\cdot2\,\text{cm} \quad Y$$
$$B \quad -21\cdot6\,\text{cm} \quad X, \quad -19\cdot4\,\text{cm} \quad Y$$
$$C \quad +\ 3\cdot5\,\text{cm} \quad X, \quad -29\cdot2\,\text{cm} \quad Y$$

where the X and Y axes are respectively the trace of the vertical plane through the air base and the trace of the vertical plane at right angles to the former trace.

Observations for absolute orientation of the model have been made with the following results—

$$A \quad +11\cdot6\,\text{mm}$$
$$B \quad -\ 6\cdot3\,\text{mm} \quad \text{in the sense Multiplex Height} - \text{True Height}.$$
$$C \quad +\ 9\cdot5\,\text{mm}$$

Calculate the lateral and fore-and-aft rotations which must be applied to the projectors, together with their direction, to obtain a correct absolute orientation of the model.

(R.I.C.S.—F., 1955)

Q.3. Discuss the processes of inner, relative and absolute orientation when setting up an analogue plotting machine. Outline practical methods of carrying out these operations and comment on the nature of the errors arising in the model from small residual errors in the settings.

(N.E.L.P.—Part II, June 1971)

Q.4. (*a*) Discuss briefly the advantages of multiplex over any other photogrammetric system.

(*b*) Name two disadvantages.

(*c*) Sketch a typical ground control layout for multiplex bridging.

(R.I.C.S.—F., Pt. I, Mar. 1966)

Chapter 12

Q.1. The Porro-Koppe principle is often used in a modified form in photo-grammetric plotting machines. Explain this principle and discuss its applications in modern photogrammetric equipment, making comparisons, where relevant, with machines using a mechanical solution.

(R.I.C.S.—F., Pt.I, 1970)

Q.2. Using note form, describe the procedure for aerial triangulation, including adjustment, by either of the following methods—

(*a*) Multiplex, using two projectors and inclinometer.

(*b*) Wild A8 or Thompson-Watts plotter.

(R.I.C.S.—F., Pt.II, Mar. 1966)

Q.3. (*a*) Explain the purpose and operation of the lazy-tongs in the A8, and state why these are not necessary in the A7.

(*b*) Suggest reasons why, in a large mapping concern, it is usually advantageous to have a range of plotting instruments. Give some indication of useful combinations of instruments, and the role which each would perform.

Q.4. A plotting machine with a Z range of 175 mm to 350 mm is fitted with a separate plotting table that has possible gear ratios of 1:1, 3:4, 2:3, 1:2, 2:5, 1:3, 1:4 and their reciprocals. The machine is to be used for 1:1,250 scale mapping using 23 cm × 23 cm photographs taken with a camera with a focal length of 152·38 mm. The flying height was 1,000 metres above mean sea level. Ground elevations vary between 150 and 290 metres above mean sea level.

(*a*) Suggest a suitable gear ratio and give reasons for your choice.

(*b*) What would be the most suitable Z range?

(*c*) What would be the arguments in favour and otherwise of using a camera with a focal length of about 300 mm for this survey? Indicate the differences that this would have made to your calculations.

(R.I.C.S.—F., Pt.I, Mar. 1969)

Chapter 13

Q.1. What sort of special problems might best be solved by the use of cine-photography? Give various examples to illustrate your answer, and suggest the ways, if any, in which the use of a stereo-cine-camera might help.

Q.2. Suggest ways in which photography might be used to provide adequate records of an archaeological dig.

Q.3. Suggest ways in which photogrammetry might be used in order to assist in an analysis of the movements under simulated load of the individual members of a model of a steel-framed structure. What additional obvious difficulties would be involved in an investigation of the full-scale structure?

Q.4. An architect is responsible for designing the layout for a large residential estate in undulating country. The area around is of particularly fine landscape value and much of it is open to the public. So that he may more readily appreciate

QUESTIONS 341

the effects of his proposals, the architect wishes to carry out his design on a physical model. In addition he will need to produce plans and other illustrations to convince committees and members of the public.

One major difficulty involves the vertical scale of the model. If this is exaggerated relative to the horizontal scale, then the buildings will also need to have their heights increased out of proportion to their plan dimensions; but if the natural scale is maintained in the model, it becomes almost impossible to detect the undulations of the ground.

Advise the architect of the ways in which stereoscopy and photogrammetry (and/or photography) can help, if at all, in viewing the model and in producing plans and other documents for presentation to committees and the public.

Note: An outline answer to this question is given under "Answers".

Chapter 14

Q.1. (*a*) In relation to air photographs distinguish between "pattern" and "texture", giving examples of both features.

(*b*) To what extent do pattern and texture affect the appearance of air photographs, and of what are these characteristics in air photo interpretation?

(*Read., June* 1971)

Q.2. You are making a study of a stereo-pair of air photographs of an urban locality that is unknown to you and no data have been supplied with the photographs.

Explain how you would attempt to determine—

(*a*) the scale of the photographs;

(*b*) the direction of true north;

(*c*) the heights of objects;

(*d*) the length of the air-base.

(*Read., June* 1970)

Q.3. (*a*) Discuss the effect that solar shadows have upon the interpretation of air photographs.

(*b*) In connexion with the study of air photographs define briefly

(i) air base,

(ii) percentage overlap, and

(iii) "crab" angle,

and explain how the values of these characteristics may be determined from measurements on a stereo-pair of photographs.

(*Read, June* 1969)

Q.4. The direct use of aerial photographs with small cartographic annotation and limited traditional techniques meets the demand for terrain portrayal better than conventional maps. Discuss this opinion in terms of cost, speed of production, legibility and up-to-dateness.

(*W.F.—4th year, Feb.* 1970)

Q.5. From the point of view of providing information, and as a base for recording further information, compare the value of an Ordnance map with that of

(*a*) a single vertical air photograph,

(*b*) a photo mosaic,

(*c*) a stereo-pair of vertical photographs.

Answers

Chapter 1

Q.1. 250 mm/sec; 0·92 sec.; approx. 100 km.

Chapter 2

Q.1. In Fig. 2.8: $Sn = 152·21$ mm, and (i) $pn = 7·97$ mm, (ii) $pi = 3·98$ mm, (iii) $in = 3·99$ mm.

Q.2. Fig. 7.1 may help to add to the information in Chapter 2. The significance is that displacements due only to variations in ground heights are radial from the nadir point.

Q.3. Height limits the use of the paper strip method, which will give plottable errors if ground heights vary by more than about 2 per cent of the flying height.

Q.4. 200·12 mm (mid-pt. of bd would be at n); and 200·36 mm.

Q.5. 1 in 20,000 at S.L.; and 1 in 18,684.

Chapter 3

Q.1. 26·12 m A.O.D.; 44·89 m A.O.D.; 38·66 m A.O.D. (Solve triangle AO_1O_2 of Fig. 3.4, using sine rule; then find $A'A$ in Fig. 3.5—repeat for point B—tedious, but not difficult.)

Chapter 4

Q.2. 25 photos. 1st photo gives no stereo cover, 2nd gives 60 per cent stereo cover (1,380 m ground distance), 3rd and subsequent give 40 per cent (920 m). But see Chapter 10 later.

Q.3. I.C.E. answers: (a) 3.90 in.; (b) 58·6 per cent. Using metric equivalents: (a) 99·08 mm; (b) 58·7 per cent.

Q.4. (a) (i) 3,340 m above S.L.; (ii) 1,840 m, since aircraft moves at nearly constant speed; (iii) 0·021 mm.

Chapter 10

Q.1. Assume length of film per exposure say 250 mm, and that each magazine holds 60 m length of film; then 46 exposures per strip, means 5 strips per magazine. No. of strips is 25—say (a) 6 magazines (1 spare) and (b) 1,150 photographs.

(a) Put $e =$ say 0·5 mm, then 116 ground control points required.

(b) e becomes 0·8 mm, then 46 ground control points required.

Super-wide-angle photography with (c) same flying height would result in smaller scale and fewer photographs—less film required, and both e and t are smaller; (d) same photo scale—t and e and therefore c remain same.

Q.2. (*a*) Min. dia. on ground: say 2·5 m. (*b*) 59·35 per cent, and 935 m. (*c*) From first principles: 12·25 m; using difference in parallax formula: 12·4 m, using differential parallax formula: 12·35 m. Tolerance in flying height: approx; 25 m.

Q.4. (*a*) 1,150 mm; 293; 27.

(*b*) 4,200 m; 121; 9.

Chapter 11

Q.2. $-1°24'$ and $+4°09'$.

Chapter 12

Q.4. (*a*) 4:1 increase in scale over photo scale; (*b*) 200 mm.

Chapter 13

Q.4. It is possible to arrange the angles of the wing mirrors of a mirror stereoscope so that a slightly distorted 3-D aerial view of the natural scale model becomes possible. If the mirrors are drawn some way apart and are large enough, the "instrument" can provide some help in this way.

Unless the scale is large enough, it is impossible to view the model in such a way as to simulate exactly the 3-D "live" view of the ground—this is because the eye-base needs to be to the same scale as the model. Single ocular peep-sight views could be arranged from points at approximately "eye" height.

Plans and vertical air cover could be provided by photographing the model in a way similar to that used under water for the survey off Yassi Ada. Obliques, and panoramic views from neighbouring vantage points (on the model) would help laymen to appreciate the effect of the proposals on the landscape.

Appendix 1

Units Used in This Book

Length	metre (m)
	1000 km = 1 megametre (Mm)
	1000 m = 1 kilometre (km)
	1/1000 m = 1 millimetre (mm)
	1/1000 mm = 1 micron (μm)
	(1 foot = 0·3048 m (exactly))
Area	10,000 square metres (m²) = 1 hectare (ha)
	100 hectares = 1 square kilometre (km²)
	(approx. 2½ acres = 1 ha)
Time	*second (s)*
	60 seconds = 1 minute (min)
	60 minutes = 1 hour (hr)
Angles	*second (")*
	60 seconds = 1 minute (1′)
	60 minutes = 1 degree (1°)
Speed	kilometres per hour (km/h)
	or metres per second (m/s)
	(30 m.p.h. = 48·3 km/h)
Velocity of light	186,000 miles/s = 299 Mm/s
Pressure	Newtons per square metre = N/m²
	10N/m² = 1 bar
	(air pressure at sea level, 14·7 lbf/in² = 101 kN/m²)

Appendix 2
The Greek Alphabet

α	A	alpha	ν	N	nu	
β	B	beta	ξ	Ξ	xi	
γ	Γ	gamma	o	O	omicron	
δ	Δ	delta	π	Π	pi	
ε	E	epsilon	ρ	P	rho	
ζ	Z	zeta	σ	Σ	sigma	
η	H	eta	τ	T	tau	
θ	Θ	theta	υ	Y	upsilon	
ι	I	iota	φ	Φ	phi	
κ	K	kappa	χ	X	chi	
λ	Λ	lambda	ψ	Ψ	psi	
μ	M	mu	ω	Ω	omega	

Bibliography

Books

1. AMERICAN SOCIETY OF PHOTOGRAMMETRY, *Manual of Color Aerial Photography*.

2. AMERICAN SOCIETY OF PHOTOGRAMMETRY, *Manual of Photogrammetry*, Vols. I and II.

3. AMERICAN SOCIETY OF PHOTOGRAMMETRY, *Manual of Photographic Interpretation*.

4. CIMERMAN, VJ., TOMASEGOVIC, Z., *Atlas of Photogrammetric Instruments* (Elsevier).

5. CRONE, D. R., *Elementary Photogrammetry* (Arnold).

6. DICKINSON, G. C., *Maps and Air Photographs* (Arnold).

7. HALLERT, B., *Photogrammetry* (McGraw-Hill).

8. HAMMOND, R., *Air Survey in Economic Development* (Muller).

9. HART, C. A., *Air Photography Applied to Surveying* (Longmans).

10. HYDROGRAPHIC DEPARTMENT OF THE ADMIRALTY, *Admiralty Manual of Hydrographic Surveying* (1948 edition).

11. LYON, D., *Basic Metric Photogrammetry*.

12. MERRITT, E. L., *Analytical Photogrammetry* (Pitman, New York).

13. MOFFITT, F. H., *Photogrammetry* (International Textbook Co., Scranton, Penn.).

14. SCHWIDEFSKY, K., *An Outline of Photogrammetry* (Pitman).

15. TROREY, L. G., *Handbook of Aerial Mapping* (Cambridge University Press).

16. ZELLER, M., *Textbook of Photogrammetry* (H. K. Lewis).

Some of the above books are no longer in print, but are available in reference libraries.

Periodical Journals

1. *Photogrammetria*: Organe officiel de la Société Internationale de Photogrammetrie. Published quarterly by N. V. Uitgeverij of Amsterdam (many of the articles are in English).

2. *Photogrammetric Record*. Published twice yearly by the Photogrammetric Society, London.

3. *Photogrammetric Engineering*. Published every other month by the American Society of Photogrammetry.

4. *Cartographic Journal*. Published twice yearly by the British Cartographic Society.

It would be misleading to refer the reader to specific articles in these periodicals, since articles written after this book obviously could not be included, and it is precisely these which would be most up to date, and therefore most useful. The *International Bibliography of Photogrammetry* is produced by the I.T.C., 3 Kanaalweg, Delft, Holland, and forms a complete reference system for the whole subject.

Index

The page numbers in parentheses refer to the illustrations appearing on those pages.